Roger Fry Art and Life

By the same author

Whistler
Magnificent Dreams:
Burne-Jones and the Late Victorians

ROGER FRY

Art and Life

Frances Spalding

LIBRARY ST. MARY'S COLLEGE
University of California Press
Berkeley and Los Angeles

University of California Press
Berkeley and Los Angeles

Designed by Harold Bartram

Printed in Great Britain by
Unwin Brothers Limited,
The Gresham Press, Old Woking, Surrey

Library of Congress Catalog Card Number: 79-3607

ISBN 0-520-04126-7

Contents

For Pamela

Preface

It has always been easier to talk about art in relation to society, religion, psychology, economics or history, than to talk about the work of art itself. Even today a large section of the community shies away from art that is abstract or which does not present an immediately recognisable subject. As art education in England ends the moment a child gives up practical involvement in the subject, the ability to understand the language of art remains sadly undeveloped because it is hardly ever taught. The most central lesson behind Roger Fry's career is that art is democratic in the experience it offers; the springboard into its meaning is not erudition or accumulated past experience but simply a mind open and an eye alert to the conglomerate of shapes, lines and colours presented. This approach does not embrace the wider social issues that cluster around art; for Fry the question of where and when a work was produced had only subsidiary interest and did not affect the aesthetic emotion aroused. Aesthetic experience, in itself, had for him a value almost beyond measure as he once admitted. 'I am the victim of a perhaps quite absurd faith, – the faith, namely, that the aesthetic pursuit is as important in the long run for mankind as the search for truth.'[1]

Today the aesthetic realignment that Fry taught is more necessary than ever before. The crisis in modern art, the breakdown of modernism and the dispersal of the avant-garde into a variety of media has revealed a failure of nerve and a loss of belief in the communicative effectiveness of art. Certain influential critics and established artists have stated publicly their doubts about the value of abstract art thus disregarding some of the greatest artistic achievements of this century. Fry's belief that art is essentially the product of passionate disinterestedness is diametrically opposed to one current view which finds the concept of the artist's freedom a romantic myth perpetrated by the bourgeoisie to disguise the fact that modern society has removed from the artist his potential effectiveness and left him socially redundant. The consequent demand for a new 'social' art which will contribute towards the making of a more egalitarian society is comparable, in its pedagogic intent, to Ruskin's belief that art should act as a moral directive. Both theories attempt to limit the function of art and are in danger of preventing fresh experience from renewing its language and extending its boundaries. Fry, on the other hand, categorically stated, 'I have never believed that I knew what was the ultimate nature of art. My aesthetic has been a purely practical one, a tentative expedient, an attempt to reduce to some

[1]*Architectural Heresies of a Painter.* (London: Chatto and Windus 1921) p.47.

kind of order my aesthetic impressions up to date. It has been held merely until such time as fresh experiences might confirm or modify it.'[2] This pragmatic approach grew out of his own experience of the practical difficulties encountered by the artist and out of his profound respect for art's capacity to universalise individual expression. And, as art is unpredictable, difficult to pin down and, like the phoenix, continually rises from its own ashes with life renewed, this open-ended approach seems in the long run more likely to capture a broader truth in that the theory is deduced from the art and not imposed upon it.

My own interest in Roger Fry dates from the 1969 Arts Council touring exhibition 'Portraits by Duncan Grant' which, when shown at Nottingham, was hung in chronological order. As one moved around the room the change from the carefully executed, naturalistic Edwardian portraits to the Post-Impressionist paintings of the 1910–14 period was sudden and dramatic. What had caused this young painter to change his direction almost overnight and abandon skill and finish in favour of bright colour and broken brushwork? The answer, simply, was Roger Fry's Post-Impressionist Exhibition of 1910, the impact of which was reinforced by the Second Post-Impressionist Exhibition held two years later. The man who had caused this stir and excitement, made visibly apparent in Grant's paintings, caught my attention and the more I read the more fascinated I became by his energy, enthusiasm and insight, which had brought about the birth of modern art in England.

Five years later I began work for a doctoral thesis on Roger Fry. My research into the various aspects of his career involved a fairly extensive programme of travel, in England, America and France, during the course of which I was shown an extraordinary range of Roger Fry paintings which confirmed the adventurous nature of his mind. As most of these paintings still belonged to the original owners, more often than not friends or relations of Roger Fry, I rarely saw a painting without also being the recipient of several anecdotes and lengthy reminiscence. Meanwhile I found his letters, books and unpublished lecture notes a stimulating store of ideas illuminating the meaning and value of both art and life. He had, as Virginia Woolf observed, the capacity to go beneath the surface and relate the particular example to some general idea. Moreover, his constant re-examination of his opinions and theories emphasised the value of doubt and intellectual honesty. Growing fascination with his personality led eventually to the decision to extend my thesis into a general account of his life and work.

Soon after my research began, I was granted access to Roger Fry's letters, then still in the possession of his daughter, and only a selection of which had been included in Denys Sutton's *Letters of Roger Fry* (1972). Certain of the early letters to his mother and father were still tied up in neat bundles according to year and out of each of these fell a card on which was written in Virginia Woolf's spidery script the main

[2]*Vision and Design.* (London: Chatto and Windus, 1920) p.188

events of each year. Under the heading 1894, for instance, I read, 'Harris. Painting. Lecturing. Italy.' These unsystematic notes (she was clearly *not* the victim of a chaotic, unmanageable card-index system) seemed lucid and reassuring, but Virginia Woolf's biography of Roger Fry at first discouraged my idea to rewrite his life. For though it is not generally considered to be among her best works, few are likely to disagree with her own opinion on it, which she confided to her diary after the biography was complete: 'I can't help thinking that I've caught a good deal of that iridescent man in my oh so laborious butterfly net.'[3]

Virginia Woolf's biography presents the reader with an insider's view. Her respect for Roger Fry's mental agility, her friendship with him and familiarity with the greater part of his life gave her a natural insight into her subject. But since 1940, when her biography was published, considerable new material has come to light and the reader will find here aspects of Fry's life which Virginia Woolf, through either reticence or lack of information, did not investigate. She was reticent, for example, about Roger Fry's adulterous relationship with her sister Vanessa Bell, thus sliding over the great passion of his life. Nor could she quote his letters to herself praising her novels, though these throw light on his literary interests. She clearly lacked certain information on Fry's friendship with the Widdrington family, with Bernard Berenson and Lady Ottoline Morrell. Added to this her closeness to the centre of his being, at times brilliantly caught in her vibrant prose, weighed against a more detached assessment of the exact position that he occupied, as a painter, a highly influential critic, as the organiser of the Omega Workshops and the instigator of various exhibitions and artists' groups.

The decision here to weave together the life and work is justified by the fact that for Roger Fry there was no separation between the two: his multi-faceted life grew directly out of the variety of his interests and activities. At times, in order to clarify the development of his aesthetic ideas and his achievements at the Omega, it has been necessary to step outside a strict chronological ordering of events, though for the greater part of the book my aim has been to interweave the various strands in Fry's life in order to create the impression of his fertile, generous and energetic nature. His wide frame of reference gave breadth and experience to his criticism, but it inevitably detracted from his success as a painter. Around 1930, after a visit Fry made to her home, Vanessa Bell wrote a telling description of him to her husband Clive. 'How he survives his existence I cannot think but he seems remarkably well. As soon as he gets here the telephone begins to go. Sibyl [Colefax] and her like pursue him all day and then he has articles and lectures and wireless and obituary notices to do by the dozen. . . . It's no wonder he can't paint.'[4]

Up to the end of his life, however, Fry continued to regard painting as his primary activity and wanted first and foremost to leave the imprint

[3] *A Writer's Diary*. (London: Hogarth Press 1954) p.326
[4] Vanessa Bell to Clive Bell, no date [c.1930], Charleston Papers, King's College, Cambridge.

of his mind in paint. His struggle as an artist was the other side of the coin to his success as a critic. One intent behind this book has been to bring out this aspect of his career, to underline the extent of his experiments and to show that his distrust of rhetoric led to a love of the quiet presentation of an underlying order inherent in the natural world. Fry left a considerable body of work and at his best his paintings strike a note of classical harmony and resolution that will in time earn him a distinct position in the history of British art.

Yet today the force of Roger Fry's character, which so impressed his contemporaries, is not fully apparent in either his paintings or writings. Indeed, if we confine our attention to his separate contributions in various fields, we fail to locate the real significance of his achievement. For Fry's creativity was not confined to any one area but embraced life as a whole. He had, it seems, a kind of genius for living combining boundless energy with alert sensibility, impulsiveness, ruthlessness, irreverence and profound belief, an intoxicating sense of fun with an underlying seriousness. Above all, he was a passionate man and his enthusiasms inevitably laid him open to ridicule and the accusation of naivety. The reader is fortunately spared the gradual fossilizing of the creative man into the respected myth and the paralysis that sometimes accompanies fame and prestige. Fry in old age was seemingly more active than ever before, still testing new ideas and examining his previous convictions, more resilient and ebullient than ever.

I am indebted to many people for generous help with the writing of this book. But without the help, understanding and enthusiastic support of Roger Fry's daughter, Mrs Pamela Diamand, it might never have been completed. Her willingness to let me pore over his letters, note-books, sketch books, photographs, oil-sketches and all sorts of memorabilia was invaluable. Our lengthy conversations not only illuminated unexpected corners of Roger Fry's life and character but taught me much else besides. The gradual accumulation of material for a biography is an enriching experience and the biographer's chief hope is that something of this experience is rediscoverable in the final book.

Acknowledgements

I wish to express my gratitude to the following people for their help with the writing of this book:

Mrs Noel Adeney; Sir Geoffrey Agnew; Mrs Tanya Alexander; Mrs Helena Aldiss; Mr Cecil Anrep; Dr and Mrs Igor Anrep; Mrs Barbara Bagenal; Captain J. Baker-Cresswell; Dr Wendy Baron; the late Keith Baynes; Professor and Mrs Quentin Bell; Mr Alan Bennett; Mrs Amber Blanco White; Mr E. Booth-Clibborn; Professor Alan Bowness; Professor Richard Braithwaite; Mr John Brealey; The Lord Bridges; Dr Trevor Brighton; Dr Penelope Bulloch; Mr Duine Campbell; Miss Louise Campbell; Mr and Mrs Richard Carline; Lady Chance; Mr and Mrs A. J. Clark; Mr Bancroft Clark; Lord Clark; Professor William Coldstream; Mrs Annabel Cole; Miss Judith Collins; Mme Dolores Courtney; Mr Alan Crawford; Mr Peter Croft; Mrs A. Crowdy; the late Mrs Elizabeth Daryush; Dr Roger Diamand; Mr Anthony D'Offay; Dr Malcolm Easton; Mr Christopher Eastwood; Miss Caroline Elsam; Miss Mary Fedden; Mr Julian Fry; Mrs Margaret Fry; Mr Peter Garner; Mrs Angelica Garnett; Professor Kenneth Graham; the late Duncan Grant; Miss Janet Green; Mrs F. L. Hadsell; Dr John Haffenden; Mr Martin Harrison; the late Mrs Joy Hedger; Mr Carol Hogben; Mr Jeremy Hutchinson; Lady Keynes; Dr Milo Keynes; Mrs Richard King; Dr Mary Lago; Professor Donald Laing; Mrs Diana Brinton-Lee; Mrs Meirlys Lewis; Mr Peter Lucas; Mrs Michael MacCarthy; Dr Eric Mackerness; Mme Alice Mauron; Mme Marie Mauron; Mr L. S. Michael; Mr Richard Morphet; Mr Raymond Mortimer; the late Dr A. N. L. Munby; Mrs Elizabeth Noble; Miss Lucy Norton; Mr G. N. Parry; Professor Ronald Pickvance; Lady Ponsonby; Mrs A. C. Pryor; Miss Marjorie Rackstraw; Professor Philip Rieff; Mr George Riley; Mr and Mrs E. Robinson; Miss Daphne Sanger; Mr Richard Shone; Mr Reresby Sitwell; Professor Alistair Smart; Miss Constance Babington-Smith; Mr Ian Stephens; Mr Denys Sutton; Dr Ann Synge; Mrs Betty Taber; the late Sir Charles Tennyson; Mr Malcolm Thomas; Mrs Chloë Tyner; Sir George Trevelyan; Mr Julian Trevelyan; Mr Philip Troutman; Mr and Mrs Van der Gaag; Mme René Varin; Dame Janet Vaughan; Mr Michael de Vere; Mrs Julian Vinogradoff; Mrs Alison Waley; M. François Walter; Mr Simon Watney; the late Dr Walter Muir Whitehill; Captain Francis Widdrington; Mr Edward Wolfe; Dr Sau-Ling Wong; Mr John Woodeson; Lady Younger.

I am most grateful to the following for giving me permission to quote from copyright sources: Miss Felicity Ashbee for extracts from C. R.

Ashbee's unpublished journals; Mrs Angelica Garnett for letters by Clive and Vanessa Bell; Professor Quentin Bell for extracts from a Vanessa Bell Memoir; Sir John Rothenstein and Mr Michael Rothenstein for letters by Sir William Rothenstein; Captain J. Baker-Cresswell for letters by Ida Widdrington; Captain Francis Widdrington for Mrs Cecilia Widdrington's diary; the Society of Authors on behalf of the George Bernard Shaw Estate for letters by Bernard Shaw (© The Bernard Shaw texts 1980, The Trustees of the British Museum, The Governors and Guardians of the National Gallery of Ireland and Royal Academy of Dramatic Art); Mrs Pamela Diamand for unpublished letters, notebooks and lecture notes by Roger Fry; Mrs Julian Vinogradoff for letters by Lady Ottoline Morrell; Mrs Pamela Diamand and Chatto and Windus for quotations from Roger Fry's *Vision and Design, Architectural Heresies of a Painter, Transformations, French, Flemish and British Art* and *The Letters of Roger Fry* edited by Denys Sutton, and to the Hogarth Press for quotations from Fry's *The Artist and Psychoanalysis, A Sampler of Castile* and *Cézanne: A Study of His Development*; to the Author's Literary Estate and the Hogarth Press for quotations from the following works by Virginia Woolf: *Roger Fry. A Biography, A Writer's Diary, The Flight of the Mind. The Letters of Virginia Woolf. Volume I, A Change of Perspective. The Letters of Virginia Woolf. Volume III*, and *The Diary of Virginia Woolf Volumes I and II*.

I would like to acknowledge the assistance I received from various libraries, in particular the American Archives of Art; the British Library; Houghton Library, Harvard University; Humanities Research Centre, University of Texas; King's College Library, Cambridge; Trinity College Library, Cambridge; J. Pierpont Morgan Library, New York; University College Library, University of London; Victoria and Albert Museum Library; Sheffield City Reference Library. I owe a similar debt to the staff of various public art galleries and educational institutions for giving me access to Roger Fry paintings in their possession. These are too numerous to list but I would like especially to thank the staff of the Metropolitan Museum of Art, New York; Mr Jo Rishel, Curator of the Johnson Collection, Philadelphia Museum of Art; Mr Philip Troutman, Curator of the Courtauld Institute Galleries, London; Mr Arthur Butterworth, Warden of University House, Birmingham.

My personal debt to Mrs Pamela Diamand is recorded elsewhere. To my parents-in-law, Mr and Mrs Peter Spalding, I am indebted for both help with the typing of the manuscript and for critical advice; Richard Morphet's enthusiasm for Bloomsbury painting gave me considerable encouragement and Richard Shone kindly answered several of my questions at an early stage; David Brown temporarily abandoned his 'cello and produced immaculate photographs of certain paintings for illustration, and Mrs Maureen Daly took up the manuscript in its final form and typed it with great speed and care. I am greatly indebted to Sheffield City Polytechnic for the research assistantship which began my study of Roger Fry's life and career, and for their financial assistance with

travel. My thanks go also to my editors at Paul Elek, Ann Dumas and Moira Johnston, and to my husband Julian for his forbearance during my repeated disappearances in chase after the elusive Mr Fry, and for drawing the illustrations to the chapter headings.

List of Illustrations

1 A Life Apart

Towards the end of his life, Roger Fry, seeking in his memory for his first conscious impression, resurrected the image of two almost square patches of light filled in the lower part with a moving green blur. These abstract shapes soon crystallised for the child into the nursery windows at the top of the house, No. 6 The Grove, Highgate, with their view out on to the lime trees lining the avenue below. On winter evenings, when the muffin man's bell could be heard in the street, the lamps in the nursery were lit well before the five o'clock tea and the falling dusk threw into contrast the protected security of the gas-lit room. Here Roger Fry first experienced intense emotion, suffering in particular from fear of his Calvinistic nurse and jealousy of his younger twin sisters who seemed forever crawling after his most treasured possessions. Yet in his memory the room was dominated not by any of the activities that went on around him, but by the presence of the trees outside. These taught him an awareness of time passing and helped fix the seasons in his mind. He recalled: 'All the changes of the lime trees from bare branches to red buds, pale green, dark green, yellow, were friendly and delightful, but almost all sentiments of awe go back for me to the anticipatory shudder of white upturned leaves against the blue black of an oncoming storm.'[1]

No. 6 The Grove was a substantial, prestigious house, one of six built in pairs by the merchant William Blake shortly after the Fire of London. Blake intended to use the rent received from these houses to fund his

1

nearby Lady's Charity School and to maintain the Elizabethan Dorchester House, in whose grounds they had been built, as a hostel for deprived children. The six houses had been built, if not completed, by 1688 by which time Blake's charitable zeal had far outstripped his financial resources and he was imprisoned in the Fleet for debt. The Grove, however, continued to prosper, attracting high class residents and earning for itself the passing nickname 'Quality Walk'. In 1863 the lawyer Edward Fry took over the lease of No. 6 from a Francis Smith who had personally planted certain of the younger trees that line the old suburban street. All this time the land on which the six houses stood had belonged to the Manor of Cantlowes, but in 1866 it was enfranchised. In that same year a second son was born to the occupants of No. 6, whom they named Roger Eliot Fry.

1 No. 6, The Grove, Highgate. Photograph

This solid, red-brick house bounded the first six years of Roger Fry's life: its ample but restrained proportions set a standard of elegance he was never to forget and its garden became for him the imagined setting of any that he read about in books. Down one side still runs a herbaceous border in front of an ancient wall (originally the boundary wall of the garden of Dorchester House), and in between the climbing plants that cling to the crumbling brick can be seen traces of niches and a doorway that once served as a garden exit. The garden is not large and at the far end a buttress wall creates a semi-circular bastion from which one can look down a drop of about sixteen feet into the garden of No. 5 which continues on beyond and below that of No. 6. The Fry children envied this extra space which was soon, however, to be theirs for in 1872 Edward Fry moved his family into the larger house next door. But it was the garden of No. 6 that remained in Roger Fry's childhood memory as something almost paradisial, apart. Looking out from the bastion towards Kenwood over the acres of parkland, the onlooker has the illusion of being in the heart of the country. 'It was a little plot', Edward Fry recalled in his memoir,

' "Not wholly in the busy world not quite
Beyond it."

And murmurs from the great city below us often stole up the hill and reminded us how near we were to the great heart of things.'[2]

Aside from the house, with its restrained wealth and lofty position, Roger Fry's early life was set apart from the rest of the world for another reason: behind him on both sides of his family lay seven generations of Quakers. Devout beliefs, ascetic habits, a rigorous life-style, fortified by the custom of holding regular meetings and intermarriage (compulsory until 1859), combined with the accumulated weight of their shared history – their trades, travels and sufferings – gave the Quakers an extraordinary cohesiveness. To be born into a Quaker family was to discover oneself part of an exclusive family network, high-minded but decidedly prosperous. The emphasis on simplicity and dignity and the distrust of entertainment and ostentation encouraged an austere cast of mind and even those who, like Roger Fry, rejected the Quaker faith, could not escape the influence of these firmly-held customs and beliefs.

The Fry family became associated with the Quaker movement soon after young preachers, inspired by the example of George Fox, brought the message to Wiltshire in the 1650's. After a spiritual revelation in 1646, Fox had begun preaching 'that of God in every man', declaring that the soul could communicate with God without the mediation of a priest. During the early years of the movement, the Society of Friends, as they called themselves, or Quakers, as they were at first disparagingly nicknamed, suffered much persecution. A record of one meeting held in the home of William Fry (1627–98), the father of Zephaniah (1658–1728), the first recorded Quaker in the Fry family, is given in George Fox's Journals:

'At ... Frye's in Wiltshire we had a very blessed meeting and quiet, though the officers had purposed to break it up, and were on their way in order thereunto. But before they got to it, word was brought them, that there was a house just broken up by thieves, and they were required to go back again with speed, to search after and pursue them; by which our meeting escaped disturbance and we were preserved out of their hands.'[3]

Meetings for worship of more than five persons were forbidden by the Conventicle Act, and, once arrested, Quakers could be ordered to take the oath of allegiance. As they followed literally the command 'Swear not at all', they were bound to refuse. In this way Zephaniah Fry was arrested in 1683 and sent to Ilchester Gaol for three months, a fairly mild punishment then, when a man could be committed to prison indefinitely.

Zephaniah Fry emerged from Ilchester Gaol unscarred. Three years later he married Jane Smith, continued living in the family's village in Wiltshire, Sutton Benger, and fathered eight children. Their youngest son, John (1701–75), who was something of a poet, described his parents as 'industrious, frugal, pious', and when he moved to London at the age of thirteen or fourteen, probably to take up an apprenticeship, he received letters from his father warning him against 'Vain fashion and foolish Discourse', urging him 'Not to lose one Meeting by going to walk with any of thy neighbours, with their enticings'.[4] John Fry disliked London but remained there until around 1726, the year he married Mary, daughter of Joseph Storrs of Chesterfield. He was only twenty-five years old but from some verses he wrote, entitled 'A Resolution Realised', it appears he had already made his fortune and presently retired from business. Neither the source of his fortune nor the nature of his business are known, but it seems probable that while other Quakers lost huge sums of money in the South Sea Bubble, John Fry may have taken his money out in time. Another possibility is that he took shares in a ship and after a successful voyage found himself suddenly a rich man.

With his wife, John Fry returned to Sutton Benger where he built a small house, carved their initials over the door, fathered six children, employed one servant, and enjoyed to the end of his days a quiet, rural life. He was active, however, in the unpaid ministry of the Society of Friends and with his verse.

'And what Time I don't in my Duty employ,
With my Garden, by Books and my Pen I enjoy,
Save in Rides and in Walks; and I then contemplate
How seldom such favours are known by the Great.'[5]

This genial character was surprised that three of his four sons should leave the peace of the countryside for Bristol and London; but from now on a certain trend continues to appear in the Fry family: astute,

analytical minds are turned to the development of industries and to the accumulation of wealth. As Quakers refused to take oaths, the older English universities and larger trade guilds were closed to them; therefore the intelligent among them turned instead to business, where their intellectual gifts encouraged experimentation, their distrust of diversion prevented distraction, and their belief in the equality of all men ensured good relations between employer and employee. At the same time the gradual increase in the general standard of living created a need for the smaller domestic commodities – soap, biscuits, tea, shoes and chocolate. Thus the combination of interior qualities developed by Quakerism and exterior social and economic factors resulted in the steady accumulation of Quaker wealth. And, as Agnes Fry noted in her memoir of Sir Edward Fry, 'The tranquil lives of its members gave them a longevity which was marked enough to affect their life insurances.'[6]

John Fry's eldest son Joseph (1728–87) began his career as an apothecary in Bristol, but ended his life having established five considerable businesses – a china works, a soap-boiling firm, a chemical works, a firm of type-founders, as well as initial experiments in chocolate-making. His son, Joseph Storrs Fry (1767–1833) built a factory in Union Street, Bristol and turned the chocolate-making experiment into a serious enterprise which descended via his three sons into the hands of his grandson, another Joseph Storrs Fry (1826–1913). This Joseph Fry transformed a small but profitable concern in which fifty-six workers were employed into a flourishing modern business with a work-force of three thousand employees. His success can partly be attributed to his paternalistic management: every applicant was interviewed by him personally; all the workers were given a regular allowance in case of illness and when illness struck he himself visited them in their home or hospital. One daily activity that brought him regularly face to face with his men was the Bible-reading and hymn-singing which he led. Unknown to himself (and only discovered after his death) he became a millionaire, and Roger Fry was one of his thirty-seven nephews and nieces to benefit substantially from his will.

Joseph Fry's reaction to this steady increase in wealth tells us much about the Quaker ethos. He refused to discard his Quaker dress, but all his life wore the wide-brimmed hat, the collarless swallow-tail coat, high shirt-collar, black tie, and Wellington boots. Indeed his only distinguishing features were his white hands lined with blue veins and his tendency to emit a chuckling laugh. He was devoted to the Society of Friends, acted as a leading Minister, spoke frequently at meetings and for almost twenty years performed as Clerk to the Yearly Meetings, the most important post in that democratic society. He was deeply committed to several religious and philanthropic concerns, making financial contributions to this aspect of Bristol's life that were both generous and unostentatious. But his own personal habits remained always exceedingly simple: when in 1890 the landlord wanted to sell the house in which he was living, he moved into a single room in Upper Belgrave Road, where

he remained quite happily, finally buying the house and arranging that the housekeeper and his wife should stay on in his employment. He never married but lived the greater part of his life with his talkative, intelligent mother, who made very good company. She lived to be eighty-nine and at the family gathering after her funeral, Joseph Storrs Fry, then a man of sixty, broke down and wept.

2 Sir Edward Fry.
Photograph

At school Joseph and his brother Edward had been considered equally gifted, but as their characters developed Roger Fry's father revealed a more severe, forbidding and greater intellect. Slightly shorter than his brother, Edward Fry had dark, deep-set eyes which retained their unusual brilliancy to old age. He very soon looked distinguished; his hair was quite white by the age of thirty and he had a smooth, sonorous voice and a grave courteous manner. He, too, first directed his abilities towards the business world and was apprenticed to a firm of accountants and then to a firm of sugar brokers and commission merchants, but soon

realised that commercial life did not suit him and in his free hours he educated himself in a number of fields. Once decided on law, his career was one of notable success: he was made a judge in 1877 and simultaneously knighted, and in 1883 became a Lord Justice of Appeal. He was responsible for a number of legal reforms, including the revision of the Judicature Acts and in his own field was widely respected, the only criticism being that his severely logical mind tended to induce too technical a view of the law and a corresponding lack of leniency. Quite

3 Lady Mariabella
Fry. Photograph

early in his career he had found his personal prophet in Thomas Arnold, when he came across Arnold's *Life* by A. P. Stanley. Arnold's Christianity left a deep impression on his mind and he went on to read his history books, lectures and sermons, and throughout his life returned to his writings when in need of moral rearmament. After Sir Edward's death, Roger Fry declared: 'My father leaned on Dr Arnold almost as much as Cézanne did on Rome'.[7]

Being a devout Christian, Sir Edward believed that his marriage in April 1859 to Mariabella Hodgkin had been guided by Divine Providence. Certainly he had found in Mariabella a character well able to uphold and confirm his severe ideals. Descended from the Eliots and the Howards, and the daughter of John and Elizabeth Hodgkin of Lewes, her most notable ancestor was Luke Howard, whose early attempts to classify clouds became the basis of all subsequent work in this field and incidentally earned him the praise of both Constable and Goethe. Mariabella's handsome appearance, her wedge-shaped nose and compressed lips denoted an imperious nature. As the traditional dress for Quaker women could be easily adapted to cope with frequent childbirth, Mariabella, following custom, bore nine children at such regular intervals that duty rather than passion is suggested. She then turned her tenacious will on the problems of childrearing and housekeeping. For instance, at Failand, their country house, the children were always made to use the back staircase, a rule that did not cease to apply even when they reached adulthood. Her rigorous practicality with regard to the wear and tear of

4 Roger Fry as a young boy. Photograph

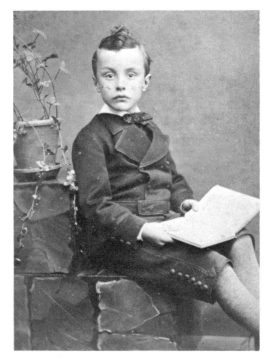

the front stair carpet can also be discerned in her advice to her cousin May Pease, about to become Warden of a university hostel: 'Give the maids boiled bacon it goes so much further.'

The young Roger, naturally closer as a child to his mother than his father, regarded Mariabella with a mixture of utter devotion and troubled awe. Being excessively anxious to please her, he suffered severe confusion when, acting as he thought on her instruction, he picked a poppy in the garden and was severely reprimanded. Maternal love mingled in Mariabella with her desire to instil into her children iron self-discipline and Roger later felt that he had been 'drilled to implicit obedience' by his mother.[8]

Home life for the Fry children was therefore austere and full of high principles; there was very little gaiety, affection or fun. One severe test was the weekly attendance at the Friends' Meeting House (either at Holloway or Westminster) because the meetings lasted, mainly in silence, for two hours. The children, aware that they were out of the 'top drawer', were imbued with the sense that, given their position, their lives should be directed towards the improvement of society. The Fry girls, to whom this also applied, nevertheless found themselves in a vacuum: not only were they cut off from worldly society by their religion, which forbade dancing, music and theatre, but Sir Edward and Lady Fry also disapproved of them mixing with the rest of the Quaker community and, though presented at court, there was no question of their being 'brought out'. Other Quaker families referred to them as 'those poor Fry girls' and even their cousins regarded them as blue-stockings because of the scientific and intellectual interests which had been awakened in them by their father. Together Sir Edward and Lady Fry successfully thwarted any suitors that Roger Fry's six sisters (a seventh died at the age of four) might have had: Mab, the eldest, was once spoken for by a doctor but after half an hour in Sir Edward's library he was never seen again; Isabel's request to be allowed to study at Cambridge met with Lady Fry's reply that she might then have the misfortune to marry one of Roger's friends and, as it was, her father's dinner-table conversation provided her with ample education; Agnes, who suffered from deafness, never succeeded in breaking away from home until after Lady Fry's death, and then in her sixties, she informed her companion what pleasure it gave her to be able to poke her own fire. Imprisoned in moral and religious sanctity, none of Roger Fry's sisters ever married. They did, however, develop strong characters and four of them were to distinguish themselves in public life, but it was perhaps with his sisters' plight in mind that Roger Fry later declared his parents' values had shown 'a want of simple humanity'.[9]

Throughout Roger Fry's childhood and schooldays the emphasis was always on science. Sir Edward himself would have liked to have pursued a scientific career at either Oxford or Cambridge but the religious tests then imposed on all entrants prevented him from doing so; his childhood interests in botany and entomology had developed in his teens, leading

him to publish two papers with the London Zoological Society. All his life he continued to be fascinated by science and before setting out for the Law Courts each morning, for a statutory half hour, he read aloud passages from scientific books to his children. Unlike most Victorians he felt no fear as to what science might reveal because he felt the tendency of its discoveries was to lead towards sublime spirituality, towards, as he put it, 'the belief that all matter is force and all force is mind'.[10] With his Highgate neighbour, Charles Tomlinson, a Fellow of the Royal Society, he obtained great pleasure from their scientific discussions, which took place every Sunday evening with the Fry children attending in silence.

Sir Edward's desire to cultivate these latent interests caused him to retire promptly on reaching sixty-five. His legal abilities were, however, by no means forgotten and his remaining twenty-six years were extremely active. As well as acting as Arbitrator in international disagreements, presiding over such vital events as the Second Hague Conference of 1907, the Casa Blanca dispute of 1909, he continued to play a part in legal affairs in and around Bristol and helped to establish the University of London as a teaching institution and not just as an examining body. And yet, in spite of this notable climax to an already highly distinguished career, one could hazard a guess that none of these occupations brought him as much satisfaction as his garden at Failand.

Failand House, situated in a small hamlet of the same name in the parish of Wraxall, about four miles from Clifton Suspension Bridge, had been purchased by Sir Edward in 1874. The Fry family holidayed there in 1875 and from then on regarded the Queen Anne house as their summer home. Surveying the two hundred acres which he bought with the house, and in particular Durbin's Batch – his wife maintained that he bought the place for that one field, – Sir Edward came to believe that in nature there was spiritual being, a spirit speaking to the spirit in man. Certainly, the view from the house, which stands four hundred feet above sea level, is exceptional; it looks out over the junction of the Avon and the Severn to the Welsh hills beyond, the panorama continuously changing with the variation of the tides, the shifting light and shadow, and the various seasons. As soon as he retired, Sir Edward made Failand his permanent home. He added a veranda of Bath stone and a library to house his four thousand books. He turned to his son, Roger, for advice on the hall panelling and on the size and shape of the wooden archway added to the hall. Three pairs of wrought iron gates were made for the garden to his son's design, one pair incorporating his and his wife's initials. To the garden, he added a small plantation of pine trees and a straight walk tiled with red bricks, lined with well-kept turf and a herbaceous border, leading to a small pond presided over by Diana the huntress. With the aid of his chief gardener, David Williams, a man who was well informed in local botany, he cultivated rare weeds and when abroad attending the arbitration on the Dogger Bank Incident he wrote home of his longing to return to the place he owned: 'I confess

that I often long for a stroll in the fields or in the Batch, for I have not seen a moss or a myxie [mycetozoa] or a fungus since I left Failand.'[11]

Roger Fry's earliest interests were directed by his father's enthusiams. Like Sir Edward, he soon learnt to become passionately absorbed in a small patch of stone wall for the varieties of moss or lichen it might contain. His earliest letters to his father discuss the rare plants he has discovered and the results of his scientific experiments made at school. He also shared his father's love of skating, enjoying it less for the exercise than for the opportunity of seeing his dignified father relatively unbuttoned. 'He skated rather badly', Roger later recalled, 'at least it was an odd style or absence of style, the way he scuttered along with legs and arms and long black coat tails flying out at all angles and the inevitable top hat to crown it all.'[12] The memory was not entirely happy as these occasions also brought the young boy into contact with the unemployed men who hung around the pond, doing odd jobs such as mending skates, in the hope of a tip. These men troubled Roger Fry as his Quaker upbringing had led him to believe that wealth was directly related to virtue and honest labour. To be so obviously poor these men, he thought, must belong to the criminal species. The Fry children did not, therefore, tip them, believing that tips carried with them the tinge of corruption and that this action would only support the men in their immorality, and were pained, on leaving, to hear a volley of abuse hurled at their backs.

On one occasion Roger Fry accompanied his father to court as the suit related to the recent discovery of the telephone and various experiments were performed in court to prove technical points, especially the power of conveying the human voice. One of the electricians, observing the boy's intense interest, gave him a length of wire to take home and make an electric light. When Sir Edward heard of the gift that same evening, he would not hear of his son keeping it and the following day the young boy had to accompany his father back to court in order to return it. (Sir Edward had an intense hatred of corruption and anything remotely akin to a bribe had to be firmly rejected.) Indeed, Sir Edward's intellectual acuity, combined with his feeling for honesty and justice, and his hatred of sloppy thinking, must have sharpened his son's responses at an early age. Old age in no way diminished Sir Edward's mental activity, for though during the last three years of his life he was blind and confined to bed as the result of a stroke, he was capable of entering into a long discussion with his friend C. P. Sanger on the effects of war on the legal conception of contract, and without any loss of attention listened as his wife or one of his daughters read him Lockhart's ten volume *Life of Scott*.

While science and intellect ruled in the Fry household, art received only passing attention. Roger Fry's awareness of art, as a child, was confined to the annual visit to the Royal Academy, to a visit to the National Gallery, and to school lectures on Greek art, some of them given by the classical scholar, Miss Jane Harrison. The family friend

Charles Tomlinson, who instigated the visit to the National Gallery, also took the Fry children around a number of factories and discussed with them what made good or bad design, what ornament was justified and whether diamonds were not better employed when used in machinery than in necklaces. On the practical side, the Fry children were given drawing lessons by a Mr Frazer, who taught them how to draw various types of trees and spiced the routine of his lessons with stories of his experiences in the Franco-Prussian war. Roger Fry's early interest in watercolour painting received encouragement from his mother, who was a fairly skilled topographical watercolourist in her own right, as was her sister, Aunt Bessie. Fry used his skill in this medium to record the house and garden at 5 The Grove, Highgate, in 1887, and must have been pleased with the result as he inscribed, monogrammed and dated it in one corner.

Through his Aunt Bessie, Roger Fry came into contact with the fashionable taste of the 1880s for she was married to one of the leading Gothic revival architects, Alfred Waterhouse, who had made his reputation by winning the competition for the design of the Manchester Town Hall in 1867–8. In their house at Yattendon, near Newbury, the 'Gothic' was mixed with the 'aesthetic' taste of the day – involving arched windows, stained glass and endless pitch-pine and black polished wood. Sensing its deference to fashion, the Fry children disliked the décor and regarded it as something to be distrusted. Alfred Waterhouse was himself a skilled watercolourist specialising in architectural scenes and he actively encouraged his nephew's talents and helped develop his love of Gothic architecture. On one of his visits to the home of his aunt and uncle, the young Roger Fry wrote to his mother, 'I have not done much sketching but have watched Uncle's, which is perhaps better. He is doing a very large and fine picture of the doorway of Chartres Cathedral'.[13]

At home the young Roger Fry felt menaced by an excess of sisters. His only brother, Portsmouth, of whom it was said that he failed to obtain a First at Oxford because of a streak of facetiousness, was six years his senior. Soon after leaving Oxford he fell while climbing in Switzerland and was consequently afflicted by a gradual paralysis which also affected his mental life, a deterioration that set in just when Roger was in need of the advice and companionship of an elder brother. Sir Edward, who had already suffered bitterly at the death of his daughter Alice, was hard hit by this tragedy and now transferred all his hopes for that brilliant scientific career, which he himself had not enjoyed, to his younger son.

At the age of eleven, Roger Fry's formal education began. He was sent, with very little warning, to Sunninghill House, St George's School, Ascot, a school run by a Mr Sneyd-Kynnersley, a tall, thin man who sported an immense pair of whiskers, dressed with great elegance, boasted aristocratic connections and in other ways revealed an undeveloped mind. The school was not, however, badly run; no rigorous code

of behaviour was imposed on the boys, but misdemeanours were severely punished. Weekly floggings were a standard event and Fry, because of his position as first or second in the school, was forced to be present. These repulsed him deeply, as Virginia Woolf recounts, and a horror of violence remained with him all his life.

As a schoolboy Roger Fry began his lengthy, regular correspondence with his parents and these letters provide the earliest glimpse into his character. He was a delicate child, suffering almost continuously from headaches, chilblains and colds. Added to this he was pathetically attached to his mother, genuinely upset if he thought his letter had failed to reach her on time, and under considerable emotional and moral pressure due to her influence. Thus while his letters burst with excited descriptions of firework displays, paper-chases and visits to the Huntley and Palmer biscuit factory at Reading, they also bring out his excessive anxiety about right and wrong. He would wake early each morning in order to read the Bible and would beg his mother for her forgiveness because he had grumbled at her rebukes. His close attachment to his mother partly explains why in Lady Fry's august footsteps there was to follow a colourful, chaotic line of ladies, all of whom, to a varying extent, were to perform a supportive, semi-maternal role.

In many ways Roger Fry was less happy at Clifton College, Bristol, to which he moved in 1881, than he had been at Sunninghill House. At Clifton, he complained that he never had enough to eat and in other ways his sensitivity felt seriously offended. For a school that 'sounds' good in official histories, was in practice ill-suited to a boy of Fry's temperament. Clifton had been modelled on Rugby and founded only seventeen years previously by John Percival, a man said to have been the greatest educational force in England after Arnold. The headmaster, Canon Wilson, whose flowing beard and shaggy eyebrows gave him the appearance of a prophet, was the exact opposite to Sneyd-Kynnersley; whereas Sneyd-Kynnersley shied clear of intelligent masters, Wilson, a distinguished academic, was concerned to acquire for the school teachers of exceptional ability and individuality. He was also a highly emotional man and occasionally wept aloud in chapel while reading from the New Testament. He had a habit of beginning his classics lessons with the sixth form by setting a ten minute question paper on general knowledge or on the solution of some problem or the invention of some mechanical device, and he no doubt encouraged Roger Fry's scientific interests.

The aim of the school was to produce high-minded Christian men, devoted to the service of their country. The corporate life of the school was seen to be in miniature the pattern of Christianity and the ideal of fellowship which it upheld was based on a classic formula distilled from the Jew, the Greek and the Roman, emphasising fortitude, self-sacrifice, self-reliance and intrepidity. It was an ideal not always compatible with the development of the individual. Outwardly Roger Fry was the model schoolboy; he applied himself with energy to his studies, showed responsibility towards the school, and took a necessary interest in the success

13

of its sporting events; but his individuality was not quickened, and inwardly he felt some lack in the system.

When one day Fry overheard a firm upholder of schoolboy 'good form' describe in scornful terms a new arrival, he felt intrigued and decided to seek out this oddity. The new boy was John Ellis McTaggart, a tall, gawky figure, noticeable for his tendency to walk like a crab, with his head and shoulders twisted towards the limestone walls of Clifton College. He was in a different house to Fry, but this did not prevent their friendship developing and McTaggart became the regular companion on Fry's Sunday evening walks. McTaggart was a most unorthodox schoolboy: at his previous school in Caterham, Surrey, he had lain down on the football pitch, refusing to take any part in the game; at Clifton he sidled about on the pitch, stood limp, melancholic, asymmetrical, and produced such a demoralising effect that, for no reason at all, it was agreed he was to be excused all sport. His brilliant intellect and philosophical bent were, on the other hand, immediately recognised and eventually earned him the respect of the other boys. Canon Wilson wrote to his mother in characteristic vein urging that her son should take up political economy: 'It will give him human interests, make him touch his fellow creatures at many points and save him from becoming a Professor in the more academic sense. I do not want to see a mind, which is capable of dealing with facts and men, losing itself in metaphysics, playing to a small audience in the clouds.'[14] With this precocious intelligence at his side, Roger Fry learnt to discuss a wide range of subjects, from Canon Wilson's sermons and Rossetti's paintings to the advantages of a republic over a kingdom. Their conversations were, for Fry, like a life-raft in a sea of deadening conventionality.

As his years at Clifton drew to an end, Roger Fry decided to apply for a place at Cambridge to read natural sciences. One of the masters urged him to consider the more worldly Oxford but he was certain of his preference and Canon Wilson, hearing of his decision, suggested King's College. In December 1884 he went up to sit the examinations for an exhibition, which were spread out over a number of days. He dined in King's College and thought the dining hall very fine, but perhaps a little florid. He felt uneasy about the examinations and was convinced he had performed miserably in his viva, but on 22 December a telegram reached his parents – 'I have got the exhibition sixty for two years they have only given this one for sciences' – and his anxiety was over. At Cambridge his education was really to begin. Neither of his schools had suited his temperament and he had inwardly rebelled against what he later described as 'the whole public school system . . . and all those imperialistic and patriotic emotions which it enshrined'.[15] The influence of Quakerism was less easy to shrug off. Quaker distrust of display, an inclination for hard work, a disregard for establishments, a willingness to stand apart from mass opinion and trust the evidence of one's own experience, all these factors, like a compass pointing always true north, continued to direct his life and to give him confidence in his

own decisions even though they soon led him to abandon the Quaker faith.

2 Cambridge

Often on a cold October morning a dank mist nestles over Cambridge, giving the town an unreal, intangible quality. From the Backs, looking towards King's College, two incongruous buildings loom into view, adding to the incredibility of the scene. For nothing could be more astonishing than the decision to build the Gibbs building, with all its classical rhetoric, at right angles to the great hulk of King's College Chapel, that supreme monument of English late Gothic. But as the visitor walks across King's Bridge towards the College, the buildings grow ever more solid and imposing as the mist dispels. Passing the Gibbs building, the visitor enters the Court, cut in two by the shadow cast by the dining hall on his right. The chapel, awash with brilliant sunlight, invites one to enter and once inside this most gracious interior, the elegant fan-vaulting breaks in waves down the nave ceiling with unparalleled exuberance.

When Roger Fry arrived at King's College in October 1885 he must have responded immediately to the beauty and grace of his new surroundings. His own appearance was not, however, very striking: tall and thin, his features as yet immature, he looked earnest and adenoidal with his jutting upper lip, thin-rimmed spectacles and inelegant quiff of hair. Canon Wilson, aware that Fry was shy and lacking in confidence, had deliberately suggested King's instead of the larger and more brilliant Trinity to which McTaggart had gone. But if, up till now, Fry's intelligence had been reined in by convention, he was about to embark on a period of self-discovery, stimulated by his environment, the people he

16

met, their ideas, ideals and speculations. The emphasis at Cambridge on rational, scientific thought enabled him to re-examine the preconceptions of his upbringing and helped him to establish the intellectual and moral basis on which he was to build a personal philosophy. Still more important, though he had arrived to read natural sciences, he came more and more to feel that art was the subject that would offer the richest field of enquiry.

At King's College, Fry found that recent university reforms had created an air of emancipation. Although half the scholarships were still confined to Etonians, in 1871 the college had been opened to all schools. Other voluntary reforms, begun by King's College in the 1860s, led to the Oxford and Cambridge Universities Act, which became law in 1882. Under the new legislation religious tests were abolished; fellows could now marry; and a student could no longer obtain a degree without sitting any examinations. King's remained, however, a small college: in 1885 there were only twenty-five freshmen. Careful selection contributed to the belief that at Oxford or Cambridge a young man would meet the most outstanding minds of his generation.

One of the most celebrated figures at King's, if not its most outstanding mind, was the history don and wit, Oscar Browning. Having been sacked from Eton without explanation, Browning had been installed at King's. He pursued a life-style similar to that which he had led at Eton, where the unpaid bill at his wine merchant amounted to eight hundred pounds. He was lazy, witty, corpulent, effeminate and a renowned snob, taking particular delight in royalty, but his warm personality made him accessible and he was liked by the undergraduates, though distrusted by the other dons. Instead of academic authority he exuded an air of worldliness, mellowed by wine rather than wisdom. His interests in Italian literature and music led him to found at King's the Dante Society as well as the Mozart Society, notable for their performances, not of the classics, but of Neapolitan shanties and German student songs. To support his ailing finances he occasionally indulged in minor commercial activities, keeping a field of chickens outside Cambridge and running a Turkish bath.

Stories about the famous O.B., as he was called, soon filtered back to Fry's parents in his letters, because he had not been settled in his rooms in Trumpington Street for long before he was invited to attend one of the O.B.'s Sunday salons. At these Browning threw all his rooms open, played music and invited as many guests as he could find. Fry enjoyed himself, but was not impressed: 'The rooms are gorgeously furnished and crowded with books (which I don't think he reads) and pictures and silver and gold and china ornaments displayed with, as I think, rather a want of good taste. Still he is, I must say, very kind and most energetic, though from all that one hears rather a fraud.'[1] Fourteen years later, Fry attempted to capture his likeness in a portrait, which was probably destroyed. 'The O.B. got very like but never very pleasant', he informed Robert Trevelyan; 'I have made him a little sanctimonious now and that don't do quite, but I believe I shall pull it through sometime.'[2]

5 Roger Fry: *John McTaggart*, 1911. Oil. Present whereabouts unknown. (Formerly in the collection of Trinity College. Cambridge.)

Of all the dons Oscar Browning was the one who openly encouraged the cult of friendship that flourished in Cambridge at this period. Fired by an interest in Hellenism, it was naturally a subject for discussion among Fry's more philosophical friends, particularly Goldsworthy Lowes Dickinson (who later wrote *The Greek View of Life*) and John McTaggart, Fry's former school friend with whom he was sharing lodgings. McTaggart made the study of friendship a central aspect of his philosophy. Love, for him, was the essence of reality, the supreme good and only through our experience of love for each other are we able to arrive at what he called the 'Saul-feeling' – a mystical experience of being at one with the world. For this harmony to exist, it was necessary for McTaggart to believe that the universe was fundamentally good and aspiring towards a state of perfect goodness. McTaggart's optimism was shared by Goldsworthy Lowes Dickinson and later by the former's pupil Bertrand Russell, and the belief that civilisation was progressing to a more and more enlightened state remained prevalent at Cambridge until around the turn of the century. Bertrand Russell later recalled: 'The world seemed hopeful and solid – we all felt convinced that nineteenth-century progress would continue, and that we ourselves should be able to contribute something of value.'[3]

Roger Fry not only shared this optimism but, led by McTaggart's metaphysical speculations, re-examined his own religious beliefs. By the age of fourteen, McTaggart had read all Herbert Spencer's works and was left a convinced materialist and atheist, but he had spared Fry this insight at Clifton out of respect for the school's Christian principles. Religious observance at King's was no less strict than at Clifton and Fry had to attend chapel at eight o'clock every morning for five days a week, and on Sundays there were two compulsory services. At first he had no complaints and informed his mother (18 October 1885) that 'the services are simply magnificent'. Lady Fry was, however, alarmed at the thought of her son sharing rooms with the precocious, free-thinking McTaggart and wrote to warn Roger of the possible effect this might have on his religious beliefs. He replied, 'I confess I do not feel that there is any danger to my own Christianity from his companionship, as I hope my Christianity is not so weak a structure as not to stand the proximity of doubt'.[4] He was mistaken: Cambridge rationalism upset the cartload of his neatly parcelled religious and moral beliefs. Three years later he wrote with typical frankness to his mother, 'Life does not any longer seem a simple problem to me with plain duties and plain sins to be avoided ... I no longer feel that I must hedge myself in from the evil of the world; that there are whole tracts of thought and action into which I dare not go.'[5]

While friendship with McTaggart expanded his mind to embrace doubt, companionship with a young man three years his elder, Charles Robert Ashbee, extended his knowledge of art. Ashbee came from a mixed background: his father was of Kentish yeoman stock and his mother of Hanseatic Jewish extraction. Emphasis on honest labour

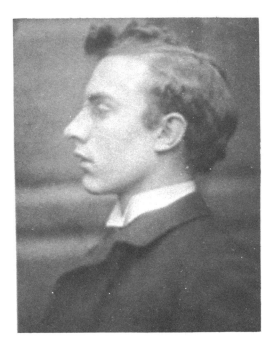

6 Roger Fry in
1885. Photograph

7 Roger Fry: A
page from a pocket
notebook, c.1886
7″ × 6″

mingled with his mother's artistic interests, and contributed to the pa
he was to play in the Arts and Crafts Movement when in 1888
founded the Guild of Handicraft and trained a body of craftsmen
produce artefacts using methods that upheld the dignity of lab
putting into practice some of the aims of Ruskin and Morris. It
probably through Ashbee that Fry was elected to the Cambridge
Art Society on 3 February 1886.

By the Easter vacation the two young men had become in
friends and together went sketching in Somersetshire, notin
church tower they came across and visiting Wells Cathedral
Ashbee recorded in his journals, they spent the entire day
masons and builders of the Middle Ages. Working so closel
their drawings became almost indistinguishable; both dev
draughtsmanship in the tradition of Samuel Prout (the early
century painter of picturesque views), no doubt inspired by
of Ruskin and by the author's own drawings. Fry himself
read Ruskin at the age of sixteen and he remained infused
enthusiasm for this lay preacher on art until his first
1891, when he discovered that he disagreed with much
written. But at Cambridge Fry's sympathy with R
Gothic architecture is made evident in the detailed
duced, the pencil describing with deft dashes, dots
cacies of Gothic carving, elaborate façades, towers a
(Plate 7). Throughout the summer term he and
sketch in the surrounding fenland countryside wh

Of all the dons Oscar Browning was the one who openly encouraged the cult of friendship that flourished in Cambridge at this period. Fired by an interest in Hellenism, it was naturally a subject for discussion among Fry's more philosophical friends, particularly Goldsworthy Lowes Dickinson (who later wrote *The Greek View of Life*) and John McTaggart, Fry's former school friend with whom he was sharing lodgings. McTaggart made the study of friendship a central aspect of his philosophy. Love, for him, was the essence of reality, the supreme good and only through our experience of love for each other are we able to arrive at what he called the 'Saul-feeling' – a mystical experience of being at one with the world. For this harmony to exist, it was necessary for McTaggart to believe that the universe was fundamentally good and aspiring towards a state of perfect goodness. McTaggart's optimism was shared by Goldsworthy Lowes Dickinson and later by the former's pupil Bertrand Russell, and the belief that civilisation was progressing to a more and more enlightened state remained prevalent at Cambridge until around the turn of the century. Bertrand Russell later recalled: 'The world seemed hopeful and solid – we all felt convinced that nineteenth-century progress would continue, and that we ourselves should be able to contribute something of value.'[3]

Roger Fry not only shared this optimism but, led by McTaggart's metaphysical speculations, re-examined his own religious beliefs. By the age of fourteen, McTaggart had read all Herbert Spencer's works and was left a convinced materialist and atheist, but he had spared Fry this insight at Clifton out of respect for the school's Christian principles. Religious observance at King's was no less strict than at Clifton and Fry had to attend chapel at eight o'clock every morning for five days a week, and on Sundays there were two compulsory services. At first he had no complaints and informed his mother (18 October 1885) that 'the services are simply magnificent'. Lady Fry was, however, alarmed at the thought of her son sharing rooms with the precocious, free-thinking McTaggart and wrote to warn Roger of the possible effect this might have on his religious beliefs. He replied, 'I confess I do not feel that there is any danger to my own Christianity from his companionship, as I hope my Christianity is not so weak a structure as not to stand the proximity of doubt'.[4] He was mistaken: Cambridge rationalism upset the cartload of his neatly parcelled religious and moral beliefs. Three years later he wrote with typical frankness to his mother, 'Life does not any longer seem a simple problem to me with plain duties and plain sins to be avoided ... I no longer feel that I must hedge myself in from the evil of the world; that there are whole tracts of thought and action into which I dare not go.'[5]

While friendship with McTaggart expanded his mind to embrace doubt, companionship with a young man three years his elder, Charles Robert Ashbee, extended his knowledge of art. Ashbee came from a mixed background: his father was of Kentish yeoman stock and his mother of Hanseatic Jewish extraction. Emphasis on honest labour

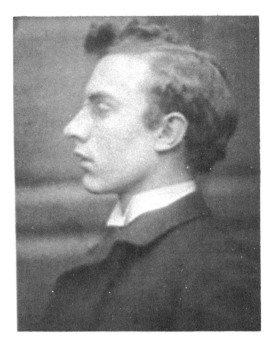

6 Roger Fry in
1885. Photograph

7 Roger Fry: A
page from a pocket
notebook, c.1886
7″ × 6″

mingled with his mother's artistic interests, and contributed to the part
he was to play in the Arts and Crafts Movement when in 1888 he
founded the Guild of Handicraft and trained a body of craftsmen to
produce artefacts using methods that upheld the dignity of labour,
putting into practice some of the aims of Ruskin and Morris. It was
probably through Ashbee that Fry was elected to the Cambridge Fine
Art Society on 3 February 1886.

By the Easter vacation the two young men had become intimate
friends and together went sketching in Somersetshire, noting every
church tower they came across and visiting Wells Cathedral where, as
Ashbee recorded in his journals, they spent the entire day with the
masons and builders of the Middle Ages. Working so closely together,
their drawings became almost indistinguishable; both developed fine
draughtsmanship in the tradition of Samuel Prout (the early nineteenth-
century painter of picturesque views), no doubt inspired by their reading
of Ruskin and by the author's own drawings. Fry himself had begun to
read Ruskin at the age of sixteen and he remained infused with passionate
enthusiasm for this lay preacher on art until his first visit to Italy in
1891, when he discovered that he disagreed with much that Ruskin had
written. But at Cambridge Fry's sympathy with Ruskin's praise of
Gothic architecture is made evident in the detailed drawings he pro-
duced, the pencil describing with deft dashes, dots and curls the intri-
cacies of Gothic carving, elaborate façades, towers and ancient buildings
(Plate 7). Throughout the summer term he and Ashbee continued to
sketch in the surrounding fenland countryside whenever possible, and

Cambridge

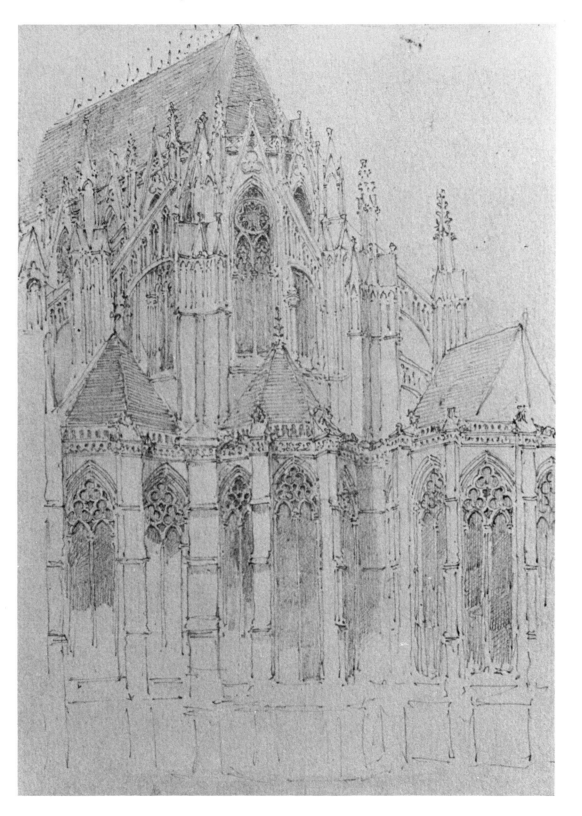

by June, Ashbee recorded in his journals 'I missed Fry, whom I begin. to regard now as a portion of my sketching apparatus'.(6)

With two other friends, Ashbee and Fry went on a four-day rowing trip down the Thames from Abingdon to Windsor. The weather was good, the company merry, and Ashbee and Fry contentedly wandered arm in arm through the fields in the afterglow of the sunset. Their friendship was tinged with romance, as Ashbee confided in his journals, confessing that Fry's nature was so sacred to him he could not write about it with unbiased judgement: 'Fry has been to me a solace in this last year and I have learnt a great deal from him. Of his character principally, and of his artistic side, for he has the aesthetic quality much further developed than I ... He with the grand Quaker intellectual foundation has been gifted with the artist's soul and imagination.'(7)

'Friendship' acquired an even loftier status among these undergraduates after the visit of Edward Carpenter to Cambridge in July 1886. 'It is as if we had a hero among us', declared Ashbee. 'We are knit together by a presence.'(8) In 1885 Goldsworthy Lowes Dickinson and Ashbee had met Carpenter at a lecture on socialism given in the hall attached to William Morris' house at Hammersmith and they invited him to Cambridge the following year. Carpenter, who had been educated at Cambridge, had taken orders but later left the church to devote himself to adult education for working men and women, under the auspices of the Cambridge Extension Movement. After 1880 he bought a smallholding at Millthorpe in Derbyshire, where he attempted to combine sandal-making and market-gardening with a literary career. He wrote on a variety of subjects – art, music, private property, industrial relations, homosexuality – but his chief aim was to further the socialist cause which at that date made no clear distinction between the desire for external social and economic improvements and the belief that change came primarily from inner spiritual transformation. Carpenter himself was appalled by the disease, dishonesty and corruption that he had observed while travelling England for the Cambridge Extension Movement. He felt it morally wrong for a man to live off the labour of the poor, 'consuming much creating next to nothing', and looking into the heart of modern life he discerned man's aim to be to maintain himself at the cost of others. His solution to the ills and class-warfare of his day was democracy: he meant by this not some definite form of political organisation, but some sexual-mystical harmony between all men and nature, where barriers of sex, class and race are dissolved. In keeping with his belief that consciousness should be shifted from the partial to the universal man and that the intellect should once again be united with the emotions and instincts, he praised physical labour, advised a vegetarian diet, simple dress, close contact with nature. In particular, he railed against the wearing of 'leathern coffins' on the feet, recommending instead that man should go barefoot or shod in a pair of his home-made sandals. His beliefs – practical, impractical, passionate and philosophic – had found expression in his prose poem *Towards*

23

Democracy (largely inspired by Walt Whitman) which, when first published in 1883, had wide-reaching influence and remains a landmark in the history of the early socialist movement.

This book would have prepared Roger Fry and his friends for Carpenter's visit, but it did nothing to lessen the impact made by his personality. Modesty and reserve were combined with a handsome appearance; his grey beard gave him a Socratic dignity; his lithe, athletic body enhanced his alert composure. He had, it seems a charismatic personality, possessing that rare ability to touch some aspect of a person's character normally guarded or concealed. If Ashbee was aroused to the pitch of hero worship by his presence, even the less effusive Fry wrote to his mother (25 July 1886), 'I had rather expected that he might be a somewhat rampant and sensational Bohemian. I am agreeably disappointed for he seems a most delightful man and absolutely free from all affectation'.

Impressed by both the man and his beliefs, Fry and Ashbee made the pilgrimage to Carpenter's house at Millthorpe the following Easter and from there, Fry, driving Carpenter's market cart, visited and sketched Haddon Hall, looked at certain of Sheffield's steel works, called at the Ruskin Museum at Walkley and admired the collection of minerals, Ruskin's own drawings and the Verrocchio *Madonna*.[9] Their discussions with Carpenter continued. After his visit to Cambridge in July 1886, Carpenter had written to Ashbee outlining one central concern: 'How to reconcile that freedom and culture of life with self-supporting labour – that is the question that vexes me.'[10] It was an idea that reverberated in Fry's mind for many years to come and which he found answered thirty years later in Provençal peasant life. As a young man he perceived that Carpenter's ideas and life-style clearly challenged the set of values upheld by his parents. Writing in 1890 to thank Carpenter for a pair of his home-made sandals, Fry added that his father was thinking of ordering a pair: 'A Lord Justice in sandals will be a landmark in the progress of civil . . . I mean decivilisation.'[11]

Inspired by Carpenter's teaching, Ashbee, on leaving Cambridge in 1886, went to live at Toynbee Hall, the East End university settlement committed to the education of the local community. Before very long his place in Fry's life had been filled by friendship with another young man, a few years his elder, Goldsworthy Lowes Dickinson. Attractive in appearance, with light brown hair and dark eyes, Dickinson had a gently penetrating mind and a whimsical sense of humour. In 1887 he gained a fellowship at King's as a result of his thesis on Plotinus and was to earn for himself a considerable reputation as a political philosopher. It was inevitable that Fry, now caught between the two intelligences of McTaggart and Dickinson, should be present at lengthy metaphysical discussions, for though neither philosopher believed in God, they did believe in immortality and in the existence of a pattern behind surface appearances. Dickinson placed his faith in science which, he argued, would confirm a positive view of the world and which would culminate

in mystic revelation. 'I remember how when I was young,' wrote Fry, many years later, 'I was surrounded by friends who only discussed metaphysical questions and I was so ashamed among them because all that made no sense to me.'[12] However, their rigorous pursuit of logic must have been stimulating and it is unlikely that he did not become familiar with the main tenets of their arguments.

In 1887 Fry followed Dickinson and McTaggart into the ranks of the Apostles. This was a secret society, originally entitled the Cambridge Conversazione Society, and founded in 1820. It was extremely select and at the most only three new members were added each year. Certain undergraduates, on arriving at Cambridge, were (unknown to them) selected as possible 'embryos' and, if their behaviour and conversation met with approval, they were invited into the society. Once accepted the new member was shown the 'ark', a cedarwood chest which contained the society's records and the list of previous members – including such names as Alfred Tennyson, Arthur Hallam, F. D. Maurice, Monckton Milnes and Henry Sidgwick. Meetings were held on Saturday evenings and members had to forego all other commitments in order to attend. Occasionally older members who had 'taken wing' from Cambridge and become 'angels' would travel up from London to attend. Tea and anchovy toast, or 'whales' as it was called, was served around the society hearth rug and a paper, generally on a literary or philosophical subject, was read. Discussion followed and a resolution proposed (which might or might not relate to the original topic) and a vote taken.

All accounts of this society underline its devotion to reason and the suppression of unnecessary displays of knowledge, egoism, prejudice and subtle argument in order to arrive at the truth. Its intimate nature is also stressed. Fry was clearly impressed by the honour that membership implied and, despite the vow of secrecy, informed his mother of his admittance. But from the papers that he wrote for this society, several of which remain, it appears that the impressive array of intellects which the society numbered applied itself not to the more profound questions concerning social and moral rights but to semi-philosophic discussion of subtle niceties, liberally sprinkled with fanciful wit. High ideals, it seems, were mixed with light entertainment. It did, however, act as a confluence, bringing together aspects of late Victorian Cambridge which have been described by another Apostle, E. M. Forster: 'People and books reinforced one another, intelligence joined hands with affection, speculation became a passion and discussion was made profound by love.'[13] The society's aim was to enlighten the world on things intellectual and spiritual and this sense of mission, no doubt held half in jest, may have strengthened Fry's decision, twenty years later, to defend the Post-Impressionists against the jibes and derision of the British public and press.

Roger Fry's third year at Cambridge was marked by the deepening of his friendship with Goldsworthy Lowes Dickinson. In his autobiography, Dickinson recalled that 'in the academic year 1887–88, which

9 Roger Fry:
*Goldsworthy Lowes
Dickinson*, 1893.
Pastel,
49.5 × 40.2 cm.
London, National
Portrait Gallery

was his [Fry's] last at Cambridge, we lunched and breakfasted every day together, and every night I used to see him to bed and then kiss him passionately. . . . He was fond of me though in no sense in love.'[14] Fry's inability to return Dickinson's love did not prevent their friendship, which lasted until Dickinson's death, from becoming a constant source of sympathy and understanding. A summary of its development is given by Dickinson:

> This first love of mine lasted, in this form, a year or two. That phase was ended by Roger falling in love with a woman. That led to explanations which had not before been desired nor sought on either side; and I learned what I had known, yet also had not known, that his feeling for me was different from mine for him. I still recall the conversation we had, late one night, in the house where he was then living, in Beaufort Street, Chelsea. I was unhappy, yet not very, nor lastingly. For Roger did not cut me off from anything I had had. Later he became engaged, then married, and I saw less of him, yet still a great deal. All our life we have been friends and I have a kind of married feeling towards him. Now, when age is coming on, we seem to have less in common in our interests but our affection will last as long as we do, it rests on an intercourse so long, so continuous, so varied. . . . That love at least transformed itself into a perfect friendship.[15]

Dickinson, whose humour and subtle questioning of accepted values Fry admired, could not share Fry's growing enthusiasm for art, and in general at Cambridge the visual arts, other than those of Greece and Rome, were ignored. The arrival of the new Slade Professor, J. H. Middleton, in October 1886 was therefore an important event for Fry, as Middleton brought with him paintings by Flemish and Italian primitives, Rembrandt etchings, Persian tiles, pottery, fabrics and other items gathered during his extensive travels. He also owned a large collection of photographs from which Fry had his first lessons on the development of Italian painting, lessons that would have been complemented by examples found in the Fitzwilliam Museum.

At first sight Middleton was an unimpressive, small man: he interviewed his students wearing a velvet cap, nervously twitching his pencil and letting his talk at the first opportunity wander off into discussion of some aspect of architectural detail. In his youth the death of a close friend at Oxford had led him to suffer a severe, painful illness which confined him to his bed for several years. This bedridden period was not, however, unproductive for he systematically read his way through the current literature on art and archaeology and emerged from his illness an authority on these subjects. His knowledge was further developed by extensive travelling in America, Mexico, Greece, Asia Minor, Egypt and North Africa, and on a visit to Iceland he met and established a lasting friendship with William Morris. On his return to England he trained as an architect under Sir George Gilbert Scott, was elected to the Society of Antiquaries and contributed significantly to the ninth

27

edition of the *Encyclopaedia Britannica* and specialist periodicals. He is said to have undertaken philanthropic work in London but had concluded that half-baked socialist schemes, co-operation, Toynbee Hall, etc., were all useless and the only real solution was revolution. Soon after his arrival Fry approached this fusty antiquarian harbouring challenging ideas, for advice on his future. Middleton advised him to apprentice himself to an architect on leaving Cambridge and, as architecture seemed the most useful of the arts, Fry was prepared to consider this idea. The following Easter he asked his father if he could accompany Middleton on a vacation trip to Bologna, but Sir Edward, possibly having heard of Middleton's disruptive politics, refused his permission.

Middleton and Carpenter were not the only champions of socialism that Fry met at Cambridge: he also attended a lecture given by George Bernard Shaw to the Cambridge Fabian Society on 'Socialism: Its Growth and Necessity', and the following day he was among the undergraduates who lunched with the speaker. He was intrigued by Shaw's understanding and penetrating insight into the machinations of social mores, dismayed when he announced that he had 'gone into' the subject of art and found there was nothing in it, and was even more shaken when, a couple of years later, he met Shaw on a bus and was informed by the great man that there was nothing more farcical than British justice. Shaw thus raised questions in Fry's mind that at the time he could not answer and had to shelve, and his attitude to socialism remained ambivalent. He wrote to Ashbee in 1887, 'Last night I brought a vote of censure on Modern Civilisation at the King's debating society wherein you would have been surprised at my socialism, but then you never can see what a socialist I am because you always have the effect of bringing out all my Toryism, all my love of aristocracy and culture.'[16] Many years later, in a letter congratulating Shaw on his seventy-fifth birthday, Fry recalled the prophet's visit to Cambridge and the impression it made on him:

> I looked upon the distinctly satanic halo which shone round you with a dreadful veneration. I felt the dangerous delight as one who dared to participate in forbidden mysteries. I remember how you dazzled us with a wit such as we had never imagined and no less with your stupendous experience of the confines of the social scene on which we were beginning to peer timidly and not without anxiety. My friends were already convinced that social service of some kind was the only end worth pursuing. I alone cherished a guilty secret, an instinctive scepticism about all political activity and even about progress itself, and had begun to think of art as somehow my only possible job.[17]

A casual letter to his parents informed them at the end of the academic year that he had received a First and therefore had a chance of later obtaining a fellowship and possibly a distinguished scientific career. To Sir Edward's bitter disappointment his son disregarded this success and determined to become an artist. Consequently Roger Fry's letters to his

father from this time on become increasingly distant and uninformative. Middleton was again called on for advice and he wisely suggested a compromise: Fry should stay on at Cambridge another term, should study drawing from antique casts and the male nude, but should also continue his work in the laboratories, act as college Botany tutor and sit for a fellowship. Fry followed this advice but his attempt at the fellowship was unsuccessful. He tried again the following year with a thesis that combined his interests in art and science, entitled 'On the Laws of Phenomenology and their Application to Greek painting', but this too, though praised by Middleton, failed to obtain him a fellowship.

While at Cambridge, Fry had designed the cover for the magazine, the *Cambridge Fortnightly* (Plate 10). The first issue appeared on 20 January, 1888, and it announced that all subsequent issues would be adorned with a lithographed title page of 'high allegorical beauty'. It represented, according to Fry, a 'tremendous Sun of Culture rising behind King's College'.[18] The image can be seen as prophetic of Fry's own career, as it was out of the fabric of thought and feeling woven at King's that he drew his personal philosophy. He had developed a sense of mission and an awareness of socialist ideals; he had learnt to adopt a pragmatic approach to theoretical problems; in the philosophies of Dickinson and McTaggart he discovered a bridge between science and art, in the belief that a sense of pattern and order lay behind surface appearances; his scientific, analytical mind and his artistic imagination and receptivity need no longer be seen in opposition to each other. The potent elixir of Cambridge, its ancient buildings, the river and meadows, had stirred his mind. Nowhere was its beauty more apparent than on King's bridge: 'Life does not seem to flow with the same dull round of increasing commonplace within a quarter of a mile of King's bridge', he had written to his mother, 'from where one can now watch the golden chestnut and lime leaves flutter down through the rising purple haze on to the river.'[19] By January 1889 this mood had been dispelled: reverie gave way to hard work; contentment turned to nervous anxiety about his own abilities and his future.

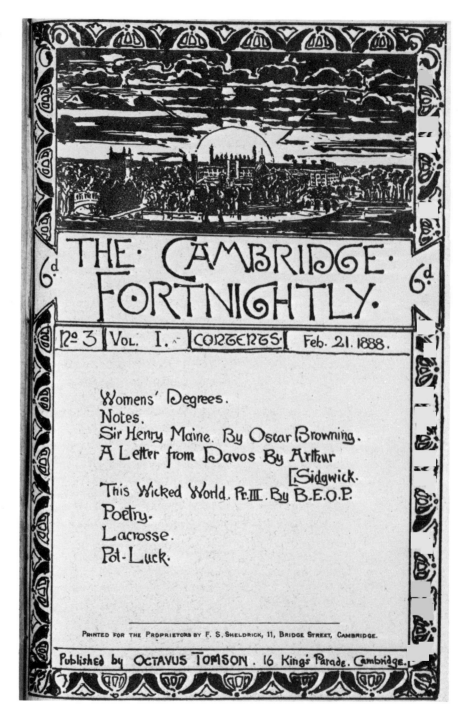

3 Painting and Romance

On leaving Cambridge, Fry decided to risk his father's displeasure and train as a painter. His determination eventually persuaded Sir Edward who consulted the artist Briton Rivière and the family friend Herbert Marshall on the matter, and it was arranged that Roger should attend the small art school run by Francis Bate in his recently built Applegarth Studio at Hammersmith. With somewhat tempered enthusiasm, he wrote to Goldsworthy Lowes Dickinson in January 1889: 'I've just finished my first days' work with Bate – it was quite as dull as I expected but not more so, and I think he teaches well – he has ideas – he teaches you more how to analyse your impressions than how to move your pencil and this seems to me the right end to begin.'[1] Fry clearly found this intellectual approach sympathetic, and after his reading of Ruskin and the detailed style of drawing found in his Cambridge sketchbooks, Bate's teaching must have hit him like a breath of fresh air.

Bate, who had trained in France and come into contact with French Impressionism, encouraged his pupils to paint out of doors (weather permitting), to use a brighter palette than was currently acceptable, and to treat the subject broadly and simply without any preconceived notion of style. Above all, he stressed observance of tone, and even when sketching in charcoal his pupils had to note the tonal values.

In his pamphlet of 1887, 'The Naturalistic School of Painting' (a copy of which Fry owned), he spoke boldly about the observation of colour in shadows and the desire among the avant-garde to find their source of

inspiration, not in literature, but in visual reality. This new subject matter, based on common experience not on classical or historical learning, would, he argued, inevitably broaden patronage. In ringing tones, this apparent socialist declared that art should 'no longer suffer itself to be petted by the half-neglectful patronage of the cultivated few. It is to become of the nation, of the people, of the world.'[2] His theory was far in advance of his practice and in his own paintings revolutionary talk about the Impressionists' use of broken colour boiled down to mundane naturalism. Fry, four years after he had entered Bate's studio, in a letter to his father asking for a testimonial for Bate, gave what seems to be a fair assessment of his qualities: 'He has a great power of expressing himself and very clear and simple methods of instruction without any cranks or extravagant theories. I think that he is almost too precise and scientific to be a very first rate artist but all that is in his favour as a teacher.'[3]

Nevertheless, by the standards of the Royal Academy, Bate's teaching was quite unorthodox. When Fry began his training, high Victorian art, consummately skillful and discreetly sensuous, still stirred the visitors to the annual summer exhibitions at the Royal Academy and earned for their creators social prestige and fortunes such as have scarcely been equalled in any other age. Leighton's elaborately composed classical and mythological subjects, Alma-Tadema's and Poynter's reconstruction of domestic scenes in ancient Greece and Rome, and G. F. Watts' allusive moral allegories were all far removed from the everyday realities of Victorian life. Nurtured by the example set by the Renaissance masters and the Elgin Marbles, these luxury products represented a final flowering of the Renaissance tradition, overblown through having their roots not in life but in style. Elsewhere on the Academy walls sentiment cloyed and trivial anecdotes were elaborated at length. Yet it was here that an artist's reputation was made or broken and though attempts had been made to challenge the Academy's monopoly on artistic taste – notably the secessionist ventures set up at the Grosvenor and New Galleries – these had soon degenerated into mere nurseries for the Academy.

A similar fate awaited the New English Art Club which had recently been formed to exhibit those artists whose work reflected the influence of modern French art. Although it attracted a wide variety of artists, it was chiefly noted for an impressionist style indebted not to the true French Impressionists but to *plein-air* painting and in particular to the art of Bastien-Lepage whose early death at the age of thirty-six in 1884 had ensured for his work considerable posthumous fame. His realism, illumined by a dull grey light, was greatly admired by Stanhope Forbes who introduced the style into England where it became the hall-mark of the Newlyn School, a major contingent in the New English Art Club. The Club, which gained considerable prestige in 1892 when a founder member, Fred Brown, took over from Legros as Director of the Slade, included in its ranks John Singer Sargent, George Clausen, Edward

Stott, Charles Shannon and Walter Sickert to name a few, and it was to become Fry's main exhibiting ground for almost two decades.

Under Bate, Fry's attention would immediately have been directed to the New English Art Club because his teacher not only exhibited there but as its Honorary Secretary turned his efficient mind to the smooth running of its business transactions. In 1889, when Fry began his training, the artist and dandy, James McNeill Whistler both exhibited with the club and sat on its selection jury. Bate's admiration for Whistler may well have sent Roger Fry to Queen's Square where in a College for Working Men and Women a comprehensive exhibition of Whistler's art was on display. This year also saw the 'London Impressionists' exhibition, put on by a group of Whistler's followers, including Sickert and Bate. These English Impressionists did not, however, trumpet the sun-bright colours of their French namesakes, but painted seedy, forgotten corners of the city in low, subtle harmonies of tone. Whistler undoubtedly influenced Fry, as the latter's portrait of his sister Margery reveals (Plate 11). Whistleran creams and buffs set the background against which is harmonised the turquoise blue of her tie with the pink of the wallpaper. On the wall behind is a Japanese fan, designed to balance the movement of the sitter as she leans against the wall, her face caught by the light from the window which is just beyond the confines of the canvas. The casual pose, fluid brushwork and the steady gaze of the sitter that haunts the canvas, surely belie the persistently voiced criticism that Fry as a painter had no natural talent.

This portrait was painted soon after Sir Edward and Lady Fry moved from Highgate to No. 1, Palace Houses, Bayswater, a large, ugly Victorian house, the proportions of which seemed pretentious after the more human elegance of Nos. 5 and 6, The Grove. At the time of the move Sir Edward remarked that 'plain living and high ceilings' would from then on be the lot of the family and so true was his prediction his daughter Isabel recalled that she spent much of her time in the Bayswater house staring at the drawing room clock. Roger Fry took up residence in this dark and gloomy house on leaving university and found his parents' views dogmatic and constricting after his experience of Cambridge liberalism. His opinions now frequently conflicted with those of his father, who criticised his son's new questioning attitude of mind. Sir Edward continued to deplore his son's choice of career and Roger found the weight of his disapproval difficult to bear at that vulnerable time when he was searching for his identity in art. Set against this background, the relaxed and informal portrait of Margery suggests a moment of shared intimacy, of respite from the taxing eye of their parents.

When Fry's relationship with his parents became unbearable, travel provided the antidote. Although the Quaker attitude to wealth discouraged all forms of ostentatious display, travel was encouraged, possibly because it had become part of the Quaker way of life ever since George Fox had given the command 'Go through the world and be valiant for the Truth upon earth'. Sir Edward and Lady Fry encouraged all their

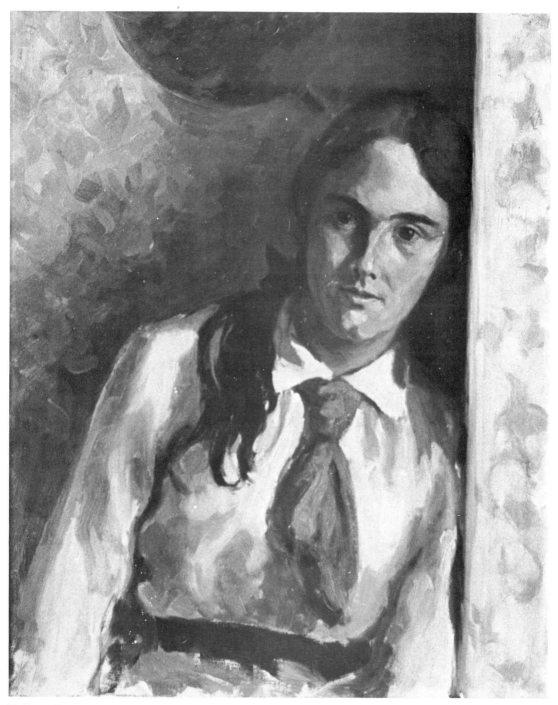

11 Roger Fry:
Margery Fry, c.1890.
Oil on canvas,
51 × 40.5 cm. *Mrs
Pamela Diamand*

children to learn foreign languages and to journey abroad without fear. The daughters were instructed to inform the guard beforehand if they had to change trains, a precaution that Roger Fry's sister Joan observed all her life even when in 1941 at the age of seventy-nine she visited the Quakers in Germany under the eye of the Gestapo. Thus when, in 1891, after two years of life in the Bayswater house, Fry engaged in direct confrontation with his father, money was quickly found to send him abroad on his first trip to Italy.

Italy, for Fry, meant more than a foreign country with local interests, customs and food to be explored; it gave him the opportunity to test his own response in front of the great works of art and architecture that he had seen in Middleton's photographs and read of in Ruskin. He took with him as his companion Pip Hughes, the son of a family friend, who was the same age as Fry but diametrically opposed in temperament. Hughes suffered from perpetual melancholy and completely lacked the will to initiate any action. It was Fry who discovered the times of trains, steered their course across Europe and, with limited Italian, argued with despotic Italian officials. Once settled in lodgings at Rome they soon recovered from their journey and began to explore the many layers of history that lay buried in the city. Fry, whose excited letters to Dickinson reflect his ability (already well-developed) to express his own opinions on works of art, felt the paralysing effect of Rome's past achievement: '. . . it transfigures everything; anything men do in Rome is so insignificant compared to what has already been done there.'[4]

Fry now began as he was to remain all his life – a voracious and tireless sightseer, combining a boundless curiosity with an independent mind. He described his thoughts on St Peter's to Dickinson: 'Of course it doesn't impress one like a great Christian Cathedral, but it is the most perfect expression of the Christianity of the Borgias and della Roveres that one could conceive. It is splendidly mundane – untinged by any religious or altruistic emotion – all based on power and wealth and the intellect that could scramble best for them.'[5] This supremely detached response, very different to that of T. S. Eliot who on his first visit to St Peter's fell on his knees at the entrance, indicates an open mind alive to fresh impressions. Fry deftly intermingled sight-seeing with sketching and socialising. He struggled to come to grips with Early Christian art through the study of mosaics, discovered the true greatness of Raphael, admired the Pantheon and enthused over Etruscan art; in between, he went for long refreshing walks in the Campagna, dined with the celebrated landscape painter Giovanni Costa and his daughter in a traditional Roman restaurant, and found art and life perfectly merged in Marie Stillman, the painter and renowned beauty who had posed for Rossetti and Burne-Jones. However, her yearning, wistful poses belonged to the Aesthetic Movement of the previous two decades and Fry, with his more up-to-date taste, found her beauty a little bloodless.

While in Rome, Fry informed Dickinson that he had executed 'six

largish oil sketches and many little drawings and copies'.[6] *Near the Villa Madama* (Plate 12) is one of the former and it reflects Bate's teaching in its observation of tone, the row of red trees being carefully balanced against the blue-purple Appenines and the pale afternoon sky. Fry omits all details that would detract from the overall effect and those that are included, such as the shepherd and his sheep, are positioned with a rhythmic deliberation. This approach to landscape is similar to that which he ascribed to Turner in an article written at Cambridge on the artist's watercolours at the Fitzwilliam. 'As understood by Turner,' he wrote, 'landscape painting is a creative rather than an imitative art. A scene is chosen as being the type of many individual scenes, and then all details are harmonised so as to convey a single impression far more intense and unified than did the actual landscape. This, it would seem, is more or less the function of landscape painting, and Turner's works show it to perfection.'[7]

12 Roger Fry: *Near the Villa Madama*, 1891. Oil on canvas, 37 × 48.5 cm. London, Tate Gallery

From Rome, Fry travelled to Sicily which more than fulfilled his expectations. No further mention is made of the dismal Pip Hughes who seems to have been abandoned or sent home. After a trip around the island, Fry crossed to Naples and from there sent Dickinson a detailed description of a religious festival observed at Syracuse and of his admiration for the harbour town and its nearby Greek ruins. Naples, by comparison, he deprecated as a mixture of squalor and the picturesque, but to his mother he sent careful descriptions of Pompeii. Responsive as he was to the art and architecture he saw, he could become almost ecstatic about aspects of the Italian landscape and in order to familiarise himself with the nearby countryside he went on a walking tour from Salerno to Amalfi and on to Sorrento, putting up at night at peasant farmhouses. By mid-April he was settled in Florence, wishing that Cambridge life could be transposed to the Tuscan city, the 'jolliest' place he had so far come across.

Though wearying of 'attitudinising saints with their heads cut open and their entrails coming out',[8] his sight-seeing continued unabated: after a visit to the Laurentian Library and the Medici Chapel he declared Michelangelo the greatest architect since the Greeks; Botticelli's *Primavera* confirmed the delight he had first felt on seeing it in reproduction, in spite of his recent loss of interest in the late Pre-Raphaelitism that it had helped to inspire. From Florence he again set out on a walking tour, stopping at Volterra, Prato, San Gimignano, Pistoia and Lucca. He also visited Siena and Ravenna and at the latter he failed to appreciate the famous fifth-century mosaics, finding the art of the period 'degraded and conventional to a degree', an opinion he was later to reverse when he recognised in Early Christian mosaics a similar expressive power to that found in Post-Impressionism. In 1891 he was, however, prepared to admit, 'What relieves it from contempt is that it shows the hesitation between the old played-out classical ideals and traditions and the first childish attempts to start an art expressive of the new ideas'.[9]

In the tradition of the Grand Tour, Fry's Italian trip culminated in the enchantment of Venice. Surfeited by sight-seeing, physically exhausted by his walking tours, he was ready for its mood of dreamy languor and soon found himself in suitably relaxing company. He fell in with a cultivated young Swede, Edvard Alkman, who revealed an unusually extensive knowledge of art. He dined several times with Horatio Brown, the authority on Venetian history, and John Addington Symonds, the historian who, like Carpenter, championed the acceptance of homosexual love. Both men loved fine wine and handsome youths and welcomed the appearance of an eager protégé, capable of good conversation. Soon Fry was discussing subjects as diverse as Symonds' literary production, touching upon poetry, science, history, aesthetics and philosophy. He was impressed by Symonds' humanistic approach to art and life and its influence later became apparent in his book on Giovanni Bellini. Symonds frequented working men's bars, where he was immediately noticeable in his purple velvet jacket, elegant but

bohemian. Embittered by the restraints conventional morality had placed upon his writing, he confided to Fry, after their association was firmly established, pornographic details about his life and even confessed to a slight infatuation for his unwilling listener.

Fry felt, no doubt, in safer company with the Widdrington family whom he had met, it seems, quite by chance. Mrs Widdrington recorded in her diary, 'Mr Fry took us to queer cafés and places and we learnt a lot of Italian and were very happy in the July heat and the beauty of it'.[10] The father, Fitzherbert Widdrington, was a man of many talents; he dabbled in architecture, was a proficient, sensitive watercolourist and, like Fry's own father, had an encyclopedic knowledge of plants. Some thirty years earlier he had sketched with Edward Lear, the nonsense writer then known chiefly as a professional artist, and under Lear's influence had adopted the latter's long, thin format and his ink and wash style. With this satisfying skill to hand, he had travelled widely in the Middle East, Egypt and Europe. He was above all devoted to Italy and attempted to transport something of its flavour to his house, Newton Hall, at Newton-on-Moor, Northumberland, where he painted architectural capriccios on his hall walls.

Aside from the cultured, much-travelled father, Fry could not help being impressed by the striking personalities of the mother and daughter. No sooner had he returned to London than the friendship with the daughter, begun in Venice, swelled to love and, before the year was out, he had, to his surprise, proposed.

Idonea Widdrington, or Ida as she was called, was the first of Roger Fry's loves. She was a dark-haired, vivacious, wilful beauty who tended to play with the emotions of others and who lived on a continuous flood of passion. Prior to Fry's arrival in Venice there had been, so her mother recorded in one of her diaries, a hot love affair between Ida and a Sicilian officer which had caused them no small anxiety. Ida's capricious nature and easy beauty intrigued Fry, but the openness of both their characters soon exposed the opposition of their temperaments, which became uncomfortably apparent in their lengthy correspondence after their return to England. Ida used Roger as a confidant, sending him twelve-page letters, densely written, in which she poured out detailed descriptions of life in Northumberland and of the proposals and advances she had received. Her frankness had obvious appeal: 'Do you know I think you are gradually discovering that you don't like me?', she wrote.[11] He could not share her enthusiasm for sport or military tattoos and he tried to puncture her devotion to anything in uniform. 'I don't agree' she wrote to him, 'about a soldier being a man dressed in uniform. I think he's quite different. Anyway, while the uniform is on, he's a *soldier* to me.' There was some attempt on her side to change Fry; she was pleased when he took up fencing, but would have preferred boxing or prize-fighting. The Northumberland moors, which made hunting and hawking possible, largely encompassed her interests. Fry received lengthy descriptions of the chase which reflected her full-blooded love of sport. 'And

when I came home,' she wrote late one evening, 'I set off over the hills with my hawk and went hard and I suppose nearly came to half the end of myself and I wanted to have my dinner like a dog and go to sleep.' She was not unaware that her life-style ill suited his sensitive temperament: 'I suppose you would not like me in my sporting frame of mind and according to you [I] made a nasty picture yesterday, sitting with a split rabbit's head in my hand, blood on my coat and hands, the merlin feeding on my fist, spattering fresh brains about, and a ferret curled up in my lap, oh most unsightly woman!'

Over the next few years Roger Fry made several visits to Newton Hall. The house had been built in the eighteenth century but Fitzherbert Widdrington had extended it in the 1860s, the two most original new features being the installation of, probably, the first central heating system in Northumberland, and the construction of a conservatory that led round two sides of the house. On entering the front door at Newton the visitor finds himself in another world: harsh Northumberland winds are exchanged for gentle warmth, bleak landscape for the bright colours of flowering plants. The floor of the conservatory is inlaid with Italian mosaic and at intervals, as the visitor strolls towards the original front door, along the corridors banked on either side with plants, souvenirs from Italy reveal themselves – a marble seat, a niche with a drinking water fountain, a relief of a Madonna and child. At the far end of the conservatory, which protects the main entrance to the house, a corner seat covered with cushions offers a delightful nook. Throughout the year, the family would make use of this informal patio to bask in the warmth and sweet stench of the conservatory, admire the begonias, geraniums, the fuchsia and the magnolia tree which eccentrically flowered twice a year. Ida, writing to Roger, dreamily suggested that he should visit Newton to keep her company while her parents were away, and they would have their meals when they liked, smoke all day in the conservatory, he should read to her and she sing to him and in the dusk they would go for long rides over the hills.

Perhaps it was the strange beauty of Newton, cut off from the rest of the world, together with the potency of Ida's audacious character that led to Roger Fry's proposal. Her letters openly admitted how important he had become to her, yet she refused him. 'I don't want to marry you, please forgive me for having written to you at all. ... Good-natured unselfish people like you are always taken advantage of, but that does not excuse me for being one of the ones to do it. The worst of it is I feel quite sure you'll forgive me, really you good people in the world are almost trying, you make one feel so inferior and yet one can't do without you ...'. She had no illusions as to her own nature and declared herself wild and lawless with a hatred of bonds of any kind, bad tempered, difficult to live with, many-sided, in short, detestable. Two main drawbacks were her inability to remain faithful to any one person and her immense attractiveness to men.

It was her mother's custom to keep separate diaries for each of her

children. In these she would record not only events that occurred but also advice. In Ida's diary she warned against marriage with Roger Fry, pointing out that since no one man would ever satisfy her completely, she ought therefore never to marry at all. Ida herself wrote to Fry: 'I love you too well to spoil your life, and I feel almost sure this would be the result. I believe us to be the most hopeless oposites [sic] in nature that can be imagined, we have widely different views on almost everything you can name, if you look back to our conversations they have been one long disagreement, a charming too delightfully charming tug of war in which I got worsted in words and commonsense but preserved my own opinions.' When she eventually married in 1899 into the Cresswell family, the marriage, as her mother had predicted, was not a success. Over thirty years later Roger Fry, listing his loves in a letter to Helen Anrep, described her thus: 'No. 1 at [the age of] 25 the heroine of a Meredith novel just sheer romance – aristocratic, high spirited, gifted daring adventurous etc. – you see how all that spelled the illusion of pure romance.'[17]

The paintings that Fry left with the Widdrington family reflect his romantic mood at the time. He sent Ida a small oil of a heron rising over a marsh, the evening sun diffusing the forms in a haze of golden light (Coll: Captain J. Baker-Cresswell). It suited Ida's taste and she wrote to thank him. 'I think it is most awfully dreamy and wild and poetic. . . . I suppose as I like it so much you will consider it one of your failures. . . . I like the slow lazy flight of the heron, nobody has frightened it, it's just got up to go and fish in another part.' The Japanese calligraphic description of plants in the foreground indicates the still prevalent influence of Whistler. This is also true of the first painting Fry exhibited at the New English Art Club, in the winter of 1891, *St Marks: Twilight* (Coll: Miss Daphne Sanger), in which all that is visible in the gaslight is the gleam of the cupolas and a few shadowy forms. It is as indistinct as a Whistler 'Nocturne'; mood subdues the realisation of form. 'Atmosphere', wrote Frank Rutter when he attempted to describe advanced taste in landscape painting of the 1890's, 'was the magical word of the time, an infallible talisman. Either a work of art had atmosphere – and it was all right, or it did not have it – and was all wrong.'[13]

Fry returned from Italy to Francis Bate's studio and to the ugly Bayswater house; he exchanged the conversation of Symonds and Horatio Brown for humourless, serious discussions with his pious parents. Fortunately, however, the situation was soon to change when in 1892 Sir Edward retired and moved permanently to their country house, Failand, near Bristol. This impending move would leave Roger free to spread his wings, find lodgings of his own and establish his own life-style. But, as if to hasten the break, it was agreed that in January 1892 he should spend two months at the Académie Julian, to further his artistic training.

The Académie Julian was, at that time, the largest private art school in Paris, attracting students of all nationalities though especially popular

13 The
conservatory at
Newton Hall with
Ida, Gerard and
Bertram
Widdrington.
Photograph

41

with Americans. It was named after its founder, a prize-fighter who, in its early days, served as the model. By 1892 the school had expanded into an aggregation of studios in the rue du Faubourg St Denis, visited by well known sculptors and painters at Julian's invitation. Bouguereau was the most famous visiting teacher, a magnificent exponent of polished, sentimental scenes. The other professors, though well known, were equally conventional. Fry's choice of Benjamin Constant and Jean-Paul Laurens as teachers seems odd after his emulation of Whistler and his desire to exhibit at the New English Art Club, but there was little alternative. William Rothenstein, who was also studying at the Académie in 1892 described Constant as 'a powerful but brutal painter with a florid taste, one of the props of the old Salon'.[14] Jean-Paul Laurens, also a Salon painter, descended from the Romantic school, was famous for his religious and historical scenes painted with detailed realism in harsh colour and often dependent for their effect on some dramatic irony or contrast. His appearance was more inspiring than his art, as his strong, bearded face, marked by small-pox and a broken nose, reminded his students of Michelangelo. Inevitably the art produced under these two men was directed towards the Salon and was free of more troublesome avant-garde ideas.

Roger Fry was disappointed both by the teaching at the Académie and by the general standard of the students' work. He felt the training merely taught a fashionable method of representation and not the essentials of pictorial design. The large numbers of American and English students meant that he was not absorbed into a French community; and though somewhat more advanced than the other students in the theory, but not the practice, of art, Fry himself failed to leave any impression on his fellows. Whereas he was later to enjoy a lively workshop atmosphere, he appeared green and insecure in the noisy, cramped studio at Julian's where the easels and stools were wedged close together, the walls were covered with palette scrapings and crude caricatures, where practical jokes and lewd personal comments abounded, the stifling atmosphere exploding at times into songs sung in many languages. This was probably the first time that Fry drew from the female nude and in the eyes of the precocious Will Rothenstein, who was six years his junior, he appeared uncertain of himself: 'This year Roger Fry also came from Cambridge. . . . He had done very little drawing; I gathered that he had moved chiefly in scientific and philosophical circles; but he had a quiet attractiveness, and was clearly very intelligent. He did not stay long in Paris; he was not much of a figure draughtsman and was somewhat shy and uneasy at first in the free atmosphere at Julian's.'[15] A liberal Cambridge education had given Fry enough confidence to challenge his strict and narrow Quaker upbringing, but not enough to withstand the rough-and-tumble world of a Parisian studio.

He had, in a sense, brought Cambridge with him – and probably it cramped his style – for back in his room in the rue de Tournon, immured

by the attic walls, was his friend, Goldsworthy Lowes Dickinson, hard at work on a drama about Mirabeau, and emerging only occasionally to attend lectures at the Collège de France. He did, however, accompany Fry to the theatre and the opera in the evenings and, on occasion, they enjoyed one or two introductions into Parisian society. Only at odd moments was Fry able to explore by himself the dove-grey streets of Paris, and his letters home reflect none of the excitement that accompanied his Italian trip.

Yet these two months in Paris gave Fry the opportunity to develop a limited knowledge of modern French art. Julian's did not ferment with new ideas and Maurice Denis, who had studied at the Académie in the late 1880s, later declared that not even the boldest student was aware that Impressionism had just revolutionised painting. By the early 1890s the situation had changed slightly, but, even so, a good first-hand knowledge of the leading Impressionists was difficult to obtain. The Caillebotte Bequest had not then been made to the Luxembourg and to see Impressionist paintings the student had to visit certain dealers, in particular Durand-Ruel whose gallery between the rue le Peletier and the rue Lafitte was, to Rothenstein, a kind of second Louvre. Fry's experience of Impressionism would have been blurred by the mass of second-rate followers who imitated the Impressionist technique without fully understanding its intentions. Although students at the Académie Julian discussed Monet, they preferred Besnard's studies of nudes under lamplight. Other artists admired were Cazin, Dagnan-Bouveret. Aman-Jean and Puvis de Chavannes, the latter's flat, idealised paintings, which became classics during the artist's own life-time, providing an important inspiration for the symbolist movement. Looking back on this period, in a lecture on modern art delivered in 1927, Fry concluded that he had arrived in Paris when outward appearances suggested a still point in the evolution of art.

> When I was a student, a very ignorant and helpless student but a fairly observant one, there in the early nineties of the last century the outlook was as follows. The Impressionist movement which had begun well before 1870 and had dominated the vital art of the next two decades had spent its force, its impetus was nearly exhausted. . . . In fact Impressionism had just become Academic . . . and the exhibitions of the day showed a distressing monotony and a universal competent mediocrity. A few attempts were being made to give to the Impressionist formula a new decorative application, but without much success except in the very particular case of Seurat whose work was too little known and too recondite to arouse at that time any echo. . . . Had I known of the forces already working underground in secluded almost inaccessible centres it would have been perhaps very different. I was familiar enough with the names of some of the works of all the artists who had brought about the Impressionist movement in 1870, twenty years before, of all that is to say except one – the name of Cézanne was absolutely unknown to the art students of that day . . . throughout my student days in Paris I never once heard of the existence of such a man.[16]

Lack of adventurousness circumscribed Fry's knowledge of modern French painting in 1892. Unlike Rothenstein, he did not haunt the galleries of leading dealers. He did, however, attempt to familiarise himself with various art theories and even grappled with the ideas behind Neo-Impressionism which had been extensively discussed in the art press in the 1880s by Félix Fénéon. This theoretical knowledge, rather than familiarity with the art itself, gave Fry the courage the following year to review George Moore's *Modern Art* in the *Cambridge Review*. In this book Moore mercilessly castigates many of the *bêtes-noires* that Fry himself was later to pursue: the adverse influence of the subject on English art, the love of moral allusions, the dismal lack of taste and judgement at the Royal Academy. Chiefly directed against the whole system of art patronage in Britain, Moore's battle cry was free trade in art. Moore was, to a great extent, reacting against Ruskin, who, according to Fry, attempted 'to make art acceptable to Puritanism by admiring a picture in proportion to the artist's adherence to the ten commandments'. He cited Moore's argument (one that Fry himself was later to use) that the Academy reflected no artistic tradition, only the desire to please the stockbroker and follow the market. Fry appreciated Moore's satire, his common sense, and his love of painting for its own sake: 'The enormous difficulty of giving any conception in words of the indefinable, unanalysable qualities of a work of art, just those qualities of technique wherein its greatness lies, has led more critics from Lessing down to Ruskin to talk about principles, psychology, ethics, anything in the world but the essential and untranslatable meaning of the picture. But Mr Moore succeeds at times in conveying almost a visual impression. . . . he seeks . . . to convey the peculiar and individual excellences and limitations of the master under discussion.'[17] It was precisely this that Fry himself later attempted in his own writings. His only criticism was of Moore's inadequate appreciation of Monet and 'pointillism', the latter point indicating his own advanced knowledge of Neo-Impressionism.

Soon after the review appeared, George Moore wrote to Fry thanking him for the article and suggesting that he should expand on his subject for the *Fortnightly Review*. Following his advice, Fry produced a lengthy essay entitled 'The Philosophy of Impressionism', but its high-brow tone failed to interest any editor. In this he applied Cambridge rationalism to his understanding of Impressionism in order to bring out its philosophical implications. He saw in it a parallel to the tendency of modern thought to reject the idea of static states for dynamic processes: metaphysicians, he argued, can no longer regard objects as 'things in themselves' but are forced to see them in relation to other things and to the self-conscious being that perceives them; and Impressionist painting was less concerned with analysing objects of experience than with analysing the experience itself; it assessed not the object of sight but the nature of visual sensation and therefore the human factor took on new importance. The result in painting, he concluded, was a new unity of colour harmony, a unity brought about by the all-pervading influence of atmos-

phere on colour at any particular moment of the day.[18]

If published, this article would have earned Roger Fry a position among the most advanced writers on art in England. Ironically, it marks a watershed in his interest in modern painting; as the decade developed he turned increasingly away from contemporary ideas both in his painting and his writing. Already his paintings were beginning to falter and lose direction and, apart from the occasional success, he now struggled unconvincingly with New English Impressionism and with a Nabi-like use of flat patterning. Before long he settled down to make a detailed study of the techniques of the Old Masters and to paint as if the Impressionists had never been born.

Soon after his return to London in the spring of 1892, Roger Fry and the poet Robert Trevelyan took a house and small studio at 29 Beaufort Street, Chelsea (now demolished). The tall, lean Bob Trevelyan made a charming, intelligent companion but a streak of madness animated his figure leaving his hair ruffled and his clothes permanently disarrayed. Some even thought this untidiness extended to his mind because, when excited, his speech became garrulous and not entirely controlled, and in his letters he tended to leave sentences unfinished. Having been educated at Trinity College, and, like Fry, a member of the 'Apostles', Trevelyan's presence continued the influence of Cambridge intellectualism in Fry's life (as Bloomsbury was to do almost twenty years later). He was as single-mindedly devoted to literature as Fry was to art and in 1901 their interests were able to complement each other when Fry provided illustrations for Trevelyan's second book, *Polyphemus and Other Poems*. At Beaufort Street the two young men began to entertain and when their cook, Harris, became incapacitated by drink, Fry concocted a risotto which the vegetarian Bernard Shaw refused, detecting a flavour of animal gravy, the first of many to look askance at Fry's culinary efforts. During working hours, Fry retired to the studio in the garden, in search of a personal style that would establish his reputation at the New English Art Club.

At Blythborough in Suffolk that summer, Fry painted a view of the estuary (Plate 14) in which the stark silhouettes of the foreground trees rise almost the entire height of the picture, forcing the distant view behind to reassert its relationship with the two-dimensional surface of the canvas. The Nabi-like design and hallucinatory colours justify Fry's claim, made in a letter to Edvard Alkman, that in Paris he had familiarised himself with the latest theories of the Independants, the Symbolists, the members of the Society of the Rose Croix and of Sâr Péladan. It may have been to this painting that Fry referred when in 1912 he wrote to the critic, D. S. MacColl, 'One of my earliest oil-paintings was essentially Post-Impressionist, but was so derided at the time – I never showed it publicly – that I gave in to what I thought were wiser counsels and my next rebellion against the dreary naturalism of my youth lay in

14 Roger Fry: *The Estuary at Blythborough*, 1892-3. Oil on canvas, 63 × 71.5 cm. *Mrs Pamela Diamand*

the direction of archaism.'[19] Fry returned to Blythborough during the summer of 1893 and, still searching for some quality other than mere imitation, he wrote to his father on his return to his studio, 'I am repainting most of my Suffolk pictures as I found they were too detailed and literal and that for the final effect I must get away from nature'.[20]

Two of Fry's paintings had been accepted by the jury of the New English Art Club of 1891, and he was therefore disappointed when, in the following spring, all his work was rejected. After this temporary set back, the recognition his work received at the autumn exhibition of 1892 led to his being elected a member the following year. From them on he exhibited regularly until his resignation in 1908, sat frequently on the selection jury and in 1903 was invited on to the Executive Committee. He waited apprehensively for the reviews, entered into the club's political and artistic discussions and hoped that, gradually, his portraits and landscapes would establish his reputation.

Fry had a flair for capturing likeness, and his relations and friends were naturally willing to make use of this talent. In April 1893, he made a sketch in oils of Mrs Widdrington in a magnificent early eighteenth-century dress at her sister's home in North Wales. The result was felicitous. Taking the sketch with her, and after a visit to Roger Fry's family home at Failand, Mrs Widdrington returned to Newton Hall from where Ida wrote to Roger:

> I have been so interested hearing all about Mamma and your own people. She's awfully fond of your Father now and keeps quoting him, and says you're all so beautifully clever. She's fearfully bored with us now and calls us all sorts of rude names. My Dad is so amused, he waxes most witty on the subject and chaffs Mother and says he feels awfully out of it now. I like yr. picture of Mamma very much indeed, I think it's really clever and very like, it's got the *spirit* of her, almost more than the letter I think, but I love her neck and chest and you've managed the age so well, neither young nor old.

It was approved by the family that Fry should produce a large full-length of the subject and with this intent he travelled, in September 1893, to Hopwood Hall in Lancashire, the home of Mrs Widdrington's mother.

Ida's letter suggests that in North Wales Roger Fry's character and that of his family had intrigued Cecilia Widdrington. Now, during the course of the artist's isolated, intense scrutiny of his sitter, Fry discovered the full warmth of her nature and her bold independence of mind. She had been born Cecilia Gregge-Hopwood, the third child in a family of daughters. Her father, disgusted by the arrival of yet another girl, immediately farmed her out to a gamekeeper's cottage where she grew up without any form of education. The beneficial effect of this upbringing was that it left her unhindered by social conventions. Attracted by her energy, directness and anti-materialism, Fry was able to ignore the fact that she was twenty-three years older than him. She had a total disregard for the value of objects, giving away silver teapots to the servants and leaving a bowl of silver permanently in the hall at Newton as she disliked being asked for change. On all occasions, even at formal dinners, she wore steel-capped workman's boots and in these would walk the six miles from Newton to Alnwick to shop, carrying all the parcels herself and overtaking the horse-drawn flat sent out to fetch her. With her husband she had travelled widely, going up the Nile by steamer before the source had been discovered: Mr Widdrington studied antiquities; she preferred to talk to the crew and learn Arabic. Her marriage to Fitzherbert Widdrington was a happy one in spite of the fact that her first child, born after marriage, was by another man. This perhaps explains her open-mindedness to her daughter's affairs and her willingness to discuss subjects from which most Victorians of her class would have recoiled with horror. When, therefore, Virginia Woolf, in her biography of Roger Fry, mentions an anonymous woman 'who was neither young nor beautiful, but old enough to be his mother', it is

surely to Mrs Widdrington, whose exceptional clearsightedness enabled her to cut through formalities like a cheese-wire, that she refers: 'She it was who undertook to educate him in the art of love. . . . Endowed, he said, with enough fire to stock all the devils in Hell, she stormed at his stupidity, laughed at his timidity and ended by falling in love with him herself. He profited by the lesson and was profoundly grateful to his teacher. . . . to the end of life pupil and mistress remained the best of friends.'[21]

15 Roger Fry: *Walberswick, Suffolk* c. 1894. Oil on canvas, 47 × 66 cm. Lady Younger

No one else in these early years, apart from Ida, came so close to Roger Fry, and when he became engaged to Helen Coombe in 1896 he wrote to Dickinson admitting that such a step must make both him and Mrs Widdrington apprehensive. As Virginia Woolf says, his marriage troubled but did not end their friendship. Cecilia Widdrington lived to be ninety-six, outliving Fry by four years. Her severely patriotic attitude to the First World War caused a temporary breach in their friendship, but on a visit to her home in 1921 he found her (aged eighty-two) still young and vigorous. By then, all disagreements were forgotten for she had returned to her previous free-thinking and revolutionary state of mind.

16 Cecilia
Widdrington, aged
92. Photograph

As to the portrait, it was probably never completed. It turned up in 1919 when Fry was moving out of his house at Guildford. 'I turned out among other things', he wrote that year to Vanessa Bell, 'a vast portrait I did ages and ages ago of Mrs Widdrington in a fancy dress costume of a sort of eighteenth-century idea, coming down a flight of steps in a park – rather terrible wasn't it but in spite of horrible lapses not altogether bad, rather new in colour and not quite helpless.'[22] This portrait no longer exists, but an unfinished one of the son Bertram remains in the Widdrington family, cut down and labelled on the back 'caricature by Roger Fry'.

Most of the portraits Fry produced during the nineties, while a vogue for portrait painting flourished, have disappeared. One portrait that does however remain and which brought Fry the praise of other artists is that of Edward Carpenter (Plate 17). It was exhibited at the New English Art Club in the spring of 1894 and, by special invitation, at the Liverpool autumn exhibition of the same year. For this portrait, Fry chose the tall, thin format, popularised by Whistler, and balanced the strong vertical of the standing figure with emphatic horizontal reflections in the mirror behind. The atmospheric space and nonchalant, momentary pose suggest a further debt to Whistler. Carpenter wore his 'anarchist overcoat' as Fry described it, the collar turned up, his hands in his pockets, and a red tie. The empty room in which he stands may just record a corner of Fry's studio or it may reflect on Carpenter's ascetic tastes and his rejection of materialism. Informal, yet dignified, it remains one of Fry's most accomplished paintings.

49

17 Roger Fry:
Edward Carpenter,
1894. Oil on canvas,
73 × 43 cm. *London,
National Portrait
Gallery*

This portrait may also owe something to Sickert because, during 1893, Fry attended evening classes at The Vale, Chelsea, run by Sickert in William de Morgan's old studio. There Fry studied the nude, listened to Sickert's criticisms and, together with Will Rothenstein, entered into lively discussions with his teacher. Sickert taught that the artist should develop his visual memory; that drawings should grow outwards from the centre of interest and should be regarded not as ends in themselves, but as notations to be worked up later into paintings. His teaching reflected his own training under Whistler and Degas and it is perhaps the latter's influence (coming through Sickert) that led Fry, in his portrait of Carpenter, to give a slight upward tilt to the floor, thereby forcing the figure into a more dynamic relationship with the picture format. The use of the mirror reflections to extend the constructional relationships within the picture is a technique often found in Sickert's Old Bedford music hall paintings of the early 1890s. Intelligent, witty, experienced, Sickert was in many ways an obvious mentor for Fry, but where Fry could not follow this master was in his desire to find poetry and magic in dim urban corners; and he was utterly nonplussed by Sickert's admiration for music hall songs with their vulgar, bawdy sentiment.

These discrepancies in taste did not prevent Fry from forming a warm friendship with the Sickert family, and on his visits to the continent he would occasionally stay at their house at Dieppe. In spite of this familiarity, he continued to regard Walter Sickert with a certain awe up until the mid-'nineties. After a visit by Sickert to his studio in 1894, Fry wrote excitedly to his sister, Margery: 'Walter Sickert was here the other day and was or professed to me and others to be quite surprised at my work; he said he'd no idea it was so good and that he's never done me justice. . . . It's given me a great spurt; praise from one who knows means such a lot.'[23] But only a year later, after a visit to an exhibition of work by Walter and Bernhard Sickert at Van Wisselingh's Dutch Gallery in London, he told his mother (20 January 1895): 'The Sickert brothers had a private show on. To me, I confess, it seems less than it would have done some years ago. Of course they are very clever but I feel that if I ever realise my ideas of a picture as well as they have theirs, it will be a better picture.'

Fry's admiration for the Sickert brothers had been undermined by his growing interest in the Old Masters and their techniques. In 1893 the portrait and watercolour painter L. C. Powles had instructed him in traditional methods of oil-painting and Fry found himself worrying whether these could be combined 'with the truth to nature which modern people have become accustomed to . . .'[24] He then read Eastlake's book on the artist's methods and materials and observed to his mother, 'I'm getting so imbued with the older traditions of painting that I shouldn't be surprised if I were to copy an Old Master some day'.[25] Meanwhile he was preparing a set of lectures on Italian art to deliver at Eastbourne and this too affected his view of the contemporary

scene. 'The more I study the Old Masters', he informed his father, 'the more terrible does the chaos of modern art seem to me.'[26] He was perfectly aware that his own painting might suffer if he spent too much time looking at past art; when the painter Alfred Thornton suggested the Symbolist solution, that his paintings would appear less laboured if he let his subconscious mind take over at times, Fry growled in reply, 'the damned thing would only produce a pastiche'.[27]

Fry had at Beaufort Street two distinguished neighbours who actively encouraged his interest in techniques – Charles Ricketts and Charles Shannon. In appearance and personality, they mutually complemented each other. Charles Ricketts, who was half French, had pale, delicate features, fair hair and a red, pointed beard. He had travelled little but had an astonishingly wide knowledge of art and this, added to his quick intelligence and good talk, led him to act as the spokesman of the two though he always prefaced his comments with 'we'. The Irish Shannon, on the other hand, had a ruddy, boyish face and startling blue eyes surrounded by fair lashes. While Ricketts loved to dominate and influence others, Shannon retained a quiet reserve. It had, however, been decided that Shannon was the better artist of the two. He had exhibited at the Grosvenor Gallery in 1887 but after that decided not to exhibit again until he had perfected the Venetian technique of oil painting, after which he would emerge an invincible master. Meanwhile Ricketts financed this intent by executing illustrations and advertisements to bring in enough money to live on. The two men also turned their talents to the production of their immaculately printed magazine, *The Dial*, and, after moving from The Vale to 31 Beaufort Street in 1894, set up the Vale Press as a further outlet for their artist-craftsmanship. Fry became a regular attender at their informal evening gatherings where, according to Rothenstein, he sat at the feet of these two men, absorbing their talk, but never became one of their intimate circle. Their attempt to continue the Pre-Raphaelite tradition, subtly transformed by their interest in Symbolism, did not appeal to Fry, but their catholicity of taste and knowledge no doubt broadened and developed his taste. And added to this was their mutual interest in traditional techniques.

Unsettled by notions about the 'right' way of painting, Fry hovered uneasily between Impressionism and archaism during two visits to La Roche Guyon in 1894 and 1895.[28] Situated on the Seine, not far from Véthueil, the village of La Roche Guyon is dominated by the Château de la Rochefoucauld which constantly reappeared in Fry's paintings. He quickly grew to love the stretch of river edge with lime trees and poplars, and the low line of hills punctuated by chalk cliffs. His companion on the first of these visits was Alfred Thornton, a painter who had spent some time at La Pouldu shortly after Gauguin had visited the place. He had however failed to understand Gauguin's art and instead his hero was Monet and his slogan, 'Effects not facts'. In search of effects he made numerous rapid charcoal sketches with almost total disregard for structure or design. Meanwhile Fry set to work on some harvest scenes,

alternately experimenting with glazes and impasto. He was eager to obtain the criticism of D. S. MacColl who was staying nearby at Vétheuil with the Australian artist Charles Conder. The Scottish MacColl, tall, thin and sober, had established a reputation as the Ruskin of the English Impressionists, having proselytised for Steer and other New English Art Club painters. He upheld the importance of 'loose' painting, preferring suggestion and charm of colour to finish and solid construction. He later remembered how the young Fry seemed desperately worried that his paintings would never look 'artistic'. However, as four miles separated the two villages and heavy boats were the only form of transport, only a brief exchange between the two parties took place. As it was, Fry was already beginning to doubt the value of Impressionism and on a visit to Giverny in an unsuccessful attempt to see Monet, he limited his admiration to the Italianate poplars. Forty years later Thornton recalled:

> Both Fry and I were steeped in the Romantics, not being satisfied with the naturalism of the Impressionists; we dimly felt that more was required than an expression of surface appearances, but, as Fry said years later, we were groping for what Cézanne, of whom we had not then heard, had already rediscovered as the essential that lay behind the passing show of light and colour. We had forgotten that human emotion with associated ideas, such as those on which the romantics depended, were as fleeting as effects, and that what is fundamental should be expressed in the graphic arts through the medium of design.[29]

In between these two visits to La Roche Guyon, Fry travelled to Italy for a second time. On this trip his companion was the erudite Cambridge graduate, A. M. Daniel, who eventually, in 1929, became the Director of the National Gallery in London. As well as this stimulating companion, Fry took with him Morelli's two volumes on Italian art and each evening carefully studied his comparisons of minute anatomic details in order to establish authorship of a work of art, a scientific approach that naturally appealed to Fry. No longer a merely curious sightseer, Fry, with Daniel, acted the part of a concientious scholar, visiting as many galleries and churches as possible in Milan, Bologna, Florence and Bergamo. Daniel insisted that detailed attention should be paid to the correct attribution of minor works, forcing Fry to look closer at Italian art than he had done before and considerably developing his knowledge of the Early Renaissance. Yet still deeply imbued with the Impressionist taste of the 'nineties he admitted, 'But I confess that after nearly a week of the early men, though I've learned to think much more highly of some than I ever did before, especially Paolo Uccello and Masaccio, I feel a yearning for some big sloppy modern like Velasquez or Gainsborough with a little poetry in his touch and a little mystery in his atmosphere.'[30] Towards the end of the holiday he realised that his approach to art history differed from that of his companion; factual information for Fry provided only the springboard for appreciation of the painter's intention; it was not enough to establish the historical significance of a work, the

expressive content had also to be assessed. And for his personal benefit, he wanted to discover what qualities in Italian art had significance for his own painting.

Mid-June 1895 found Fry again at La Roche Guyon, where he painted for hours at a stretch, breaking only for meals and cooling bathes in the river. From there he moved to S. Pierre-en-port, near Fécamp on the Normandy coast, where MacColl was holding another summer party, but though Fry enjoyed the company he found the surrounding countryside disappointing. On his return to England his French landscapes were again subjected to more leisured contemplation in the studio. 'I have already begun again on my French landscapes,' he informed Lady Fry, 'and I think my study of Italian drawings has influenced my work somewhat in the direction of demanding more complete design in a picture . . . much modern work now seems to me empty.'[31]

Of the handful of French landscapes that remain from these two visits to La Roche Guyon, *The Valley of the Seine* (Plate 18) is the largest. It was exhibited at the New English Art Club winter exhibition of 1896 and had probably been worked up from sketches during the course of

18 Roger Fry: *The Valley of the Seine*, Exh. 1896. Oil on canvas, 79.5 × 112 cm. *Private Collection*

that year. It represents the bend of the river at Les Andelys, guarded over by the Château Gaillard, which he had visited in 1894. An ambitious painting both in its size and in the drama of the view, it is not wholly successful; the technique is clumsy and the rhetorical design remains flat and unconvincing in the great sweep of space it strives to represent. Fry, however, was not unsatisfied with it and when Robert Trevelyan decided to buy it for £30, the price asked at the New English, Fry told him that he thought it the best thing he had painted so far. To his mother he repeated this view: '... the largest and most significant landscape I have yet done, a great view of the Seine valley which has been a good deal praised in the press ... but still better it has brought me a good deal of appreciation from artists.'[32]

Even at this date painting did not tap all of Roger Fry's intellectual energies, and, while still making it his main occupation, he continued to develop his decorative skills and began, in 1894, to lecture on art for the Cambridge Extension Movement. After two short courses of lectures given at Eastbourne and Brighton, he expressed surprise at their easy success. 'My success in that seems out of all proportion to the amount of work put into it while I think it is rather the other way with my painting,' he told his mother (26 June 1895). As a designer, he advised his father on the choice of a stucco frieze for the dining-room at Failand, contributed spidery illustrations to C. R. Ashbee's *From Whitechapel to Camelot* published in 1892, together with a frontispiece reminiscent of Herbert Horne's cover for the *Hobby Horse*. He hoped other publishers would use him as an illustrator and when no further work was forthcoming contented himself by designing bookplates for Lucy Hodgkin, Bernard Berenson, Cecilia Widdrington, Bertrand and Alys Russell and others. He was prepared to turn his talents to any problem, designing furniture for McTaggart, curtains for Alys Russell, a drawing-room frieze for the Trevelyans, and even a Band of Hope banner. Of the latter, he wrote to Trevelyan, 'I wish I could get more work just on this level of decoration. I love working within the slight limits which such a thing imposes. Why won't the architects use me?'.[33]

Though at this time he found small outlet for his interest in interior decoration (later to flower so exuberantly at the Omega), one architect who did make use of his talents was his old friend, C. R. Ashbee. For Ashbee, Fry executed a wall painting on the chimney breast in the drawing room of 'Magpie and Stump', 37 Cheyne Walk, a house (now demolished) built by Ashbee for his mother on the site of a well known inn from which it took its name. It was completed in 1895 when the *Studio* published an article on it, making mention of Fry's mural. 'The room is papered with a peacock blue paper of a formal pattern in two shades, and the painting by Mr Fry is cleverly planned in the same key of colour, so that it grows out of the walls as part of them, and does not at first sight detach itself as a painting is apt to do ... its symmetrically-treated formal garden, with a central fountain, is very happily imag-

ined.'[34] The attempt to relate the wall painting to the rest of the décor reflects the influence of Whistler, as did Fry's choice of colours for Hubert Crackenthorpe's house at 96 Cheyne Walk. Fry advised white walls and a black wood dado, and, with a Whistlerian fanaticism, was horrified when Crackenthorpe upset this ascetic scheme by hanging sepia-coloured photographs on the walls.

In 1896 Fry executed for his parents a mural on one end wall of the stone veranda at Failand, in a style imitative of the frescoes he had recently seen and admired in Italy. He unfortunately disregarded the technique of fresco painting and covered the wall with strips of canvas, which was ill-suited to the open-air and as a result only a ghost of the original picture remains in position today. This, and other, of Fry's early decorative attempts are uninspiring – a mixture of classicism and late Victorian aestheticism. But his belief in their importance, his willingness to experiment and his conviction that art should enter life at all levels laid the foundation for his later revolutionary venture, the Omega Workshops.

The autumn of 1896 found Fry hard at work arranging an exhibition of contemporary painting in the Bijou Theatre at Cambridge, from where he wrote to the painter Helen Coombe, 'I see that everyone here thinks it a queer sort of a joke, this art business and that a sensible chap must excuse himself for caring about it at all.'[35] He had decided to exhibit work by younger British artists, irrespective of any single artistic dogma, but the weighting must have favoured New English Art Club painters as the *Cambridge Review* noted that generally 'unity of effect' was favoured over 'precision and charm of invention'.[36] Fry, on home territory, had his own paintings warmly praised and similarities were noted with the art of D. S. MacColl. The interest and appreciation which the show aroused must have gratified Fry as its organisation and hanging had been solely his responsibility. He had loaded paintings by Steer, Tonks, Rothenstein, Conder and others on to handcarts and wheeled them through the slums of Cambridge; but the astonishment he caused was mild compared to the furore he unleashed fourteen years later with his first Post-Impressionist exhibition.

4 Marriage and Old Masters

One afternoon in 1896 the civil servant Edward Marsh, accompanied by a young lady, called at 29 Beaufort Street where he hoped to introduce his companion to Bob Trevelyan. The poet was out and learnt later from Marsh of his loss: 'I had for you a rose of Shiraz, the direct descendant of the one which intoxicated Hafiz when he looked on it, and led his spirit forth like wine on the turnpikes of imagination into a land of luminous horizons. As it was I took it round to Fry who fell violently in love with it and fell to painting it.'[1] The woman was Helen Coombe, a tall, large-limbed creature whose slow movements and seeming nonchalance hid a quick wit and an instinctive intelligence. It was difficult to say whether her smooth, regular features and gentle expression were beautiful or not. Even the voluble Marsh felt undecided:

> She is so completely out of the common that the question of beautiful or ugly scarcely seems to me to arise, but if I were forced to use one word or the other I believe I should after all say beautiful, there are certain positions of her head in which the lines of her face compose so finely – and certain positions of her figure which are simply *du Luca Signorella* [sic]. Her personality is out of my ken altogether, I felt it as something mysterious and grandiose made human by her frank and generous humour. Her aloofness and impenetrability give way at once on any common ground of fun – I have met very few women who seemed to have more of the dignity and less of the limitations of their sex. Don't imagine that you can dispose of all this by saying that her few teeth are brown.[2]

Helen was one of a family of twelve. Her father, a corn merchant, had died young and the family fortune had been largely absorbed by her elder brother Russell, who trained as a surgeon. She herself had left home at an early age, determined to establish her reputation as a painter and stained-glass designer and in the latter role had executed the 'Mary and Martha' window in the south aisle at High Cross Church, Hertfordshire, in a style very similar to that of Selwyn Image who executed the West window in the same church. Like Image, Helen moved in an artistic circle that centered around Herbert Horne's and A. H. Mackmurdo's Century Guild based at 20 Fitzroy Square, which, despite its membership of two, attracted many visitors. It was inevitable that before long she and Fry should meet, and Mackmurdo, many years later, claimed that he had brought about their introduction.[3]

19 Helen Fry.
Photograph

Fry's courtship of Helen was sealed by the decoration of the Dolmetsch 'Green' harpsichord. Arnold Dolmetsch, whose concerts of early keyboard music had first begun at 20, Fitzroy Square, intended this harpsichord for the Arts and Crafts exhibition of October 1896. By mid-July work on the instrument had advanced far enough to allow Helen to begin the decoration on the inside of the lid. She stayed at the Dolmetsch home and inveigled Fry for advice. He recommended medallions and she thanked him for this suggestion, adding that he was not to trouble himself with their design. Her next letter reads: 'It's most awfully good of you to have drawn out those medallions. I think they would look very jolly ... if you are inclined to send me *subjects* I should be so glad of suggestions who [sic] you say are in your lucky head: mine' seems empty.'[4] October arrived and only the panel over the keyboard and the

interior of the lid had been completed. The exterior was hurriedly coated with a green lacquer (in the erroneous belief that further decoration would be added at a later date), and the instrument takes its name from this uncharacteristic colour. Selwyn Image executed the medieval inscription and Herbert Horne the roman lettering over the keyboard, but it was probably to Fry's contribution that Helen referred when she informed him of the instrument's arrival at the New Gallery: 'I will only tell you of the harpsichord, "our child", as Frances Dodge [pupil of Dolmetsch] now calls it. I rushed off to the Arts and Crafts and found Dolmetsch performing on it. He jumped up and exclaimed, "Here comes the artist who painted it". Tableau and amusing throng. Met at Paddington by announcement of Morris' death so all the influential people stayed away.'[5]

20 The Green Harpsichord decorated by Helen Fry in 1886. *Haslemere, The Dolmetsch Foundation*

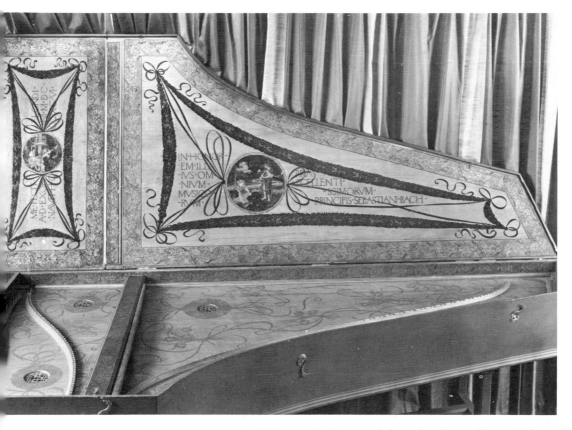

The nervous excitability and elisions of thought that enliven Helen's letters must have warned Fry of her mental instability. Prior to their meeting, a relationship had developed between Helen and Mackmurdo but Mackmurdo, suspecting mental illness, had broken it off and Helen had temporarily become almost suicidal. Fry not only had to assure his parents that Helen's father had been well connected 'with an admiral somewhere in the offing and the mother's family is distinctly higher in

point of birth than we are', but had also to add that there was 'no insanity or tendency to it in Helen's family'.[6] This may, however, have been a standard concern with Quakers, among whom persistent inter-marriage had caused much insanity. (Ironically, The Retreat at York, built by Quakers to cope with this problem, was to be Helen's home for the greater part of her life.) In spite of their son's assurances, Sir Edward and Lady Mariabella at first opposed the marriage on the grounds that the thirty-two-year-old Helen was penniless and Roger (two years her junior and still living on an allowance from his father) had not yet established any secure professional position.

They first learnt of Helen in July, but by September had come to accept Roger's decision. On December 3, Roger and Helen were married at St Bartholomew's in the City. According to Lady Fry's diary, five of Roger's sisters were present as well as many friends and some relations, and the service was followed by tea at Mrs Coombe's house. Sir Edward and Lady Fry, now totally converted to the marriage, gave it their full approval; nor did they ever remind Roger of their warnings even when the full horror of Helen's illness became clear. He, however, attracted like a moth to a flame, had already sensed disaster, as he later described to Helen Anrep in his list of loves: 'No. 2 at 30 (my wife). The fated

21 Roger and Helen Fry on the veranda at Failand. Photograph

inevitable thing the predestined wife – too many tastes and interests in common and she with wit and a strange touch of genius and I fell completely in love with her in one afternoon's talk, and it was so inevitable that I thought she must see it too but she didn't for nearly a year. And there was beauty too; and a certain terror on my part at the mysterious ungettableness of her – I suppose what become her madness later on, but the terror tho' very definite, so that I felt certain of tragedy when I married, added a fearful delight.'[7]

The couple honeymooned in Tunis and Bizerta and on their outward journey paused at Paris and Avignon. At Avignon the weather was so warm, they took their sketching things, crossed the bridge to Villeneuve-les-Avignon, and marvelled at the view of the Popes' Palace suspended in the blue evening air. (In 1913 Fry painted a large oil of this scene which hung in Helen's room at the Retreat). At Bizerta they stayed with the Vice Consul, Terence Bourke, whose Irish humour smoothed over their difficult relations with his intense, dull wife. Bourke introduced them to the customs of the East: they attended a service of the Isa Weir, a sect of the Mohammedans, and the wild hypnotic dances ended with acts of physical outrage, one performer crushing glass between his teeth, another scraping his scalp with prickly leaves and another even plunging a sword into his belly. Fry recorded it all in his letters home with scientific precision and thought the explanation behind it all was auto-suggestion induced by the hypnotic power of the music. Still more impressive, he felt (remembering his discussions with Carpenter), was the social equality he observed between sheiks and servants, and the Eastern conception of life. 'What is so extraordinary about these people is that they have no idea of movement. All the functions of life are regulated and provided for – their religion prevents them from bothering about a future life and so they actually live and enjoy instead of preparing to enjoy as we do ... No one is disappointed by not getting what he hasn't got because the idea of struggling and competition hardly exists – everything is accepted as it is.'[8]

They returned to London in the spring, took lodgings at 7 Beaumont Street, Portland Place, until a flat in the Temple promised to them by a friend of Helen's fell vacant. From there, Fry intended to begin house-hunting. He also approached the publishers Elkin Matthews and Grant Richards, in the hope of being given illustrational work. But before their London life could take on any clear pattern, Helen fell ill with pleurisy and, advised by the doctor to find a warmer climate, they left London in April 1897 for an extended honeymoon in Italy. They returned home in the late summer, but by November were back in Italy, staying at Ravello, a town south of Naples, where they hired a studio and settled down to paint. Fry, his thoughts still tinged with romanticism, painted the ruins at Taormina, which he populated with figures in eighteenth-century dress,[9] as well as a picture of a satyr appearing to St Anthony which he explains in a letter as merely an excuse for an elaborate rocky landscape. But when in the spring of 1898 they moved to Rome, he

copied a classical landscape by Gaspard Dughet in the Colonna and studied the Carracci lunettes in the Doria Gallery perhaps to correct his leanings towards the fantastic.

Not all his time was spent painting and on both these visits to Italy he took pains to extend his knowledge of Italian art. With the added responsibilities of marriage, the future of his career had to be reconsidered and seemed at this moment to hover uncomfortably between two interests – one practical, the other historical. It was still his desire to pursue a career as a painter, but his success at lecturing and relative failure as an artist forced him to realise that the study of past art was a more profitable use of his time, and this slight but definite shift of allegiance (he still continued to paint whenever possible) very quickly brought out his talents as critic.

Just at the moment when his knowledge of Italian art reached maturity, a letter reached him in Florence in the spring of 1898 from the Sign of the Unicorn publishers commissioning a ten thousand word monograph on Giovanni Bellini for the fee of £25. As he was actively engaged in preparing a set of lectures on Venetian art for the Cambridge Extension Movement, the commission could not have been better timed. It injected fresh impetus into his studies and gave him confidence to approach certain leading authorities in the field, among whom was the young Bernard Berenson.

Berenson, a small dapper individual with a neatly-clipped beard, was only one year older than Fry but already much further advanced in his career. After studying at Harvard, he had travelled widely in Europe on a scholarship before deciding to devote himself to the work already begun by Crowe and Cavalcaselle, and by Morelli – the cataloguing and correct attribution of Italian painting. Eloquent and composed in company, he had Pater's gift of translating a refined sensibility into lively readable prose which contrasted greatly with Crowe and Cavalcaselle's dry reference books. During the 1890s he had travelled all over Italy, visiting galleries and churches, and had also visited many important private collections in England. His extensive knowledge had already found outlet in four books, *The Venetian Painters of the Renaissance*, *The Florentine Painters of the Renaissance*, *The Central Italian Painters of the Renaissance* and a monograph on the early sixteenth-century Venetian artist, Lorenzo Lotto.

The first of these books had appeared in 1894 and may have come to Fry's attention at this time as it coincided with a large exhibition of Venetian art held at the New Gallery. His book on the Florentine painters, published in 1896, had, however, more importance for Fry as in it Berenson put forward his notion of 'tactile values' as vital to the understanding of the Florentine tradition. He believed that there is a fundamentally physical response to the representation of form and space and that the onlooker's experience of the everyday world enables him or her to relate tactile values to retinal sensations. The painter's first concern therefore, said Berenson, was to arouse the tactile sense, to give

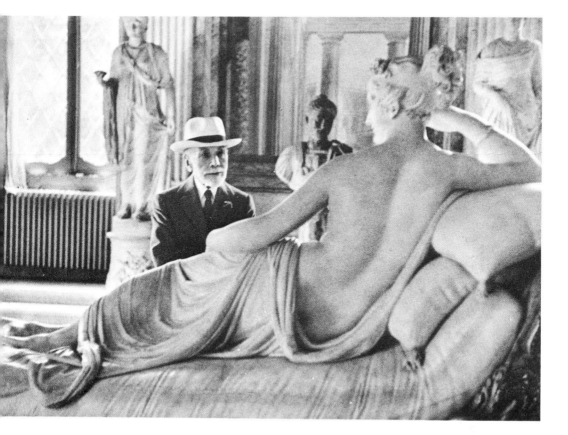

22 Bernard
Berenson at ninety,
visiting the
Borghese Gallery,
Rome. 1955.
Photograph by
David Seymour

the illusion that the figures and objects represented had convincing weight and solidity. His theory is indicative of the move towards greater stress on form in art, as opposed to its representative, evocative or dramatic content, and Fry's later emphasis on 'plasticity' descends directly from Berenson's 'tactile values'.

When Fry's *Giovanni Bellini* appeared in 1899 he immediately acknowledged in the preface his debt to the 'generous encouragement and learned advice' of Bernard Berenson. He had helped Fry obtain photographs and lecture slides of out-of-the-way works and no doubt suggested sources of information, but in his *Venetian Painters* Berenson had only given passing mention to Bellini, and Fry's monograph must be recognised as a pioneering achievement. Bellini's debt to his predecessors was analysed for the first time and Fry was the first to recognise 1460 as the date that marks the onset of Bellini's mature style. He responded profoundly to the pathos and adoration expressed in Bellini's early work and this, combined with his failure to appreciate the difference in Bellini's approach to large-scale altarpieces and his earlier small devotional works, led him to argue that as Bellini's art grows ever more gracious and beautiful, it declines in intensity of feeling. This view is not generally held by modern scholars such as Giles Robertson who

63

finds in the majestic ease of Bellini's atmospheric late work a sublime and moving synthesis of form and content.[10]

Lacking the conversational ease of his subsequent books, *Giovanni Bellini* leaves one with the impression that it is the product of an earnest young scholar who is all the time looking anxiously over his shoulder at his fellow scholars and critics. In spite of his admitted debt to Berenson, Fry's intellectual background grows out of his reading of Ruskin, Pater, Morelli and John Addington Symonds. He had since his first visit to Italy in 1891 rejected the ethical conclusions that Ruskin drew from his study of Italian art, and the humanist tone of *Giovanni Bellini* emulates instead the approach of Symonds. He concentrates at length, in certain instances, on his response to the paintings, inspired perhaps by Pater's insistence in his preface to *The Renaissance* (1873) that the first step in critical appreciation is 'to know one's own impression as it really is, to discriminate it, to realise it distinctly'. Fry's attention to minute anatomic detail imitates Giovanni Morelli's morphological comparisons. For instance, the early *Crucifixion* in the Correr Museum is found to have the following characteristics of Bellini's early style: 'the disproportionate length and straightness of the forearm, the obtuse insertion of the thumb which gives to the large metacarpus a regular pentagonal form.'[11] More than anything, it is Fry's associative response that makes this book very much the product of the late nineteenth century, because though he avoids drawing moral conclusions, as Ruskin had done, the influence of the great author still permeates his way of seeing and in front of the Pesaro *Coronation of the Virgin* (Plate 23) Fry cannot resist expounding on the moral characters of the four saints.

> The S. Francis is the least aetherealised, the most human conception of the man in Venetian art, and the most convincing in the rendering of spiritual passion. The S. Jerome is a perfect expression of the dogmatic theologian whom the abstruseness of his studies has cut off from human intercourse; but it is in S. Paul that Bellini's concentrated realism is most felt. Even he never conceived anything more convincingly self-consistent than this imposing figure, perfect alike in the slow gravity of its movement and in the large design of its drapery, but most sublime as an expression of a rare type of character, in which the saint and the man of the world are harmonised. The organiser of Christianity might well have been a man of such rapid insight, such a plausible and imposing presence, so gifted, so polished and with such power to command, as Bellini has here conceived him.[12]

Shortly after the appearance of this book, the old Cliftonian Henry Newbolt asked if he could have some of Fry's Italian lectures to publish in his new periodical, the *Monthly Review*. Fry was the first contributor Newbolt approached, and the six articles (mainly on early Florentine art) that appeared in the first and subsequent issues throughout 1900–01, established Fry's reputation as a leading English scholar in this field. Overnight Fry had arrived. He was courted by the art publishers George

23 Giovanni Bellini: *Coronation of the Virgin*, c.1480. Tempera on Panel, 262 × 240 cm. Pesaro, Museo Civico

Bell and Sons who commissioned him to write a more extensive book on the Bellini family. Fry also offered a book on Cima da Conegliano for their series on Old Masters but the editor C. C. Williamson replied that they would prefer one on Paolo Veronese or Leonardo. Unfortunately, due to pressures on his personal life, none of these propositions ever took shape. Fry's remaining notes suggest that the book on the Bellini family was a considerable loss. In one of his many small notebooks, filled with times of trains, jotted-down expenses, quick sketches and notes on paintings he had seen, he recorded his belief that beneath

Gentile's 'apparently prosaic realism ... there lay the same deep imaginative intuition' as is found in the work of his brother. He notes that Gentile's desire to record costumes and gestures, a curiosity often inimical to the sense of overall design, is never allowed to encroach on the general idea of the picture. Added to this, he found in his landscapes a keen sense of the appropriate mood and in his figures a solemn dignity, gravity and composure, 'a certain severity which is rare in Venetian art'.[13]

Just at the moment when Fry's career struck a note of success, his life was hit by disaster. During the early summer of 1898 Helen suffered her first bout of mental illness. Its cause was never diagnosed and only after her death in 1937 was it discovered that the ossification of a cartilege had been pressing on the brain. In 1898 Fry experienced the first of many turbulent periods that left him feeling completely helpless. To his mother he wrote:

> Isabel's letter to Father will tell you all the terrible truth about this great sorrow – you will know that it is difficult for me to speak about – there are things I have been through which I dare not recall to mind. This is literally the first moment I have had since the beginning of the attack – as my lectures had to be finished though the last was postponed till last night when I managed to get through. Now I have been arranging with the doctors to try hypnotism a faint hope but I will leave nothing untried. Dr Savage has been quite splendid and she is having the best care that can possible be devised for her and everyone that has had to do with the case has recognised what an exceptional nature hers is and have spared no pains. I can never forget Dr Savage's kindness.
> You won't tell more than is necessary – I think for the present we are justified in saying that it is a complete nervous breakdown which requires special nursing.[14]

The disparity between the chaos of Helen's disordered mind and the careful cataloguing of facts necessary to his study of Italian art now seemed unbearable. 'I'm grinding away at my writing', Fry wrote to Trevelyan, 'but it's difficult to make the jump from Helen, who seems all-important, to the date for Bissolo's death, for which I don't care just now a tuppeny damn ...'[15] Helen, illogical and disturbed, kept up long periods of silence throughout the course of her illness and regarded Roger with an unreasonable distrust.

Gradually the semblance of order returned. In the winter of 1898–99 Fry delivered a series of lectures on Italian art in a large public room, administered by the nearby Albert Hall. By the autumn of 1899 Helen appeared to have fully recovered and she was able to accompany him on an art-historical trip to Berlin, Dresden and Florence. In Berlin they met two leading scholars, Wilhelm von Bode, who was actively engaged in building up an important collection for the Kaiser-Friedrichs Museum, and Georg Gronau, the expert on Titian and Leonardo. Fry, now part of an international network of scholars and connoisseurs, knit together

by competitive friendships and jealousies, had become associated with Berenson, the arch-connoisseur, whose dependence upon perceptual appreciation was distrusted by the Germans, with their greater emphasis on documents and meticulous research. Berenson's extensive knowledge acted as a sounding board against which Fry would test his opinions, and, to begin with, the continuing success of his career seemed dependent upon his maintaining the good will of this rather precious mentor.

At first their friendship wafted along quite happily, animated by magnanimity on one side and respect on the other. Berenson was unstintingly generous with information and Fry praised Berenson's *The Study and Criticism of Italian Art* in the press in 1901, remarking that the essays it contained were 'marked by the intellectual alacrity and critical discrimination which distinguishes his work'.[16] In 1900 Berenson married Mary Costelloe, the sister of Logan Pearsall Smith, and to celebrate their union Fry painted a marriage tray (Plate 24) with the Garden of Paradise, in a mock Quattrocento style, thus alluding to their shared interests. Around the circumference he inscribed a dedication that leaves no doubt as to the warmth of his feelings for Berenson at this

24 Roger Fry: Marriage Tray for Bernard and Mary Berenson, 1903. Panel, diameter 44.5 cm. *Florence, Villa I Tatti*

date. But this honeymoon period was not to last, and before long their friendship, which had begun on such a civilised note, ended in a state of curdled dislike.

Admittedly, this friendship had to flower in a scholars' greenhouse, in a world fraught with suspicious jealousy and closely guarded ambition. Their letters, which passed through Mary who took charge of Berenson's correspondence, were mainly concerned with attributions, and, by inference, with valuations. As collecting was still largely in the hands of the private patron and art scholarship in a relatively early stage, the power wielded by someone like Berenson was immense. Disinterested scholarship could all too easily be turned towards financial gain, and it is significant that the greater part of Berenson's achievement predates his association with Joseph Duveen, the dealer who successfully sold European masterpieces for large prices to America. This association, which began around 1906, brought Berenson an annual salary of twenty thousand pounds on top of which he received a ten per cent commission on the price of every work sold which he had authenticated. Even when Fry first met Berenson, the connoisseur's chief income came from a private collector – Mrs Isabella Stewart Gardner, whose famous collection was largely Berenson's responsibility.

Within the confines of their discipline, Berenson's writings influenced Fry's development, not only as a scholar, but also as a critic. It is possible to find in Berenson's *Florentine Painters* the germ of the idea of 'significant form', that famous and infamous phrase which became the battle-cry of adherents to Fry and Clive Bell's aesthetic during the second and third decade of this century. Of all the authors that Fry would have read in the 'nineties, Berenson placed the greatest emphasis on both form and significance. He argued that form in Florentine art was the principal source of aesthetic enjoyment; its discovery lent a higher coefficient of reality to the object represented. Moreover, the Florentine tradition, for Berenson, is marked out by the desire to render the material significance of visible things. Though there is little immediate influence of Berenson's ideas in Fry's *Giovanni Bellini* (a Venetian artist and therefore not part of the tradition that Berenson was here describing), emphasis on the realisation of formal significance soon became the key-note in Fry's criticism.

As Fry's standing as a scholar received increasing recognition, his relationship with Berenson grew strained. Soon after the *Burlington Magazine* was founded in 1903, twice in one year Berenson was offended by publications for which he held Fry responsible. The first was an article by Langton Douglas on Sassetta with which Berenson disagreed, and he asked Fry, who had considerable influence on the editorial policy, to prevent its publication. Fry argued that it would be undiplomatic to reject a previously accepted article but added that they would publish a follow-up containing Berenson's criticisms. He took the opportunity to add that the magazine should not be seen as belonging solely to Berenson's clique. Tension between the two men increased during the

complicated dispute over the Gambier-Parry Collection, now housed in the Courtauld Institute Galleries. In 1902 Fry had visited Sir Hubert Parry's house, Highnam Court, near Gloucester, in the company of Berenson with the intention that both should collaborate on an article bringing this remarkable collection to the notice of the public. Due to ill-health and pressure of work Berenson was unable to contribute to the article Fry published in the *Burlington Magazine* in July 1903, and when he eventually read it he was infuriated by mention of two St Cecilia Master altarpieces, recently discovered by Herbert Horne. Berenson was enraged not only because he had not been informed of these two important altarpieces, but because, as Fry stated in a footnote, Herbert Horne intended to publish on them in a subsequent issue and this led Berenson to suspect that Horne had been asked to collaborate in the writing of the Gambier-Parry article without his being informed of this. Finally, he felt further humiliated by the secrecy that surrounded these two altarpieces because they had been discovered on his own home territory, in Florence.

With Berenson, Fry trod an emotional minefield. His letters to the connoisseur (the most courteous he ever wrote) give the impression that he is dealing with a prickly, sensitive, exotic plant on which the utmost consideration has to be lavished. But it was impossible to disguise for long the opposition of their temperaments: whereas Fry had complete disregard for prestige and was without pretensions of any sort, Berenson jealously guarded his position and ended by turning his whole personality and appearance into a carefully presented work of art. His envy of any success in his own field that did not have his authorisation made it difficult for him to accept Fry's growing independence. Friendship gradually turned to dislike, soured by Berenson's distrust. His paranoia is clearly revealed in his diaries (tinged with a deep distaste for Bloomsbury as a whole), written many years after Fry's death. There he spoke of 'the way Roger Fry resented my authority in Bond Street, and as good as declared war against me if I did not leave London to him'. Further on he wrote: 'The most perfidiously hypocritical of my enemies, like Roger Fry, seldom published anything not inspired by the wish to assert himself against me.'[17]

While the friendship lasted, their continuous exchange of letters and photographs helped broaden and deepen Fry's knowledge of Italian art. Three years after this association began, Fry wrote an authoritative forty-seven page outline of the development of Italian art for Macmillan's *Guide to Italy*, published in 1901. His account spans three centuries and encompasses a complexity of detail which no present-day general history would attempt. The need to compress information allowed little room for personal commentary, but when writing of the artists' guilds, he added: 'In marked contradistinction to the present view, that painting is a luxury of the wealthy, and that creation is a fanciful or capricious activity on the artist's part, the medieval citizens of an Italian town regarded it as a pre-eminently necessary and practical craft, which

enabled them to realise through the medium of a well-understood symbolism their municipal or parochial unity and their religious communion.'[18]

If the *Guide to Italy* underlines Fry's broad knowledge, the lectures which he wrote for the Cambridge Extension Movement and delivered in places as distant as Dunfermline and Aberystwyth, disclose his insight into Italian art. The manuscripts of these lectures, now at King's College, Cambridge, reveal his desire to follow J. A. Symonds and place Renaissance art in its wider context. Each set of lectures begins with an analysis of the social, political and economic background. For instance, the lecture on the Trecento artists begins by relating an economic loss of confidence in Florence to the Trecento artists' tendency to imitate certain mannerisms of Giotto. Taddeo Gaddi is seen merely to caricature Giotto's characteristics and his paintings are regarded as 'wanting in the spring and vitality which can only come of personal conviction'. Giotto's followers, Fry continues, replaced the dignity and nobility of the great master's subjects with an almost childish delight in the grotesque side of Christian mythology. Only with Orcagna do we discover, as Fry argues, 'the severe intellectual tenacity of great Florentines' and that emphasis on structural design 'which more than anything else distinguishes the Florentine tradition'.[19]

His admiration for the discipline, order and sense of design found in Florentine art sharpened his dislike of modern art; compared to the great tradition of Renaissance art the work of his contemporaries now seemed sadly lacking in structure. This problem was considered in the lecture 'Transition to Quattrocento' in which he declares (echoing Michelangelo's famous critique of Flemish painting), that while Italian art is 'constructive', modern and Dutch art is 'perceptive': 'I mean that the unity, which is an essential quality of all works of art, of an Italian picture was built up from within, it was pre-ordained by the artist and then filled in with a content which was more or less derived from the study of nature, whereas in modern and Dutch art the unity is for the most part accepted as given by nature and then modified more or less according to the internal demands . . .'[20] Thus for Fry, Italian naturalism never implied the passive, receptive approach of a contemporary Impressionist, but instead displayed a sense of logical design, continuity and a pervading rhythm.

Added to this, the great Florentines, for Fry, were able to elevate a particular idea to a level of universal significance. He cited as an example Masaccio's representation of beggars in the Brancacci Chapel, which are 'lifted into the region of disinterested contemplation where we can consider them without instinctive repulsion'. He concludes: 'This is realism in the finest sense of the word, where the real is opposed to the actual.'[21] For Fry, Masaccio married the Florentine love of abstract truth with an ability to condense into his forms the essence of the ethical situation. He pointed out that in Masaccio's *Expulsion from Paradise* (Plate 25), in spite of limited space and means, the two poses are subtly

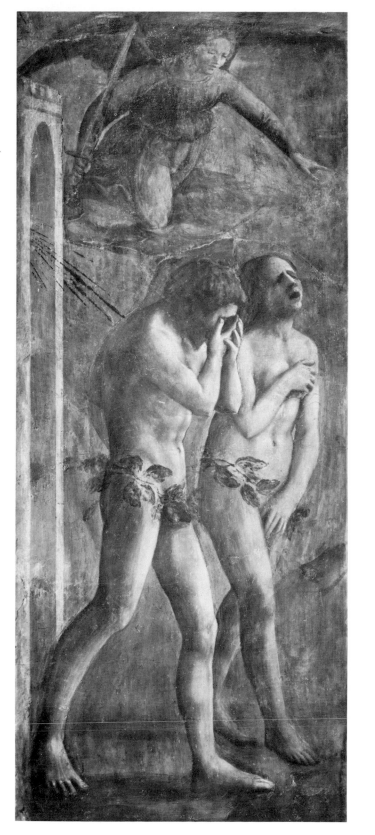

25 Masaccio: *The Expulsion of Adam and Eve from the Garden of Paradise.* Detail from the frescoes in the Brancacci Chapel, S. Maria del Carmine, Florence.

varied in gesture, complementary yet mutually interdependent, in order to express fully their spiritual loss. 'In every part of the figures', Fry wrote, 'there is the same sense of leaden weight of despair and shame under which they labour, dragging their reluctant steps along by the force of an irresistible internal compulsion.'[22]

In these lectures, Fry frequently refers to techniques and to the actual *matière* of a work; but his dominant interest lay in the Italian's architectonic use of form and in the conceptual bias underlying Italian naturalism. This emphasis did not prevent occasional use of a more associative response. Fry said of Lorenzo Monaco's *Journey of the Magi* (a painting that he had copied in the Nazional Galerie at Berlin) that the landscape vividly evokes 'the long and weary journey of the three Kings, the mountain ranges they have surmounted, the seas they have crossed'. He continues: 'nor were he [Lorenzo Monaco] tied to the exigences of real structure could he give with quite such fantastic vehemence their gratified longing as they recognise again the star which they had lost sight of behind the mountains, nor in a convincingly realistic scene could the feathery pink clouds flushed with the coming dawn give us so pure an abstract of the poetical quality of the idea.'[23] His intense responsiveness and clear exposition gave freshness and lucidity to his lectures: his extensive knowledge is never paraded as an end in itself nor does he ever slip into antiquarianism. Ultimately it is always for aesthetic reasons that a work of art is praised.

Certain themes recur in these lectures that Fry was to pursue all his life: the relationship of art to religion, of representation to design, and of art to life. The latter had particular relevance for Fry as it not only determined the role of art, but, for one whose life was to be devoted to the understanding and creation of art, it determined the justification for his own existence. He had begun his career when Ruskin's belief that art had a moral directive was being challenged by the notion of 'art for art's sake'. Fry could agree with neither faction: the former led to the distortion of art as a means to an ulterior, non-aesthetic end; the latter was in danger of divorcing art completely from life and it left no standard of judgement other than personal, subjective taste. Art, no longer the handmaid of religion, needed some other justification. 'What makes ART so dangerous, I think', Fry wrote to Nathaniel Wedd in 1899, 'is that it has got separated from religion and life; by religion it could hang on to life, without it it can't, and so one has to make it a religion by itself, to the great detriment of both or .rather of all three.'[24] The conclusion which Fry reached in the course of his unpublished Florentine lectures (one that both the moralists and the autonomists failed to see), is that the morality of a work of art is inseparable from the process and means that went into its making. In Masaccio's art, he noted, 'For the generosity of temperament he expresses, the dignity and nobility of the types he creates are intimately bound up with his feeling for large and easy composition, for clear and decided chiaroscuro ... his art is to be clearly distinguished from the cult of a minute and esoteric preciosity,

which would make art a thing apart from and antagonistic to the issues of life as a whole.'[25]

For Fry, art revealed, not a set of moral principles, but the motivation on which the artist acts: it therefore teaches not rules but understanding. In 1905 he returned to this problem of the relation of art to life in an essay on Watts and Whistler in which he criticised the latter for attempting to separate one from another. 'For beauty cannot exist by itself; cut off from life and human realities it withers. It must send its roots down into other layers of human consciousness and be fed from imaginatively apprehended truth, as in religious art, or from human sympathy, as in dramatic art, or from a sense of human needs and fears in the face of nature, as in all great landscape art.'[26]

Fry's tendency to theorise was encouraged still further by the writing of regular articles and reviews. As a result of the success of *Giovanni Bellini*, he was offered the post of art critic first to the magazine *Pilot*, and then in 1901 to the leading literary periodical, the *Athenaeum*, where he took over from the Pre-Raphaelite critic, F. G. Stephens. Criticism suited his abilities: he quickly developed a conversational style and with his practical experience as a painter he revealed an insider's understanding of his subject. But even when writing scholarly articles for the *Monthly Review*, he deliberately adopted the position of middleman, between the art historian and the amateur, and always regarded the scholar's laborious research as raw material on which to build aesthetic appreciation, an important aid (but not in itself an end) in the discovery of an artist's unique qualities. Not content with the shepherding of facts, he allowed his experience of Renaissance art to help shape his aesthetic demands and establish critical criteria. Italy acted as his springboard, as he explained to his father: 'You see whatever success I have had has been the result of my Italian studies, not only in lecturing and writing but in painting. It is there that I find the real source of all my ideas and there I must go often to get them.'[27]

His understanding of Italian art had a two-fold effect on his criticism: on the one hand it biased him in favour of classical art, and on the other, it led him to look with a severely critical eye at the work of his contemporaries. In 1923, looking back at this period, he perceived a tinge of melancholy in all that he had written. 'I maintained that impressionism had made artists so insensitive to constructive design that perhaps the world would have to wait a century or two before it would once more apply the great principles of painting as they were exemplified in the great works of the sixteenth and seventeenth centuries.'[28] His partisanship in favour of classical artists is equally apparent. Reviewing the Paris Exhibition of 1900 for the *Pilot*, he criticised Delacroix for letting his intellectual ambitions outrun his powers of conception, and praised Ingres for 'that paradoxical simplicity which comes of a passionate imaginative embrace of formal structure, and which is the very antithesis of a cold and academic calculation'.[29]

In the same review Fry praised a Daumier painting of a washerwoman

for its power of suggesting 'that overpowering significance which ordinary men can only find in [everyday] things at rare moments of imaginative exaltation'.[30] Though this emphasis on the discovery of absolute or 'significant' form, as it was later to be termed, repeatedly recurs in Fry's criticism, equally as many passages can be found that reveal his non-formal approach to appreciation. The best known examples are his two essays on Giotto, later compressed into one and republished in *Vision and Design*. Here Fry argues that Giotto's first preoccupation was with the dramatic idea behind each subject and he proceeds to demonstrate how Giotto translated his vision of the story into pictorial terms. By 1920, when the essay was republished, Fry felt it necessary to apologise for this emphasis and he appended a footnote that reads: 'It now seems to me possible by a more searching analysis of our experience in front of a work of art to disentangle our reaction to pure form from our reaction to its implied associated ideas.' But during his period as a regular art critic Fry not only felt that such separation was impossible but also detrimental to the appreciation of art. We find him criticising Whistler in 1905 for failing to realise that 'in the great classic art of China and Japan, design does not mean mere agreeableness of pattern, but embraces that perpetual play of two motives – the motive of form as a delight to the eye, and of form as directly expressive of moods and images to the feelings and intelligence'.[31]

Whistler's death in 1903 had occasioned one of Fry's most perceptive *Athenaeum* articles in which he pinpoints objectively both the achievements and limitations of this master. His early appreciation of this artist was now tempered with criticism. He noted an over-concern with exquisiteness, a 'pre-occupation with the surfaces of things rather than with their inner meaning'; he discerned 'critical taste rather than creative energy', and a want of any generous imaginative impulse. His art was 'too much a matter of nerves too little sustained by spiritual energies from within'.[32] According to Fry, one fault that Whistler and his followers shared with the English Impressionists at the New English Art Club was a lack of any underlying design comparable to that found in all great Florentine art. And he referred specifically to these two contemporary schools when he later tried to summarise his position at this date: 'The Naturalists made no attempt to explain why the exact and literal imitation of nature should satisfy the human spirit, and the "Decorators" failed to distinguish between agreeable sensations and imaginative significance ... I came to feel more and more the absence in their work of structural design. It was an innate desire for this aspect of art which drove me to the study of the Old Masters and, in particular, those of the Italian Renaissance.'[33]

These views, unfashionable and unpopular, forced him into a conservative role on the jury of the New English Art Club to which he had been elected in 1900. It comes as a surprise to learn that he occasionally found himself opposed to the more progressive views of Professor Tonks, to find D. S. MacColl pigeon-holing him at this time as a 'pastichist of

the ancients and opponent of modern French painting'.[34] Turning to his painting we find this man, notorious for his subsequent introduction of modern art to England, producing painstaking and derivative paintings of Italian villas and their gardens, meticulously designed and laboriously executed. One example is *The Pool* (Plate 26) where careful control of chiaroscuro and design creates an effect of classical balance and harmony. The effect of stillness is heightened by the movement of the swan across the water, giving the sense of a suspended moment. Two women lean towards the swan, their artificiality and sentiment explaining, perhaps, why Osbert Sitwell jokingly described Fry's work of this period as 'in the style of Alma-Tadema'.[35] *The Pool* is nevertheless a sustained painting, with a convincing, contemplative mood, but Fry was perfectly aware that this and other of his pictures derived rather too obviously from the art of Claude Lorrain, as he wrote to Robert Ross of the Carfax Gallery in 1902: 'I am fearfully pleased and excited at the idea of selling a picture. Do tell me about it. I hope so much it is to some outsider, I mean not to a near relation or an intimate friend who have been almost

26 Roger Fry: *The Pool*, Exh. 1899. Oil on canvas, 42 × 68.5 cm. *Private Collection*

75

my sole patrons hitherto – their motives are always suspect. But I think you must be a brilliant salesman – did you pass it as a Claude d'Alsace or under my name?'[36]

If Fry's career had ended in 1903 he would be remembered as a critic whose tastes favoured the Old Masters and as a painter of mock seventeenth-century landscapes. This latent revolutionary, who was capable of spending up to three years on an oil-painting, was investigating the various ways in which a beautiful surface quality could be achieved. By now he had a considerable understanding of Old Master techniques and consequently, like Ricketts and Shannon, looked with a critical eye at the methods of his contemporaries. 'Since all knowledge of technique is lost', he wrote to the artist Sturge Moore, 'we must ... try not to notice the surface quality of a [modern] picture'.[37] Will Rothenstein recalled that 'Fry wished the quality of my paint to be other than it was; for he was then anxious to revive the precious surface achieved by earlier painters, "If I could only have your pictures to work on after you have done with them!" he said.'[38] Fry's obsession with surface quality led him to write an article entitled 'Mere Technique' in which the apostle of Post-Impressionism reveals that he is still, in 1904, very far from conversion:

> ... but I believe in the long run people will come to cherish more and more whatever has this permanently satisfying quality of material beauty, and prefer to have on their walls even what is in some respects tentative and incomplete, if it only possesses this enduring quality to the eye of fine material and choice texture, rather than the most startling reproductions of nature wrought in a coarse and unsympathetic substance.[39]

Two years earlier he had uttered his bleakest note of despair when, faced with the task of reviewing the New English Art Club winter exhibition, he observed in the artists' work 'the poverty of their emotional and intellectual condition' and concluded there had arrived a 'dead point in the revolution of culture'.[40]

Anxiety over Helen may partly have nurtured his pessimism. After her first attack of illness a shadow hovered permanently over their marriage. For a brief period at the beginning of the century they enjoyed a short spell of happiness, and Fry felt their life together was perfect, harmonious, and complete. In 1900 he took a house, Ivy Holt, at Dorking, and there in March 1901 his son Julian was born, followed a year later by his daughter, Pamela. Some months after the birth of Julian, they heard of Mackmurdo's engagement and Helen's letter congratulating him catches a rare moment of domestic security.

> I was so very interested and delighted by your news and have wanted so much to write and tell you just how pleased I am: but your letter came just as we were a sick household: Roger in bed in one room and the baby

27 Roger and Helen Fry with their son Julian. Photograph

with bronchitis in another, and there seemed no time for anything but poultice making – quite a high art – they are both much better – and I have a little more time now.

I know that I shall like your charming house as much as its inmates; when are you and Miss Carte to be married, it all seems a very perfect ending to what was a long and great friendship, and when I believe in an organising heaven instead [of] a vague space, I shall think of yr. marriage as arranged there especially.

My husband sends his sincerest congratulations.[41]

Helen was in many ways a perfect companion for Fry, and he often relied on her knowledge and taste. When he was abroad she would contact scholars and dealers for him or would send her opinion on a picture. Their compatability only emphasised the tragedy of her illness. During the winter of 1903–04 she suffered a severe attack under which her mind fell apart and she was reduced to incoherent ramblings or long periods of silence broken only by requests to see her children. Her recoveries were only to create the illusion of happiness and by 1906 Fry, in a letter to Helen, looked back wistfully to their early days at Ivy Holt: 'We who could somehow have loafed so perfectly thro' life with nothing to do but look at bits of weeds and could have found that enough, we have to grind through so many grinds and now it looks like such a vista of them.'[42]

In his professional life, Fry now enjoyed friendships in two different spheres: his serious and unfashionable paintings had earned him a respected position in an artistic circle that included Max Beerbohm, Tonks, Rothenstein, Sickert, and the critic MacColl, among others, and on the other hand he continued to enjoy the friendship of scholars and connoisseurs. Whenever possible he crossed to Europe to see paintings and on occasion travelled extensively in England. On a visit to Scotland he took the opportunity to call in en route at Newton Hall and see Mrs Widdrington who frankly told him that she thought his interests had narrowed.

By 1904 Fry had become heartily sick of writing reviews and short articles for the Athenaeum. He longed to devote more of his time to painting and seized whatever moments he could find for his own work. Watercolour now took the place of more time-consuming oil-painting and when in 1903 Robert Ross at the Carfax Gallery gave Fry his first one-man show, he exhibited thirty-four watercolours and only seven oils. To everyone's complete surprise, the exhibition was a tremendous success. Ross informed Fry, 'I think I told you that numerically we have never done so well at any exhibition except Max Beerbohm. ... Under the former management nothing modern except Conder ever paid expenses. Steer, Max [Beerbohm] and yourself have been our three triumphs.'[43] Edward Marsh arrived, bought a picture, and thought the display 'by far the best modern show they have had.'[44] Marsh was to become an important collector of modern British art, but at this date his taste was still largely confined to the art of the eighteenth and nineteenth centuries, and one of Fry's paintings would not have looked out of place among his collection of English watercolours. Fry in fact consciously imitated the technique of the early English watercolourists, using the medium at first as a form of coloured drawing, outlining his forms in pencil or ink and then adding washes of tint. Gradually, as his watercolour style developed, his translucent washes of colour begin in themselves to create form. His handling is always competent and sensitive and his composition often depends on some contrast of light and shade. When in 1907 he wrote an article on watercolour painting for the Burlington Magazine he argued that it had an important role to play in modern painting and was more suited than oils to the lighter colour schemes of modern decoration used by the 'semi-detached householder, who will never own large oak-panelled halls'.[45]

In the same year as his Carfax exhibition, Fry sat on the consultative committee involved with the founding of the Burlington Magazine; his distinguished colleagues included Bernard Berenson, Sir Sidney Colvin, Sir Herbert Cook, Campbell Dodgson, Herbert Horne and Sir Claude Phillips, and all were united by a sense of mission. England alone, of all cultured European countries, lacked a serious periodical devoted to the disinterested study of ancient art: the Burlington was to fill this shameful want. Nor was Fry alone in his desire to avoid fustiness, antiquarianism and the pedagogic. In the first issue, the editor, Robert Dell wrote that

28 Roger Fry:
*Betchworth
Limeworks*, 1903.
Watercolour,
206 × 290 cm.
(irregular)
Cambridge,
Fitzwilliam Museum

'the danger is lest this scientific activity should absorb too much of our attention; should come to be looked on as an end in itself, and not as a means to a quite different end, aesthetic satisfaction, and the exercise of the aesthetic faculties: these an attitude of mere scientific curiosity may even atrophy'.[46]

By December 1903 the editor was interrupted in his lofty meditation on the aims of the magazine by the nagging awareness that he had lost all practical power: serious financial difficulties had caused production and responsibility to pass out of the hands of the proprietors into those of the printers who were now planning to exercise their control and, by a sudden coup, bring about a change of editor. With this intent in mind, they approached the critic, D. S. MacColl. Meanwhile, Fry, unaware of how treacherous the situation had become, tried to persuade Dell to take in C. J. Holmes as joint-editor. MacColl then frustrated the printers' plans by informing Fry and Dell of the proposed change of editorship. Dell, shocked to discover what was going on behind his back, now firmly sided with Fry and Holmes, and as a result in January 1904 a new company was set up with Dell and Holmes as joint-editors.

This reorganisation did not however solve the magazine's financial

difficulties. 'At every point money seemed to flow out', wrote Holmes, 'at none did any seem to come in.'[47] Originally based at 14 New Burlington Street, the magazine was forced to move premises in order to save rent and early in 1904 established itself at 17 Berners Street. Fry was involved in both financial and editorial matters: he dined with Holmes regularly once a month to discuss the format and content of the forthcoming issue; he made numerous suggestions, criticised articles with which he disagreed and generally tried to ensure a high level of scholarship. For more than thirty years he was closely identified with its policy and it is not generally recognised how large a place it occupied in his life.

When in November 1904 it was discovered that the magazine had insufficient capital to keep going for more than another few issues, it was Fry who went to America in response to a telegram from Robert Grier Cooke, the *Burlington's* agent in New York, and there, through his persuasive charm, raised considerable financial support. Elated with his success, Fry wrote to Holmes: 'But now I mean to devote serious attention to the *Burlington*. No more nonsense for me about original research, serious criticism and such bunkum. Give it 'em hot and strong I say, The Picture of the Year, How to Collect Carpet-bags, Alma-Tadema at home –, Oh you'll see.'[48] Few of the rest of his letters written from America are as flippant and teasing as this and most contain considered discussion of a unique offer he had received shortly after his arrival in New York. It was an offer that to other men in his position would seem the apotheosis of a successful career, an exceptional challenge and one rich in opportunity. For Fry there were equivocal facts to be considered and, though tempted, he hesitated at first to accept.

5 American Millionaires

For seven long days Roger Fry endured, like a feverish nightmare, his first Atlantic crossing on board the R.M.S. 'Teutonic': he failed to sleep and the persistent blowing of the hooter jarred on his nerves; he suffered continuously from nausea, and generally compared his state to that of an oyster with a very large grain of sand in its shell. On arriving at New York the art-dealer Eugene Glaenzer met him at the landing stage and then delivered him into the care of William Laffan, proprietor of the *New York Sun*, trustee of the Metropolitan Museum of Art and right-hand man of its President, J. Pierpont Morgan. Laffan had visited London in July 1904 and had let it be known that the Metropolitan Museum was looking for new staff. Fry may have expressed interest as he was tiring of his commitment to the *Athenaeum* – 'these weekly snippets are ruining my mental digestion', he told Mary Berenson in October 1904.[1] He suspected, therefore, that the invitation to go to America to raise funds for the *Burlington Magazine* hid an ulterior motive, and soon after his arrival his hopes were confirmed. Arrangements were made for him to visit the Museum and meet its President and Laffan led him to believe that he was to be offered the post of Director.

Once the strangeness of New York and the effects of the passage had worn off, Fry began to assess his surroundings. His first visit to the Museum warned him of the kind of problems he would have to face because he immediately detected among the paintings on display a number of blatant forgeries. He was advised that for the time being certain of these should be overlooked because if the millionaire-donor

29 J. Pierpont
Morgan. Cartoon

AUT CÆSAR AVT NIHIL

heard of his reattribution, no further gifts would be forthcoming from
that source. If this offended Fry's Quaker spirit, he adopted a pragmatic
outlook and at first kept silent. Meanwhile, important introductions took
place and among the influential people that he met was John G. Johnson,
the Philadelphian lawyer and chief legal adviser to Pierpont Morgan.
He immediately recognised in Johnson a man of the highest integrity
and as it was some days before his meeting with Morgan could be
arranged, he travelled to Philadelphia to see Johnson's collection of

paintings which he had no difficulty in praising. Johnson, in turn, told Fry of his great admiration for his *Athenaeum* articles, and on this basis of mutual respect their friendship began. At their first meeting Johnson urged him to accept the Museum's offer.

Five days after Roger Fry's arrival in New York the Museum revealed its hand. The offer was that of second-in-command, the post of Director having just been accepted by Sir Caspar Purdon Clarke of the South Kensington Museum. The salary, at £1,600 per annum, had the additional attraction of a travel allowance to allow for six months of the year being spent in Europe, and a proviso stated that on top of his commitment to the Metropolitan he would be allowed to continue to write and lecture. It was an excellent offer and Fry's immediate response was to accept.

Shortly after the terms had been announced, Fry travelled to Washington to meet Pierpont Morgan and to attend a large dinner at which President Roosevelt was to be present. Morgan's private observation car, tacked on to the end of an express train, had been put at his disposal and as the train rattled on its way Fry, in high spirits, reflected on his good fortune. The pay was good, the opportunities enormous; the Museum, with apparently unlimited finance, was served by a dynamic board of trustees and not by a hesitant, equivocating British equivalent. Moreover, he felt in the air a very genuine desire for good art. Nor did this euphoria disappear in the presence of Pierpont Morgan, though the financier's swollen, livid nose, the result of *acne rosacea*, reminded him of Ghirlandaio's *Portrait of an Old Man and Boy*. His buoyant mood enabled him to parry Morgan's jokes and when granted a confidential talk the great man assured Fry of his complete support. Always susceptible to optimism, Fry, feeling like a courtier who has won the ear of a potentate, had the illusion of wielding absolute power and in a burst of confidence wrote home to Helen that evening, 'There is going to be an immense boom here in art – everything is shaping and arranging itself for it and I am regarded as the person who can give the direction to it in lots of ways'.[2]

At this first meeting Fry failed to estimate the sovereign efficacy of Morgan's character and financial power. Morgan's success in business was primarily due to his foreign connections; he managed to persuade British investors to put money into the development of the American railroads, inspiring their confidence by reorganising hard-pressed or bankrupt companies and by attempting to end mismanagement and cutthroat methods of competition in which less scrupulous magnates then indulged. In 1895, Morgan, together with August Belmont and the Rothschilds, saved the credit of the United States government during the run on gold. In 1901 he formed the United States Steel Corporation, the first billion dollar trust, and thereafter became the acknowledged leader in Wall Street. A consolidator of banks, the organiser of huge corporations and the acknowledged authority on American finance, J. Pierpont Morgan (as the committee, set up during the last years of his

life to investigate his practices, discovered) directed the action of most corporations in the country, influenced their credit and effectively controlled American business.

This heavy, six foot man found an outlet for his deep emotionalism and impetuosity not only in the exercise of business acumen, but also in the acquiring of the trappings of wealth and power through which he hoped to establish his immortality. In both activities he was guided by faith, in outward appearance conventionally religious, but inwardly a supreme faith in himself, his power, money, and judgement. His interests as a collector led him to sit for several years on the Metropolitan Museum's board of trustees, before being made President in 1904. He desired for the Museum the same aggrandisement that he sought in business. He filled vacancies on the board of trustees with millionaires of his own choosing and if at a meeting a deficit was announced, he would simply pass his eyes around the table, interrogating each millionaire in turn until the sum needed had been raised. Edward Steichen, the photographer who took Morgan's portrait, once said that meeting the eyes of Pierpont Morgan was like confronting the headlights of an approaching express train.

It took Fry barely a week to discover Morgan's true nature. Led on by his awareness of the expanding American economy, he tried to negotiate a higher salary and argued that if he was to fulfil the post to the best of his ability he should be totally free of the need to acquire money by other means and therefore his salary should be raised to £2,400 per annum. Fry's action reflects his misjudgement of Morgan's character: once the financier had made a decision he liked to see it acted upon. He had regarded Fry's appointment as settled and was furious that all his plans were now thrown into question. Fry now focused a little more clearly on the potentate and observed: 'I don't think he wants to have anything but flattery. He is quite indifferent as to the real value of things; all he wants experts for is to give him a sense of his own wonderful sagacity. I shall never be able to dance to that tune . . .'[3]

Fry had at his fingertips all that the Museum required: his study of Italian art had brought him into contact with art historians, connoisseurs and private collectors all over Europe and his knowledge and experience were guaranteed to prevent unscrupulous dealers taking advantage of the Museum's wealth and voracious desire for works of art. Moreover recent occurrences in the Museum's history, such as the Jacob S. Rogers' bequest of $5,000,000, settled in 1904, made its need for a man with Roger Fry's knowledge and experience more necessary than ever before.

Since 1904 when Pierpont Morgan took over the Presidency, the Museum had begun to place less emphasis on education and more on its role as a repository for great and original works of art. Gold and optimism joined hands to create a notable period of expansion, as Henry James observed: 'There was money in the air, ever so much money – that was, grossly expressed, the sense of the whole intimation. And the money was to be for all the most exquisite things – for *all* the most

exquisite except creation, which was to be off the scene altogether. . . . The Museum, in short, was going to be great, and in the geniality of the life to come such sacrifices, though resembling those of the funeral pile of Sardanapalus, dwindled to nothing.'[4] And in keeping with its new role, the Museum, since 1902, had been clothed in Richard Morris Hunt's imposing neo-classical Fifth Avenue façade, which successfully hid the earlier, humbler buildings.

Thus when Fry's negotiations, dashed by Morgan's fury, ended in failure, the tremendous possibilities previously offered him collapsed like a pack of cards. Yet his courageous action had revealed how little independence he would have had if he had accepted Morgan's initial offer. 'He's not quite a man', he told Helen, 'he's a sort of financial steam-engine and I should have been in the position of watching the cranks work and dancing attendance.'[5] Morgan was so annoyed that Fry at first felt unable to ask him for money for the *Burlington Magazine*. And if he failed in this, his visit would truly have ended in utter disaster. However, Quaker fearlessness combined with an uncanny gift of persuasion enabled him before his first American trip ended to secure financial aid from Morgan, as well as from H. C. Frick, John G. Johnson and his friend J. W. Simpson, and from Henry Walters of Baltimore.

A similar persuasive charm induced Mrs Isabella Stewart Gardner to open up her famous collection of paintings at Fenway Court to Fry on his visit to Boston shortly before his departure for England. Initially she had proved difficult and on his arrival had announced that some of the most important Italian paintings were not on view because of preparations for a Japanese tea ceremony. But by the end of his visit Fry had not only gained access to these masterpieces but had so charmed his hostess with his talk that he was invited back a couple of days later and had again to go round the collection giving her his opinion on every work.

Fry wrote an effusive letter to Mrs Gardner thanking her for his visit; but equally if not more important during his trip to Boston was his meeting with Dr Denman Ross of Harvard University. Ross had written a book entitled *Theory of Pure Design* (not published until 1907) in which he discussed the role played by forms and colours in art, considered as *abstract* entities in themselves. He had concluded that a composition will continue to attract the eye in proportion to the variety of directional lines and formal relationships found in it. For Fry, this would have explained his liking for seventeenth-century masters with their subtle mastery of complex compositions. Ross' refreshing emphasis on abstract design gave direction to Fry's thoughts on art and in 1909, in his 'An Essay in Aesthetics', Fry refers to Ross' *Theory of Pure Design* immediately before proceeding to outline 'the emotional elements of design', an idea clearly indebted to the American's abstract reasoning. In Boston, Fry pursued further his discussion of aesthetics with Matthew Prichard, then on the staff of the Museum of Fine Arts, and was impressed by his severity. Prichard filled voluminous notebooks with his thoughts on art,

but his cult of anonymity prevented him from publishing a book. He developed a very austere, esoteric system of aesthetics which enabled him at the end of his life to look on nothing with pleasure except a few Byzantine coins. Either Prichard or Ross introduced Fry to George Santayana's book *The Sense of Beauty*, based on lectures originally delivered at Harvard in the 1890s, in which he discussed in depth certain key issues such as the nature of beauty and the various ways in which form is perceived. Fry admitted his debt to Santayana in his preface to the 1905 edition of Reynolds' *Discourses* which he edited on his return to England.

America left an ambivalent impression on Fry's mind, arousing in him both admiration and horror. New York he found a mixture of advanced progress and wilful barbarism; outward sentimentality, he felt, hid hardness of heart, while external stylishness hid emotional and imaginative poverty. On the other hand, there was a freshness, energy, and openness to ideas, all far removed from the English tendency to prevaricate and compromise. He had enjoyed the keen air and bright sunlight, and the friendly, sympathetic society of the intellectuals he had met, and he wrote to Helen of 'the feeling that if you have grasped an idea you can realise it, instead of beating your head against the bars of prejudice and prestige'.[6] With regard to his personal position, he returned to England empty-handed, but throughout 1905 he continued to keep one eye turned to America in the hope of some fresh offer.

Soon after his return to England Fry learnt that he was in the running for the Directorship of the National Gallery in London. He could scarcely believe this rumour as only the year previously his application for the Slade Professorship at Cambridge had been rejected. On several occasions he had criticised the Royal Academy and the National Gallery's acquisition policy in the press and had antagonised several of the older guard in the London art world, including Sir Edward Poynter, then President of the Royal Academy, who had deliberately opposed his application for the Professorship. This and other failures made Fry less anxious for himself than for his parents. 'I feel that my want of worldly success has caused you more and more anxiety', he apologised to his mother, 'and that you have felt that it must be my fault. So no doubt in a sense it is, that is that if I were a different kind of person with different ideals, I might have succeeded more conspicuously.'[7] As soon as he heard the rumour concerning the post at the National Gallery, he informed his father knowing he would be gratified. Sir Edward's name in fact advanced his position: during an interview at Whitehall for the Directorship a high-up official asked Fry to name a referee whose reputation would be well-known in government circles. After searching desperately in his mind for a suitable establishment name, Fry mentioned that of his father, which so impressed the official the interview was instantly concluded. No decision, however, was reached immediately

and the appointment was delayed. To occupy his mind throughout the remainder of this strained year Fry wrote an introduction and notes for a new edition of Reynolds' *Discourses* which he dedicated to the memory of Theodore Llewellyn Davies, a Cambridge graduate a few years younger than Fry who died that summer by drowning.

In Reynolds Fry found considerable relief. The social-climbing, obsequious, artificial President of the Royal Academy, though directly opposed in character to Fry, shared his desire to teach the basis of aesthetic appreciation and thus raise standards in art. Fry agreed to edit the *Discourses* because he believed Reynolds' mental attitude, his method of combining practical knowledge with an ability to generalise, still had relevance. 'He keeps as a rule', Fry argued, 'close to the point at which the artist must attack the problems of aesthetics, and he succeeds in proportion as he does so. When he endeavours to find support in abstract philosophical principles he is less happy, though he never fails to be ingenious and suggestive.'[8] Fry praised Reynolds' detachment which he felt essential in a critic and he admired 'that nice poise of mind which for just criticism is so necessary, and yet so rare, a complement to keenness of perception and quick sensibility'.[9] Above all, Reynolds confirmed Fry in his search for the enduring qualities in art and in the need for tradition. Fry's description of the central tenet behind Reynolds' teaching applies also to his own writings.

> Reynolds' contention was that art was not a mechanical trick of imitation, but a model of expression of human experience, and one that no civilized human society could afford to neglect, that this expression required for its perfection serious intellectual effort, and that, however diverse the forms it might take, it depended on principles which were more or less discoverable in the great tradition of past masters.[10]

Reynolds also directed Fry towards an essentialist belief in the universal nature of art. In his notes to the Seventh Discourse, Fry underlines Reynolds' belief that in great art, of whatever country or century, certain ideas are expressed which can be universally recognised: 'It is thus that a good judge of Western art is able at once to recognise the beauty of an Egyptian statue or a Chinese painting. ... This view ... reinforces ... Reynolds' main conclusion, that the more the appeal is made to what is common and universal in human nature the wider the space and the longer in time will be the acceptance of the work.'[11] Many other similarities of idea and attitude can be noted, and when, during the last year of his life, Fry assessed his own achievement, he said: 'Looking back on my own work, my highest ambition would be to claim that I have striven to carry on his [Reynolds'] work in his spirit by bringing it into line with the artistic situation of our own day.'[12]

During the summer of 1905 Fry travelled to Vienna, Budapest, Prague, Frankfurt and Berlin looking at Old Masters on the art market. It is not

known, however, on whose behalf he made the trip. During this year he
brought certain purchasable works of art to the attention of John G.
Johnson, but he was also involved with the National Art-Collections
Fund in England. In July Pierpont Morgan approached Fry for advice
on a picture and this probably marks the beginning of further negotia-
tions with the Metropolitan Museum. Certainly in New York pressure
was being put upon the Director and trustees to reconsider Fry. F.
Ehrich of the Ehrich Galleries in New York wrote to Sir Caspar Purdon
Clarke, 'My hope has been that a man of the stamp of Mr. Fry would
be secured. The services of such a man would be above all price'.[13] By
November a fresh offer had been made as Fry wrote to Sir Caspar asking
him to clarify the terms of agreement because his relationship with the
Metropolitan was troubling his role on the National Art-Collections
Fund. In the same letter he asked for a catalogue of the museum's
collection so that he could draw up an acquisition policy, and in Decem-
ber he sent in a report on paintings he had examined with a view to
their acquisition by the Museum. By December the Museum ratified
his appointment and announced in the 36th Annual Report: 'Roger E.
Fry who has just accepted the Curatorship of Paintings at the Metro-
politan Museum, is a young English painter, who in recent years has
achieved a prominent position as a critic and historian of art.' The
announcement was premature as Fry did not finally accept the curator-
ship until late January 1906 and no sooner had he done so than a frantic
telegram reached him at Queenstown, en route for New York, from the
Prime Minister, Sir Henry Campbell Bannerman, offering him the
Directorship of the National Gallery. He felt unable to accept because
he had already committed himself to the Metropolitan but it was with
regret that he completed his journey. 'I felt myself morally bound to
America,' he wrote to his mother, 'though it was a huge temptation to
go on shore and get back instead of having that weary voyage to this
uninviting harbour.'[14] He had kept open his commitment to America
until the very last moment, but it is possible that when the offer of the
National Gallery finally came, some small part of him was glad to refuse
it.

When Roger Fry arrived in New York on 8 February 1906 the terms
of employment had still not been finally clarified. The Curatorship had
been offered to him in conversation with William Laffan but nothing
had been put in writing. Worried that Morgan might create difficulties,
Fry, on his father's advice, had written shortly before leaving, asking for
confirmation of his position.

As the arrangement between the Metropolitan Museum of New York
and myself was made verbally between you and me, I think it will be well
to put in writing the terms agreed upon and to ask you to be so kind as
to confirm them.
 The arrangement is that I am to act as Curator of the paintings in the
Museum, visiting New York as often and for such periods as I may think

needful, but residing in Europe where I am to act in the interests of the Museum; that I am not to be at liberty to accept commissions on the purchase or sale of pictures but that I may receive remuneration for professional opinions on pictures and that, whilst making the service of the Museum my primary business I am allowed to employ my leisure in painting, writing, etc.

For my services I am to receive a salary of £1,000 a year clear of working expenses and to be allowed expenses and sustenance whilst travelling for the Museum.[15]

Laffan's business instincts led him to evade replying and Fry arrived in New York with no clear statement having been made as to how much of his year was to be spent in America. This was the main point of disagreement and Morgan, soon after his arrival, tried to lay down terms which Fry felt unable to accept. Meanwhile Helen, who had initially urged Roger to accept the Curatorship, was now doubting the wisdom of the decision. Even more tantalising was the fact that the National Gallery post still remained open. Eventually Fry sent Laffan an ultimatum: if Morgan did not accept the terms stated in the above letter, then he would resign. This forced an agreement but the question of how much of each year Fry should remain in New York continued to trouble his relationship with the trustees and was eventually to bring about his resignation from the Curatorship.

Since Fry's previous visit, the staff at the Museum had changed. Sir Caspar Purdon Clarke had arrived to take up the Directorship but it soon became apparent that this distinguished grey-haired gentleman, who had trained as an architect, built consulates and embassies, and who had spent the greater part of his life in the British civil service, was ill-suited to the post. He was more at home in the well-oiled bureaucracy of his former South Kensington Museum than in the dynamic cut-and-thrust world of New York. The Museum was in need of radical, professional reorganisation; Sir Caspar was a quiet, dignified upholder of established traditions. Almost as soon as he arrived his health began to decline and the main burden of the administrative duties fell on his assistant, Edward Robinson, previously Director of the Museum of Fine Arts in Boston. Fry immediately recognised Robinson's professional standards and quickly learnt to direct all important administrative problems his way. Not long after Fry's arrival, Bryson Burroughs was appointed Assistant Curator of Paintings. Burroughs had originally trained as a painter in Paris where he had developed a deep admiration for Puvis de Chavannes, and his combination of practical and professional experience made him sympathetic to Fry. He described Burroughs as 'a man who has never bothered about anything but just gone his own way with no money and no reputation, but with peace in his heart.'[16] A close friendship was established between them and Fry also enjoyed the company of Burroughs' short, roundfaced wife, who developed a mild infatuation for Fry.

Fry's social life in New York was never entirely divorced from

Museum affairs. He dined out almost every night, often meeting people he had been introduced to before but who had left no impression on him. Most of the intellectuals he met he found entirely sympathetic. He had the good fortune on one occasion to be seated next to Mark Twain at a dinner and found him a 'generous and liberal-minded gentleman, altogether one of the fine men – and he has the courage to speak out for what is honest and humane'.[17] The millionaires were more intractable: Mrs Douglas, Pierpont Morgan's mistress and the real power behind the throne, demanded slide-shows; George A. Hearn, a trustee, insisted on dedicating his collection of American paintings to the Museum and demanded that a special room bearing his name be devoted to them. Fry had to learn to disguise low opinions on nineteenth-century American art behind tactful comments as Hearn was not the only enthusiast: 'At a dinner t'other night at a club,' began one description Fry sent to Helen, 'they began to say how iniquitous it was that we didn't buy examples of the great American school: "Perr-haps the great-est school of po-etical lands-cape that this planet has ev-er pro-duced, etc." I slid out of it on the ground of inexperience, but the damned thing will have to be faced, and all I can hope to do is to exclude the worst and ultimately keep it in a thoroughly disinfected room by itself.'[18]

His duties as Curator concerned the preservation, presentation and acquisition of paintings. He outlined his aims in a paper which was read at a committee meeting in November 1906 and which was published in the Museum Bulletin the following year. In it he underlined the main gaps in the collection: 'There is only one aspect of the art which is adequately represented and that is the sentimental and anecdotic side of nineteenth-century painting. For the rest we can only present isolated points in the great sequence of European creative thought. We have as yet no Byzantine paintings, no Giotto, no Giottesque, no Mantegna, no Botticelli, no Leonardo, no Raphael, no Michelangelo.'[19] These were ideals rather than practicalities and his more general concern was to fill out the collection of Western European art so that historical developments could be traced. This, he felt, was one role of an art gallery, the other being to encourage aesthetic appreciation. Acquisitions, therefore, became his major concern and the need to exercise taste and judgement in a way that would benefit the public led him to re-examine his aesthetic standards in art. Added to this, association with the Metropolitan opened the doors of many private collections and dealers' stores, extending Fry's knowledge and deepening his appreciation. He bought brilliantly, fifty-four paintings being acquired during his year as Curator, and during this and the subsequent years of his association with the Museum, it added to its collection works by a number of major European artists including Giovanni Bellini, Crivelli, Lorenzo di Credi, Gerard David, Andrea del Sarto, Holbein, Renoir and Whistler, to name a few. It is admitted by Winifred E. Howe and Calvin Tomkins, historians of the Museum, that by 1913 the major gaps in the history of Western painting outlined in Fry's accession policy had been filled, if not in all cases by

the giants, at least by their close followers and associates.

Fry admitted that his purchasing was assisted by luck. The prestige attached to the Metropolitan meant that private owners and dealers were eager to sell to the Museum and willing to accept low prices. A Guardi *Fête on the Grand Canal* that Fry estimated was worth £4,000 was offered for £400. Among the masterpieces acquired during his first year at the Museum were Lotto's *Portrait of a Young Man*, Nicolaes Maes' *Portrait of a Woman*, Jan Steen's *The Kitchen Interior*, William Blake's *The Creation of Eve* and *The Rest on the Flight into Egypt*, Goya's *Don Sebastian Martines*, Puvis de Chavannes' *The Shepherd's Song*, Giambono's *The Man of Sorrows*, a Master of Flémalle *Virgin and Child*, Whistler's *Nocturne in Green and Gold: Cremorne Gardens, London, at Night* and Holbein's *Portrait of a Man* (probably Benedict von Hertenstein). By April 1906 Fry had spent his entire allowance for picture buying that year but in June an extra $5,000 was placed to his credit in London so that he could acquire small, interesting items that appeared on the market.

Before he left New York in the spring of 1906, Fry arranged for the Museum's Gallery 24 to be rehung with a display selected not according to any school or historical period but for its aesthetic interest. Among the exhibits were certain recent acquisitions and to show them with good effect, Fry took the utmost care over the redecoration of the gallery, working in close co-operation with the architect and workmen. Several of the pictures had been reframed and he taught the gilder how to use Cennino Cennini's method of gilding. He personally mixed the colours for the walls in order to obtain the exact effect he desired. The colours chosen were those that later became almost a trademark of the Omega Workshops: the walls were painted a grey-gold on top of pure ultramarine; the woodwork was covered with pure raw umber over a burnt sienna stain and the result, as Fry described it, was 'a wonderful smalto effect – quite lovely'.[20] The pictures darkened and glowed in their setting, gave him great pleasure and the whole venture was praised in the press.

Praise turned to open criticism in the *Academy Notes* published by the Buffalo Art Academy that year. A Dr Charles M. Kurtz from Buffalo, after a visit to the recently decorated gallery, accused Fry of having overcleaned certain pictures. Fry, with the help of Bryson Burroughs, had carried out cleaning and restoration on a number of paintings but in the case of two of the three paintings Dr Kurtz singled out for attack, he had merely removed the glass that protected the front of the canvas. In the case of the third, Rubens' *Holy Family*, Fry had removed a discoloured coating of varnish which had confirmed the conventional belief that Old Master paintings were distinguished by a mellow, golden-brown patina. Its removal revealed Rubens' bold flesh tones which Dr Kurtz likened to 'underdone beef', a phrase that was quickly picked up and bandied around by the popular press. This was not the first complaint about Fry's cleaning activities that reached the trustees and as a result

the Director and his Assistant were asked to draw up a report. According to this by April 1906 Fry had cleaned or restored thirteen works using four different solvents. It lists the kind of work undertaken on each picture and firmly concludes, 'We did not find that in any of the pictures treated by him the original paint was in any way affected'.[21]

This second American visit, of three months duration, did not dispel Fry's ambivalent attitude towards America. However, his anxiety over Helen's health and her letters begging him to return home must have affected his judgement. With his heart and mind turned towards England he was unable to commit himself wholeheartedly to the life around him and as a result his views on New York and its inhabitants are those of an outsider. He criticised a certain callousness: 'Life to them is simply and blankly sentimental. As all the sentiments are cut to a particular pattern and they always believe they come to that exactly there's no room for psychology.'[22] Personal unhappiness coloured his attitude towards America and he continued to hold this unfavourable view all his life; as late as 1928, he wrote to Virginia Woolf, 'France is really the chief hope of any resistance to America; we have already given in'.[23]

At the end of April 1906 Fry returned home, to Helen and the two children, now living at 22 Willow Road, Hampstead, a house Fry had taken in 1903. It was an ill-proportioned Victorian terrace but it faced on to heathland and had the seclusion and peace of the countryside with the amenities of London close at hand. He was visited at this house by the young Vanessa Stephen. Vanessa (who was later to play an important matriarchal role in the Bloomsbury Group) had heard of Fry as a lecturer on art, but due to her hatred of lectures had never attended any of his talks. She had caught a glimpse of him and his wife in the Fellows' Garden at King's College in either 1902 or 1903. 'Those are the Roger Frys', Walter Headlam had murmured and she had looked and seen a tall couple cross the grass. Two or three years later she found herself seated next to Fry at a dinner given by Desmond MacCarthy and prepared herself to be silenced and awed by his presence. To her surprise he listened encouragingly to her remarks and before she knew what had happened they fell into a violent argument over the merits of John Singer Sargent's art. Against Fry's statement that Sargent as a draughts-man had no talent, she produced the example of Madame Gautreau (Plate 30) and Fry reconsidered his opinion, admitting that in that portrait the arm, at least, was drawn. Helen was also present, looking melancholy and ill and wearing a dress designed by Fry which Vanessa later remembered hastily and silently criticising as 'arty'. After the dinner, Fry invited Vanessa to visit them in Hampstead and though the invitation was not taken up with any immediacy, she finally went and never forgot the experience of her visit. Helen again looked ill at ease and rather forlorn and Fry seemed hypersensitive to her condition. A sadness hovered in the air: Helen complained she had no time for her own work and was clearly depressed. Vanessa later recalled: 'But though the scene is clear to me I cannot remember what we talked of – only the

30 John Singer
Sargent: *Madame X
(Madame Gautreau)*,
1884. Oil on canvas,
220 × 110 cm. New
York, Metropolitan
Museum of Art,
Arthur H. Hearn
Fund, 1916

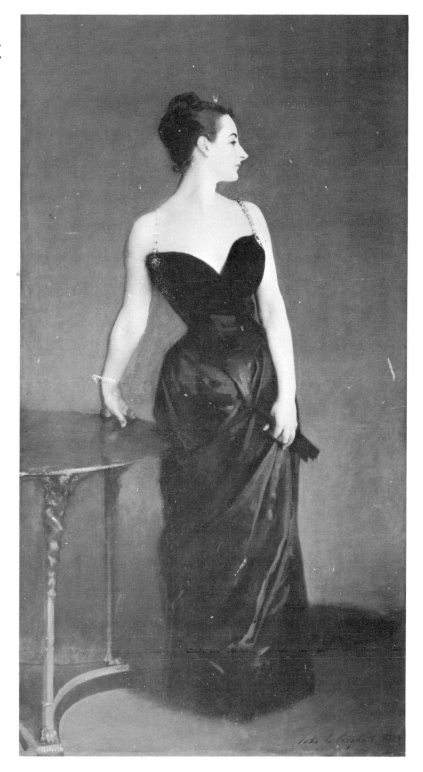

general impression remains of a strange alive household, not altogether happy but with a tremendous force and interest of some kind at work in it.'[24] The friendship did not at this time develop further: Vanessa's responsibilities brought on by the death of her father Sir Leslie Stephen, and Fry's American commitments carried them on separate paths for a few more years.

During the late summer and autumn of 1906 Fry travelled in France, Holland, Italy and Spain in connection with his work for the Metropolitan Museum. In Paris he met up with Pierpont Morgan and Henry Walters to discuss the possible acquisition of a Degas, which Morgan eventually decided against, feeling that it would offend the more conservative element in the Museum's board of trustees and public. In London Fry acted as courier to John G. Johnson during the lawyer's visit that summer, taking him to see, among other things, the Salting collection of Old Masters. In both England and Holland Fry was actively buying important Dutch Old Master drawings, and while in Spain he revealed that his taste was by no means bound by convention as he wrote to Sir Caspar Purdon Clarke: 'There is no doubt that we shall do well to cultivate the Spanish primitive school before it becomes fashionable. But we must confine ourselves to those of first rate condition.'[25]

In October, shortly before his return to New York, Fry sent in a report on his activities over the previous months. Listing gifts offered through him and pictures seen by him, it gives an indication of the energy he had expended on his job. He did not let his own tastes and interests limit his suggestions for acquisitions. When the widow of Arthur Melville, the Scottish watercolourist, approached him with a gift for the Museum, he advised in his report, 'While I am not personally in sympathy with Mr Melville's aims as an artist, I think his work is brilliant and accomplished, and that he is of sufficient importance to be represented under the circumstances'[26] After a visit to Dijon, Fry strongly supported Mr George Gray Barnard's suggestion, mentioned in the report, that the Museum should acquire and transport the cloister of Saint-Michel-de-Cuxa, and a small Gothic house (almost certainly the hôtel Chambellan), which Fry recommended as one of the masterpieces of late Gothic art. However, only the former was acquired and is now housed in The Cloisters, New York. Several of the acquisitions Fry proposed in this report, such as Fiorenzo di Lorenzo's Nativity, Salomon van Ruysdael's A Country Road, Simon Vlieger's Calm Sea and Lorenzo di Credi's Madonna and Child were added to the Museum's collection and the report as a whole consolidated Fry's position at the Museum and affirmed his authority.

On his return to New York Fry felt confident enough to begin work on the collection of drawings, making a number of radical reattributions. Nearly seven hundred Italian drawings had been donated to the Museum by Cornelis Vanderbilt (whose fortune descended from the Staten Island Ferry) and this gift had effectively bought his position on the board of trustees from 1878–1899. His collection, which listed among its items

nine Michelangelos, two Raphaels, eleven Titians, nine Rembrandts and two Leonardos, had been attacked by a perceptive critic at the time of its donation, but in spite of this it hung in a prominent position for several years. Fry immediately recognised that the majority of drawings, which had been bought rather hurriedly in Florence, were copies or school studies. He set to work to lower its attributions and to raise the scholarship of the Museum, but made up this loss of brilliance by adding the drawings he had acquired over the summer, among them a Campagnola, a Rembrandt, a Cuyp, a Gainsborough landscape, a J. R. Cozens and a *Head of an Old Man* by Leonardo, an attribution that has been questioned but which is accepted by Jacob Bean in *One Hundred European Drawings in the Metropolitan Museum of Art, New York* (1964). Fry also added some drawings by British artists, among them a Ruskin which he admired for its vitality of line and nervous variety of rhythm, and he himself donated a portrait of Rodin by Will Rothenstein.

Fry had no intention of staying long on this, his third, visit to New York as his absences from home increased the nervous strain under which Helen lived. Early in December he informed the trustees that he intended sailing home on the nineteenth of that month and this sudden announcement of his impending departure was ill-received. Fry, forced to realise that he was unable to sustain the full-time responsibilities of a Curator, approached William Laffan to see if his title could be changed to that of European Adviser. Morgan, aggravated by Fry's independence, grudgingly admitted that the Museum did need a permanent contact in Europe but he refused to come to any immediate decision and Fry left New York under a cloud, with the dispute unresolved.

Once on board the R.M.S. 'Baltic' he sent John G. Johnson an account of his disagreement with Morgan. Johnson was fully aware of the difficulties Fry faced and had earlier warned him, 'The trouble is that everyone is under the coercion of Mr M's dominating will. No one does, or dares, resist it'.[27] Fry could not help comparing in his mind Johnson's tact, charm and generosity with Morgan's despotism. Both men were currently forming their own collections. Morgan's was largely housed at 13 Princes Gate, London, the home inherited from his parents, and because of the heavy import duty then imposed on works of art entering the United States, there was considerable doubt that it would ever reach America, still less the Metropolitan Museum, as Morgan ultimately intended it should. As President of the Museum his allegiances sometimes became confused and he had no qualms of conscience about using Fry's expertise to benefit his own collection before that of the Museum. In May 1907 Fry wrote to Johnson describing one example of Morgan's underhand behaviour: 'I have found several other Italian pictures which I wanted for the Museum and on my calling Mr Morgan's attention to them he secured three for himself and expressed the pious hope that the Museum might be able to buy the rest. When I think that you who have nothing to do with the Museum always generously stand aside

when we are in for things, I confess this from the President of the Museum surprises me.'[28]

Fry had been advising John G. Johnson on his collection (now housed in the Philadelphia Museum of Art) since the spring of 1905. Johnson had begun collecting in middle life when the large fortune which he had amassed through his brilliant legal mind enabled him to develop sensibilities previously suppressed by the practical nature of his career. He first bought work by modern Italian painters but soon became dissatisfied with these, sold them, and discovered that bad art is also a bad investment. His taste then turned to nineteenth-century French artists, Corot, Courbet, Degas, Delacroix, Manet and Sisley and before long he developed a fine appreciation of Old Masters. He lived in Society Hill, the eighteenth-century part of Philadelphia and his relatively small house was crammed full of paintings which hung on the walls, rested in stacks against the walls or were displayed on easels or chairs. His taste became extremely perceptive and he never bought primarily because of value, but loved to discover the little known artist, or the work which had some unusual curiosity attached to it. As a collector he was directed by an interest in art history rather than a desire for social assets and he therefore acquired not only masterpieces of Italian and Flemish art but also important examples of the lesser known Burgundian, Provençal and Catalonian schools.

The first painting to enter Johnson's collection on Fry's recommendation was a Jerome Bosch *Mocking of Christ*, now thought to be one of several copies after a lost original. Fry was convinced that it was by the master himself, and had given his reasons two years earlier in an article on the picture in the *Burlington Magazine*.[29] Soon after this painting entered Johnson's collection, Fry sent him a photograph of a Bellini *Madonna and Child* available for acquisition.

In the *Burlington Magazine* Fry described the discovery of this painting: 'It was entirely unknown before coming to light at a provincial auction in England. It was then almost unrecognisable from repaints in oil, even the contour of the Virgin's robe having been altered to a rounded emptiness more pleasing to late owners than the sculptural angularity of the original.'[30] It is not known where this auction was held nor who bought the painting, but when Fry first told Johnson about it, it was evidently in his care as he had undertaken its cleaning and restoration. Venturi later stated that it had been in Fry's own possession,[31] and certainly Fry's study of Bellini would have made him one of the first to discover the genuine article beneath the repaints.

Fry, it seems, had no hesitation in undertaking restoration on important works of art. This was perhaps less surprising then than it now seems, as it was still the period of the amateur and Fry must have felt that his artistic training and reading of Eastlake and Cennino Cennini gave him enough background knowledge and experience to undertake such work. He sent Johnson a detailed description of his work on the Bellini:

You will see that the flesh is covered with *craquelures* and in restoring (the shadows of the flesh were the most perished, the lights almost intact) I have done it with very thin scumbles which leave the original *craquelures*. The fingers of the Madonna's right hand and the back of the left palm though complete in outline had to be almost entirely remodelled. The blue robe had to be stippled more or less all over and the lower part of the sky on the right hand side and to a less extent on the left, had also to be gone over.[32]

Since entering the Johnson collection, apart from the setting of blisters on two occasions, the surface of the painting has not been touched and the sensitivity of Fry's restoration can still be assessed.

The second major piece of restoration undertaken by Fry for Johnson was the cleaning of his Van Eyck *St Francis receiving the Stigmata* and the cutting away of the upper part of the panel. The cleaning not only brought out much exquisite detail, but also produced the first conclusive evidence that the artist was practised in the art of manuscript illumination. According to Fry:

From the moment I got to work on it I had no doubt that this was an original work of Hubert Van Eyck and that the Turin version was a copy. When it came to me, the panel was considerably larger at the top, and a dull, opaque sky concealed the join where the extra piece had been added to satisfy some owner who did not appreciate the compressed composition of the original. The sky had been enlivened, if I remember right, with a crowd of small white, cloud-like forms suggesting the presence of a cohort of angels. These all came away with the sky and then, to my surprise, I found that the original panel appeared surrounded by a brilliant scarlet margin, painted on the panel, just as might have been seen on the border of a manuscript illumination.... This border made me suppose that van Eyck had conceived this as a miniature in oil on panel, and that it might indicate a date not very far removed from the drawings of the Turin *Book of Hours*.[33](Plate 31)

The restoration of this panel coincided with Fry's period as Curator of Paintings at the Metropolitan. His allegiance at this time lay first with the Museum and for a while the number of purchasable paintings brought to Johnson's attention by Fry decreased. In 1906, however, he did urge Johnson to buy Giovanni di Paolo's *Christ Carrying the Cross* after the Museum had acquired the *Paradiso* (Plate 32) by the same artist. Then, between 1907 and 1909 the Museum placed a curb on Fry's buying policy, arguing that they wished to save up for great and impressive things, and as a result the number of works entering Johnson's collection on Fry's advice again increased. Although Fry's recommendations were governed by availability and price, he was alert to the sensitivity that governed Johnson's taste. It is possible to detect in his choice of paintings a taste for the primitives and a love of sombre colour harmonies. The latter can be seen in the rich browns, purples and greens in the Master of the Mansi Magdalane's *Salvator Mundi*, bought by

31 Attributed to
Hubert van Eyck: *St
Francis receiving the
Stigmata.* Panel,
12.5 × 14.5 cm.
*Philadelphia
Museum of Art, the
John G. Johnson
Collection*

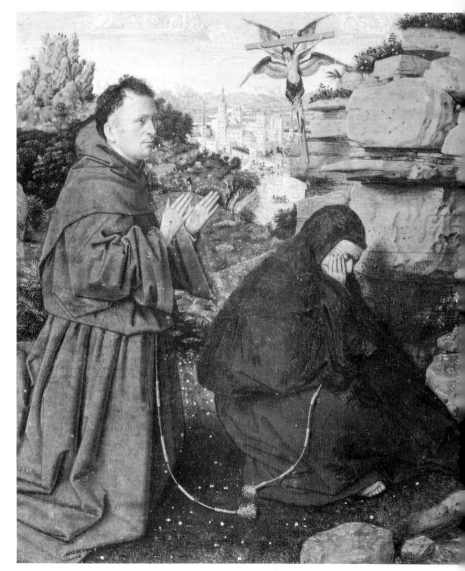

Johnson after it had been refused by the Museum, and of which Fry
said, 'I have no hesitation in saying that this is one of the very finest
Flemish pictures of the early sixteenth century, to be compared with
your Gerard David'.[34]

Yet of all the paintings that entered Johnson's collection through Fry,
the most individual and distinctive are perhaps the four predella panels
by Botticelli representing scenes from the life of the Magdalen. These
had been discovered by the Botticelli expert, Herbert Horne, in Florence
and brought to Johnson's attention at Fry's suggestion. The subject
matter had led Horne to conclude that these were the missing predella
panels of an altarpiece executed for the convent of Sant' Elizabetta di

98

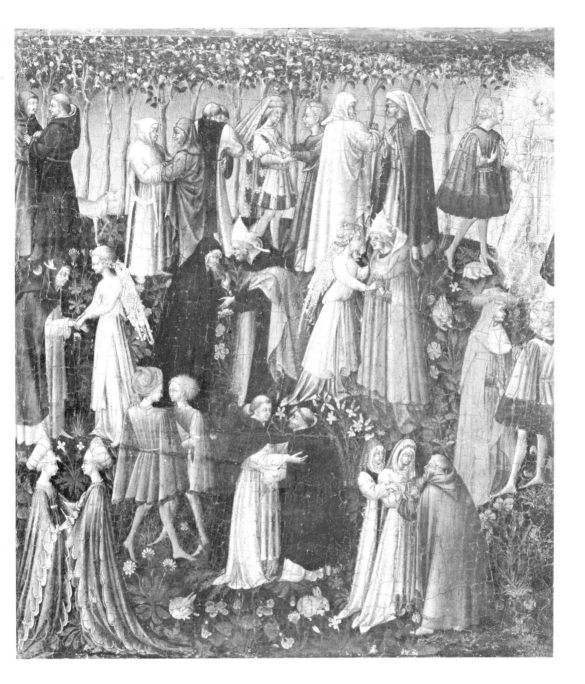

32 Giovanni di
Paolo: *Paradiso.*
Tempera on canvas,
46.9 × 40.6 cm. New
York, Metropolitan
Museum of Art,
Rogers Fund 1906

Convertitie which had been founded in Florence in the fourteenth
century for penitent prostitutes. As the subject of the predella panels
was never recorded, Horne's correlation of these four panels with those
of the missing altarpiece rests on pure hypothesis. Neither Horne nor
Fry, however, had any doubt as to their authorship, perceiving the work
of the master in the subtle manipulation of the architectural setting in

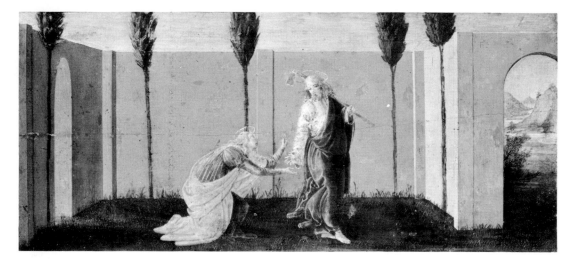

33 Sandro Botticelli: *Noli me Tangere*, one of four predella panels on the story of Mary Magdalen, 18 × 42 cm. *Philadelphia Museum of Art, the John G. Johnson Collection*

each scene to heighten the emotional drama and to off-set the calligraphic description of the figures. Fry informed Johnson that the panels had 'that peculiar imaginative intensity and intimacy which I find to be the real note of your collection'.[35]

Johnson bought the panels and wrote to tell Horne of his delight in them, but his enjoyment diminished when his chief adviser Bernard Berenson declared them to be the work of 'Amico di Sandro', a compound creation of his own invention whose existence has now been rejected. Horne argued that the panels belonged to Botticelli's early period and were close in 'hand-artistry' to the two small *Judith and Holofernes* panels in the Uffizi; Fry added that the influence of Lippi is discernable in certain of the faces, and that the intense drama and imaginative psychology militated against Berenson's attribution. Finally Berenson, after seeing Botticelli's two early *Adoration of the Magi* in the National Gallery, London, retracted his earlier opinion and affirmed their authenticity. This small squall in a scholar's tea-cup, however, confirmed Fry and Horne in their growing opposition to the hegemony of Berenson. Johnson, now reassured, could again enjoy these four small panels which evoked from Fry an extraordinarily sympathetic insight: 'There are few figures in Italian art more wonderful or more touching than that of the Magdalen irresistibly drawn by Christ's preaching and yet ashamed to come near with the others. It comes near to Rembrandt's sympathy and understanding.'[36]

Meanwhile Fry had pulled off a bold coup for the Museum. He had bought Renoir's *La Famille Charpentier* (Plate 34), painted almost thirty years previously, yet the most modern French painting to enter the Museum during Fry's term of office. Even so it angered certain trustees and had been bought while the more conservative among them were out of town. The dealer Durand-Ruel had first brought the painting to the attention of the Museum and Fry had immediately travelled to Paris to inspect it. The painting was to be included in the Charpentier sale

100

and at the last moment Fry telegraphed to the Museum, 'magnificent museum masterpiece attractive purchase Wolfe Fund would be a great coup recommend bid'. He received permission to go up to $20,000, money being supplied from the Catherine Lorillard Wolfe Fund, and he instructed Durand-Ruel to bid on their behalf. The painting was acquired at just under this price and the dealer waived his right to the commission.

Fry tried to convey his enthusiasm for this painting in his notes on it for the Museum Bulletin. He argued that Renoir's temperament was opposed to the central classic tradition in European art.

> His is a purely poetical and constructive genius. He has followed a certain inspiration with naive directness and simplicity of spirit. He has obeyed its dictates without reasoning about them, without formulating a theory. In this way he appears as curiously unlike the majority of his countrymen, as wanting in that logical precision, that clear cut classical efficiency which means the French school. He may be said to be the most English of modern painters, having much of the impulsive, unreflecting sentiment for beauty, which crops up sporadically and unexpectedly in the British race.

He continues with this theme by likening Renoir's treatment of surfaces and his understanding of the 'grace of womanhood' to that of Gainsborough. The Charpentier painting, he concludes, is a celebration of motherhood and of the 'animalism of childhood', and he has no hesitation in declaring it 'by common consent one of the finest, if not the finest work by the painter'.[37]

La Famille Charpentier only confirmed certain trustees in their distrust of the unorthodox Englishman. Since his sudden departure from New York in December 1906 it had been recognised that some change in his status should be made and the Annual Report for 1907 announced: 'Mr Roger E. Fry, Curator of Paintings, found himself unable to remain in the United States for as long a period of time as he originally anticipated when he accepted the Curatorship. He has consequently resigned, and has been appointed European Adviser to the Department of Paintings, in which position he will be able more effectively to represent the Museum abroad.' Over the next two years he travelled widely in Europe on behalf of the Museum, and in the summer of 1907 he accompanied Pierpont Morgan on a tour of Italy.

Morgan, accustomed to leaving America around March each year in order to divide his summer between London and the continent, in 1907 ordered his huge ocean-going yacht to await him at Ancona while he travelled to Perugia to meet Fry. Their intention was to visit the exhibition 'Mostra d'Antica Arte Umbria', held in the Palazzo del Popolo, to spy out possible purchases, and then to continue with a tour of central Italy. Fry arrived in Perugia a few days ahead of Morgan and set to work on a watercolour on silk of the church of San Domenico. He

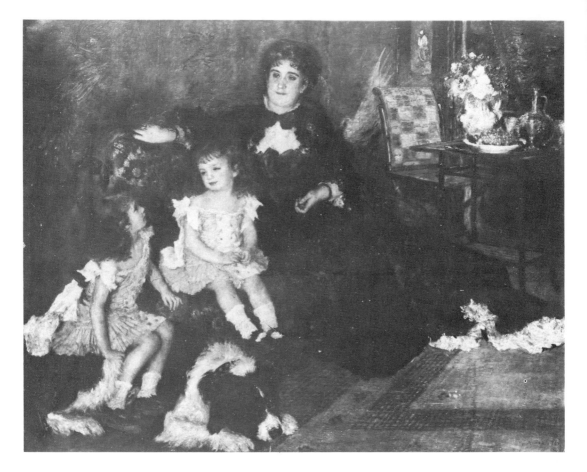

34 Pierre Auguste
Renoir: *La Famille
Charpentier*, 1878.
Oil on canvas,
153 × 187 cm. New
York, Metropolitan
Museum of Art

found the city too sophisticated for his liking and wanted simply to walk off into the surrounding countryside and get a taste of peasant life and food. Instead came the rude awakening of Morgan's arrival: the millionaire's reputation had gone before him and, though unannounced, he was treated like royalty; crowds flocked; officials bowed; and keys were produced to unlock sacred sites and private collections. 'Somehow' Fry observed to Helen, 'he has touched the imagination of the people as no other millionaire has.'[38] Fry now became part of Morgan's motley entourage. It consisted, he observed, of the 'stately and enamelled' Mrs Douglas; the courier, a 'lank hungry Italian cadger'; and Mrs Douglas' chaperone, Mrs Burns (Morgan's sister) who 'was entirely unnoticeable and the only evidence of her presence was that at proper intervals and whenever it seemed appropriate she uttered little shrill mouse-like squeals of admiration at pictures, scenery and Mr Morgan's remarks'.[39]

After Perugia the company proceeded by car to Assisi in high spirits. Morgan joked about a tear in his gloves; his exclamation that he could not afford to buy another pair produced high pitched screams of laughter from Mrs Burns. The car spun along at a reckless speed, leaving oxen plunged into ditches, chickens, dogs and children screaming in their

wake. Suddenly the car hit a pot-hole and Morgan's head hit the roof of the car, leaving his hat crushed down over his eyes. He exploded with rage, the aggressive *cavaliere* was severely reprimanded, and after that the vehicle proceeded at a less extrovert pace.

The main object of this bizarre journey was the acquisition of works of art. At every stopping place Fry observed that news of Morgan's arrival spread quickly and poverty-stricken families, dealers and sharks would appear, clutching heirlooms, fakes and curiosity pieces, which they hoped would attract the eye of the munificent collector.

Morgan had at first confined his collecting to books and rare manuscripts and it was not until the turn of the century that he began that vast accumulation of objects associated with his name, among them ivories, jades, bas-reliefs, bronzes, snuff-boxes, miniatures, watches, Bibles, glass, terracottas and medieval reliquaries. His collecting was not creative; he never expended the same energy and zest on the housing of it as Mrs Isabella Stewart Gardner did at Fenway Court. He was motivated simply by greed and the desire for aggrandisement, and his chief pleasure lay in the acquisition not in the appreciation of works of art. Valuable manuscripts and books were glanced at perhaps after their return from some expensive binder, but were then added to the ever-growing pile and never looked at again. A number of related factors determined his taste: a romantic love of the past; a desire for a beauty far removed from modern industrial America; a genuine admiration for craftsmanship and a love of bright, even garish colour. In short, it was the exotic, the expensive and the rare that appealed. 'Having become the greatest financier of his age,' the *Burlington Magazine* declared after his death, 'he determined to become the greatest collector.'[40] In pursuit of this aim, he spent more than half his fortune. He relied heavily on the policy of sudden attack and would turn his eye on the seller and offer the price the owner or dealer had originally paid plus fifteen per cent. The abruptness of the offer would more often than not take the seller by surprise and the deal was swiftly concluded. At other times, he would prefer to acquire an entire collection rather than go for carefully selected piecemeal acquisitions. At the end of every foray into Europe, the pile of booty acquired was packed up and shipped back to his house in London. The money spent was forgotten: he argued that no price was too high for an object of unquestioned beauty and known authenticity. He had the added wisdom to realise that the high prices he sometimes paid forced up the market all round and thus increased the value of his investments. Simple psychology, investment sense and unlimited gold made Morgan's collection. As Fry observed, 'a crude historical imagination was the only flaw in his otherwise perfect insensibility'.[41]

The 1907 tour of Italy took Morgan and Fry to Florence where the latter dined with Berenson. By now thoroughly disenchanted with his previous mentor, he observed that the connoisseur quizzed him on certain paintings in an attempt to prove his ignorance. Fry found he

collaborated more easily with the other Florentine specialist, Herbert Horne, who, though equally difficult in character, was unfailingly generous to Fry at this date with information on Florentine paintings, and if Fry had turned immediately to Horne for advice on a Fra Angelico when he first discovered it in the summer of 1910, his position at the Metropolitan might never have been terminated.

Fry's position at the Museum was already troubled by his infrequent visits to New York. He made one short visit in 1907, arriving in November and returning home a few days before Christmas. Since then he had not reappeared. In November 1908, August Jaccaci, a New York contributor to the *Burlington* warned Fry that his situation was insecure.

> Mr Johnson tells me that he has spoken very frankly to you when he was in London this summer as to the mistakes you might be making in your relations with the Museum. . . . the crux of the whole question is this – that you are becoming a remote person, that the things you recommend and which are entirely worthwhile . . . are not bought . . . that you are losing your influence and that it is of vital importance that you should come here to regain it and place yourself properly before the Museum people so that they will feel anew your value, your influence and therefore follow your suggestions and lead.'[42]

Jaccaci's warning coincided with Helen Fry's worst attack of mental illness, from which she never fully recovered. It occurred while the entire family was staying at Chantry Dene, Guildford, the last occasion on which they were all together. Fry as usual constructed for Pamela and Julian ingenious toys, a puppet theatre or a waterwheel in a nearby stream. But already the children were accustomed to being strangers in their own home and, when Helen became violent and strange, they were not surprised to be sent away; after the age of seven and eight they never saw their mother again. Helen's insane hatred for Roger alternated with morose silences. During the previous winter she had entered the care of Dr Chambers at The Priory, Roehampton and now she was forced to return. Fry wrote to her daily and visited her whenever he could. Her letters in return became rambling, child-like and incoherent. Her gentle humour that had earlier teased his more dogmatic views – she said of Henry James' *What Maisie Knew*, 'it makes the great middle class what it so deplorably and persistently is – there I quote you one of your own sentences,'[43] now collapsed into pathetic repeated demands to be allowed to return home and to see her children. With Helen in such a condition, Fry could do nothing but ignore Jaccaci's letter.

The tensions underlying Fry's position at the Metropolitan Museum found explosive outlet in the disagreement over the Fra Angelico. In June 1909 he saw at Kleinberger's gallery in London a *Virgin and Child* attributed to Fra Angelico and which at one time had belonged to King Leopold of Belgium. He asked that it be put on one side for the Museum while he wired for the trustees' agreement on the acquisition. Mean-

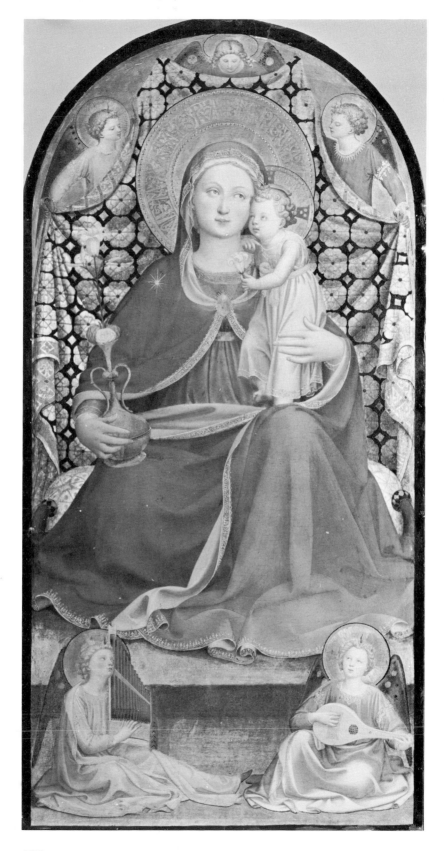

35 Fra Angelico:
Virgin and Child.
Oil on panel,
100 × 49 cm.
*Lugano, Thyssen –
Bornemisza
Collection*

while, Morgan saw the painting and bought it for his own collection: the dealer, thinking he was buying for the Museum, sold it to him without informing Fry. Infuriated by this, Fry wrote a letter to Morgan making little attempt to disguise his annoyance at Morgan's underhand behaviour: Morgan, who conducted most of his affairs by telegram and telephone, was astounded by the letter, which he presumably returned to Fry as he pencilled across the top: 'The most remarkable letter I ever received. I don't propose to answer it until I see you. Bring it back.'[44] By this time Horne had received a photograph of the painting from Fry and, though Berenson affirmed the attribution, the opinion Horne now sent Fry has been upheld by modern scholars. According to Horne, the painting was not by Fra Angelico: it was, he declared, too decorative, lacking in structure in the drawing of the figures, vulgar in sentiment. He concluded: 'The decorative qualities are over-stated. In short Providence evidently designed it from the beginning as a snare and a lure to Morgan. I am very glad that your Museum has missed it; tho' I am very sorry you have had so much vexation of spirit over it. What Morgan buys will soon be forgotten: but what the Museum buys will remain.'[45]

Horne's prediction became true of the greater part of Morgan's collection which never entered the Metropolitan as he intended. When the collection was shipped to New York in 1912 after the import tax on works of art had been removed, the amount of money and space needed to house it forced the Museum to approach the City for an appropriation, which was consistently opposed by the Hearst newspapers. Public opinion had begun to turn against Morgan and it was announced that the City Fathers should not spend taxpayers' money in order that Morgan could 'parade his wealth'. The suggestion that Morgan himself should put forward the necessary money to house his works of art so infuriated him he left his entire collection, valued at up to fifty million dollars, to his son, and the need to pay off estate duty meant that it was soon widely dispersed. The so-called Fra Angelico was sold soon after Morgan's death and is now in the Thyssen Foundation at Lugano.

After his angry confrontation with Morgan over the Fra Angelico, Fry was advised to resign. He saw no reason to do so as he felt he had always done his best for the Museum. The loss of salary was no minor consideration as his wife's illness caused him crushing expense, on top of which he felt he had fallen out of the running for equivalent posts in England. The offer of the joint-editorship with Lionel Cust of the Burlington Magazine in September 1909 slightly eased his position as it brought with it £150 a year. It required two days work a week and would not, so Fry informed Edward Robinson, affect his work for the Museum. However, in February 1910 his association with the Metropolitan ended. No copy of the letter terminating Fry's appointment is to be found in the Museum's archives and from the cold, formal reply that he sent to Mr de Forest, secretary of the board of trustees, it appears that no reason for the termination was given.

Association with one of America's leading museums had given Fry

the opportunity not only to extend his knowledge and broaden his taste, but also to assess what qualities in art are of lasting value, and it is significant that as his association with the Metropolitan drew to a close, he published his first major statement on aesthetics. His experience of America chased away the *fin-de-siècle* mood of the 1890s; the toughness and vitality of the American life-style prevented any tendency towards aesthetic effeteness. ('Americans kill all dreams', Fry told Helen. 'They are so intelligent and on the spot.'[46]) But in its final rejection of him, America also gave Fry the opportunity to redirect his career, and, at the age of forty-four, when he could expect to be entering upon a period of mature achievement, consolidated upon earlier struggles, his life was to take on an entirely new direction. In many ways, the struggle had only just begun.

6 New Foundations

During the years of his association with the Metropolitan Museum, Roger Fry's ideas on art gradually crystallised into a theoretical framework capable of embracing both his love for the Old Masters and his growing appreciation of Post-Impressionism. Faced with the complexity of experience offered by art, his scientific training naturally led him to look for some underlying pattern, for generalisations that would co-ordinate and explain his impressions. He admitted that when buying for the Museum he felt the need for 'a faith in the existence of something more universal in art than a merely casual and arbitrary predeliction'.[1] Gradually he came to believe that the constant in art was 'form', and with this came the realisation that the content (not the subject matter) in a work of art is inseparable from the formal design. After a decade spent musing upon the essentials in art, he published in 1909 'An Essay in Aesthetics' which signals the onset of the major part of his career.

All Fry's writings prior to this date had been haunted by the problem of the relationship between representational content and the formal qualities used to express it. The most notorious examples are his two essays on Giotto published in the *Monthly Review* in 1901 (later reprinted in *Vision and Design*). Preoccupied with Giotto's presentation of drama, Fry praises his ability to make the local and particular stand for the universal. Thus when describing the *Pietà* in the Arena Chapel, Fry notes how the movement of the angels contributes to the sense of cosmic disaster: 'the air is rent with the shrieks of desperate angels

whose bodies are contorted in a raging frenzy of compassion.'[2] Other passages of such freely associative criticism could be cited and, as the essay proceeds, Fry admits that he is treading on questionable ground. After the passage describing Joachim's mental condition in certain scenes ('even in his sleep we guess at his melancholy dreams'), Fry admits:

> It is true that in speaking of these one is led inevitably to talk of elements in the work which modern criticism is apt to regard as lying outside the domain of pictorial art. It is customary to dismiss all that concerns the dramatic presentation of the subject as literature or illustration, which is to be sharply distinguished from the qualities of design. But can this clear distinction be drawn in fact? ... To be able then, to conceive just the appropriate pose of a hand to express the right idea of character and emotion in a picture, is surely as much a matter of a painter's vision as to appreciate the relative 'values' of a tree and cloud so as to convey the mood proper to a particular landscape.[3]

When reprinted in 1920 in *Vision and Design* Fry felt it necessary to append a footnote stating that his current aesthetic views varied with those expressed in the essay; by then, as has been mentioned, he felt it both possible and necessary to disentangle the reaction to pure form from the associated ideas.

Shortly after writing these two essays on Giotto, Fry had an important experience in front of a Chardin still-life at a loan exhibition in 1902. The painting represented some glass retorts, bottles and a still, and had been executed as a signboard to hang outside a druggist's shop. On looking at it, Fry realised that a painting could arouse a deep emotional response purely through its formal means, quite apart from what those means might represent. 'It gave me a very intense and vivid sensation', he recalled. 'Just the shapes of those bottles and their mutual relationships gave me the feeling of something immensely grand and impressive and the phrase that came into my mind was " 'This is just how I felt when I first saw Michel Angelo's [sic] frescoes in the Sistine Chapel' ". Those represented the whole history of creation with the tremendous images of Sibyls and Prophets, but aesthetically it meant something very similar to Chardin's glass bottles.'[4]

Now alert to the direct effect of 'form' on the spectator's mind, Fry did not immediately arrive at an evaluation of abstract elements in their own right. He had, however, taken a step beyond the behaviourist theories of Vernon Lee and Bernard Berenson and wrote to the latter, 'For the moment I find myself thinking of art more psychologically less physiologically than you do'.[5] Having established this link between form and the spectator's emotional, i.e. not just haptic, response, he proceeded to develop this idea in a series of unpublished lectures on Dramatic, Lyric, Comedic and Epic art which he delivered in New York and London with considerable success. He prefaced the lectures with a quote from Okakura Kakuzo's *Book of Tea* – 'The canvas upon which the artist paints is the spectator's mind' – and then proceeded to outline

the different emotional points of view drawn upon in each of his four categories. For instance, he argued that epic art deals with events. 'The epic artist watches the procession and recalls it for the wonder, amazement and delight of his kindred, but he refuses to penetrate beneath the surface, he never analyses the causes which lead to the events.' By contrast, dramatic art focuses in on individual experience, lyric art is a medium for the confession of the soul, and comedic art, which Fry likens to prose, takes for its key the emotional pitch of everyday life. The comedic artist has one advantage over artists working in the other three categories; he can, Fry says, 'maintain a critical attitude and his idea may be conveyed by satire, irony and wit'.[6]

Although Fry never attempted to re-use these rather artificial and a priori categories, the lectures provide clear evidence of his belief that art is concerned with the communication of emotional states. Neither mere imitation of nature, nor a mere product of sensuous charm, art's domain is seen to be the imaginative appeal to human emotions. It is almost certain that Fry had read Tolstoy's What is Art? before writing these lectures, and in 1909 he wrote: 'This view of the essential importance in art of the expression of the emotions is the basis of Tolstoy's marvellously original and yet perverse and even exasperating book, What is Art?, and I willingly confess, while disagreeing with almost all his results, how much I owe to him.'[7]

For Tolstoy, art's central activity was the expression of feeling and experience: 'Art is a human activity, consisting in this, that one man consciously, by means of certain external signs, hands on to others feelings he has lived through, and that other people are infected by these feelings, and also experience them.'[8] He argues that art is always judged by the religious perception of the age. Previously art production had been determined by the upper classes whose loss of religion caused late nineteenth-century art to become involved, affected and obscure. A modern religious perception lay in the consciousness that man's spiritual and economic well-being depended on the growth of brotherhood among all men, and good art, therefore, was that which increased the sense of brotherhood between men. Fry rejected Tolstoy's concern with the moral effectiveness of art (which involved a confusion of ethics and aesthetics even worse than Ruskin's), but when in 1910 he introduced Post-Impressionism to London, he struck at the idea that art appreciation was the priority of an educated élite; sensibility, not knowledge, was all that was needed, he argued, to appreciate a Matisse. Fry, therefore, indirectly carried out Tolstoy's demand for increased brotherhood by popularising an art that, in the words of Francis Bate, was 'of the people, of the world'.

In 1909 Fry followed the lectures on Dramatic, Lyric, Comedic and Epic art with a series on 'The Language of Art'. He began with a talk on linear design in which he expressed his belief that drawing is the most intellectual and spiritual mode of artistic expression. Again his performance was highly commended and the praise he received prefi-

gured the tremendous success of his public lectures given in the late 'twenties and early 'thirties. A representative appreciation is that expressed in the *Art Journal*: 'Mr Fry feels deeply, thinks courageously, expresses himself lucidly and concisely; in a word, is a vital and illuminative lecturer.'[9]

While his aesthetic ideas lay germinating in his mind, Fry continued whenever possible to paint. He still exhibited twice yearly with the New English Art Club but felt increasingly dissatisfied with the Club's dominant styles. It had by this time become identified with pupils and tutors of the Slade School of Art, notably Steer, John, Orpen and McEvoy. The Slade's reputation rested on the importance it attached to draughtsmanship, not the over-finished style of drawing associated with the academies, but one that had originated in France and depended upon a bold, incisive use of line and swift hatching. It has been described as 'precise and yet free, intelligent but nevertheless a little sentimental',[10] and a similar leaning towards sentimentality had spread to the selection jury of the New English, which tended to favour feeling rather than thought in their choice of paintings.

Fry's interest in the expression of emotion in art made him not antipathetic to this emphasis on sentiment, but he continued to abhor the milk-and-water type of Impressionism associated with the Club. In 1905 Durand-Ruel brought a large exhibition of French Impressionism to London yet even at this date the bright colours, which Whistler had once described as 'screaming blues and violets and greens', did not appeal to the general public and few of the paintings sold. But the modified French influence reflected in much New English Art Club painting was gradually gaining recognition and in 1906 Agnew's agreed to show work by a number of New English artists in an exhibition entitled 'Some Examples of Independent Art of Today'. This marked a break-through for the Club as the gallery was traditionally associated with Old Masters and stalwarts of the Royal Academy. Fry exhibited *Château de Brécy*,[11] a ruined gateway dappled with sunlight. Its sharp focus and formal design must have looked out of place, but its nostalgic mood was in keeping with the general tenor of the show. The critic Frank Rutter praised Fry's work of this period for 'its scholarly qualities of classical composition and a rich soberness of colour'.[12] *Château de Brécy*, however, failed to sell and remained in Agnew's possession until 1910 when it was sold at auction.

In the spring of 1907 two of the three paintings Fry sent to the New English were rejected and he was forced to realise that he was no longer in sympathy with the aims of the Club. 'I know they are quite sincere in their judgements', he wrote to Rothenstein, 'and I don't feel annoyed with them, only it's no good forcing oneself when one isn't wanted.'[13] He consequently resigned from the Club the following year.

In spite of the unfashionable element in Fry's painting, it earned him considerable recognition and sold well. In July 1907 he shared an exhibition at the Alpine Club Gallery with the Hon. Neville Lytton, a

painter who, like Fry, was rebelling against the 'direct' painting of the New English Impressionists and who looked instead to the Old Masters, and in his watercolours, to the Early English Masters, for inspiration. Fry exhibited seven oils and fifty-seven watercolours and in the latter he, like Lytton, upheld the pre-Turner tradition of simple wash-drawing. His paintings were being praised in the *Morning Post*, illustrated in the *Art Journal*, and were bringing him financial gain; yet all this brought him little pleasure and to his mother he admitted, 'I've never had so much recognition of my work, 'tho it comes at a time when I have lost my ambitions in that direction, and indeed in all directions just now.'[14]

Still anxiously concerned for Helen, in April the following year he seized on a new project which he hoped would benefit her and absorb his own creative energies. He informed Sir Edward of his idea:

> I am thinking of taking a piece of land close to the Chantries at Guildford and building a house there. It seems clear that whatever happens the best chance for Helen is to have a more or less country life without the excitement of London. . . . I find I can buy an acre of land on the edge of a chalk hill just outside Guildford (20 min. from the station). It faces S. and S.W. and is sheltered from N. and E. and has a lovely view. The land will cost £600 which is just the sum you kindly gave me lately and which I set aside for some such purpose. Having bought the land I could I find borrow the money for the building on mortgage. I have found that a home such as would fulfil our requirements would cost £1650 and that I could borrow this at 4%.[15]

Possibly Fry had difficulty in obtaining the mortgage needed, because the final house was so economically designed that the cost, before the shutters were added, came to just under £1000. He found that, given the large number of rooms required, the cheapest method of arrangement was to build in an L-shaped block, with the top-floor housed in a hipped or Mansard roof. This need to design in as concentrated a shape as possible meant that the height of the rooms left unsatisfied Fry's love of high interiors. He was determined, therefore, to have one room of generous proportions. Thus on entering the front door on the north side, which is on a higher level than the south side (the house being built on a slope), the visitor crosses the small hall-way and passes down a few steps into the main central living area which rises the height of two floors and is lit by tall windows almost the same height as the room. Facing south, the room is frequently flooded with sunshine, while the door in the centre of the outside wall opens on to the terraced garden.

Fry designed 'Durbins' (named after Durbin's Batch at Failand), in collaboration with his builder and without any outside advice, simply drawing upon his knowledge and experience of European architecture. His chief functional consideration was the size and disposition of the rooms and once this had been settled an element of artistic choice went into the design of the exterior elevation, particularly the south front which was visible from the main road. His demand for as much light as

36 Roger Fry
outside Durbins.
Photograph

possible determined that windows should make up a large part of the
façade, and he was careful to select a pane, the size of which echoed in
its relationship to the window as a whole, the relationship of the window
to the total façade. According to local bye-laws, the central part of the
house had to project slightly and this enabled Fry to balance the strong
horizontal of the roof with vertical brick pilasters on either side of the
central projection. In this way a building that had begun without thought
of style, was given clarity of design, rhythmic unity and balance. These
qualities, Fry argued in an article entitled 'A Possible Domestic Archi-
tecture' (reprinted in *Vision and Design*), had been achieved partly
through gross indifference to public opinion. Situated in an area full of
large mock-Gothic and mock-Tudor picturesque residences for stock-
brokers and country gentlemen, Fry's house was regarded by his neigh-
bours as an eyesore that glittered with too much glass and looked
suspiciously foreign.

37 Durbins. The
south façade.
Photograph

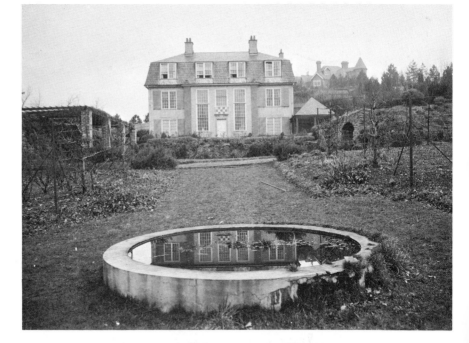

Inside the house was marked by an austerity in strange contrast to the
gay colours that later danced their way over Omega products. On top
of bare polished wood floors lay a few rugs; the pale greys and discreet
greens of the walls contrasted with the dark browns of the creosoted
doors and woodwork; the fireplaces, without ornament of any kind were
made out of bare exposed firebrick; and the nature of the materials used
was nowhere disguised. Most visitors, while admiring the generous
proportions of the main hall, found it bare, austere and uncomfortable;
ice-cold in winter and sun-baked in summer. For the sake of convenience
as well as comfort, meals were often eaten in the small breakfast room

38 Durbins. Roger
Fry's study.
Photograph

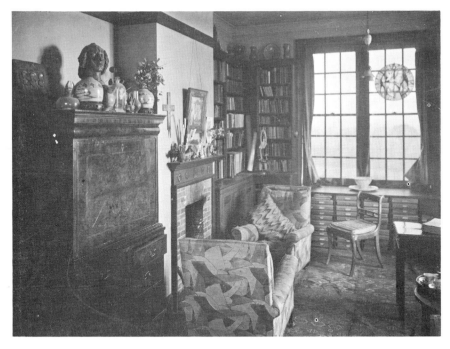

and not at the long table in the main hall. Comfort and warmth only existed in Fry's studio-study where easy chairs, a peat fire and central heating pandered to the lower instincts. This room ran the whole width of the house and had windows facing north and south. Around the side of two walls ran specially designed drawers filled with his collection of

39 Durbins. The
main hall.
Photograph

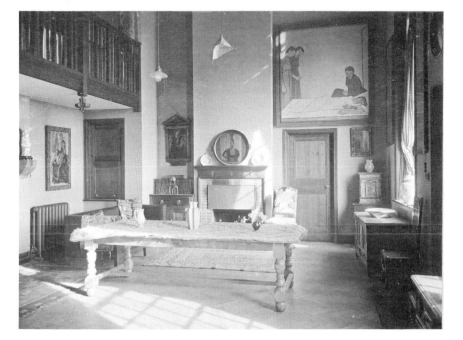

photographs of Old Masters. In one corner stood an easel with a painting ready for work. Papers lay strewn around the room, shelves bulged with books, interspersed with pottery, carvings and other ornaments selected for their visual interest. Cluttered, but creative, it expressed a life-style that sprang directly from his interests and not one imposed by any conscious, theoretical attitude to interior design.

The house looks out over the River Wey to Sandhills and St Catherine's Mount and the garden slopes down to the road in between. Fry took as much care over the design of the garden as he spent on the south façade. Miss Gertrude Jekyll, the well-known landscape gardener, was invited to draw up plans and advise on the planting and she paid several visits to the house. A short, severe, elderly lady, looking not a little like Queen Victoria, she peered kindly over her spectacles at Fry's children and in her usual fashion inspired both awe and affection. She drew up an elaborate plan dividing the garden into six different levels: a terrace, an area of flower beds, a lawn with a lily pond in its centre, espaliered fruit trees surrounding a round pond, a tennis lawn, and finally, lowest of all, a vegetable garden. In keeping with Fry's request the design was kept simple: a solid, continuous bed of lavender interspersed with small pink Chinese roses surrounded the terrace; aubrietia was encouraged to flower on the dry-stone walls of the buttresses that flanked the central area. The only mistake, for which Fry took full responsibility, was the planting of two cypresses, one either side of the garden door. With time, these grew so tall they prevented full appreciation of Fry's carefully designed south façade.

One of the main watersheds in this period of transition was Fry's gradual awakening to the art of Cézanne. A Cézanne had first been exhibited in London in the International Society Exhibition of 1898 but as a single item it did not attract much attention. Then in 1905 Durand-Ruel included ten of his paintings in his London exhibition of French art, but as all the paintings chosen came from the 1873–7 period, they did not stand out dramatically from the rest of the Impressionist pictures. Not until 1906 when, faced with two Cézannes at the International Society Exhibition, did Fry suddenly realise that here was a contemporary artist whose work fully satisfied his demand for an architectonic sense of underlying design: here at last was the solution to the problem that had obsessed him for almost a decade – 'how to use the modern vision with the constructive design of the older masters'.[16] The two Cézannes have never been authoritatively identified, but one can be reasonably sure, as Alan Bowness was the first to point out in a lecture at the Courtauld Institute, that one was *Still-Life* (Venturi No. 70) and the other, *Winter Landscape*, later illustrated as Fig. 27 in Fry's book on Cézanne. Though Fry's interest in the emotional content of art caused him to modify his praise, it is worth quoting his first assessment of this artist in full:

Here indeed, certain aspects of the Impressionist School are seen as never before in London. There were, it is true, a few of M. Cézanne's works at the Durand-Ruel exhibition in the Grafton Gallery, but nothing which gave so definite an idea of his peculiar genius as the *Nature Morte* (199) and the *Paysage* (205) in this gallery. From the *Nature Morte* one gathers that Cézanne goes back to Manet, developing one side of his art to the furthest limits. Manet himself had more than a little of the primitive about him, and in his early works so far from diluting local colour by exaggerating its accidents, he tended to state it with a frankness and force that remind one of the elder Breughel. His *Tête de Femme* (188) in this gallery is an example of such a method, and Cézanne's *Nature Morte* pushes it further. The white of the napkin and the delicious grey of the pewter have as much the quality of positive and intense local colour as the vivid green of the earthenware; and the whole is treated with insistence on the decorative value of these oppositions. Light and shade are subordinated entirely to this aim. Where the pattern requires it, the shadows of white are painted black, with total indifference to those laws of appearance which the scientific theory of the Impressionistic School has pronounced to be essential. In the *Paysage* we find the same decorative intention; but with this goes a quite extraordinary feeling for light. The sky and the reflections in the pool are rendered as never before in landscape art, with an absolute illusion of the planes of illumination. The sky recedes miraculously behind the hill-side, answered by the inverted concavity of lighted air in the pool. And this is effected without any chiaroscuro – merely by a perfect instinct for the expressive quality of tone values. We confess to having been hitherto sceptical about Cézanne's genius but these two pieces reveal a power which is entirely distinct and personal, and though the artist's appeal is limited, and touches none of the finer issues of the imaginative life, it is none the less complete.[17]

Fry, the first in England to publish such a lengthy appraisal of this artist's work, was by comparison with his colleagues in Florence – the scholars and connoisseurs – slow to develop an appreciation of Cézanne's art. Though he makes no mention of having seen any Cézannes prior to the 1905 exhibition, it is unlikely that he did not know of those in private collections in Florence. Even Berenson, who never bought a Cézanne because he felt his art did not harmonise with Italian villas, had sent Leo Stein to Vollard to see his Cézannes in 1903. The two main Florentine collectors of this artist were Signor Egisto Fabbri, who owned sixteen Cézannes by 1899, and Charles Loeser, the heir of a Brooklyn department store, who bought his paintings from Vollard and had by around 1907 several small examples of Cézanne's landscapes. Though Loeser at first kept these paintings hidden away in his bedroom and other private rooms upstairs where they would be out of sight of his more conservative visitors, by the turn of the century the Florentine cognoscenti had fully accepted Cézanne. Fry had first met Loeser at La Roche Guyon in 1894 and with Helen he visited him in Florence in 1897 in order to see his collection; another visit was made in November 1908. Between these two recorded visits, others could easily have been made and friendship with Loeser makes it unlikely that Fry had not

seen a Cézanne before 1905. It is just possible that he saw an example of Cézanne's art in Paris in 1892, for though Cézanne was largely unheard of even in Paris until Vollard gave him his first one-man show in 1895, Rothenstein recalled that through his friendship with Anquetin he had first seen Cézannes during the early 1890's at Vollard's and one or two other dealers. But as Rothenstein, himself, admitted: 'It never occurred to me, nor to anyone else at the time, that Cézanne would become an idol to be worshipped.'[18]

By 1908 Fry wrote confidently, in a letter to the *Burlington Magazine*, that Cézanne's 'position is already assured';[19] but his appreciation of this artist did not fully develop until 1910 when the large number of Cézannes included in the first Post-Impressionist Exhibition gave him the opportunity to familiarise himself in depth with his art. Then he wrote: 'I always admired Cézanne, but since I have had the opportunity to examine his pictures here at leisure, I feel that he is incomparably greater than I had supposed.'[20] However, by 1908 he had recognised that the art of Cézanne, Gauguin, Denis and Signac offered an expressive alternative to the Impressionists' passive acceptance of surface appearances which, in its desire to render the flux of appearances, tended to blur outline and form and deny personal expression. In reaction to this, Fry argued, 'the first thing the neo-Impressionist must do is to recover the long obliterated contour and to fill it with simple undifferentiated masses.'[21]

The theory preceded the practice: when in April 1909 Fry had a one-man show at the Carfax Gallery, instead of dazzling his audience with clearly defined contours and undifferentiated masses of brilliant colour, soft greys, browns and blues predominated and the general effect was impalpable and dreamlike. Even a highly idealised watercolour of a New York skyscraper could not jar the mood of otherworldliness. The critics were charmed but wary. 'A land of everlasting twilight would be a dreary place' sighed *The Times*.[22] Instead of advancing into the ranks of the avant-garde, Fry seemed to have sunk back on a bed of nostalgia, piping a melancholy antique tune. 'His inspiration,' the *Morning Post* ruminated from a distance of six or seven hundred years, 'filtered through these long centuries, has become so refined that many people will have to be under its influence for a time to appreciate its beauty. His pictures suggest the work of an old-world dreamer who has wandered in haunted places.'[23]

Nor was this exhibition a mere hiccup in Fry's progressive understanding of the new movement, as he failed dismally to understand Matisse's art on a visit to his studio in 1909. Alfred Barr has stated that Fry first met Matisse at the Steins' in 1908, but there is no evidence to prove this statement which seems unlikely given Fry's confused response in 1909.[24] Writing to his wife after the visit to the studio, Fry compared the artist's work to the products of his seven-year-old daughter. 'Then we went to Matisse's studio. He's one of the neo, neo Impressionists, quite interesting and lots of talent but very queer. He does things very

much like Pamela's . . .'[25] This same year Fry enjoyed his first and last visit to Degas' studio, an artist he never accorded full recognition, partly because he felt uneasy about Degas' ambiguous relationship to his subject matter.

The most difficult aspect of Post-Impressionism for Fry was its use of strident colour, naturally antipathetic to his taste for subtle greys. In his 'An Essay in Aesthetics' he underplays the importance of colour, arguing that 'its emotional effect is neither so deep nor so clearly determined' as the other so-called 'emotional elements of design'.[26] When in 1909 he visited the 'Exhibition of Fair Women' at Agnew's, a brightly coloured portrait by Simon Bussy (who had trained with Matisse under Gustave Moreau) drew from Fry the most querulous review he ever wrote, and which must have puzzled several readers of the *Burlington Magazine*.

> Take the colour alone: the man who can co-ordinate perfectly in a single scheme such strange and unexpected notes of colour, magenta and emerald green, fierce orange-scarlet, citron-yellow and apple-green, without for a moment breaking the decorative harmony or the complete suggestion of a very subtle atmospheric effect of twilight – the man who can do this . . . must be possessed of a quite astonishing artistic intelligence. . . . And yet for the present, I do not quite see it. I can suppose myself capable of seeing it; I can argue that I ought to; but I still fail.[27]

The same remarkable honesty and hesitating frame of mind can be discovered in a large oil painting entitled *St George and the Dragon* (Plate 40) in which in the far distance Fry made use of precisely those

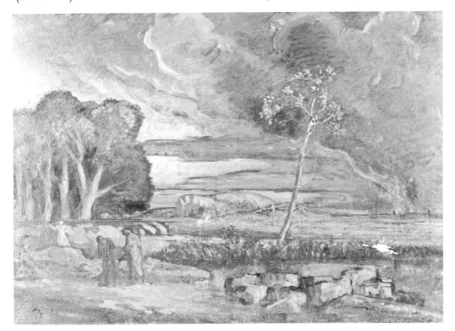

40 Roger Fry: *St George and the Dragon*, Exh. 1910. Oil on canvas, 79 × 112 cm. Birmingham, University House

colours he had noted in the Bussy portrait. This cumbersome classical landscape marks Fry's first attempt at something bolder and less tasteful than his accustomed style. The brusque, almost careless treatment matches the brash choice of colours in the far distance: the sky is tinged with chrome yellow and orange and immediately below, on an emerald green sward, a minute St George valiantly tilts his lance at a brilliant blue dragon. The rest of the composition is, however, dark and glowering, the dusky colours approaching to black. On the right smoke rises from a distant burning city and on the left the princess runs towards the safety of the wood, followed by two mysterious shrouded figures. The whole is replete with an unexplained psychological drama, and though the design is weak and the fitful use of brilliant colour unconvincing, this Janus-like work marks the moment when Fry finally rejected the technical elegance of his earlier work in favour of something more personal and expressive. He regarded it as sufficiently important to send to the large Japan-British exhibition held at Shepherd's Bush in 1910.

If in his painting he had failed as yet to discover a convincing new style, he had at last arrived at a coherently argued theoretical standpoint. His 'An Essay in Aesthetics', first published in the New Quarterly in April 1909, did not make any radical new contribution to the history of the subject, but it clarified and popularised an attitude that had been maintained by the aesthetes of the late nineteenth century. By 1909 the ideas Whistler had first expressed in his Ten O'Clock Lecture were fairly widely held in artistic circles; but what had been a precious sensibility confined to the few was to become, under the influence of Fry's teaching, the robust demand of the many. This wider audience, to which the essay is addressed, still believed that the success of a painting is directly related to its truth to natural appearances. But if art is mere imitation, Fry argues, it would no more engage our attention than an ingenious toy, nor would it arouse such complex feelings. Fry proceeds to argue that our experience of art differs from our experience of life because the former acts on man's imaginative (as opposed to his actual) life, and his experience of it is therefore freed of practical and moral responsibilities. 'Morality, then appreciates emotion by the standard of resultant action. Art appreciates emotion in and for itself.'[28]

Having freed his readers from the confusion of ethics and aesthetics brought about by Ruskin, Fry then lists the qualities art must have in order to be effective: it must be adapted to contemplation; it must exhibit both variety and order in order to stimulate and satisfy the mind; and finally, it must awaken in the spectator a consciousness of the artist's purpose. His aesthetic does not at this stage arise purely from consideration of formal means, because central to the aesthetic experience is this recognition of the emotive content put into the work by the artist. And it is this recognition of purpose or appropriateness that according to Fry separates our experience of beauty in art from our experience of beauty in nature.

Fry then analyses the artist's formal means and argues that the

spectator is affected by the manipulation of 'the emotional elements of design'.[29] These are line, mass, space, light and shade, colour and the inclination of plane. The list is not exhaustive and it is unlikely that Fry intended to do more than direct the reader's attention to the kind of formal elements at work in a painting. Indebted to Berenson's concept of 'ideated sensations', Fry argues that these 'emotional elements of design' are related to our physical experience of life: rhythm relates to muscular activity, mass to our experience of gravity, and so on. Having outlined these formal elements and their effects, Fry admits that their effect on the spectator's mind is greatly enhanced if they are combined with some representational content, in particular, with that of the appearance of the human figure. He then brings the essay to a note of confident conclusion: 'We may, then, dispense once and for all with the idea of likeness to Nature, of correctness or incorrectness as a test, and consider only whether the emotional elements inherent in natural form are adequately discovered, unless, indeed, the emotional idea depends at any point upon likeness or completeness of representation.'[30]

The brilliance and speed of Fry's argument does not disguise the fact that he leaves the reader with one essential dilemma, which Berel Lang has succinctly posited as 'Significance or Form?'.[31] Though he admits that formal elements have an augmented effect if combined with representational content, he nowhere analyses the nature of the relationship between the two. While stressing that one should appreciate a work first for its formal qualities, he as yet refuses to adopt a purely formalist approach: he cannot deny either the need to be aware of the artist's purpose, nor the psychological appeal of subject matter.

The second main weakness in his argument is his failure to discuss the complex issues raised by the notion of 'emotional elements of design'. Fry's attempt to link design elements with their emotional effect needs further explanation, as it is precisely his refusal to regard form as autotelic that prevents him from being a strict formalist. The term 'emotional elements of design' suggests that there are also 'non-emotional' design units, but Fry does not pursue this implied comparison and problematic areas like this leave the reader with a fundamental lack of clarity about the relation of 'form' to 'representational content'.

'An Essay in Aesthetics' is a rough diamond in the history of this philosophical discipline. It touches upon a number of problems peculiar to the subject, such as the relation of art to morality and the nature of aesthetic emotion, without pursuing any of these questions in depth. It therefore raises a multitude of hares and leaves the philosopher with the continual need to ask the author to define his terms. But had Fry, like G. E. Moore, felt the need to qualify and analyse every statement made, the essay might never have been written. His concern was not to make a carefully-reasoned attack on certain key issues in aesthetics, but rather to popularise a new attitude towards art. As such, the essay must be appreciated for the verve of its argument rather than for the originality of its ideas. Highly compelling in the simplicity of its prose style, it had

wide-reaching influence when republished in *Vision and Design* in 1920, redirecting the public's attitude towards art. Its achievement was to open people's minds and make them look at what *is* there in a painting, rather than at what they knew, thought or imagined was there.

Fry's life during these years had been persistently overshadowed by the horrible feeling of hopelessness and impotence in the face of Helen's suffering. 'I have sometimes thought', he wrote to J. G. Johnson, '... that death would be less terrible than the life to which she seems condemned.'[32] Inevitably a certain desperation entered his life, replacing caution with daring energy. Virginia Woolf wrote of this period: 'He laid himself open to all experience with a certain recklessness, because so many of the things that men care for, as he said later, were now meaningless. The centre which would have given them meaning was gone. From this experience sprang both his profound tolerance and also his intolerance – his instant response to whatever he found genuine, his resentment of what seemed to him false.'[33] As his wife's illness hovered on the brink of permanent insanity, the need to reconcile the beauty with the horror of life grew more intense. 'I do believe almost mystically in *tout comprendre c'est tout pardonner*', he told Dickinson, but generally he found the understanding of this 'too impossibly difficult'.[34] An underlying theme in his career is the search for an enduring reality, to be found chiefly in art. 'Art is the only method in which partial solutions of life's inevitable contradictions are attained', he had declared in his introduction to the lectures on Dramatic, Lyric, Epic and Comedic art. His turning to Post-Impressionism was one more instance of this search, this belief that under certain conditions chaos would resolve into order, the moment could be 'struck into stability',[35] could be made complete.

7 Love and Colour

The year 1910 began as one of utter disaster for Roger Fry: his prestigious position at the Metropolitan Museum was abruptly terminated; his application for the Slade Professorship at Oxford was rejected in favour of the artist-writer Selwyn Image; and the need to certify his wife and have her permanently committed to an asylum became a brutal reality. The suffering caused by Helen's illness had hardened him, as he admitted to Goldsworthy Lowes Dickinson: 'I've given up even regretting the callus that had to form to let me go through with things. Now and again it gives and I could cry for the utter pity and wastefulness of things, but life is too urgent.'[1] Grief and despair gave birth to fresh energy which became allied with a new commitment to the present. 'I feel a new hope altogether about art', he announced to Will Rothenstein in January 1910, 'and all those who care and who are not fossilised must get together and produce something.'[2] Yet the chances of Fry being able to bring about such a renewal were extremely slight: he had resigned from the New English Art Club in 1908 and had no influence with any official body of artists; he had no part in the Fitzroy Group that met at Sickert's studio, 19 Fitzroy Street, then the most avant-garde centre of art in England; still more important, he was out of touch with the young generation of artists emerging from the Slade School of Art. But early one Monday morning in January 1910, while waiting on Cambridge station for the arrival of the London train, a chance meeting brought to an end his relative isolation.

For one instant the direction of future events hung on a knife-edge balance. It was Vanessa Bell (formerly Vanessa Stephen) who spotted Fry on the station that morning and at first hesitated to approach, feeling it unlikely that he would remember her. Quenching her timidity, she went forward and introduced her husband Clive and when the train arrived all three travellers entered the same compartment. Fry had with him the materials with which to write an article, but he was diverted from his task by the conversation that developed, chiefly with the heavy-jowled, amiable Clive.

Clive Bell came from a well-to-do family whose fortune derived from coal. His hunting and shooting background had been modified by a Cambridge education and a personal interest in art. At Cambridge (where he met Vanessa's brother, Thoby) he surprised his friends by hanging a reproduction of a Degas in his room. After completing his tripos, a hunting expedition in British Columbia had been followed by

41 Roger Fry:
Vanessa Bell, c.1916.
Oil on canvas,
46 × 53.5 cm.
Professor Philip Rieff

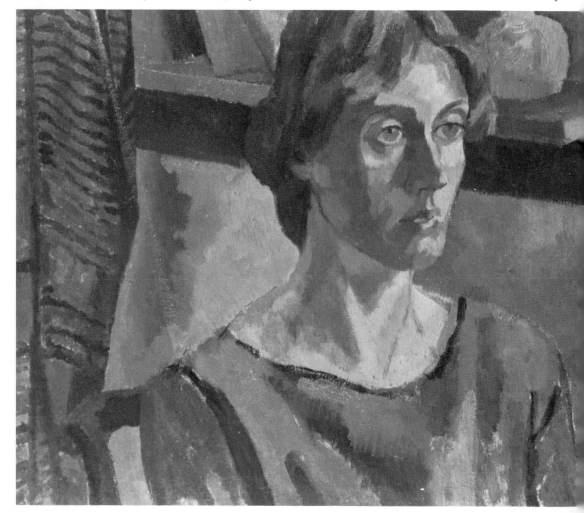

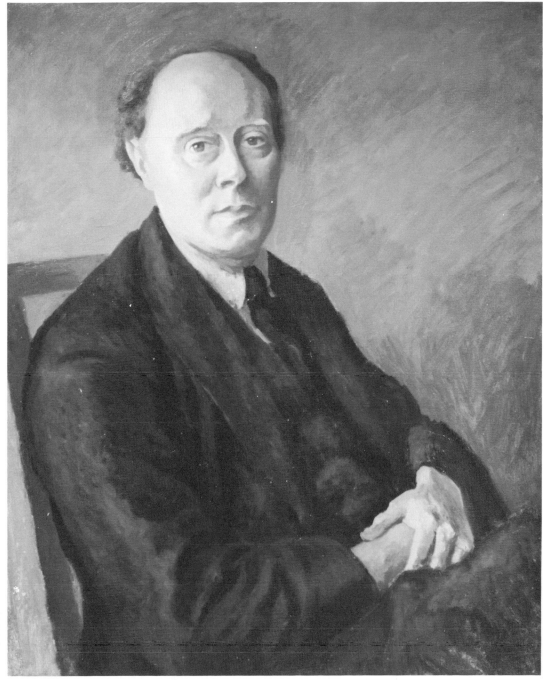

42 Roger Fry: *Clive Bell*, c.1925. Oil on canvas, 73.5 × 59.5 cm. *London, National Portrait Gallery*

a period in Paris where he endeavoured to pursue historical research in the Archives Nationales. More time, however, had been spent in cafés, in the company of artists. Among his particular friends were the painters Gerald Kelly, who described to him the various techniques of oil-

125

painting, J. W. Morrice, the Canadian who introduced him to the art of Matisse, and Roderick O'Conor, who extended Bell's knowledge through his talk of Gauguin and Pont-Aven. Inevitably, therefore, the conversation between Fry and Bell in the train that cold January morning turned on modern French painting. According to Clive, Fry already had the idea for a Post-Impressionist exhibition in mind. 'When Roger Fry told me that morning', he later recalled, 'that he proposed to show the British public the work of the newest French painters, I told him that I would be proud to help in any way I could but that his scheme was fantastic.'[3]

While the idea took shape in the minds of the two men and the conversation bandied back and forth, Vanessa sat silent, closely observing her renewed acquaintance. 'As he sat opposite me in the corner I looked at his face bent a little down towards his MS but not reading, considering, listening, waiting to reply, intensely alive but quiet. "What astonishing beauty" I thought looking at the austere modelling in the flat bright side lights from the train window. I do not think I talked much but he was becoming a real person to me, and it was suggested that we should go and see him at Guildford.'[4]

This auspicious start to their friendship was then almost wiped out by the mismanagement of their visit. The Bells emerged from Guildford Station to find no-one to meet them and the town immersed in Sunday gloom. None of the passers-by they approached had heard of the recently built Durbins, but eventually a cab-man gave them vague directions and they set off to find it on foot. Everything conspired against them: the directions were wrong; Vanessa, some months pregnant, was quickly tired; and irritation turned to misery when it began to rain. Cross and weary, they retired to a local inn for lunch and there Vanessa penned a letter to Fry explaining their non-arrival. She was in no mood to disguise her annoyance at their wasted journey, but some instinct softened her anger and a sentence was added stating that her complaints were not to be taken too seriously.

Fry apologised effusively and a second visit to Guildford was arranged a week or two later which coincided with an attempt to reintegrate Helen into home life. The Fry children had been sent to Failand with their Aunt Joan who did much to restore their confidence in grown-ups by allowing them controlled freedom. Their absence only underlined for Vanessa the tragedy of Fry's personal life. At lunch Vanessa and Helen sat either side of Fry, Helen miserable and silent, taking no part in the conversation and at times murmuring vaguely to herself. In the afternoon, Fry suggested a walk (which filled Vanessa with silent dismay). On their return, as they reached the bottom of the narrow drive leading up to the house, Helen, murmuring the names of her children, moved off in a different direction to the rest. Fry made no attempt to follow her and explained that though the children had been sent away, Helen frequently thought she heard them calling. When Helen eventually returned to the house, she took Vanessa upstairs to rest, having noticed

that she was with child, and Vanessa then glimpsed the well of unhappiness in which Helen lived: 'She looked so utterly miserable standing there that I nearly put my arms round her and asked if I couldn't help, but I was too shy, the moment went and we came down.'[5]

This new friendship between Fry and the Bells benefited both parties. Fry opened up for Clive and Vanessa the Bond Street art world, taking them to see rare primitives and Old Masters hidden away in dealers' stores. They, in turn, put Fry in touch with the young artists attached to Vanessa Bell's Friday Club which put on exhibitions and met to hear papers read. When it was founded in 1905, Vanessa's sister Virginia noted that 'one half of the committee shriek Whistler and the French Impressionists, and the other are stalwart British',[6] but in spite of its divided loyalties the Club flourished and by 1910 included in its ranks a strong contingent of young, Slade-trained painters. Vanessa, herself, had been painting for almost ten years, having trained first under Sir Arthur Cope and then at the Royal Academy Schools. The year previously a picture she had exhibited at the New English Art Club had been praised by Sickert. Fry, attracted no doubt by her commitment to art as well as by her Grecian beauty, willingly agreed to address the Friday Club, which he did on 21 February 1910. Unfortunately no record of his paper remains.

Still more important, friendship with the Bells drew Fry into the very heart of the Bloomsbury Group, that intimate circle, with whose humour, intellect and philosophy he felt immediate accord. His first appearance in the Group's ambience remained vividly impressed in Virginia Woolf's memory:

> It must have been in 1910 I suppose that Clive one evening rushed upstairs in a state of the highest excitement. He had just had one of the most interesting conversations of his life. It was with Roger Fry. They had been discussing the theory of art for hours. He thought Roger Fry the most interesting person he had met since Cambridge days. So Roger appeared. He appeared, I seem to think, in a large ulster coat, every pocket of which was stuffed with a book, a paint box or something intriguing; special tips which he had bought from a little man in the back street; he had canvases under his arms; his hair flew; his eyes glowed. He had more knowledge and experience than the rest of us put together.[7]

Moreover, as Virginia Woolf goes on to describe, this man some years their senior began to discuss *Marie-Claire*, a recently-published autobiographical novel by a seamstress, Marguerite Audoux, and before long the entire company was involved in a complex literary argument.

When Fry entered Bloomsbury the group had already formed a closed corporation, held together, not by a set of rules or a mutually-shared doctrine, but by a less easily defined, subtle chemistry. Certain habits of thought and feeling (largely influenced by the philosophy of G. E. Moore) knit together this group of disparate individuals and separated them off from the outside world. The tenor of their lengthy discussions

127

was partly determined by their upper-middle class, intellectual and monied backgrounds, which gave them the confidence to indulge in liberal thought, and their chief weapon of attack on the moral legacy of the previous age was conversation, which they developed to a fine and devastating art. The writer Gerald Brenan has compared Bloomsbury in full flight to an orchestra, performing a familiar score:

> The solo instruments ... were Virginia Woolf and Duncan Grant; they could be relied upon to produce at the appropriate moment some piece of elaborate fantasy, contradicting the serious and persistent assertions of the other instruments. Roger Fry would drive forward on one of his provocative lines; Vanessa Bell, the most silent of the company, would drop one of her 'mots', while Clive Bell, fulfilling the role of bassoon, would keep up a general roar of animation. His special function in the performance was to egg on and provoke Virginia to one of her famous sallies.[8]

Fry shared Bloomsbury's primary belief – that civilisation, in order to develop, must depend on intellectual honesty; likewise, he shared their distrust of society, with its love of display, fame, power and easy success, and he confirmed their contempt for Philistinism, vulgarity and over-emphasis. Over the years that followed, he helped develop Bloomsbury's love of French life, art and food, emphasising a life-style based on intellectual values and one comparatively free from cant. (He introduced into their circle *Boeuf en Daube* which he himself was very good at making, and the dish later ensured the success of Mrs Ramsay's dinner party in *To the Lighthouse*.) But the main difference between these new friends and those with whom he had grown to middle life, was that they were more ribald, gayer and more pleasure-loving. If, like his Cambridge friends, they too had a penchant for abstract speculation, it was punctuated with wit, artistic feeling and bawdy-jokes. From now on the ethos of Bloomsbury formed the background to his life, and in their conversations, in their agreement and conflicts, Fry contributed to and was sustained by an undercurrent of sensibility and intelligence that was to create, as Stephen Spender has written, 'the most constructive and creative influence on English taste between the two wars'.[9]

After the early morning discussion in the Cambridge to London train, Fry formed a committee to carry out his exhibition proposal, but once formed it did nothing and the idea remained in limbo for the next six months. It was perhaps a little premature; during this intervening period – apparently confused and directionless – he was steadily sifting through various ideas on art and gradually strengthening his understanding of modern developments.

One important realisation came to him while reviewing Helen Tongue's *Bushman Drawings* for the *Burlington Magazine*. Looking at her illustrations, Fry noted that the bushmen in southern Africa had pro-

duced drawing with a sharpness of perception that could not in any way be described as primitive. The Bushman's organisation of a battle scene followed not the artist's mental image of what the battle ought to look like, but his understanding of it according to the emotional response which it aroused in him. The combatants are represented in every conceivable pose, flying about in all directions, kneeling, crouching, or in direct confrontation with the enemy, with the result that it is as if the battle was seen from above. These drawings provided Fry with vivid proof that in art actual appearance could be sacrificed to lucidity of statement, logical reality to expressive effect.

Like others at this time, Fry was becoming increasingly interested in non-European art. He, himself, helped widen artistic appreciation by writing a two-part review of the Mohammedan exhibition held in Munich in May 1910, which, like Matisse, he made a special visit to see. This *Burlington Magazine* review again valued expressive force over mimetic exactitude: 'The smallest piece of pattern-making shows a tense vitality even in its most purely geometrical manifestations, and the figure is used with a new dramatic expressiveness unhindered by the artist's ignorance of actual form.' The Bobrinsky horse from the Hermitage, for example, is praised for its 'large co-ordination of parts, a rhythmic feeling for contour and the sequence of planes'.[10] Nowadays critics readily appreciate the formal significance in art from cultures different to their own, but in 1910 the legacy of the Greco-Roman tradition was still dominant enough to blind Fry's contemporaries to the value of non-European art. Thus in May of that year we find Professor Tonks, drawing master at the Slade, writing to the critic Robert Ross, 'I say, don't you think Fry might find something more interesting to write about than Bushmen, Bushmen!!'.[11]

That same month Fry was given the opportunity to put into practice his new understanding of expressive design when Sir Andrew Noble commissioned from him a ceiling decoration for his house at Cairndow in Scotland. Fry visited the austere, baronial house, Ardkinglas, and consulted with its owner over a suitable subject, but on his return to London he informed Sir Andrew that his initial ideas had changed and the decoration would now represent Apollo driving his chariot across the sky. He rented a barn outside Guildford to house the enormous canvas and work proceeded throughout July and August. As it approached completion, Fry had severe doubts about its success. Nevertheless it was exhibited in November at the New English Art Club where the astonished look of the two horses quite matched the surprise on the faces of the visitors. By November Fry's name had become associated with Post-Impressionism, yet here was a classical subject (admittedly an uncertain Apollo in an unconvincing chariot) treated with solemn literalness. The result was an odd mixture of Puvis de Chavannes (whose work had been featured at a Friday Club exhibition earlier this year), the Bobrinsky horse and Ferdinand Hodler. But the subject itself has considerable precedent in art and Fry may have had

in mind Delacroix's Galerie d'Apollon ceiling in the Louvre. D. S. MacColl, on seeing Fry's painting, was reminded of Guido Reni's *Aurora* ceiling in the Casa Rospigliosi in Rome. Fry hurriedly refuted any influence of Reni in a letter to MacColl, but, unable to disguise his embarrassment, added that the 'work had been commissioned and designed more than a year before I began to paint it, and obviously I couldn't in fairness change the whole thing to something quite other than I had contracted to do'.[12] This was untrue, but it may well have seemed like a year to Fry between the start and finish of the painting for during these summer months his view of art changed rapidly. Sir Andrew, having unfortunately given Fry this commission at a transitional period, was disappointed with the end product, but it was placed in its intended position, where, in excellent condition, it still hangs today.

One event that probably unsettled Fry's confidence in the stylised classicism of the Apollo ceiling, was the exhibition 'Modern French Artists' organised at Brighton in June 1910 by Robert Dell. Here Fry was again exposed to the work of Derain, Signac, Gauguin, Cézanne and Matisse, though the two paintings by the latter artist were hung too high for critical examination. But the potential impact of these revolutionary pictures had been muffled by the large quantities of Impressionist and academic work included. The two artists best represented were the conventional Louis Legrand and the sober Alphonse Legros. This event, however, undoubtedly encouraged Fry to revive his idea of a show devoted purely to the Post-Impressionists.

Throughout this period of uncertainty, Fry had an anchor in his house at Guildford. The joint editorship of the *Burlington Magazine* and a lecturing commitment at the Slade kept him in London two or three days of the week, but the rest of his time was spent at Durbins, where his sister Joan acted as housekeeper and took charge of his two children. She was aided by two servants, Nellie Boxall and Lottie Hope who remained in Fry's employment until 1916 when they went to work for Virginia and Leonard Woolf. There was also 'Tweenie', the maid-of-all-work, Madeleine Savary, the Swiss governess, and a full-time gardener who also looked after the boiler. With this staff, Fry was able to entertain and he frequently received visitors. One of those who arrived that summer was Ida Widdrington (now Mrs Cresswell) with her young son. The Fry children immediately noted that this lady with her hearty upper-crust manner differed from most of their visitors. Middle-age had done nothing to diminish her forthright approach and after Joan Fry finished reading to the children, Ida declared that she read just like a board-school child. It may have been a reaction to Ida's sudden reappearance (but more likely his awareness of growing industrial unrest) that led Fry for the first and last time this summer to become actively involved in politics during the 1910 election. He spoke on the Liberal platform at Guildford but, for his efforts, saw in a Tory majority of four thousand. Sometime during this summer Fry painted *The Wey at Guildford* (Plate 43) in which the massive clouds that push their way

43 Roger Fry: *The Wey at Guildford,* 1910. Oil on canvas, 46 × 76 cm. *Private Collection*

across the sky have been simplified into rough-hewn blocks. This abbreviated method of depiction jars with the more naturalistic treatment of the landscape and it was not until the following year that Fry was able to apply rhythmic simplification of form to the entire picture.

In October, with very little warning or preparation, the idea that had first been mooted in January was snatched out of limbo and put into effect. Early one morning Fry woke Desmond MacCarthy, who was suffering from a cold, with a bottle of champagne to start them on their journey to Paris, where they were to meet up with Clive Bell. Their aim was to approach all the main dealers and private collectors in the hope of gathering together the best available modern French art. It had been arranged that the show would be held at the Grafton Galleries, Dover Street, then owned by the Yorkshire Penny Bank. To the bankers Fry declared that the venture would be a certain financial success; to MacCarthy, the exhibition secretary, he admitted that the venture was doomed to failure and urged him to keep the expenses down. Until he reached Paris, however, Fry had little idea what the exhibition would include: he was seeing many of the pictures for the first time. 'In Paris we spent day after day looking at the pictures', MacCarthy recalled, 'and nearly all those which Roger preferred were at our disposal. I remember his raptures. He would sit in front of them with his hands on his knees groaning repeatedly "Wonderful, wonderful".'[13] Once their work in Paris had been completed, Fry and MacCarthy went on a short

131

bicycling tour of the provinces before MacCarthy departed alone for Holland and Munich where he selected the remaining pictures, including a number of Van Goghs from the artist's sister-in-law Mme Gosschalk-Bonger. Until all these paintings reached London, Fry could have had no complete idea as to how dazzling these Roman candles would appear amid England's prevailing artistic gloom.

Once almost all the paintings had arrived a quick decision had to be

44 Exhibition poster for 'Manet and the Post-Impressionists'

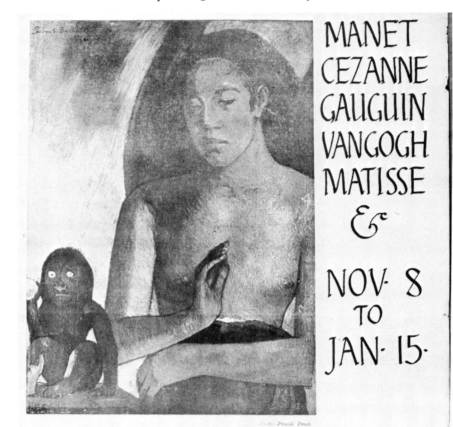

MANET
CEZANNE
GAUGUIN
VANGOGH
MATISSE
&
NOV· 8
TO
JAN· 15·

GRAFTON·GALLERY
MANET AND THE
POST-IMPRESSIONISTS

made as to the title of the exhibition. Fry initially favoured the term 'expressionists', because expressive design seemed the quality most evident in the paintings selected. But a young journalist with whom he was discussing the problem disliked the title and all others that Fry proposed. Losing his patience, Fry flung out, 'Oh, let's just call them Post-Impressionists; at any rate, they came after the Impressionists'.[14] The label stuck; the exhibition was entitled 'Manet and the Post-Impressionists'; and the name entered the art historian's vocabulary as vague and unsuitable as most umbrella terms.

When the press day arrived MacCarthy was so fraught with nervous anticipation he was unable to read a laudatory review in the morning newspaper of a book he had recently published. Instead he set off straight for the gallery. He worried that Fry, in his desire to group the paintings not according to artist or style but to create effective contrasts, might alter the position of a painting at the last minute, leaving the visitor to find Van Gogh's *Station Master at Arles* catalogued as a nude. As the press view preceded the official opening by two days, the newspapers were able to fan into a blaze public interest, already warm to the event, by pouring forth in print scorn, ridicule and unstinting abuse. Nothing had so disrupted the leisurely flow of the London art world since the Whistler v. Ruskin trial.

Most of the paintings that shocked and horrified the London public had been produced twenty or even thirty years ago. Indeed Manet was by then an accepted Old Master. He had been included, however, not just as a sop to the public, but because both Fry, in his 1906 review of the International Exhibition,* and Julius Meier-Graefe in his book *Modern Art* (of which an English translation had appeared in 1908) argued that Cézanne was directly descended from Manet, being the logical inheritor of Manet's use of flat oppositions of local colour. Manet apart, Cézanne, Van Gogh and Gauguin were the three stars of the show (listed in the catalogue were thirty-five Gauguin oils, twenty-two Van Goghs and twenty-one Cézannes) and among these exhibits were paintings that have since become some of the most famous and best loved works in the history of art; for example, Manet's *Un Bar aux Folies-Bergères*, Cézanne's *La Vieille au Chapelet* (Plate 47), Matisse's *Femme aux Yeux Verts* (Plate 46) and a whole range of Van Gogh's finest work culminating in his *Crows in a Wheatfield*.

But in 1910 these paintings were almost totally new to a British public and therefore looked strange and difficult. Prior to this show only three Van Gogh paintings were to be found in England and all three were in private collections, one hanging outside Fisher Unwin's flat at the Albany where it was the object of frequent derogatory comments. Admittedly Fry's selection had tended to emphasise the expressionist aspect of Post-Impressionism and among the Cézannes were three early paintings, crudely drawn and abruptly impastoed. Of the three greats, Gauguin enjoyed a moderate success, Van Gogh was simply laughed at,

*See page 117.

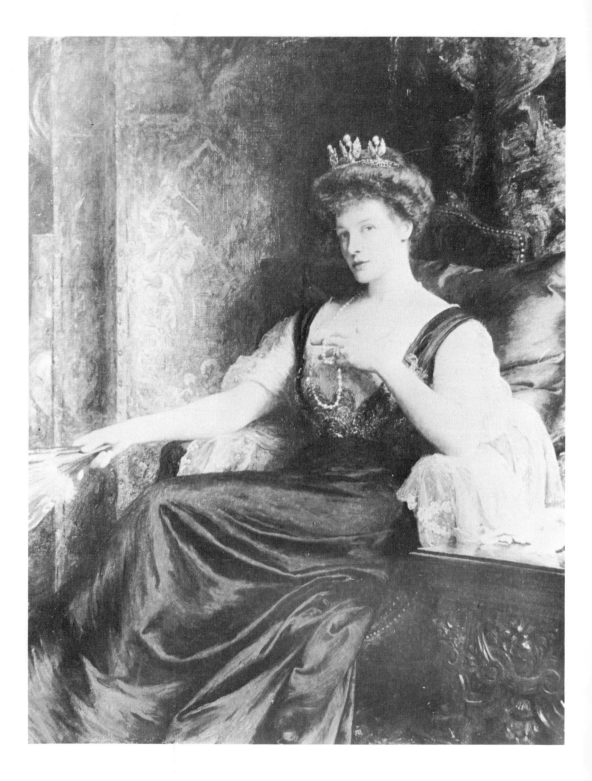

45 Sir Frank
Dicksee: *The Lady
Inverclyde*, Exh.
Royal Academy
1910. Present
whereabouts
unknown

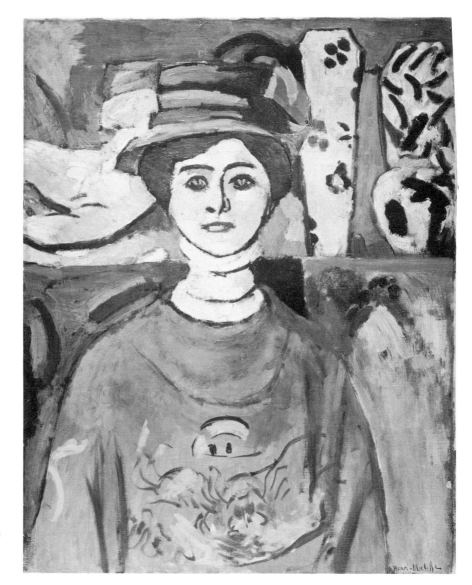

46 Henri Matisse:
*Femme aux Yeux
Verts*, 1908–9. Oil
on canvas,
66 × 50.8 cm. *San
Francisco, Museum
of Modern Art,
Harriet Lane Levy
Bequest*

and Cézanne was found impossibly difficult to understand. The large number of paintings by these three artists deflected attention from more recent developments, notably Fauvism and Cubism, and the latter movement was represented by only one work, Picasso's *Portrait of Clovis Sagot* (Kunsthalle, Hamburg). Nowadays Cézanne, Van Gogh and Gauguin are among the best known names in the history of art, yet, to the lasting discredit of British critics, in 1910 these artists were described in the press as 'bunglers' and 'lunatics'. To Ebenezer Wake Cook, writing in the *Pall Mall Gazette*, the paintings looked like 'the output of a lunatic asylum';[15] Robert Ross voiced a similar opinion in the *Morning Post*: 'The emotions of these painters (one of whom, Van Gogh, was a lunatic) are of no interest except to the student of pathology and the specialist in abnormality.' His review culminated in hysteria when, perceiving that the show had opened on the fateful November 5, he wrote that it revealed 'the existence of a widespread plot to destroy the whole fabric of European painting'.[16]

Several critics turned to the catalogue introduction for explanation. It had been written by MacCarthy from notes made by Fry and its chief argument was that the artists were attempting to capture 'the emotional significance which lies in things, and is the most important matter in art'. This vague explanation had to be applied to a variety of styles and, not surprisingly, aroused confusion. 'Where are the "emotional ideas" in these daubs?' stormed Robert Morley in a letter to the *Nation*; 'There are none, absolutely none, nothing but the base negation of all that was great in the past'.[17] *The Times* likewise criticised Fry, the 'distinguished scholar and critic', for abandoning the great artistic achievements of the past.[18] Laurence Binyon, the Keeper of Prints and Drawings at the British Museum found instead of personal expression only an 'affected naivete',[19] while others, like Ross and Wake Cook, believed the paintings to be the products of pure incompetence or insanity. Wilfred Scawen Blunt entered an opinion in his diary for 15 November 1910 that summed up the feeling of many.

> The drawing is on the level of that of an untaught child of seven or eight years old, the sense of colour that of a tea-tray painter, the method that of a schoolboy who wipes his fingers on a slate after spitting on them. ... Apart from the frames, the whole collection should not be worth £5, and then only for the pleasure of making a bonfire of them. ... These are not works of art at all, unless throwing a handful of mud against a wall may be called one. They are works of idleness and impotent stupidity, a pornographic show.[20]

The miscomprehension must partly be blamed on the insularity and provincialism of English art. The public had been blinded and its imagination dulled by an excess of detail and story-telling in paint. The persistent emphasis on representation and subject matter had deadened apprecation of form. Even in 1905 Fry had ironically remarked in his introduction to Reynolds' Thirteenth Discourse that 'the power to die

with a perfect imitation of every physiological circumstance has become the test of greatness in an actress, while the introduction of a real hansom cab, a real waterfall, or what not, is the proof of scenic completeness'.[21] By 1910 the only firm tradition still upheld by the Royal Academy was mimetic veracity, and visitors to the annual summer exhibitions had the pleasurable experience of having their values confirmed: Scottish 'burn' pictures evoked memories of Scotland; Lady Butler's battle scenes aroused patriotic sentiment; John Singer Sargent's portraits presented Edwardian society to themselves; Quiller Orchardson, Dicksee, Collier and others enjoyed the vogue for 'problem' pictures in which the onlooker could indulge in his own interpretation of the scene. All these painters depended, to various degrees, on the mimetic tradition, the *raison d'être* of which had largely been undermined by the invention of photography. Fry, who, despite his earlier interest in technique, abhorred meaningless displays of skill, described John Collier as 'outstripping the camera in his relentless exposition of the obvious and insignificant', and for him the Academy became every year 'a more and more colossal joke played with inimitable gravity on a public which is too much the creature of habit to show that it is no longer taken in'.[22]

The contrast between Dicksee's *The Lady Inverclyde* exhibited at the Academy that year and Matisse's *Femme aux Yeux Verts* at the Grafton Galleries was too great for most of the general public (Plates 45 and 46); the two paintings seemed scarcely the product of the same century, let alone the same decade. Dicksee's portrait drew upon the Edwardian love of eighteenth century elegance, a fashionable taste reflected in the steady rise in sale-room prices of eighteenth century portraits. His portrait is pure pastiche and the decorative details of the elaborate dress, tiara, fur and pearls are used to flaunt the sitter's position in society. Matisse's portrait, on the other hand, tells us little about the sitter. To the 1910 visitor it looked brash, illogical, unfinished and unreal. The composition lacks space; the objects on the shelf behind are brought into direct conjunction with the head; there is little attempt to model the face with light and shade and the features have been crudely outlined in black; the bright colour, particularly the vermilion of the sitter's robe, had been loosely handled with no attempt to conceal the brushmarks. Even Augustus John, who by this date was using bold brushwork and bright colour, thought this painting vulgar and spurious. Walter Sickert said that the Matisses at the Grafton Galleries amounted to nonsense. Fry himself still had reservations when the show opened, but after prolonged examination of the exhibits became convinced of Matisse's greatness. He wrote persuasively in praise of *Femme aux Yeux Verts*: 'Regarded as representation pure and simple the figure seems almost ridiculous, but the rhythm of the linear design seems to me entirely satisfactory; and the fact that he is not concerned with light and shade has enabled him to build up a colour harmony of quite extraordinary splendour and intensity. There is not in this picture a single brushstroke in which the colour is indeterminate, neutral or merely used as a

47 Paul Cézanne:
*La Vieille au
Chapelet*, 1895–6.
Oil on canvas,
85 × 65 cm. *London,
National Gallery*

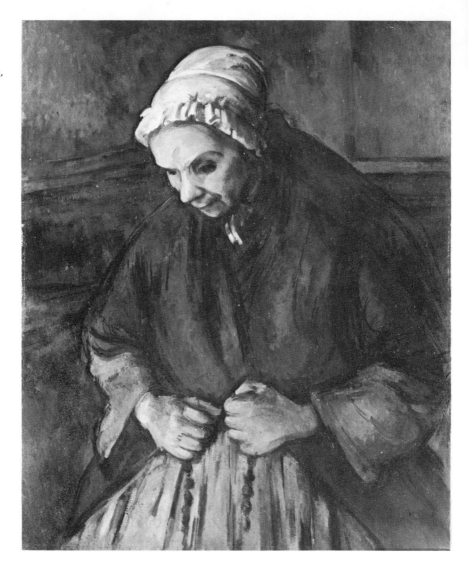

transition from one tone to another'.[23] With the Dicksee we are referred back to past traditions of portraiture and to our knowledge of the social milieu from which the sitter was drawn; but with the Matisse the means used cohere sufficiently to retain our interest; the picture speaks for itself.

In another article on the exhibition Fry admitted that the selection was open to criticism. 'One kindly critic is quite right in saying that there are too many Gauguins, and that there are Van Gogh's [sic] which it would have been most desirable to add. Then again, Matisse, owing to the absence of a well known collector, is quite inadequately repre-

sented, and Picasso should have been seen in bigger and more ambitious works.'[24] But, he argued, the main value of the event was that it offered the British public the opportunity to become familiar with a great artistic movement of which it had previously been ignorant.

The threats, the scorn, the umbrellas shaken at the paintings by an angry public, the attacks on Fry's morals and the angry abuse hurled at the exhibition secretary are not explained in terms of artistic prejudice alone: the public saw a hidden violence in these revolutionary paintings and related it to a general political unrest. The ensuing debate, which has been investigated in some detail by Ian Dunlop and William C. Wees,[25] revealed that in the minds of many Post-Impressionism was related to the demand for Home Rule in Ireland, the Welsh coal-miners' strike which in November was broken up by troops, the fear of German invasion, and the growing violence of the Suffragettes. Reports on the latter mingled with those on the Post-Impressionists as only a few days after the show had opened the Suffragettes marched on the House of Commons while Asquith spoke on the Women's Rights question, and the ensuing scuffle with the police which lasted six hours resulted in one hundred and seventeen arrests. This 'Black Friday' set off a programme of window-smashing, picture-slashing, arson and bombs as the Suffragettes came increasingly to realise that without the means to change government their only resource was violence. Vitality and absolute commitment motivated both the Suffragettes and Post-Impressionism, as the former were quick to point out. Christina Walshe, writing in the *Daily Herald*, declared: 'The Post-Impressionists are in the company of the Great Rebels of the World. In politics the only movements worth considering are Woman Suffrage and Socialism. They are both Post-Impressionist in their desire to scrap old decaying forms and find for themselves a new working ideal.'[26] The Suffragettes were attacked for being unfeminine; Post-Impressionism was seen to assault accepted standards of female beauty. J. Comyns Carr, the critic and director of the New Gallery, was one of several to detect in Post-Impressionism a note of moral indecency: 'It seems to me to indicate a wave of disease, even of absolute madness; for the whole product seems to breathe not ineptitude merely but corruption – especially marked in a sort of combined endeavour to degrade and discredit all forms of feminine beauty.'[27]

The response aroused by the exhibition confirmed Fry in his belief in the inextricable relationship between art and life. Looking back on this period, he realised that his show had not only attacked aesthetic standards, but had also subtly undermined the existing social order.

I found among the cultured who had hitherto been among my most eager listeners the most inveterate and exaggerated enemies of the new movement. The accusation of anarchism was constantly made. From an aesthetic point of view this was, of course, the exact opposite of the truth, and I was for long puzzled to find the explanation of so paradoxical an

opinion and so violent an enmity. I now see that my crime had been to strike at the vested emotional interests. These people felt instinctively that their special culture was one of their social assets. That to be able to speak glibly of Tang and Ming, of Amico di Sandro and Baldovinetti, gave them a social standing and a distinctive cachet. This showed me that we had all along been labouring under a mutual misunderstanding, i.e. that we had admired the Italian primitives for quite different reasons. It was felt that one could only appreciate Amico di Sandro and Baldovinetti when one had acquired a certain considerable mass of erudition and given a great deal of time and attention, but to admire a Matisse required only a certain sensibility. One could feel fairly sure that one's maid could not rival one in the former case, but might by a mere haphazard gift of Providence surpass one in the second. So that the accusation of revolutionary anarchism was due to a social rather than an aesthetic prejudice.[28]

By exhibiting the Post-Impressionists in London, Fry had overnight, as Quentin Bell observed, 'destroyed the whole tissue of comfortable falsehoods on which that age based its views of beauty, propriety and decorum'.[29]

On a personal level, the exhibition changed the course of Roger Fry's life. Like many good shows, it had been largely motivated by the desire to learn and while it was open Fry never lost the opportunity to discuss the paintings, to explain his own opinions and listen to those of others. But chiefly he simply looked, as Virginia Woolf described: 'And there was Roger Fry, gazing at them, plunging his eyes into them as if he were a humming-bird hawkmoth hanging over a flower, quivering yet still. And then drawing a deep breath of satisfaction, he would turn to whoever it might be, eager for sympathy.'[30] The excitement the show engendered decided him to abandon his role as connoisseur and adviser on Old Masters, and to devote himself afresh to his own painting and to modern art. He bought from the exhibition Derain's *Le Parc de Carrières, Saint-Denis* (Courtauld Institute Galleries), a modest choice partly determined by price as the building of Durbins had left him fairly short of money. However, the painting had a profound effect on his style, for the rhythmic reductionism of form found in the treatment of the foliage proved the starting point for his own form of Post-Impressionism.

Fry's eagerness to turn appreciation into practice infected both Vanessa Bell and Duncan Grant. Under Fry's influence, Grant abandoned stylish naturalism in favour of bold experimentation, floundering a little from one style to another in the attempt to discover a personal language. But the excitement expressed in Grant's sudden use of bright colour and broken brushwork was felt generally in the Bloomsbury group which now found itself at the centre of a raging artistic debate. Overnight the tasteful Edwardian world had been dispelled. Fry discovered some bold patterned cloths printed in Manchester for the African market; he bought several examples and when produced at 46 Gordon Square they made the pastel-tones of the interior decoration look instantly old-

fashioned. The vigour of Post-Impressionism crept not only on to the walls but into the lives of all those associated with it. 'Oh, how I'm damned by Roger!', wailed Virginia Stephen to her sister, 'and we in a Post-Impressionist age.'(31) Damned they all were when Fry, Vanessa and Clive Bell, Virginia and Adrian Stephen and James Strachey appeared as Gauguinesque savages at a fancy dress ball at Crosby Hall, their limbs browned and draped in little else than the Manchester African cloth.

This new spirit of excitement needed fresh stimuli to be maintained. As Fry had argued that the Post-Impressionist revolution could be compared to the advent of Byzantine art after the decline of Roman naturalism, it was suggested that a visit should be made to see some of the famous Byzantine mosaics. And in April 1911, the Bells, H. T. J. Norton and Roger Fry set out for Turkey.

This trip to Turkey was almost forestalled by a sudden romance, a storm in a tea-cup involving Roger Fry and his friend and admirer Lady Ottoline Morrell. A tall red-head, with a jutting chin, Hapsburg nose and a taste for theatrical dress, Lady Ottoline might have looked absurd if her aristocratic background had not imbued her with a sublime unselfconsciousness and the necessary panache to sustain her eccentricities. In reaction to her upper-class background, she had taken up certain artists, the bohemians Augustus John and Henry Lamb, whom she attracted initially by her striking appearance and her nasal drawl. She gave them her confidence and generous hospitality and in return enjoyed the somewhat vicarious pleasure of familiarity with the intrigues and passions of their lives. She did have an unusual capacity to make artists and writers feel that their ideas were important and for this reason they remained in her court long after they had noticed the encrustations of face powder.

The first reference to Lady Ottoline in Fry's life occurs in a letter to him from Helen written while he was in America (though an earlier introduction may well have taken place through their mutual friend Logan Pearsall Smith). The two women struck up a friendship while Fry was abroad and Helen visited Lady Ottoline immediately after the arrival of her twins in 1906, one of which died soon after birth. Then, when Helen's illness forced her to spend several months at a time at The Priory, Roehampton, Lady Ottoline wrote to Fry, 'I do indeed realise what at times agony it must mean to you, to see that wonderful and beautiful spirit wrapt in cloud'.(32)

As their friendship developed Fry discovered in Lady Ottoline both taste and an independence of mind. Nor was she uninformed about recent developments in French art: on a trip to Paris in October 1909 she had visited a Post-Impressionist exhibition with Dorelia John, accompanied Mrs Chadbourne, the wife of a Chicago lawyer, to Matisse's studio, and with her husband had called on Gertrude and Leo Stein to see their unique collection of Cézannes, Matisses and Picassos. When,

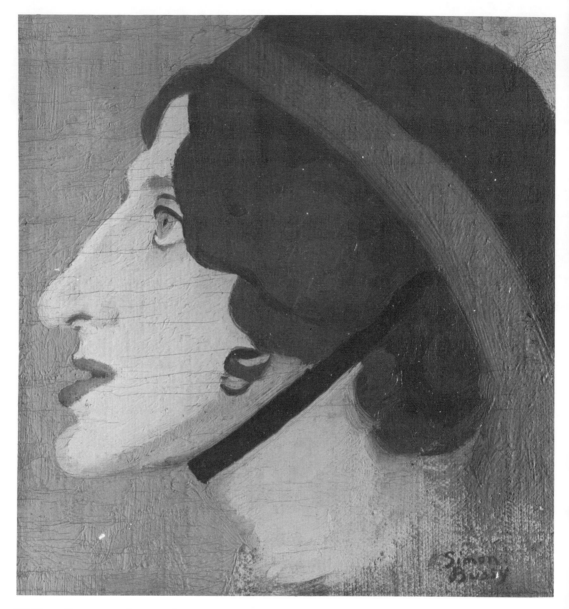

48 Simon Bussy:
*Lady Ottoline
Morrell*, c.1920. Oil
on canvas,
31 × 29 cm. *London,
Tate Gallery*

during the summer of 1910, Fry felt badly in need of advice on his Apollo ceiling, he turned to Lady Ottoline. She, moreover, allowed him to put her name down for the Post-Impressionist exhibition committee and personally wrote round enlisting support for the venture. Fry even hoped she would be present at the choosing of the pictures: 'I must have one really delightful thing this horrid year and have decided that it is to be meeting you in Paris and going to the Autumn Salon and looking at some of the Cézannes, Van Gogh's etc., which are to come to England.'(33) She took him at his word and arrived in Paris in October 1910 while Fry, Bell and MacCarthy were busy selecting pictures. Nor

142

was Fry disappointed by her appearance. She was, he told Dickinson, simply 'splendid'.

The exhibition which Fry predicted would wake up the British public 'more than anything that has happened for ages',[34] had the effect of shaking himself out of his despair. 'It is very strange that just as my inner life which was all bound up in Helen seems definitely crumbling to pieces the general life seems to have suddenly become so immensely more worthwhile', he told Ottoline, 'and in all that you know how much you have counted.'[35] Ottoline, who naturally leaned towards expressionism, had no difficulty in appreciating the Post-Impressionists. 'I ran into the Grafton Gallery on Friday', she informed Fry, 'and Van Gogh simply gripped me ... with his Vision of Soul in everything.'[36]

Such enthusiasm naturally cemented their friendship. During the winter of 1910–11, Fry accompanied Lady Ottoline and her less extravagant husband Philip to concerts, visited their house Peppard, near Henley-on-Thames, and in turn invited them to Durbins where he took the opportunity to paint her portrait in what she regarded as 'indifferent colours'.[37] Then, almost the day before Fry was due to leave for Turkey, their friendship suddenly flowered into an affair. Fry, thrown into extreme confusion, pencilled hurried notes to her full of gratitude and glowing appreciation of her person. He wondered if his ticket could be exchanged for one of a later date in order to make possible another meeting. He was quite oblivious of the fact that Lady Ottoline was currently having an affair with both the painter Henry Lamb and the philosopher Bertrand Russell, and had probably only allowed their relationship to develop in this way knowing his departure for Turkey was imminent.

The ticket was not exchanged, however, and Fry with H. T. J. Norton crossed the Channel and arrived in Ghent where they awaited the arrival of the rest of the party. The Bells had been delayed by Vanessa's fainting fits, the result of a near miscarriage, and there was some uncertainty as to whether she was fit to travel. In this interim period Fry wrote daily to Lady Ottoline, telling her the precise days he would be at Bruges and Ghent so that letters could be sent to him Poste Restante. The outcome of their affair was in the forefront of his mind: 'I know you will decide right for us and that together we shall have strength to do whatever you decide'.[38] Lady Ottoline replied in an ardent but languorous fashion, writing at length in her curlicued script about the sacred fire of friendship. She had taken herself off to lodgings at Studland in an attempt to cure her cold and neuralgia. Unfortunately the house was situated in the middle of a cabbage patch, but apart from this there was little to jar her romantic mood and she went for long meandering walks barefoot on the sand.

While Lady Ottoline had her Vision of Soul on Studland Beach, Fry and the rest of the party (the Bells having now joined them) reached Constantinople. No sooner had they arrived than Fry was immediately transformed, shedding a layer of tension and pent-up nervous energy

like a snake sheds its skin. Earlier in January he had taken a week's holiday in the Jura mountains with Logan Pearsall Smith but had had to return immediately to London to close down the exhibition and to complete a series of lectures at the Slade. He was, therefore, badly in need of a long holiday and had set out from London tired and distraught. In Constantinople, his curiosity instantly aroused by his surroundings, he began to unwind.

On arriving, the Bells followed up an introduction they had been given to the British Embassy, but their contacts proved of little help and the party found they fared better when left to wander around on their own. Fry, versed in a small amount of Turkish acquired from a teach-yourself book, would sit at the front of the carriage alongside the driver and, clutching the phrase book in one hand and gesticulating with the other, managed to convey them to all the places of interest which they wanted to see without having to resort to guides or touts. Untroubled by the traditional awkwardness of the British abroad, Fry communicated directly with the natives; he talked, joked and bargained with them and as a result was treated with respect, the Turks keeping their children out of the way while he sketched. Once, while Vanessa and Fry were painting with their backs to the wall of a weaver's house, a hand suddenly emerged from the doorway offering two cups of coffee, and this was followed by an invitation to enter the house. The interior was bare and whitewashed and the Turk, responding to Fry's charm, did all he could to assist his efforts at conversation. The result was that Fry sat down to paint his portrait, while Vanessa painted the wife.

From Constantinople they visited Stamboul where Fry bargained for the hire of a boat, obtaining it for half the original asking price, and they sailed on the Sea of Marmara past the red Byzantine walls that came down to the water's edge, above which rose the occasional ruined Byzantine palace, the grey huddle of chalets and the great white mosques. After lunch Roger and Vanessa sketched outside the city walls while the other two explored the town, which Fry felt was aptly described as 'a mixture of New Jersey city, the slums off the Fulham Road, the worst surburbs of Paris and God knows what rubbish heaps of civilisation.'[39] Generally, he felt completely at his ease. 'I feel such complete confidence with all this riff-raff . . . it's all so immediate and instinctive.'[40]

After some days the party travelled to Brusa (sometimes spelt Broussa or Bursa), intending to stay only two days, but no sooner had they arrived than Vanessa suffered a fresh fit of fainting and they were forced to remain until her health improved. Fry, taking stock of his surroundings, responded immediately to what he saw: Olympus was capped with snow, its sides red and purple; the plains below were dotted with pale golden and silver poplars and below them lay a sea of almond blossom. The town with its tall minarets and cypresses rising above the rooftops was to reappear in a number of large paintings executed on his return to England. While he made quick sketches in oil of his surroundings, Vanessa suffered a miscarriage and fell seriously ill. Little medical help

was available in Brusa and while the rest of the party felt helpless in the face of this disaster, Fry, with his long experience of nursing, took charge. He wrote to Lady Ottoline: 'What really alarms me is the state of mental terror which she goes into afterwards as tho' everything were slipping away from her. I suppose from my immense experience of such things I was able to help her.'[41] His nursing was most unorthodox: instead of order and calm, pandemonium reigned. Vanessa's room was cluttered with all kinds of objects, sanitary and otherwise; glasses, bottles, books, letters, canvases, palettes – all seemed to multiply the next day. After his brief forays into the town, he would return laden with printed handkerchiefs, shawls and rugs bought in the bazaar, and when he left her for longer periods of time he would return with innumerable pochades, quick sketches in oils, which he would prop up around the room for her approval. He nursed her day and night and in spite of the seriousness of her condition and the lack of medicines available, he never doubted her return to health. It was then that Vanessa discovered the source of his energy and confidence in his own convictions. She recalled: 'He told me then that he possessed some tremendous power, some queer force which gave him complete self-confidence and made him able to do all he thought best, some power to deal with himself, with me and with others.'[42]

Sitting opposite Fry on the return journey (now accompanied by her sister Virginia who had travelled out to help bring the invalid home), Vanessa marvelled at this holiday companion who had willed her back to health and had begun to stimulate in her a seemingly endless stream of speculation. They shared an immediate sympathy and it seemed as if they talked without break from Vienna to London. She was astonished by his responsiveness to scenery; no sooner had the train rattled past a particularly impressive view than he whipped out his sketchbook and pencil and made intelligible notes on its character. His pockets contained a store of resources – knives, india-rubbers, bottle-openers, scissors and keys, and their contents earned him the nickname 'the White Knight', who similarly attached to his person a great variety of objects. On reaching England, Vanessa saw it as if through Fry's eyes – crude, complacent, vulgar and mean, and in London she could not help noting that the blue, which was fashionable that year, was excessively bright compared to the luminous many-toned blues of the East.

Throughout his life Fry felt the need for the critical advice and encouragement of a female friend. During 1910 his muse had been Lady Ottoline, but the situation was now altered by the love that had developed between himself and Vanessa in Turkey. Vanessa, whose uncompromising nature found expression in the clarity and beauty of her facial features, would not have been willing to share Fry's affections with Lady Ottoline, and it seems probable that she now urged Fry to make a positive, clear-cut break with his former confidante. Even if Lady Ottoline was partly to blame for the quarrel that ensued, the extent of Fry's anger seems unwarranted considering her earlier kindness to

himself and his wife. On 18 May 1911 he dined at Lady Ottoline's house at a dinner given in honour of Winston Churchill. Two days later he entered her house after lunch with a look of grim determination and the scene that followed was recorded in Ottoline's diary: 'He suddenly turned on me with a fierce and accusing expression, commanding me to explain why I had spread abroad that he was in love with me. I was so utterly dumbfounded, for this thought had never entered my head – and I had certainly not uttered such an absurd thing to anyone.'[43] But Fry may not have acted as unreasonably as Lady Ottoline (writing for posterity) here suggests, and her biographer concludes that Lady Otto-line may well have been guilty of dropping certain allusive comments about Fry to act as a smokescreen for her affair with Bertrand Russell.[44]

Vanessa, on her return, was still far from being in perfect health and on a two day visit to Durbins, her illness showed signs of recurring. The doctor advised her to convalesce apart from her family and in July she took lodgings at Millmead Cottage in Guildford, conveniently close to Fry and throughout that month they spent a great deal of time in each other's company. At first she kept her relationship with Fry from her husband, a thing that was not difficult to do as their marriage had fallen somewhat apart owing to Clive's flirtation with her sister, Virginia. Moreover, Fry's position in the Bloomsbury Group made it natural that the painters, Vanessa and Duncan, should spend much time in his company.

To Vanessa, the summer of 1911 seemed magical: exceptional heat set the background to the new interest in painting. Fry and Duncan Grant would arrive unexpectedly at Guildford, ruffling Joan Fry with their need for food and their desire to sleep out on the terrace on mattresses. At night, Duncan, Vanessa and Roger lazed in boats on the river and the two men swam in the nude. By day, Vanessa, wrapped in a Turkish shawl and seated in a deckchair, posed for Fry. On one occasion they were visited by Edward Carpenter, whom Fry still admired but who seemed to Vanessa simply a sentimental and slightly silly old man. He was shocked when Vanessa failed to reprimand her three-year-old son, Julian, for dropping a handful of earth and gravel over her hair and neck. The idyll continued in September at Studland Bay where Fry and his sister Joan rented a house in close proximity to the Bells. But the lodgings for both parties were cramped, the children demanding and, though they still managed to paint and sketch, Vanessa did not recall that their time there had been as perfect as the July at Guildford when her feeling for Fry, and his for her, had been equal and intense.

On his return from Turkey Fry had determined to discover for himself a Post-Impressionist style. He had noted at the Grafton Galleries that the French paintings had projected a strong sense of reality and a 'force and completeness of pattern'.[45] Cézanne's *La Vieille au Chapelet*, for example, though mocked by the critics for her apricot-coloured face, presented to Fry 'that self-contained inner life, that resistance and

49 Roger Fry:
Turkish Scene, 1911.
Oil on canvas,
101.5 × 152.5 cm.
Birmingham,
University House

assurance that belong to a real image, not to a mere reflection of some more insistent reality'.[46] But the artist who really crept under his skin was Matisse. Soon after his arrival back in London, Fry wrote to Simon Bussy, 'I am now become completely Matissiste. I was very suspicious at the beginning of our exhibition, but after studying all his paintings I am quite convinced of his genius'.[47]

His first essays in the new style took the form of a series of large Turkish landscapes (Plate 49). The forms of the landscape are outlined in black and then filled in with flat areas of unmodulated colour – a style as much indebted to the example of mosaics as to Matisse. Among those that Fry would probably have seen on his visit to Turkey were the famous examples in the Kariye Djami at Istanbul as well as those in the Koimesis church at Nicaea, near Brusa. The rhythmic treatment of form that grows naturally out of the limitations of the medium of mosaic, gave to Fry's 1911 paintings a new expressive vigour, as can be seen in *Studland Bay* (Plate 50), where representation has been firmly subordinated to the structural and rhythmic demands of the composition. Fry found justification for this clipped reductionism of form in Reynolds' *Discourses*: writing of Gordon Craig's stage designs in the *Nation*, he said: 'Mr Gordon Craig realised what Sir Joshua Reynolds had already pointed out in his "Discourses" that this elevation of mood which belongs to what Reynolds called the Grand Style, necessitates, above all, abstraction and generalisation, that any particularisation of the forms tends to a lowering of the emotional pitch.'[48] All this conspired to give

147

50 Roger Fry:
Studland Bay, 1911.
Oil on canvas,
58.5 × 90 cm.
*Rochdale City Art
Gallery*

a more consistent rhythm to the design. 'Rhythm' denoted modernity at this time, and became the title of an avant-garde magazine published by John Middleton Murray, the first issue appearing in the summer of 1911. Fry's stress on this quality is revealed in a letter to Horace Brodzky (who had asked for criticism of his work), in which he advised: ' . . . if I were to criticise I should say that in the heads and to some extent in the landscapes a good deal that has merely representative and not expressional value is left. The design should permeate all the form with a more consistent and purer rhythm.'(49)

Meanwhile, Vanessa Bell had been sharing her enthusiasm for mosaics with Duncan Grant. 'My paintings were all stuck but I think not seriously', she told Fry. 'Duncan was very nice about them and sees that mosaic is the one thing to be done.'(50) But the Bloomsbury painters were not alone in their interest in mosaics: Sickert in 1910 described the group of artists who gathered round him at Fitzroy Street and who also exhibited at the New English Art Club as using 'a clear and solid mosaic of thick paint in a light key'.(51) He was, however, referring to a technique closer to Impressionism than to Byzantine mosaics, the broken touches of colour relating to the fall of light rather than consideration of a decorative purpose. Vanessa Bell's imitation of mosaic work differed subtly from this: 'I am trying to paint as if I were mosaicing', she

148

informed Fry, 'not by painting in spots but considering the picture as patches.'[52] Bloomsbury imitation of mosaic-work, therefore, came closer to stained glass in the attempt to reconcile three dimensional representation on to a two-dimensional canvas. While enthusiasm was at its height, a mosaic of badminton players was begun, but not finished, in the summer house at Durbins, by Fry, Grant and others, and when the Omega Workshops opened in 1913, reproductions of Byzantine mosaics were thought fit to hang upon the walls of one room.

This marriage of Byzantine art with Post-Impressionism reached its climax with the Borough Polytechnic murals. In the summer of 1911, Basil Williams, one of Fry's Cambridge friends, then the Chairman of the House Committee of the Polytechnic, invited him to organise the decoration of the Polytechnic's dining hall. Fry undertook the venture with enthusiasm. 'I believe you do have an extraordinary effect on other people's work', Vanessa told him; 'I always feel it when I'm with you.'[53] He brought together Grant, Frederick Etchells, Bernard Adeney, Macdonald Gill and Albert Rutherston (the last two were brought in after the work had begun to expedite the completion of the project), and once the theme – 'London on Holiday' – had been decided upon, Fry left each artist free to design his own panel. Grant and Etchells, working in a remarkably similar style, produced the most successful designs, but all, to a greater or lesser extent, made use of bold outline and flat areas of colour to reinforce the decorative effect. Grant's *Bathers* (now with the rest of the designs in the Tate Gallery) made specific reference to Byzantine art in his handling of the water which he simplified into waving bands of transparent colour. All the designs are surrounded by a bold diaper design and Fry made deliberate play on the contrast between illusion and reality by allowing the elephant's foot in his scene, *London Zoo*, to extend into the patterned border. Elsewhere in the polytechnic, the walls were redecorated in bright tones of orange, yellow and blue, in keeping with the gaiety of the murals. When the decorations were hung in position they looked startlingly original and were both praised and criticised by the press and by polytechnic officials. 'I know nothing about art', remarked a young mechanic whose opinion was sought, 'but I do know that this sort of thing makes me want to whistle.' 'That', replied Fry, 'is just the mood I wanted to create.'[54]

In the autumn Fry crossed to France in order to visit the Salon d'Automne and to take a holiday with Clive Bell and Duncan Grant in the environs of Poitiers. At the Salon an entire gallery had, for the first time, been devoted to Cubism, but as neither Braque nor Picasso exhibited, the movement was represented by lesser artists. Fry in his review noticed that certain artists merely applied a veneer of Cubist faceting to straightforward realism. Even so, his own understanding of the movement only really embraced the early stages: 'The notion is, of course, a very ancient one, and almost all early sculpture shows traces of the idea of a geometrical simplification and classification of natural form. But undoubtedly the Parisian artists use this reduction of complex

149

surfaces to their elementary geometric statement in a new way ... not
... as a stepping stone to a completer rendering of natural form, but as
a means of expression in itself.'[55] This exhibition left its effect on Fry's
own painting as after being exposed to this display of Cubism, he began
to create form with small shifts of sharply-defined planes, a method that
freed him from his former dependence on outline. Ideas for pictures
came to him during his tour of Poitiers, Le Dorat, St Savin and Chau-
vigny, but as he and Grant travelled by bicycle (Bell, preferring more
leisurely means of travel, took trains), he is unlikely to have executed
more than a handful of sketches. One of these was probably that
(formerly in the collection of Leonard and Virginia Woolf) which later
provided the starting point for the Tate Gallery *River with Poplars*. As
it was, Fry's excited response to the French landscape, to the roof tops,
the poplars and the occasional Romanesque ruin, combined with the
bicycling, sketching, sight-seeing and the wine, left him at the end of
each day exhilarated but exhausted.

The sketches made on this trip and the more finished oils worked up
on his return home were added to the growing pile of paintings that
threatened to choke his studio. Then in January 1912 he exhibited fifty-
two of these in a one-man show at the Alpine Club Gallery. The critics
naturally leapt at the opportunity to assess how the impressario of the
new movement had himself responded to its influence. On the whole
they favoured this English interpretation. 'Mr Fry makes quite English
what proceeds from France,' pronounced Robert Ross in the *Morning
Post*. 'There is none of the unpleasant atmosphere emanating from the
canvases of Van Gogh or Matisse, or the appalling sense of evil which
no aesthetic formula can obviate when contemplating the undoubtedly
interesting work of Gauguin, or the atrophied and perverted talent of
Picasso.'[56] Fry's rhythmic simplification of form was more advanced
than anything yet seen in a one-man show by an English artist and *The
Times* felt obliged to admit that this reductionism did produce an illusion
of reality, 'the more intense because it is not obvious and immediate'.[57]

Fry had even applied this new severe style to portraits of Vanessa
Bell (present whereabouts unknown), John McTaggart and E. M. Forster
(Plate 51). Living at Weybridge, Forster was a frequent Sunday visitor
to Fry's home at Guildford and it was no doubt after the Sunday joint
and a glass or two of cider that he agreed to sit. He viewed the progress
of the portrait with equanimity, informing a friend:

> Roger Fry is painting me. It is too like me at present, but he is confident
> he will be able to alter that. Post-Impressionism is at present confined to
> my lower lip which is reduced thus ... and to my chin on which soup has
> apparently dribbled. For the rest you have a bright, healthy young man,
> without one hand it is true, and very queer legs, perhaps the result of an
> aeroplane accident, as he seems to have fallen from an immense height
> on to a sofa.[58]

Despite the awkwardness of the pose, Forster duly paid £17.10.0 for the

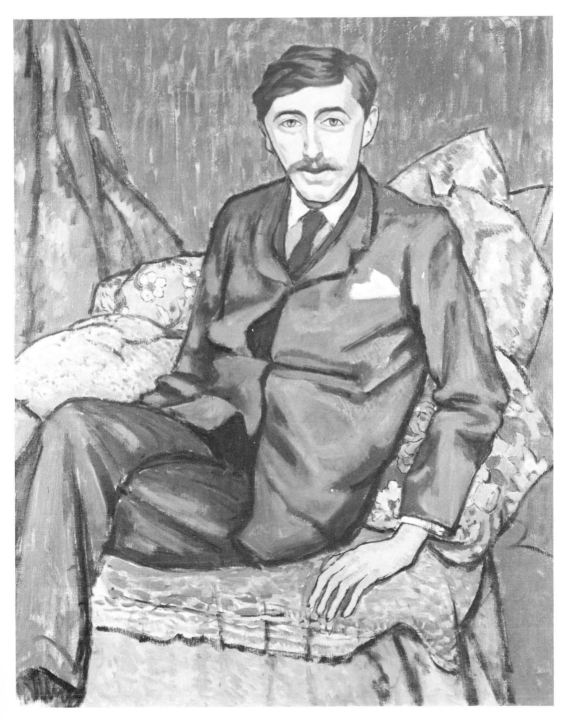

51 Roger Fry: *E.
M. Forster*, 1911.
Oil on canvas, 72.5 × 59 cm.
Private Collection

portrait and carried it home to Weybridge where his female relatives hung it in the drawing room in pride of place until a visiting vicar, eying it with great seriousness, enquired of Forster's mother, 'I hope your son isn't queer?'[59]

The Alpine Club Gallery exhibition testified that Fry was painting with more energy and conviction than he had done for years; nor was he any longer painting in a cultural vacuum, but in the midst of young painters and with his eye on contemporary developments in Paris. After the success of the first Post-Impressionist exhibition, the directors of the Grafton Galleries offered Fry the control of their galleries during the autumn of each year and though nothing was arranged for the autumn of 1911, in July 1912 Fry crossed again to Paris to select examples of recent French art for a second show. Before leaving he wrote to his mother, 'The British public has dozed off again since the last show and needs another electric shock – I hope I shall be able to provide it'.[60]

8 Significant Form

Prior to 1910, England had remained largely insulated from the artistic revolutions that were revitalising Europe. But in 1910 the floodgate had been opened and by the end of 1912 the safely-moored craft of English cultural life was reeling from the repeated shock waves that had swept in from the continent bringing with them thirty years of artistic revolt. The first Post-Impressionist exhibition had been quickly followed by the publication in English of a selection of Van Gogh's letters, but an exhibition of Van Goghs and Gauguins at the Stafford Gallery, London, in 1911 went comparatively unheeded because already public opinion was being attracted by fresh bait, by news of Cubism and Futurism which was gradually filtering into England. In March 1912 the Italian Futurists mounted a full-scale attack on London, exhibiting a large display of their art at the Sackville Gallery, heralded in the catalogue by the Futurist Manifesto. Fry gave it a cautionary review. He noted that the artists had failed to discover a visual language adequate to their purpose and he suspected that the 'states of mind' they desired to create had more to do with scientific curiosity than with art. 'As yet the positive elements in the creed', he declared, 'their love of speed and mechanism, have failed to produce that lyrical intensity of mood which might alone enable the spectator to share their feelings.'[1] Not surprisingly, this new wave of modernism made no appearance in his Second Post-Impressionist Exhibition.

Fry was in a fortunate position, having both time and opportunity to digest these violent innovations. He had visited certain artists' studios,

the innovatory Salon d'Automne of 1911 and the important 1912 Son-
derbund exhibition in Cologne, which he had seen in the company of
the Bells. Other critics were less fortunate and their confusion is revealed
in their arbitrary application of the new 'isms – Post-Impressionism,
Cubism, Futurism and the term (which has since passed out of use)
'Neo' or 'Proto-Byzantinism', a style that was thought to descend from
Gauguin and Van Gogh, to have some resemblance to mosaic work,
and to be specifically the innovation of Roger Fry. Certain young artists
felt equally as confused as the critics. Mark Gertler, a Jewish painter
from the East End wrote to Dora Carrington in September 1912, 'So I
went out and saw more unfortunate artists. I looked at them talking art,
Ancient art, Modern art, Impressionism, Post-Impressionism, Cubists,
Spottists, Futurists, Cave-dwelling, Wyndham Lewis, Duncan Grant,
Etchells, Roger Fry'. Disgusted and confused he returned home to his
mother, to hot coffee and home-made bread. 'You, dear mother, I
thought, are the only *modern artist*.'[2]

The idea for a second Post-Impressionist exhibition had first been
discussed in 1911 when, after the success of the 1910 show, the directors
of the Grafton Galleries suggested Fry should put on an annual autumn
exhibition. Fry's idea for the autumn of 1911 was to exhibit the best
non-academic art currently being produced in England. He explained to
Clive Bell, 'To make it strong I would have to devote one or two rooms
to the conservatives, Steer, Tonks and Co., and then allow *les jeunes* a
free opportunity in the others'.[3] Probably aware that they were only
being included to give weight to an immature movement, Steer, Tonks
and Rothenstein refused to concur and the exhibition planned for that
year never took place. This lack of co-operation forced Fry, when
organising the 1912 Post-Impressionist exhibition, to adopt a more
separatist position thereby antagonising the old guard still further. Even
Augustus John who at first agreed to exhibit in the English section in
the 1912 show, was obliged to refuse out of loyalty to Will Rothenstein.

Until 1910 Fry regarded Rothenstein as one of his most sympathetic
colleagues. Their friendship, which had begun at the Académie Julian
in 1892, was based on mutual respect; Fry admired Rothenstein's seri-
ousness of approach and praised his work in the press; Rothenstein, in
turn, recognised Fry's ability as a critic and when the Slade Professorship
at Oxford came up in 1910, Rothenstein withdrew his application on
hearing that Fry was one of the candidates. Professional sympathies
were combined with personal friendship. Helen Fry had known Alice
Rothenstein prior to her marriage to Will and the two women remained
close friends until separated by Helen's illness. Their children were
much the same age and descriptions of Fry-Rothenstein childrens' tea-
parties feature in Helen's letters to Roger in America. Immediately prior
to the first Post-Impressionist exhibition, Fry praised Rothenstein's art
in the press for its sense of underlying design: 'With chiaroscuro cut off,
with shade translated more or less completely into colour contrasts, he
is forced to construct the scaffolding of his design with extreme perfec-

tion.'[4] He had long admired Rothenstein's portraits, but now he discovered in his art a similar integrity to that which he was beginning to discover in the work of Cézanne.

Rothenstein had been in India at the time of the first Post-Impressionist exhibition. His fascination with that country had led him to found the India Society, which Fry joined out of loyalty to Rothenstein and not because of any interest in Indian art. In India, Rothenstein heard about the Post-Impressionist exhibition at second-hand, from his wife Alice and from Eric Gill, and pieced together some idea of the furore the show had aroused. Suspicious of such notoriety, he wrote to Fry on his return to England with a touch of acerbity: 'art is not an affair of social excitement, no one knows that better than you, and drawing room discussion does nothing any good I think. I fancy it has been a brilliant and gallant charge of the light brigade – a glorious episode, but leaving things very much what they were before.'[5] He soon realised that he had greatly underestimated the event. Before leaving for India he had enjoyed a central position in the world of contemporary art, but on his return the centre of interest had shifted and his position had become a little *passé*. He had treasured his position as talent-spotter and was irritated to find that Fry had taken on his mantle.

When Rothenstein heard of Fry's proposal for a show of non-academic English art to be held in the autumn of 1911, he raised a number of objections. Fry replied with a letter written immediately before the departure for Turkey; he intended to soothe, but instead incited Rothenstein's anger still further.

> I feel rather sorry that you think so little of what we, who care for a really vital art in England, have done while you were away. The mere fact that I have been made adviser to the Grafton Gallery company and control their galleries for the autumn months seemed to me a real acquisition of power for the younger and more vigorous artists. I can give them a chance they never had before of being well seen but if it is to succeed I must rely on the loyalty to the cause of those like yourself who have a more established name.[6]

In the same letter Fry outlined his idea for this 'general secession show' in which the older members of the New English would exhibit alongside younger 'Post-Impressionists'. The detailed arrangements were left vague, but it was clear that Fry would be responsible for the selection and hanging. The letter drew Rothenstein more fully into the debate: he argued, in his reply, that the selection should be managed not by Fry, but by a committee; he warned against one-off occurrences that just aroused gossip; and finally he ruefully admitted, 'the people who are your enthusiastic supporters look upon me as a dullard with an interesting past, who has done his best work 20 years ago'.[7]

The crux of this disagreement concerned neither aesthetics nor the technicalities of exhibition organising, but the question of power.

Michael Holroyd has noted, 'Fry ... seems to have been anxious to establish his Grafton Group to a point where Rothenstein, once admitted, could not influence it'.[8] Mary Lago in her introductory notes to the book *Max and Will* also points to Fry's evasiveness, but how much was conscious evasion and how much the result of the pressure of events and general vagueness, it is doubtful if we will ever know. Certainly Fry wanted to avoid the formation of a selection committee such as Rothenstein proposed and tried to paper over the cracks in their disagreement by writing from Turkey that the show 'would be in general character sympathetic to you and that in particular your work would receive a hearty welcome.'[9] Fry had some reason to be wary of Rothenstein's desire for power. He may well have recalled the rumpus Rothenstein had caused in the Society of Twelve when he had persistently proposed the election of Lucien Pissarro, whose nationality made him ineligible. Each time Pissarro's name was rejected Rothenstein promptly resigned and had to be cajoled back into membership. Renowned for his tenaciousness, Rothenstein eventually saw Pissarro admitted.

Without the support of Rothenstein and others, Fry's idea for the 1911 secessionist show fell through, and when the following year plans were made for the Second Post-Impressionist Exhibition, an alternative to the old guard had to be found as the younger artists had so far produced only a limited amount of work. The idea to include a Russian section provided the solution.

Interest in Russian art and literature had steadily been growing in London; Chekov's plays and Dostoievsky's novels were held to assert a similar belief in the individual to that which was to be found in Post-Impressionism. The Russian Ballet had also been warmly received in London, Karsavina making a brief appearance at the Coliseum in 1909, followed by Anna Pavlova in 1910. In 1911 Diaghilev caused a tremendous stir when he brought the Imperial Russian Ballet to Covent Garden, starring Karsavina and Nijinsky, a success that was to be repeated when the Ballet returned the following year. Aware of this current enthusiasm, Fry agreed that Boris Anrep, the Russian mosaicist, should go to Russia to select a good display of contemporary Russian art. He brought back paintings by Soukoff, Roerich, Stelletzsky, Ciurlionis, Bogaevsky, Komarovsky and Petroff-Wodkine, most of whom had exhibited with the World of Art group. They were largely influenced by Gustave Moreau, Puvis de Chavannes and Vrubel and it is not surprising that Fry was disappointed when the first batch of paintings arrived. It was not until after the exhibition had opened that the more avant-garde work by Natalia Gontcharova and Mikhail Larionov reached London.

The two other sections in the exhibition were devoted to French and English art; Fry took responsibility for the selection of the former, Clive Bell for the latter. Again, Fry had toured the leading Parisian dealers and collectors, approaching Vollard, Kahnweiler, Druet, Sagot, Bernheim-Jeune and Leo Stein among others, but this time his selection was far more up-to-date. Cézanne was the only true Post-Impressionist

52 Poster for the
Second Post-
Impressionist
Exhibition

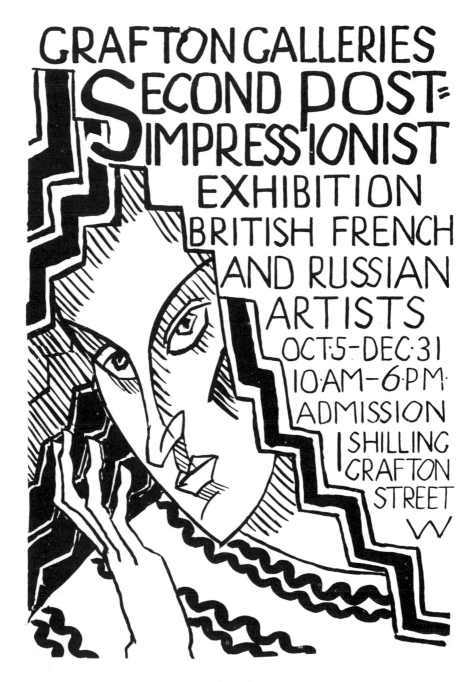

represented; the focus now rested on the younger generation, on Picasso, Matisse, Derain, Chabaud, Doucet, Flandrin, Girieud, Herbin, Marchand and Vlaminck. The Douanier Rousseau, represented by a forest scene, was shown in England for the first time, emphasising the new importance attached to naive art, while Russian popular prints decorated the staircase walls.

157

In his catalogue introduction, Fry praised the diversity of style in modern art, evidenced by the disparate work of Picasso and Matisse. Picasso, now seen predominantly in his Cubist period, was represented by fifteen works; Matisse by more than double that quantity. Matisse, therefore, stamped the exhibition with his personal note, with his brilliant pure colour, spatial ambiguities and daring distortion of the human figure. After passing through one room devoted to Cézanne watercolours, and another full of paintings by Picasso and Matisse, the visitor came upon the focal climax of the show – Matisse's *Dance* (Plate 53), which hung on the end wall in the end gallery. This vibrant painting, with its expansive design that seemed about to burst the confines of the canvas, presented planar simplification on a more severe scale than anything yet seen in England; it made use of only four colours and the nude figures were freely distorted to recreate the joyousness and bounding sensation of the round dance. Fry, recognising the difficulties such a painting presented to the public, praised its intense and persuasive rhythm and wrote of Matisse's ability to recreate the sensation of the dance in pictorial terms. He showed Lady Bonham-Carter around the exhibition and when she objected to the shape of the legs, he urged her instead to study the spaces created in between the legs, shifting her attention from the representational subject to the formal content.

Compared with these brilliant French paintings, the English exhibits looked dull and colourless. The critics immediately pounced on their derivative qualities: 'Every word of their artistic language is traceable to some French root. There is no eccentricity, no affectation, no mannerism in French that does not find a ready echo in English Post-Impressionism. And let it be said at once, like every echo, it is feebler than the original sound.'[10] Had certain of the Scottish colourists been included this criticism might not have been made, but Bell's selection had concentrated on a select handful of artists, mostly his friends – his wife, Fry, Grant, Frederick and Jessie Etchells, as well as Stanley Spencer, Eric Gill, Wyndham Lewis and Spencer Gore. The critics found Grant the most uneven: his *Pamela* (Plate 54) was compared to Vuillard, his *Queen of Sheba* (Tate Gallery) on the whole admired, but his *Countess* (Private Collection) regarded as a flippant emulation of Matisse. His *Dancers* (Tate Gallery) inevitably suffered from comparison with the greater ease and largeness of conception in Matisse's *Dance*. Vanessa Bell was accused of producing a 'linoleum' type of Post-Impressionist landscape; her *Spanish Lady* (Plate 55), it was said, exhibited the good beginning of a sketch, but nothing more. Fry himself was treated not unkindly; P. G. Konody found in his *The Terrace* (Plate 56) 'emphatic structural design, pure colour, insistence upon the permanent and elimination of the transitory elements in Nature'.[11] Of the English artists, Wyndham Lewis was the most disliked. His sophisticated, semi-abstract designs for *Timon of Athens* aroused in the reviewers a condemnation only surpassed by the utter scorn and miscomprehension which they reserved for Picasso's Cubism.

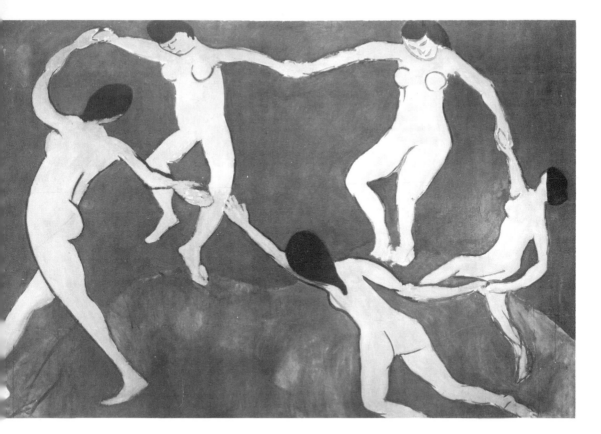

53 Henry Matisse:
The Dance (First
Version), early 1909.
Oil on canvas,
260 × 390 cm. *New
York, Museum of
Modern Art. Gift of
Nelson A.
Rockefeller in
honour of Alfred H.
Barr, Jr.*

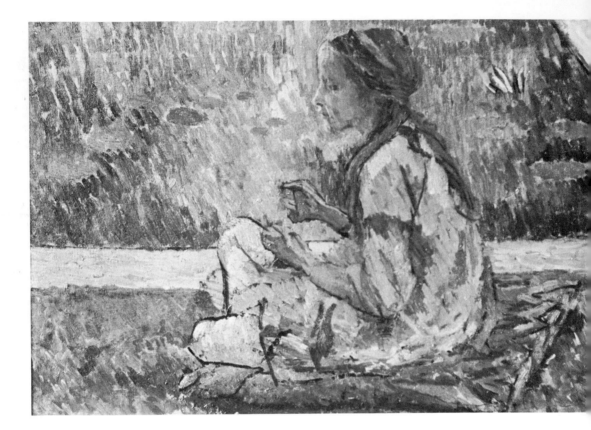

In the catalogue introduction, Fry now approached his subject with complete confidence: the searching hesitancy of his 1910 articles on Post-Impressionism is replaced by a resounding conviction. 'Now, these artists do not seek to give what can, after all, be but a pale reflex of actual appearance, but to arouse the conviction of a new and definite reality. They do not seek to imitate form, but to create form; not to imitate life, but to find an equivalent for life.' He now perceived that complete freedom from illusionistic imitation led ultimately to abstract art. 'The logical extreme of such a method would undoubtedly be the attempt to give up all resemblance to natural form, and to create a purely abstract language of form – a visual music; and the later works of Picasso show this clearly enough.' The extreme sophistication of Picasso's 1911 paintings had taken analytic Cubism dangerously close to pure abstraction as Fry realised when he looked at the fugal arrangement of forms initially extracted from natural objects. Intellectually he could appreciate these paintings, but in both the catalogue introduction and in the article which he wrote for the *Nation* (9 November 1912) a note of hesitation enters his description of Picasso's contribution. He refrained from judgement, admitting that he felt insufficiently accustomed to such abstractions, and he predicted (rightly) that they represented an intermediate stage on the way to a clearer and more explicit

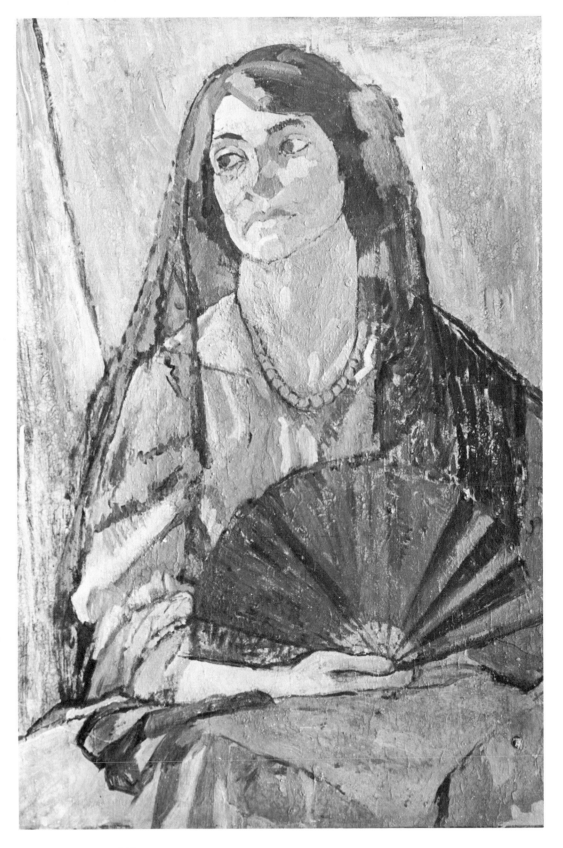

161

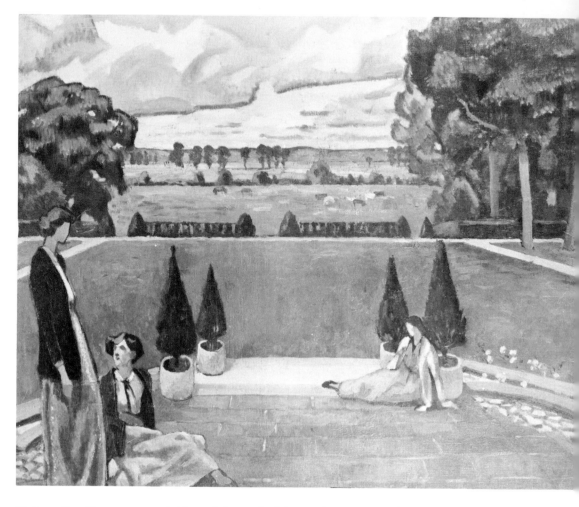

56 Roger Fry: *The Terrace*, 1912. Oil on canvas, 64 × 81 cm. *Private Collection*

presentation of form. In his catalogue notes he turned with relief from Picasso to Matisse whom he praised for his rhythmic use of line and design, the reality of his forms, his logical use of space, and his inventive, strident colour.

At the end of his introduction, Fry played his trump card; he had discovered alive and well in modern French painting a 'classic' quality, because these artists did not 'rely for their effect upon associated ideas, as ... Romantic and Realist artists invariably do'. Classic art had for Fry, as for Reynolds, a value that endured the changes of fashion. This he explains in his conclusion:

All art depends upon cutting off the practical responses to sensations of ordinary life, thereby setting free a pure and as it were disembodied functioning of the spirit; but in so far as the artist relies on the associated ideas of the objects which he represents, his work is not completely free and pure, since romantic associations imply at least an imagined practical activity. The disadvantage of such an art of associated ideas is that its

effect really depends on what we bring with us: it adds no entirely new factor to our experience. Consequently, when the first shock of wonder or delight is exhausted the work produces an ever lessening reaction. Classic art, on the other hand, records a positive and disinterestedly passionate state of mind. It communicates a new and otherwise unattainable experience. Its effect, therefore, is likely to increase with familiarity. Such a classic spirit is common to the best French work of all periods. ... It is because of this classic concentration of feeling (which by no means implies abandonment) that the French merit our serious attention. It is this that makes their art so difficult on a first approach but gives it its lasting hold on the imagination.[12]

Fry was right to recognise the difficulty presented by this exhibition. The disturbance it caused was largely due to the relentless distortion, by some artists, of the human figure. Yet the shock, horror, dismay and excitement that the show aroused did not prevent it from being a financial success; the paintings sold easily and around eight hundred shillings were taken each day in entrance fees. Fry again spent the greater part of his time in the gallery, explaining, discussing and being attacked verbally by respectable but fearless old ladies. Henry James visited the show and Fry took him down to the basement for a cup of tea where the portly author perched uneasily on a small chair and explained in convoluted sentences his response (unrecorded) to the paintings upstairs. C. R. Ashbee arrived to find another of his friends, H. A. Roberts, already present and Fry pressed on both men an exhibition poster (which Roberts carefully folded into eight and deposited in his card case). Fry took them around the show emphasising the difference between pictorial 'illusion' and 'reality'. Then, as if to reassure them, he took the two visitors to lunch in a pub in Albemarle Street, where, according to Ashbee, 'there were oleographs of horses and the Royal Family on the walls, and we ate great succulent dumplings, and drank Burton with huge red and succulent slabs of boiled beef floating in gravy. There was no mistaking the reality'.[13]

Benedict Nicolson was the first to note that the aesthetic discussion resulting from the second Post-Impressionist Exhibition differed noticeably from that arising from the first: 'whereas the first had popularised the notion that artists were romantic geniuses, the second gave birth to the much more rigid doctrine of "significant form".'[14] Aesthetic discussion gathered momentum during the course of the exhibition which was extended in a slightly altered format into January 1913 when the exhibition originally planned for that month fell through. By February 1913, Fry informed Dickinson, 'I want to find out what the function of content is and am developing a theory which you will hate very much, *viz.*, that it is merely directive of form and that all the essential aesthetic quality has to do with pure form'.[15] Later that month Clive Bell entered a dispute in the *Nation* begun by a slating review Fry had written of the

Alma-Tadema Memorial Exhibition; he took the opportunity to argue that recently art appreciation had crystallised into two opposing points of view – the 'official' and the 'aesthetic': the former judged art by its accuracy of representation and the latter by its power to evoke 'a peculiar emotion called "aesthetic" '.[16] A definition of the 'aesthetic' view was clearly required. By 1913 it was no longer adequate to explain modern art as the product of the artist's desire to express a particular emotion; the search began for a more profound, unifying and authoritative aesthetic theory.

57 Max Beerbohm: Caricature of Roger Fry, 1913. Inscribed, 'We needs must love the highest when we see it.' Cambridge, King's College

Lytton Strachey had already observed the invigorating effect of the first Post-Impressionist exhibition on the Bloomsbury Group. Himself extremely suspicious of the new art, he left a telling observation of the situation at Studland in 1911: 'Clive presents a fearful study in decomposing psychology. The fellow is much worse – fallen into fatness and fermenting self-assurance, burgeoning out into inconceivable theories on art and life – a corpse puffed up with worms and gases. It all seems to be the result of Roger, who is also here, in love with Vanessa. She is stark blind and deaf. And Virginia (in dreadful lodgings) rattles her accustomed nut.'[17] It fell to Bell to expand upon their new ideas in public because Fry, having been approached by Chatto and Windus in 1913 to write a book on Post-Impressionism, declined, as he was busy preparing for the opening of the Omega Workshops, and therefore recommended Bell instead. The result was the book *Art*, published in 1914, in which Bell put forward his belief that aesthetic experience depends upon the recognition of 'significant form' – 'a combination of lines, colours and forms that move one aesthetically'. The phrase, if not the exact idea, had earlier appeared in a review by Fry. Writing of Cézanne's development, Fry had said, 'he seems, as it were, to have touched a hidden spring whereby the whole structure of Impressionist design broke down, and a new world of significant and expressive form became apparent'.[18]

Many other concurrences with Fry's thought can be detected in *Art*:

like Fry, in his 'An Essay in Aesthetics', Bell undervalues the role of colour which he regards as subordinate to form; like Fry, he is suspicious of the Futurists' attempt to arouse certain states of mind; in a footnote he echoes the view expressed in Fry's article 'The Art of the Bushmen' that palaeolithic art is far superior to neolithic; for Bell, as for Fry, Post-Impressionism implied no break with the past but 'shakes hands across the ages with the Byzantine primitives'.[19] In his preface Bell admits his debt to Fry and to his 'An Essay in Aesthetics', but adds that on some points they disagreed profoundly. How severe these disagreements were at the time of publication is difficult to assess. Fry wrote a restrained review of the book, raising certain points, but he chose not to develop any dialectic in the press.

Fry agreed with Bell that 'significant form' is the source of aesthetic enjoyment. Bell, however, pushed this idea to an extreme:

> But if a representative form has value, it is as form, not as representation. The representative element in a work of art may or may not be harmful; always it is irrelevant. For to appreciate a work of art we need bring with us nothing from life, no knowledge of its ideas and affairs, no familiarity with its emotions.[20]

This severe standpoint, which undervalues subject matter and ignores the spectator's individual psychology and visual sensibility, was one which Fry shared briefly in the early 1920s, but which he was later to find inadequate. His chief criticism of Bell's theory in 1914 was, however, that his hypothesis rested on a circular argument: significant form is defined as that which arouses aesthetic emotion, and aesthetic emotion as that which is aroused by significant form. Fry realised that form in itself was not the constant in aesthetic experience, but that something had to be fused with it to give it significance; 'And is it not just the fusion of this something with form that makes the difference between the finest pattern-making and a real design? ... We should have to admit that this something, this X in the equation was quite inconstant, and might be of almost any inconceivable nature.'[21] If the notion of 'significant form' is considered from this point of view it becomes a far more elastic aesthetic doctrine than critics of Fry normally allow.

Though Fry later felt affronted, on several occasions, at Bell's appropriation of his ideas, in 1914 he admitted that Bell had arrived first at a theory of art towards which he himself was slowly moving, Bell having reached his conclusions with an assurance that Fry felt was denied him. Bell conveyed his ideas with startling clarity and journalistic punch. He made an approach, previously confined to aesthetic philosophers and an art-educated élite, assimilable to popular understanding, though his bold conclusions were occasionally reached too quickly, at the expense of reasoned argument. *Art* was understandable too, to the literary contingent in Bloomsbury and they were, from now on, able to share in the *mêlée* of aesthetic discussion. Indeed, the book contributed significantly to the extraordinary cohesion which the Group then enjoyed, and which

after the shattering experience of World War I they never, to quite the same extent, recovered.

At home and abroad, Bloomsbury effervesced with excitement; phrases and ideas seemed to hang quivering in the air; architecture, painting, sculpture and mosaics were discussed interminably and enthusiasm generated more than normal energy for sight-seeing. Two trips to Italy were made, in the spring of 1912 and 1913, and on the first of these Clive Bell observed that Fry was as much a marked man in Italy as he was in London, with acquaintances continually stopping him in the street. In 1912 they stayed in Florence at Henry ('Bogey') Harris' villa, where Vanessa had measles while Herbert Horne, who had been taken in by the owner of the villa, lay slowly dying in another room. They visited Berenson's Villa I Tatti, which Clive found full of Old Masters, mysterious contessas and unspeakable Americans. For Fry the second Italian trip was marred by a slight shadow on his relationship with Vanessa; she, feeling the need to re-establish her independence, would not always share his enthusiasms or follow his suggestions. Nevertheless, the trip was a success and Fry particularly enjoyed the visits to Toscanella and to Arezzo where he marvelled again at the frescoes by Piero della Francesca, a master of significant form.

On their return to England, in the summer of 1913, Fry, Grant and Vanessa Bell all painted Lytton Strachey, seated on the patio of the Woolfs' house, Asheham. Though working close together, their canvases highlight the differences in their temperaments.[22] Vanessa, who sat closest to the sitter, painted a half-length in a few sharp colours, turning Strachey's red beard chrome yellow. The portrait has a boldness and dash that verges on the loose and insubstantial but which confirms the burst of confidence she was enjoying at this date. Grant's portrait is less impersonal, revealing an amused and affectionate interest in the sitter. The colour is again bright and gay but there is a much greater interest in the brushwork which is deliberately used for decorative effect and he transforms the background flint wall into a series of tremulous arcs that enclose the sitter. In contrast to both these paintings, Fry's portrait at first sight appears passive, sober, deliberate and overtly restrained. Its chief quality is its careful, rhythmic interlocking of one part into the next, so that, like a jig-saw, every piece has the feeling of inevitability. Fry's personal talent lay not in the juxtaposition of bright colour, nor in the creation of decorative surface vibration, but in his instinctive feeling for the rhythmic arrangement of form.

Of the three artists, Grant was probably the first to begin using *papier-collé*. To begin with he applied pasted paper merely to establish the position of certain forms on the canvas and the paper was often obliterated with paint as the work developed. Fry and Bell also mixed the two mediums, Bell achieving a delicate balance between the two in her *Triple Alliance* (Weetwood Hall, Leeds) and Fry using a marbled paper

58 Roger Fry,
Duncan Grant and
Vanessa Bell
painting Lytton
Strachey at
Asheham in 1913.
Photograph

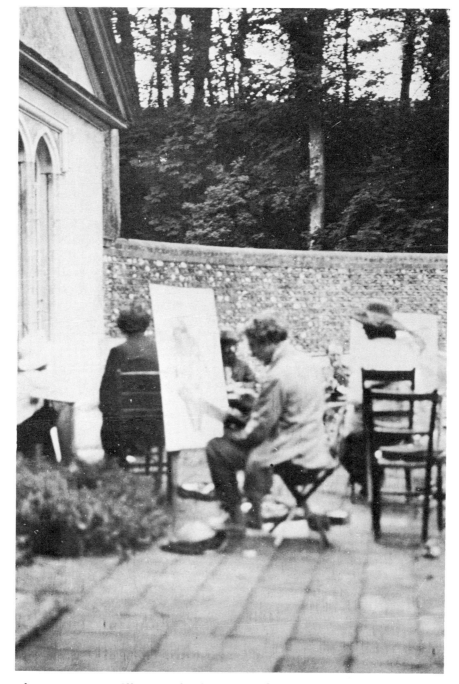

often as a mere fill-in in the background of a still-life or in his joke-portrait of Queen Victoria (Private Collection). None of these artists ever used this medium with the same clarity and wit as Picasso or Braque, even though by 1914 Fry owned two Cubist collages, one by Picasso, the other by Juan Gris.

167

Papier-collé, flat and autonomous even when incorporated into a picture, led to experiments with purely abstract shapes. If in the catalogue introduction to the Second Post-Impressionist Exhibition Fry had arrived at theoretical acceptance of abstract art, he was finally convinced of its effectiveness when he saw abstract paintings by Kandinsky at the Allied Artists Salon held at the Albert Hall in 1913. Paintings by Kandinsky had been exhibited at the Salon d'Automne of 1911 and the Cologne Sonderbund exhibition of 1912, but it was only now that Fry realised the innovatory significance of this master. He wrote: 'One finds that . . . the improvisations become more definite, more logical and more closely knit in structure, more surprisingly beautiful in their colour oppositions, more exact in their equilibrium. . . . They are pure visual music; but I cannot any longer doubt the possibility of emotional expression by such abstract visual signs.'[23] He began himself to experiment with abstract art, as in *Bus Tickets* (Plate 59), in which he incorporated two tickets in a layout similar to the Picasso *Head of a Man* which he owned.[24] His experiments with abstract forms were limited to a handful of works as were those of Grant and Bell. Lacking a conceptual base or philosophy with which to justify the forms used, the Bloomsbury artists never developed a consistent abstract language. Their most 'advanced' creation in this field was Grant's fourteen foot long scroll decorated with rectangular abstract coloured shapes, which he intended should be viewed through an aperture, as it was slowly wound past to the accompaniment of music by J. S. Bach, a gentle civilised equivalent to the interest in kinaesthetics also shared by the more aggressive Italian Futurists.

When Grant was asked in conversation why he had not pursued this exploration into pure abstract art further, he replied that none of his friends seemed interested in it and therefore he presumed it could have no lasting value.[25] This remark, undoubtedly only partly true, nevertheless reveals one of the more severe limitations of Bloomsbury artists. Instead of measuring their work against external professional standards, they tended to rely for support, criticism and encouragement on their friends, on the tastes and sympathies of a small, intelligent élite. This is less true of Fry than of Grant and Bell. However, a certain amateurism is apparent in all three artists' work, not least in their frequent use of whatever was available as a painting support, without much regard for the durability of the material. If Bloomsbury had been less inclined towards literature, it is just possible that these experiments with abstract art might have flourished more positively and taken root. Against this, it can, however, be argued that Bloomsbury painting is essentially concerned with the artist's personal response to the world around him, and that pure abstract art could never have held their attention for long.

Fry believed that by 1914 the small group of artists who had now gathered round him and who called themselves the Grafton Group, had developed to such a point that their art was no longer inferior to that of their French contemporaries. In January that year. the Group's second

59 Roger Fry: *Bus Tickets*, c.1915. Oil and collage on plywood, 36 × 26.5 cm. London, Tate Gallery

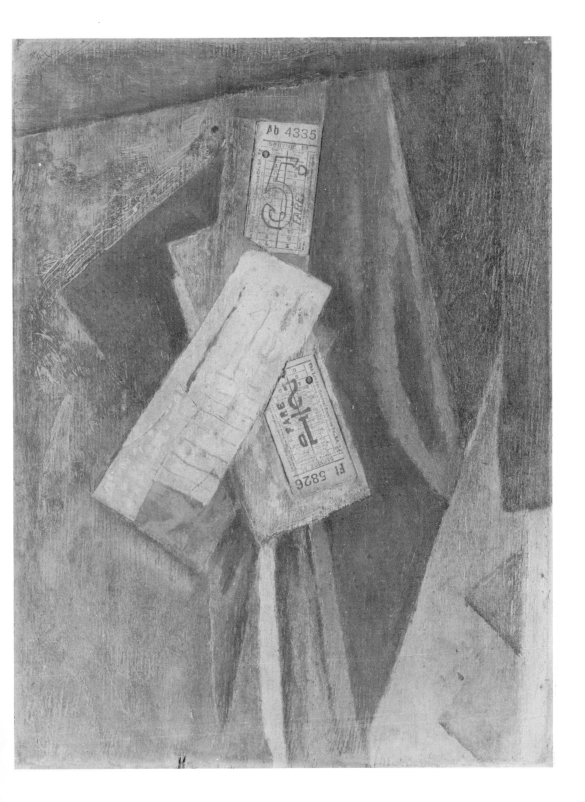

exhibition included work by the French artists Jean Marchand, Henri Doucet, Lhôte and Friesz, sent over by the dealer Charles Vildrac, as well as photographs of Picasso's recent sculptures and constructions, many of them made out of studio refuse, cardboard and string, and therefore too fragile to travel. Fry exhibited eleven paintings including *South Downs* (Plate 60) and a wood-carving of a mother and two children (Coll: Mrs Pamela Diamand), his only known venture into this medium. The painting that attracted the most attention was Grant's *Adam and Eve* (present whereabouts unknown) in which Adam was shown standing on his hands, a pose which naturally irritated those critics already aggravated by his wilful use of distortion for expressive effect. Fry, looking round the exhibition, happily concluded 'now we are beginning to construct real pictures'.(26) This was certainly partly true, but the critic T. E. Hulme (close friend of Wyndham Lewis, with whom Fry had recently quarrelled) thought otherwise; with his sharp perception, he recognised that the experiments of the previous three years had failed to arrive at a coherent, personal and truly modern language of art. He said of Fry's work that the artist had 'accomplished the extraordinary

60 Roger Fry: *South Downs*, 1914. Oil on panel, 43 × 59 cm. *Private Collection*

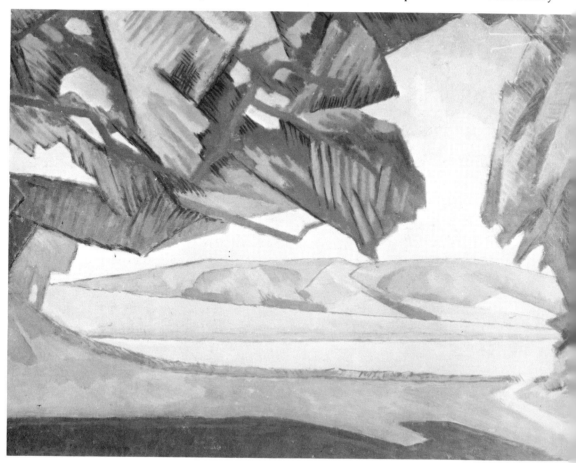

feat of adapting the austere Cézanne into something quite fitted for chocolate boxes'.[27] This judgement was unjust; not at this date nor any other did Fry's tenacious search for significant form become slick or commercial, as Hulme's criticism implies. Nor did any other critic share this opinion. On the whole the show was praised and, according to the *Pall Mall Gazette*, 'the chief delight of the exhibition lies in the landscapes of Mr. Roger Fry'.[28]

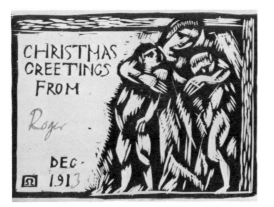

61 Roger Fry: Christmas Card, 1913. Woodcut

Around 1912 a tall, slim, dark-haired young girl named Joy Brown came to live at Durbins as governess to the Fry children. She was a Quaker and had a gentle voice, a sense of taste, and was a keen amateur photographer. She quickly became aware that the house and its contents reflected an exceptional personality, and taking out her camera she made the first photographic record of the interior, as it was soon after the Second Post-Impressionist Exhibition. The paintings then hanging on the walls were mostly French and included work by Lhôte, Vlaminck, Thiesson, and Marchand. On a plinth fastened to one wall was a Brancusi *Head of Mlle Pogany* and outside, mounted guard over the garden, was a semi-nude statue by Eric Gill. (An earlier, less discreet carving by Gill, commissioned by Fry, had been rejected as being incompatible with his sister Joan.) Gradually the French paintings in the main hall gave way to work by English artists, to Grant's *The Ass* (Private Collection), his *Seated Woman* and Etchells' *The Tub* (both now in the Courtauld Institute Galleries), and to Vanessa Bell's *Nativity* (probably destroyed). And in the entrance hall, three mighty nudes were painted by Grant, Bell and Fry in a crude distorted style that made no attempt to charm or please the eye. Indeed it is surprising that this vigorous example of English Post-Impressionism at its most uncompromising is still visible today, though the house has changed hands several times since Fry sold it in 1919.

Sadly, as Fry's confidence in English art grew, his relationship with Vanessa foundered. His love for her was unlike anything he had previously experienced. It had begun with his sheer exultation in her physical

beauty, in the swelling of her throat when she threw back her head, in the rhythm and line of her torso, hewn, as he thought, in great planes, and he experienced with almost physical delight small things like the movement of her head as she turned to look round. But this strong sexual attraction was married to his love of what he described as the beauty of her soul. He likened her to a calm lake which penetrates into rock and woodland and reflects on its surface the movement of the air, something clear, deep, equable, unruffled by gusts of vain caprice and having a profound allegiance to the centre of the earth. He struggled in his passion to describe her in words, only to regret that he lacked the verbal skill necessary to make permanent the essence of her beauty. 'There have been men, oh V', he wrote in a letter that may not have been sent, 'the very great men, in whom the spirit of beauty pushed with such sure and rhythmic flow that they could wring from dull words the power to ravish beauty such as yours from the grasp of all-devouring time.'[29]

During 1913 the relationship between them changed, due largely to Vanessa's complete return to health, her growing confidence in herself and in her work. Less dependent on Fry, she withdrew herself slightly, re-established a more stable relationship with Clive, and at the same time (to add to the confusion) found herself increasingly attracted to Duncan Grant. When Fry learnt that his equable lake had been less constant than he supposed, he was shattered. Vanessa partly blamed her change of affection on the recently opened Omega Workshops: 'I think in a way that did change things a good deal. It meant that I saw much more of you and in a very exasperating way. I think that seeing so much of me made you want me more . . .'[30]

Vanessa's break with Fry affected not just one part of him but his whole being as he found in her the key to that equilibrium of existence after which he constantly strove. 'Nessa I should be a real artist really truly and without doubt if I could draw you often because you have this miracle of rhythm in you and not in your body only but in everything you do. It all has the same delightful reasonableness and after all beauty is a kind of reasonableness you know. It means ease in all the things around you and in all your relations.'[31] Realising her importance in his life, Vanessa exercised diplomacy, edging him little by little from the centre of her life; only gradually did his full loss become apparent. Aware of Grant's homosexual inclinations, Fry could not believe that the love between Duncan and Vanessa would develop into a lasting relationship. But by November 1914 his position had become painfully clear, and after a brief period of happiness, which coincided with the excitement over Post-Impressionism, his life again lost its centre.

When in 1913 he wrote to his mother explaining his lack of official position and his outward failure, he argued that the loss of Helen had killed in him any desire for this kind of reward. This lack of ambition had given him a hidden strength over other men in his field. 'Any kind of success seems such a tiny thing compared with what I have lost', he

told his mother; 'and with that has come a kind of recklessness perhaps which has enabled me to say what I really think about art without considering the consequences.'[32] Between 1910 and 1914 he had overturned the London art world with his introduction of modern art to England; he had stimulated a wide range of artistic experiment and done more than anyone else in encouraging a growth in the appreciation of art. Even today his reputation still largely rests on the fame of his two Post-Impressionist exhibitions.

The optimism that lay behind Fry's achievement was part of a wider faith born at Cambridge and developed among the Bloomsbury Group: they felt they were in the process of creating a new society, free, rational, civilised and devoted to the pursuit of truth. With the onset of war this optimistic belief was shattered, the social conditions on which it was founded, destroyed. 'I really think it is time someone pointed out', wrote Vanessa Bell years later in 1931, 'that Bloomsbury was killed by the war'.[33]

9 Omega

During the summer of 1911 Roger Fry entertained the young French painter Henri Doucet at Durbins and commissioned from him a portrait of his daughter, Pamela, then aged nine. In accordance with the Bloomsbury belief that, given freedom, an individual would automatically find the right solution to any problem, Fry encouraged his daughter to adopt whatever position she wished. Pamela, flattered and most willing to co-operate, sat on the ground beside the lily pond with her legs stretched out in front of her and with some sewing in her hands. Before long her back ached and the pose became painful and difficult to maintain. But as both Doucet and her father had begun their portraits, she was duty bound to maintain this awkward position during morning and afternoon sessions for three to four days. Fry had also invited Duncan Grant to make use of this model, but Grant did not at first appear at Guildford as expected. When he did arrive, a day or two late, he explained that he had lacked the one shilling and sixpence necessary for his train fare from London until quite by chance he had found a florin in a drawer. He too began his portrait with Pamela in her difficult position, but quickly adapted it when the young girl unselfconsciously adopted a pictorially better and more comfortable pose during a break. Of the three portraits, Grant's is the most successful and when exhibited at the Second Post-Impressionist Exhibition it was favourably compared to the work of Vuillard (Plate 54).

Grant's delay due to his impecunious state drew Fry's attention to the hand-to-mouth existence led by many young artists whose work fell

outside accepted taste. It has been suggested that the incident gave rise to the idea of the Omega Workshops, where a young artist, in return for decorative and design work during three mornings of the week, could earn thirty shillings, nine shillings more than Fry paid his full-time gardener and therefore more than a living wage.

Soon after this Fry was asked to contribute to *The Great State*, a compilation of essays edited by H. G. Wells and others dealing with social progress in all spheres of life. He chose to discuss what economic conditions favour artistic production. Though he rejected the label 'socialist', he firmly believed that a greater distribution of wealth and its corollary – a lower standard of ostentation, would do much to improve the situation facing artists and designers. But he remained sceptical about state or corporation patronage. 'Indeed, the tradition that all public British art shall be crassly mediocre and inexpressive is so firmly rooted that it seems to have almost the prestige of a constitutional precedent'[1] – and because he saw freedom from restraint as essential to creative artistic production, he distrusted any all-embracing social or economic tyranny that would curtail this freedom.

Turning to the applied art of his day Fry asks the Ruskinian question – how far is the artist's creative energy and enjoyment in his work apparent in the end result? He takes for investigation the decoration of a railway refreshment room, and with detailed observation and an indignation worthy of his great Victorian predecessor, he describes the stained glass windows, lace curtains, the lincrusta wall-covering, the pseudo Greco-Roman moulding, the wall-paper imitating satin brocade, the printed tablecloths 'artistically' placed in a diagonal position on top of another, the pots, plants, tables, light-fittings and chairs. The variety of imitative techniques and styles involved and the heavy use of mechanised ornament make this a devastating catalogue of horrors. From this inventory Fry draws the following conclusion.

> Display is indeed the end and explanation of it all. Not one of these things has been made because the maker enjoyed the making; not one has been bought because its contemplation would give anyone any pleasure, but solely because each of those things is accepted as a symbol of a particular social status. I say their contemplation can give no one pleasure; they are there because their absence would be resented by the average man who regards a large amount of futile display as in some way inseparable from the conditions of that well-to-do life to which he belongs or aspires to belong. If everything were merely clear and serviceable he would proclaim the place bare and uncomfortable.[2]

Art, Fry realised, is valued by most people for its symbolic value, for the prestige, wealth or social status it implies. He therefore hopes that under the Great State, with its levelling of social conditions, a more genuine scale of values might develop. Increased mechanisation, if confined to structural needs, would create a new kind of rational beauty. 'But', he continues, 'in process of time one might hope to see a sharp line of

division between work of this kind and such purely expressive and non-utilitarian design as we call ornament; and it would be felt clearly that into this field no mechanised device should intrude ... since its only reason for being is that it conveys the vital expressive power of a human mind acting constantly and directly upon matter.'[3] This sharp division between design and decoration later became very apparent in Omega products. It is with the Omega in mind that Fry ends urging artists to turn more of their energies to applied art in order to purge fine art of its 'present unreality' and to give society 'a new confidence in its collective artistic judgement'.[4]

By December 1912 the idea for the Omega Workshops had fully crystallised. The title, being the last letter in the alphabet, was intended to imply 'the last word' in fashion. It offended the religious susceptibilities of Fry's family because of Christ's words – 'I am the Alpha and the Omega', and Logan Pearsall Smith criticised it sharply, for 'its suggestion of Eureka and other horrors',[5] but both opinions were ignored. Meanwhile, letters were sent out asking for financial aid; one, previously unpublished, to Bernard Shaw, contains a full exposition of Fry's intent:

> I am intending to start a workshop for decorative and applied art. I find that there are many young artists whose painting shows strong decorative feeling, who will be glad to use their talents on applied art both as a means of livelihood and as an advantage to their work as painters and sculptors.
>
> The Post-Impressionist movement is quite as definitely decorative in its methods as was the Pre-Raphaelite, and its influence on general design is destined to be as marked. Already in France Poiret's École Martine shows what delightful new possibilities are revealed in this direction, what added gaiety and charm their products give to an interior. My workshop would be carried on on similar lines and might probably work in conjunction with the École Martine, by mutual exchange of ideas and products. I have also the promise of assistance from several young French artists who have had experience of such work: but in the main I wish to develop a definitely English tradition. Since the complete decadence of the Morris movement nothing has been done in England but pastiche and more or less unscrupulous imitation of old work. There is no reason whatever why people should not return to the more normal custom of employing contemporary artists to design their furniture and hangings, if only the artists can produce vital and original work.
>
> The group of young artists who decorated the Borough Polytechnic a year ago have, I feel sure, the power to do this and have already formed the habit of working together with mutual assistance instead of each insisting on the singularity of his personal gifts. This spirit is of the utmost value in such decorative work as I propose, where co-operation is a first necessity. (...)
>
> I calculate that the total expenses of running this workshop will be about £600 or £700 a year. I require about £2,000 capital to give the scheme a fair chance; for at the end of three years it will be evident whether I am right in believing that there is a real demand for such work.

I propose to begin with those crafts in which painters can most easily and readily engage – the design of wall decorations in tempera and mosaic; of printed cotonnades; of silks painted in Gobelin dyes for curtains and dresses; painted screens; painted furniture. I hope to develop gradually the application of our designs to weaving, pottery and furniture construction.[6]

Fry adds that all the products will be signed with a registered trademark based on the Omega sign and that he has the promise of technical assistance from certain well known design firms. Shaw must have been convinced by the letter as he wrote across the top of the first page, 'Sent £250'.

By February 1913 Fry had found £1,500 and in April he took over the lease of 33 Fitzroy Square. This elegant Adam town house had good storage cellars, ground floor show-rooms and workshops on the first floor. The top floor was sub-let, bringing in approximately £120 a year. Work must have begun very early this year as by February Fry had already interested some cotton printers in his ideas for fabric designs and by March, at the first Grafton Group exhibition, decorative work was exhibited alongside the paintings. In May 1913 the company was officially registered under the Companies Consolidaton Act of 1908, with Fry, Grant and Vanessa Bell as directors and a nominal capital of £1,000. Everything was therefore ready for the official opening of the Workshops in July.

The recent, colourful success of the Russian Ballet in London helped make the Omega viable. Prior to 1913 the use of pure bright colour in interior decoration was unthinkable; heavy browns and greens and closely-patterned Victorian wallpapers, often covered with layers of preservative varnish, still lingered in people's homes. Those who had indulged in the 'aesthetic' taste, fashionable during the last two decades of the nineteenth century, had redecorated their interiors using lighter, tasteful pastel shades. Into this world of dinginess and restraint burst the Russian Ballet with exotic décors by Bakst, Gontcharova and others, introducing the fashion for hot, brilliant colours and for the art of dressing-up, both trends that were to be developed at the Omega.

If the Russian Ballet brightened the Omega's spectrum, the death of Fry's Uncle Joseph considerably brightened its prospects. His effects, at first estimated at £700,000, were resworn at £1,332,525 11s 3d. His will was immensely complicated and ran to nineteen pages. It began with his bequeathing his large silver inkstand to his nephew Albert Magnus Fry, and then continued with a list of small benefices to various individuals with whom he had had contact, even including the sisters, nurses and female domestics at Bristol General Hospital. Every single employee in the chocolate firm, J. S. Fry and Sons, was benefited, the amount varying according to their years of service. The will continued with a lengthy list of bequests to religious and philanthropic institutions and societies at home and abroad. Certain lump sums were made over to his

brothers and sisters and then the remaining money, stock funds and securities were made over or placed in trust for his thirty-seven nephews and nieces. The exact amount that Roger Fry received is not known but it is estimated that the invested capital brought him in an unearned annual income of at least £1,000 a year. Without this benefit, the Omega might not have survived the war because while the Workshops remained in existence they acted as a constant drain on Fry's financial resources.

On July 8, 1913, the Omega officially opened with the press and private view. On entering 33 Fitzroy Square the visitor met with a kaleidoscope of colour, applied in seemingly chaotic fashion to whatever was capable of receiving some form of decoration. In the large upstairs room (normally used as a workshop) hung a pair of hand-dyed curtains by the French artist, Henri Doucet, representing Adam and Eve in the Garden of Eden. He had employed crude hatching in purple, blue, green, crimson and yellow leaving the more traditional visitor convinced that this was nothing but pictorial madness. Doucet's distortion of the human figure was carried still further by Grant and Wyndham Lewis in two painted screens on display, in which unpredictable parts of the anatomy bulged while others were abnormally long and thin. 'But how much wit there is in these figures', Fry rounded persuasively on one reporter. 'Art is significant deformity.' Taking his cue, the same reporter began his piece, 'If you want to obey Nietzsche's dictum, "Learn, I pray you, to laugh", fill your house with Post-Impressionist furniture.'[7] It would have been hard for the visitor to detect any logical principles behind the exhibits, nor did they display any consistent 'house' style but seemed to draw freely on a whole range of styles and techniques. Yet the exuberance of the work created a unity of its own and the opening was a considerable success. Even the aristocrats present – among them the Countess of Drogheda, Lady Ottoline Morrell, Lady Desborough and the Princess Lichnowsky, the wife of the German Ambassador – maintained their equanimity, expressed enthusiasm and left orders. Princess Lichnowsky gave names to all the fabrics, naming one 'Mechtilde' after herself, another 'Maud' after Lady Cunard, and two others 'Margery' and 'Pamela' after Fry's sister and daughter.

The aims guiding Omega products were few and simple. Unlike William Morris's firm, the Omega had no underlying political motivation, nor was it, like the Bauhaus, an attempt to forge closer links between design and industry. Instead of imposing restrictions in order to arrive at a recognisable style, Fry simply wanted to give full rein to the artist's sensibility, hoping that his or her delight in its free play would be conveyed to the owner of the product. Instead of the Bauhaus' self-conscious seriousness, Omega products flaunt a sense of fun. They proclaim Fry's belief that art is essentially the product of joy. Some years later, when Helen Anrep entered his life, he wrote to her, 'How satisfactory it is that you enjoy things so intensely – I believe that that's the supreme moral quality provided that they're the right kind of things to enjoy'.[8]

178

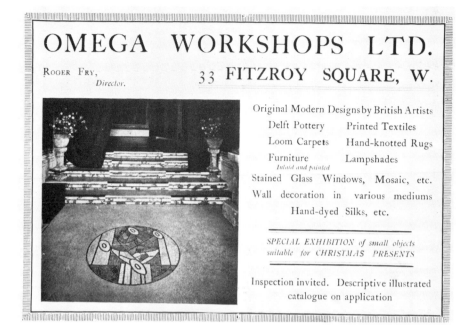

OMEGA WORKSHOPS LTD.

Roger Fry, *Director.* 33 FITZROY SQUARE, W.

Original Modern Designs by British Artists

Delft Pottery Printed Textiles
Loom Carpets Hand-knotted Rugs
Furniture Lampshades
Inlaid and painted
Stained Glass Windows, Mosaic, etc.
Wall decoration in various mediums
Hand-dyed Silks, etc.

*SPECIAL EXHIBITION of small objects
suitable for CHRISTMAS PRESENTS*

Inspection invited. Descriptive illustrated
catalogue on application

If exuberance was the first aim, the desire to avoid machine-made deadness and pretentious, expensive finish was the second. Fry declared that he wanted 'the spontaneous freshness of primitive and peasant work',[9] and, in keeping with this intent, he decided to sell at the Omega examples of the Manchester cloth made for export to the African market, as well as shawls and traditional peasant handkerchiefs that he had bought in Turkey. His distrust of 'finish' arose from his belief that it deadened man's imaginative life. When in 1913 he reviewed the Alma-Tadema memorial exhibition, he damned the artist not for his love of mawkish sentiment and domestic anecdote but for his love of polished finish: 'It [his art] caters with the amazing industry and ingenuity which we note in all Sir [Lawrence] Alma Tadema's work for an extreme of mental and imaginative laziness. . . . He gave his pictures the expensive quality of shop finish . . . an extreme instance of the commercial materialism of our civilisation.'[10] Not surprisingly, a furious debate ensued in the pages of the *Nation* where the review had appeared and Fry was accused by Philip Burne-Jones (son of the famous painter) of believing 'sordid ugliness and technical incompetence' an 'all-sufficient passport to applause'.[11] Sir William Blake Richmond entered the debate with the suggestion that society should boycott Fry.

Parallel to Fry's distrust of finish was his lack of interest in craftsmanship. The title 'Omega Workshops' has often given rise to the erroneous belief that Fry, like Morris, wanted to revive craft. On the contrary, anything requiring skilled labour was sent out to trained craftsmen and the actual work that took place at 33 Fitzroy Square was decidedly experimental. Wyndham Lewis recalled: 'Frederick Etchells

was I think the most technologically minded of us: but with no preliminary workshop training it was idle to suppose that half a dozen artists could cope with all – or indeed any – of the problems of waxing, lacquering, polishing, painting and varnishing of furniture – chairs, tables, cabinets and so forth – or the hand-painting of textiles which the plan involved.'[12]

Omega artists, therefore, concerned themselves more with decoration than with design. Most of the furniture was bought ready made and then painted. Chairs and tables were selected for their unpretentious functionalism. A rush-seated wooden-backed chair designed by Ernest Gimson was ordered by the Omega from the firm of Edward Gardiner, at Priors Marston, near Rugby. Another very simple, straight-backed, cane and wood chair was made to Fry's own design by the Dryad Company at Leicester. Both chairs on arrival would be covered with gesso (parchment size and whitening cooked in the basement by the caretaker), and then sand-papered down ready for painting, favoured colours being indigo blue and Venetian red. When one day someone brought to the Omega a Roorkhee chair, as used by the Indian army and which could be taken apart and packed up, Fry immediately imitated its design, substituting leather for the canvas seat and back. It enjoyed a vogue during the war years, as did the Omega black velvet-covered

63 Roger Fry seated in an Omega chair. Photograph taken by Robert Tatlock, c.1920

180

settee which made an excellent background for brightly coloured cushions.

One decorative language distinctive to the early years of the Omega is semi-Cubist in style. It perfectly suited the technique of marquetry where different facets could be picked out in different coloured woods. Three trays were designed in this medium, one by Duncan Grant based on an elephant, another by the young sculptor, Gaudier-Brzeska, using a favourite motif of his – two wrestlers, and a third by Vanessa Bell, a little later in date, using an abstract design. But the Cubist influence had its most dramatic effect in the fabrics where for the first time in England an abstract Cubist patterning (since hideously vulgarised) entered applied art. The results are startlingly fresh and original and in their day contrasted greatly with Morris's tight, medieval, floral designs. Here design and decoration came together and the artists were not troubled by the need to adapt a motif to a given object. Fry insisted that

64 Omega writing desk, 1913. Inlaid design by Duncan Grant (?) Present whereabouts unknown

the irregularity in the artist's initial design (expressive, as he thought, of human sensibility) should not be stamped out by the mechanical regularity of the machine. He had great difficulty at first in finding a manufacturer that would preserve the spontaneity and freedom of the originals, but eventually discovered the firm Besselievre at Maromme, to the north-west of Rouen. Meanwhile Omega carpets, to which the same problems applied, were loom-woven by Wilton, but hand-knotted rugs were also sold, made from designs drawn up on graph-paper, each square relating to a knot of wool. Bold abstract patterns and strong colour made these rugs and carpets unequalled in England until the 1920's. They depend for their success on slightly imperfect geometry, the imperfections reflecting the artist's subtle manipulation of the abstract language. One rug, for instance, had at its centre a large irregular red oblong, which earned it the unfortunate title 'The Pool of Blood'.

If Fry favoured simple geometry in Omega designs, one principle on which he insisted, in accordance with workshop practice, was anonymity: no piece of work was ever signed with anything other than the Omega stamp and all designs were stored anonymously in a communal folder. He believed this would encourage experiment as in fact it did. Often

65 Amenophis. Omega fabric designed by Roger Fry

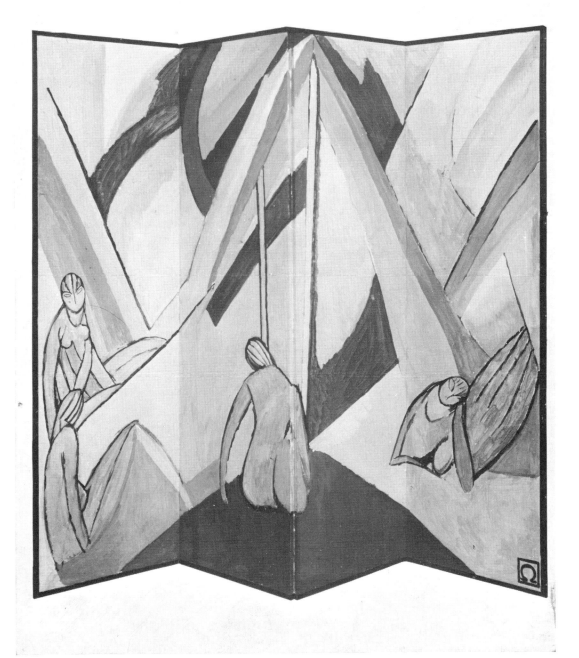

66 Omega screen
designed by
Vanessa Bell.
*London, Victoria
and Albert Museum*

183

the larger and more inviting the surface the bolder and more daring the result. Screens and large table-tops invited colourful, free experiment and one of the most flamboyant Omega products is the Lily-Pond screen (Victoria and Albert Museum) executed by Duncan Grant. The initial idea was based on Fry's lily-pond at Guildford, but after Grant had mixed his paints ready for use, Fry suggested that to give the design spontaneity he should simply pour on the paint straight from the cans and only vaguely push it into position with the brush. In the end result lilies, water and goldfish merge into a whirling mass of soft abstract shapes, still somehow suggestive of the shifting patterns of colour and light created on the surface of the pond.

No object, however, was too small for decorative consideration nor did the workshop restrict the range of items sold. If a child's high-chair was required, one was hurriedly found, painted, stamped with the Omega trademark and sold. An onslaught of colour attacked hand-carved and painted lamp holders, lamp shades, pottery, men's ties, boxes of every shape and variety, fans, umbrellas, jointed wood toys, Christmas cards and menu cards, while necklaces, handbags, and opera bags were also on sale. On a small scale the artist's personal style often struck just the right intimate note: a fan could be flicked open to reveal a witty motif, simple yet pungent, or a parasol unfurled to reveal a delicate, abstract design.

67 Showroom at the Omega. Photograph

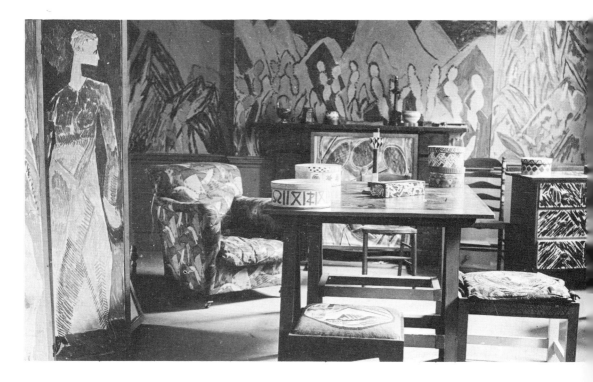

Fry's haphazard open-ended approach proved stimulating to Omega design but less advantageous to the smooth running of its administration. At first artists were paid as and when they appeared – if cash was available. But soon after the official opening of the Workshops some semblance of order was instituted when Mr Charles Robinson was appointed manager and thereafter artists were paid regularly, on Fridays. A bald man with a sandy beard, he was regarded by the female workers at the Omega as a rather romantic figure, having at one time run an ostrich farm in South Africa and been married twice to the same girl (some legality having been omitted from the first ceremony). He only stayed at the Omega a year, leaving towards the end of 1914 to join the Friends' War Victims' Relief Fund in Corsica, but his devotion to the Workshops was only surpassed by that of Mr Miles, the caretaker, who went so far as to name his son Arthur Omega Miles.

If the Omega began with an excellent start, scarcely four months had passed before it was riven with dissent. Fry had succeeded in attracting to his venture an impressive array of young artists, including Gaudier-Brzeska, William Roberts, Edward Wadsworth, Cuthbert Hamilton and Frederick Etchells, all of whom were later coerced (not without protest) into Wyndham Lewis's Vorticist movement. The critic William Lipke has discovered in some of the Omega's semi-Cubist designs and in the letter-heading on the Omega notepaper (attributed to Wyndham Lewis) a 'proto-Vorticist' style. Certainly, these young artists made a significant contribution to the Workshops and when, in the autumn of 1913, Lewis, accompanied by three others, withdrew his support after a row with Fry, the Omega suffered a severe loss of talent.

The quarrel concerned the *Daily Mail's* commission to decorate a room for the 1914 Ideal Home Exhibition. The newspaper had asked the critic P. G. Konody to make recommendations, and as Wyndham Lewis and Spencer Gore had recently completed some extravagant, colourful decorations for Madame Strindberg's nightclub, The Cave of the Golden Calf, he put forward their names together with that of the Omega. Gore was then asked to see an agent connected with the Ideal Home Exhibition and from his interview learnt that the commission was given to himself, Lewis and the Omega. He went straightway to the Workshops after the interview, found both Fry and Lewis out, and left a message with Duncan Grant. According to Fry, no message from Gore ever reached him. Grant, when questioned about the matter many years later, could not remember whether he had passed the message on or not and expressed surprise at hearing that Gore had initially been offered part in the commission. Having left the message in July, Gore, rather surprisingly, did not reappear at the Omega until September, nor did he attempt to contact Fry in order to discuss the commission.

In the meantime Fry had received a letter from the *Daily Mail* giving

the commission to the Omega. The misunderstanding that now developed may have been assisted by two factors: first, the artists connected with the Omega were an amorphous group, free to come and go as they pleased, and the *Daily Mail* may have assumed that Gore like Lewis was associated with the venture and therefore thought it unnecessary to mention him by name in the commission; secondly, Fry's letter came from Carmelite House, the offices of the *Daily Mail*, and not those of the Ideal Home, and its author was probably a different person to the agent with whom Gore had initially discussed the commission.

Lewis heard that this important commission had been given to the Omega. He asked what his contribution should be and Fry suggested that he should undertake the carving of the mantelpiece. Fry himself willingly turned his hand to any design problem, but Lewis felt offended by this suggestion as carving was not his métier. According to Lewis, he then asked if the walls of the showroom were to be decorated and received from Fry the off-hand reply that they were only to have 'a few irregular spaces of colour'. On his return from his summer holiday in France he was annoyed to find instead of the irregular spaces of colour, large decorative murals based on dance movements and no doubt inspired by the Russian Ballet. Lewis inferred from this that Fry had deliberately lied about his intentions; it did not occur to him that during the course of the summer the initial idea might have been revised.

Lewis's suspicion of Fry was not totally unwarranted. After the Second Post-Impressionist Exhibition closed in London, Fry had sent fifty-two works by French and English artists to Liverpool. He had approached all the English artists involved to see if their work would be available for the Liverpool show, except Lewis. His explanation for omitting to ask Lewis was that he simply forgot. Secondly, in October 1913 Frank Rutter organised a Post-Impressionist show at the Dore Gallery in London and wrote to Fry asking if Etchells had any work available for this show. According to Lewis, Fry, without asking Etchells, replied that he had none available, nor would have any until the following year. Another letter from Rutter to Lewis, concerning the same exhibition, never reached Lewis having been mixed up – it appears mistakenly – with Fry's papers.

Lewis, infuriated by the handling of the Ideal Home commission, made mention of the above two issues in the 'Round Robin' letter which he composed to exorcise his fury. This letter, which was sent to all the Omega's friends and patrons, reveals how deeply antagonistic Lewis had become to the way the venture was run: '... its Shows are badly organised, unfairly managed, closed to much good work for petty and personal reasons, and flooded with the work of well-intentioned friends of the Direction.' Then, drawing up on his singular ability to write vitriolic, bombastic prose, he proceeded to criticise the Omega's aesthetic.

As to its tendencies in Art, they alone would be sufficient to make it very difficult for any vigorous art-instinct to long remain under that roof. The

Idol is still Prettiness, with its mid-Victorian languish of the neck, and its skin of 'greenery-yallery', despite the Post-What-Not fashionableness of its draperies. This family party of strayed and Dissenting Aesthetes, however, were compelled to call in as much modern talent as they could find, to do the rough and masculine work without which they knew their efforts would not rise above the level of a pleasant tea-party, or command more attention.

It was, however, less a conflict of taste and more a clash of personalities that lay behind this tirade of abuse. Lewis was too egotistical to care for the Omega ruling about anonymity, and Fry, unbusinesslike and vague, clearly neglected to ensure that all his artists felt they were fairly treated. Not surprisingly, Lewis ends his 'Round Robin' with a personal attack on Fry: 'But a new form of fish in this troubled waters of Art has been revealed in the meantime, the Pecksniff-shark, a timid but voracious journalistic monster, unscrupulous, smooth-tongued and, owing chiefly to its weakness, mischievous.'[13] The letter was signed by Lewis, Etchells, Hamilton and Wadsworth and ended with the announcement that all four were withdrawing their support from the Omega. Prior to this letter a sharp exchange had taken place between Lewis and Fry on the first floor at 33 Fitzroy Square which ended with Lewis clattering downstairs and slamming the front door.

In between the verbal disagreement and the appearance of the 'Round Robin' letter, Fry, having attempted to clear his name with Gore, left for a previously planned holiday in and around Avignon, where he intended to paint with Henri Doucet. The imbroglio that followed upon the appearance of the 'Round Robin' letter has been traced in detail by Quentin Bell and Stephen Chaplin, and by Richard Cork.[14] In brief, Vanessa Bell, who had been left in charge of the Omega, obtained from the *Daily Mail* a letter stating that the commission had been given to 'Mr Roger Fry without any conditions as to the artists he would employ', and with this Fry could have successfully taken Lewis to court. His Quaker pacifism led him to maintain an infuriating silence. To Shaw, Fry wrote: 'I thought it [the Round Robin] bore such internal evidence of its entirely imaginary nature that it would be [a] waste of time to contradict it, though I have a letter from the Daily Mail which completely disposes of their suggestions. As you've been so much interested in the Omega you may like to hear that the defection is really fortunate as only one of those four artists has been of any real use.'[15] Fry, referring here to Etchells, may have been underplaying this dispute which has fascinated recent historians, but even Lewis felt it merited scant mention in his autobiographical writings. He recalled, 'certain transactions of a disagreeable nature caused me to sever my connection with the Omega, and as there is no purpose in returning to such matters here I will pass on to my next milestone ...'[16] On leaving, he set up the Rebel Art Centre in competition with the Omega but after only a few months the venture collapsed. As William Roberts, another Omega artist, cannily observed, 'This was not a dispute of two erudites over a subtle point of

aesthetics but a clash between rivals for the profits of the English interior decorating market'.[17]

In the long term, the loss of Lewis and his followers was more damaging to the Omega than Fry at first admitted. These four artists had kept an eye on recent European developments and had endeavoured to translate the excitement and ideas found in avant-garde art into their designs. Drained of this talent, and also that of Roberts and Gaudier-Brzeska who left to take part in the war, Omega products during the next few years lost something of the crispness and dynamic that had characterised the early designs. In March 1916 Duncan Grant and Vanessa Bell withdrew to Wissett Lodge, a Suffolk farmhouse near Halesworth where Grant, a conscientious objector, could undertake agricultural work. After this, all the important decorative work at the Omega fell largely on Fry, Nina Hamnett, and her husband Roald Kristian.

Nina, a natural bohemian, found the Omega's unconventional approach well suited her nature. As a painter, however, she inclined towards emphatic, often rigid compositions and careful realisation of form, qualities ill-suited to decorative work. Less is known about Roald Kristian and from the few designs in the Victoria and Albert Museum attributed to him, it appears that he had come into contact with German Expressionism, particularly that of Franz Marc, as he was fond of executing animal designs in an angular style. Neither artist made up for the loss of Lewis, Etchells or Gaudier-Brzeska; and though Omega products are often difficult to date with any certainty, the work produced during the war years tends to be darker in colouring, denser in texture and heavier in design, in marked contrast to the often dazzling clarity and rhythmic brilliance of the pre-war objects and fabrics.

As early as March 1914 the venture had run into financial difficulties. Fry informed Bernard Shaw that the initial capital was entirely used up and that though he himself was putting in another thousand pounds, more was still needed from other sources. Shaw, in his previously unpublished reply, gave his assessment of the Workshops, making particular reference to the angular designs of figures dancing that hung, rather incongruously, in the two niches either side of the first floor window on the façade of 33 Fitzroy Square.

Dear Roger Fry,
The balance sheet is eminently sportsmanlike; and if you really think when you return from your holiday that you can safely venture £500 in the concern, you may possibly persuade me to make it up to £1,000. I looked in at the Workshops one day, and even went the length of buying intarsia which struck me as cheap. I am not quite so convinced about this now; for I regret to say that the artificer, not having had the opportunity of being apprenticed to the people who did the intarsia work at Bergamo cathedral, does not know all the secrets of the trade. His beautiful surfaces are beginning to burst up as if a traction engine has gone over them; and my wife has naively proposed to send the plate back to get it set right.

68 Nina Hamnett
(right) and Winifred
Gill modelling
Omega dresses with
Omega fabrics on
display on the wall behind

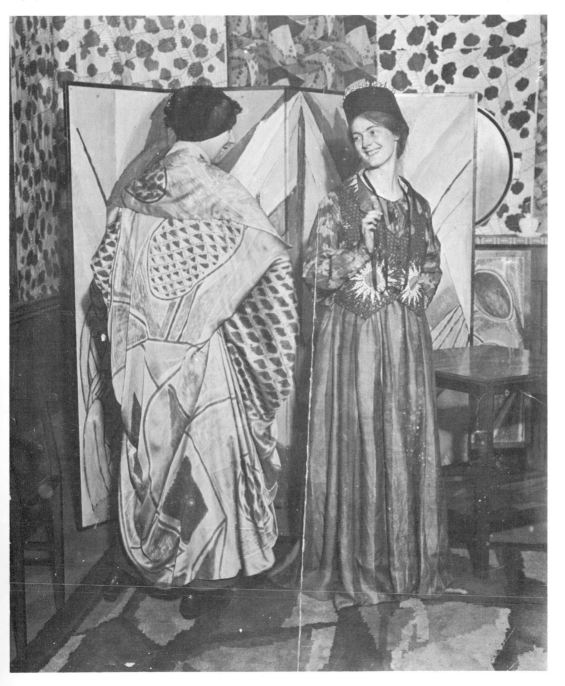

And indeed it might be as well to let the hopeful reviewer of the lost art see what happens when his slices of wood begin to blister and curl up. I think the fabrics and bit of carpet which they showed me extremely good; but the painted table tops and one or two other efforts in the same direction seemed to me simply foolish. The place retains a true Fitzroy Street squalor and will have to be pulled together a little in that respect, as business will have to be done mainly with the more fastidious sort of millionaire. The exterior decorations are unkind. That noble façade which is the glory of the square may not be in your line; but why insult it?

Still, with all the drawbacks, I think you have enough designing power to pull through. But you will need above all things a shop window. Morris found that out. It is all very well to live in a quiet London square and look like an Orthopaedic Institute, but the price you pay is that your business remains the secret of a clique.[18]

69 The Cadena Cafe, Westbourne Grove, showing Omega pottery, wall decorations, lamps and painted tables

Shaw's astute letter points to a central weakness in the running of the Workshops: apart from the signboard by Duncan Grant that hung over the front door and the odd notice in the *Burlington Magazine* and the

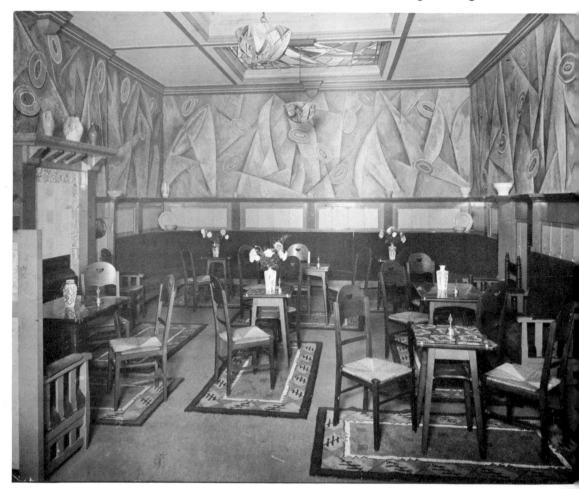

Art Chronicle, Fry made no attempt to advertise. It is not surprising that by October 1914 the Omega still failed to cover its running costs. Two years later Fry's accountant pointed out that it was not even making half the necessary amount needed to cover its outgoing expenditure.

Financial failure did not prevent the Omega from enjoying a number of small triumphs. Fry was particularly keen to decorate complete interiors. The Cadena Cafe, 59 Westbourne Grove – an early commission – was given a dramatic abstract mural possibly inspired by Severini's abstract experiments with light (Plate 69); Lady Ian Hamilton ordered bold stained glass and mosaic floor decorations for her house, No. 1 Hyde Park Gardens; Henry Harris entrusted a room at 17 Bedford Square to a complete decorative venture designed by Grant, Bell and Fry, and Arthur Ruck who lived at 4 Berkeley Street had his landing painted in 1916 with scenes of London life, by Fry, Nina Hamnett, Roald Kristian and Madame Courtney.[19] The Berkeley Street decorations were closer to mural paintings than decoration, the subject being treated in a style akin to poster design; light and shade were suppressed, and plasticity suggested purely through contour. The prominent use of the London Underground sign may have been inspired by Sickert's *Queen's Road, Bayswater Station*, (Courtauld Institute Galleries), a painting exhibited at The Carfax Gallery this year and shortly after acquired by Fry. Of all these decorative ventures, none was as important for the firm as Madame Lalla Vandervelde's commission to have her entire flat decorated and furnished by the Omega, because being the wife of the Belgian Ambassador, she entertained a great deal, herself acting and reciting at her soirées to raise funds for Belgian refugees.

The element of the bizarre in Omega products meant that they appealed mainly to an élite, freed either by intelligence or money from more conventional taste. When, therefore, in 1917 Fry set up an evening club to introduce refugee musicians and artists to a London audience, he had no difficulty in persuading Yeats, Arnold Bennett and many others to attend. Initially six entertainments were planned and the charge for attendance was reduced if the visitor came to more than two or three. Large cushions filled with straw improvised as chairs and refreshments were provided – petits fours, sandwiches made with Gentleman's Relish, tea, French coffee and lemonade. These were organised by the female assistants headed by Margery Shearer and all would retire to an upstairs room beforehand to make the necessary fundamental reconstruction to their Edwardian underwear before they could don low-necked dresses. On one occasion Fry entered the room to discover four of them in a state of almost total undress. Surprised and apologetic, he added, 'However, as I am here Miss Shearer perhaps you would tell me where the Address Book is?'[20]

On one occasion the famous 'cellist Madame Suggia performed and in the course of the evening a small fire broke out on the roof. The manager exercised such discretion the audience never knew of this

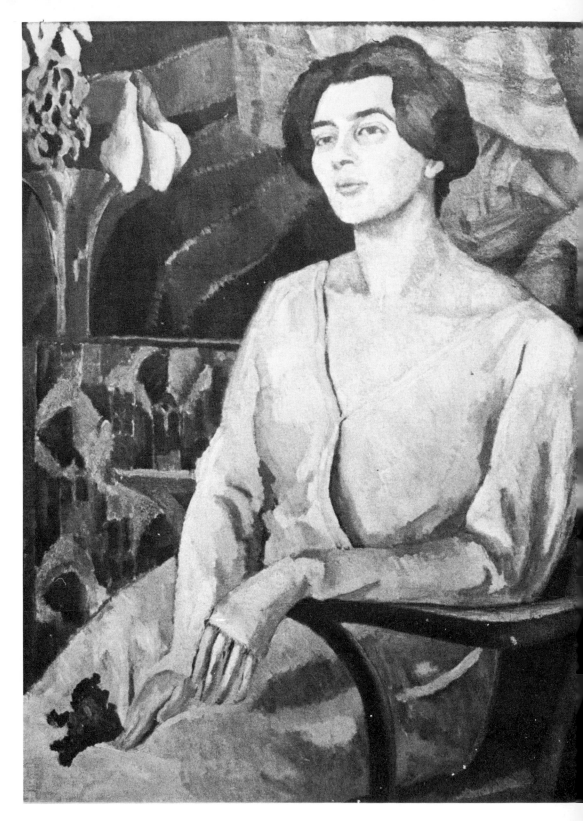

70 Roger Fry:
Madame Lalla
Vandervelde, 1918.
Oil on canvas,
89 × 68.5 cm.
Belgrave Gallery,
London

event, as the firemen who had to walk past an open door removed their helmets before mounting the stairs to avoid causing alarm. Another memorable evening saw a performance of Debussy's *Boite à Joujoux* with puppets and set made by Omega artists. Over all these activities resided, undisturbed, Eva Gore-Booth who lived in the top flat with her friend Miss Roper. But then even the war left her relatively unmoved; being devoted to the women's cause, she was capable of typing energetically throughout an air-raid.

As the war proceeded a camouflage look began to spread over Omega products. On certain pieces of Madame Vandervelde's furniture a great deal of yellow ochre was freely stippled over a black ground. These darkening colours coincided with a desire for more solid design, a change partly brought about by an exhibition Fry organised at the Workshops in 1917 entitled 'Copies and Translations of Old Masters' to which Omega artists were invited to contribute. After this colour was more often applied to fill in a given area, than for experimental effect.

71 Madame
Vandervelde's bed,
decorated by Roger
Fry. *London,*
Victoria and Albert
Museum

One aspect of Omega production unaffected by war was its ceramics. Of all the various branches of design, it was pottery, Fry felt, that suffered most from industrial commercialism: 'Our cups and saucers are

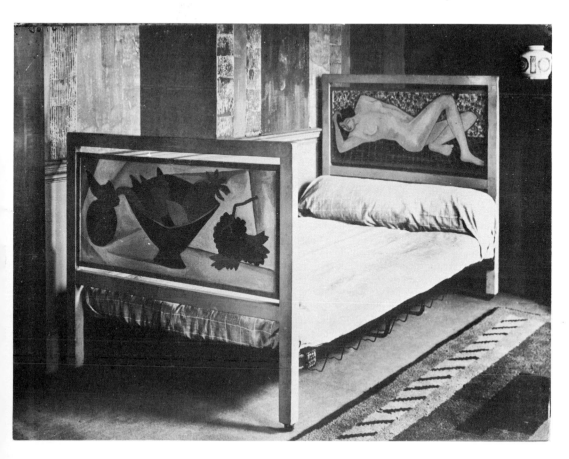

193

reduced by machine turning to a dead mechanical exactitude and uniformity. Pottery is essentially a form of sculpture, and its surface should express directly the artist's sensibility both of proportion and surface.'[21] At the start, Fry had bought commercially made pottery and then decorated it at the Omega with an over-glaze, which, some customers complained, tended to wash off. After this, he found a potter's workshop at Mitcham and would travel down on the No. 88 bus in an attempt to get the man in charge to produce the shapes he desired. The un-named potter found his hands controlled by habit and unable to produce the required shapes, so Fry taught himself to throw and the man allowed him and Vanessa Bell to produce their own pots. This arrangement worked well until the potter was called up and the premises changed hands. Fortunately, Fry's ex-secretary and fellow worker at the Omega, Winifred Gill, then introduced him to the Carter family who owned a pottery at Poole where he developed his natural talent for the medium; his subtle feeling for form led him to discover the sculptural shapes he desired and his designs for tea and dinner services were then mass produced from moulds, in white, dark blue or black. The plates were thick and mysterious-looking, and had the irregularity of surface on which Fry insisted. When the pottery had to be decorated, with figures, flowers and fruit or simple geometric patterns, Fry normally left the painting to Grant and Bell, and himself preferred subtle glazes of a single hue imitating either celadon or *sang de boeuf*, inspired by the Chinese example. For some, the results were merely imitative; Harold Acton thought them 'the products of scholarly amateurs who had studied

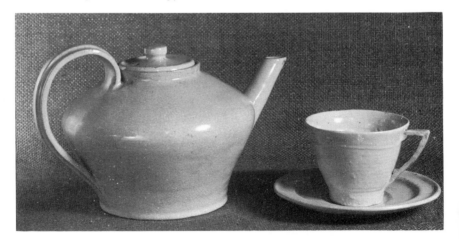

72 Teapot, cup and saucer made for the Omega by Roger Fry, c.1915. *London, Victoria and Albert Museum*

archaeology in the British Museum'.[22] But one expert from this museum told Fry, at the time, that in his opinion Omega pottery was better than any other then being produced in England.

The Omega Workshops fit uneasily into the history of design, A certain anarchical element annoyed Lewis and others at the time, and continues to irritate design historians and museum officials today. 'What

is interesting and to me rather surprising is the intense hatred it arouses among the collector and art historian and generally over-cultured circles,' wrote Fry to Bernard Shaw in 1914. 'I hear that the Burlington Fine Arts Club spends its time abusing me – the more friendly ones excusing me on the grounds of insanity – and yet not one of them has ever been to see what we are about. I think perhaps it's a sign that we've got hold of something real ...'[23] Compared to the later Bauhaus, the Omega lacked direction and professional commitment; instead of making good design more widely available, its products sold to the few who could afford to be avant-garde and *outré* in their taste. It did however share in the new twentieth-century desire for greater simplicity in design and when in 1915 the Design and Industries Association was set up to promote 'fitness for purpose' and 'an efficiency style', neither aim was antagonistic to Omega but already reflected in certain of its products.

It is not, however, for its radical re-investigation of the principles of design that Omega is appreciated today. Its most original contribution lies in its hand-made, creative quality, its preference for the display of human sensibility rather than the display of wealth. The anti-material-ism, exuberance and energy expressed in an Omega design are aspects of Fry's character and indicate the extent to which the venture was his own personal achievement. The emphasis on delight inevitably encour-aged a certain flippancy: Omega crotcheted hats and garish, even erotic, hand-made paper flowers enjoyed a vogue towards the end of the war; and practical commercial considerations never controlled the method of production. At its best Omega expressed Fry's belief, that 'the greatest art has always been communal, the expression – in highly individualised ways no doubt – of common aspirations and ideals';[24] at its worst it resulted in an amateurish dabbling with dissonant shapes and hues.

On a personal level the Omega had immense significance for Fry. The experience of working daily with other artists, the constant need to adapt a motif or design to suit a given object developed in his own painting a greater fluency and assurance. During the war years he arrived at a style, best seen in his still-lifes and portraits, that is both personal and confident, and which had taken him almost thirty years to achieve.

10 The War Years

As pacifists, the Bloomsburies refused to share in the wave of patriotism that swept the country after the declaration of a war which they regarded as merely an illogical disruption. Clive Bell took action and wrote a pamphlet entitled 'Peace at Once' which was suppressed by order of the Lord Mayor of London. After the introduction of the Conscription Bill in January 1916, they were all involved in the anxiety this caused, and Fry, sharing Vanessa's concern about Duncan Grant, did everything in his power to prevent him being called up. (Fry himself was exempt from military service due to age.) Bloomsbury managed to survive the war physically unscathed, but they could not escape the heavy psychological pall cast by war on everyone and everything. From friends in high places Fry heard tales about the bungling of the old-guard generals, making the tragic slaughter seem even more senseless. Yet while his friend Dickinson despaired utterly, he could observe with some bitterness to Vanessa Bell, 'I've known since Helen that the world was made of the worst conceivable horrors'.[1]

Fry's resilient temperament perhaps suffered less from the war than from his loss of Vanessa, as this affected the innermost part of his being, and, as he noted with dismay, temporarily unsettled his position in the Group. 'In painting Nessa and Duncan have taken to working so entirely together and not to want me', he ruefully told Clive Bell in 1915, 'and altogether I find it difficult to take a place on the outside of the circle instead of being, as I once was, rather central.'[2] To take his mind off

this fact, in the spring of that year, Fry crossed to France to visit his sister Margery, then working for the Quaker War Victims' Relief Fund in the districts of the Marne and the Meuse.

He arrived to find the area badly ravished, and helped briefly with relief work, the building of temporary huts, the distributing of seed, repairing of agricultural machinery and the like, but soon found that philanthropic work ill suited his temperament. Borrowing a bicycle he set off on a tour of the region, afterwards writing an account (never published) of what he saw.

In each small town that he visited, he was struck by the tenaciousness with which the inhabitants clung to the remnants and routine of their daily lives. At Sermaize, though the town had been razed to the ground, the people were still living in the cellars used for storing the champagne of the district. Wherever a piece of tubing stuck out from the ground emitting smoke, life continued. 'The full wonder of it', Fry recorded, 'becomes apparent on Sunday afternoon when all Sermaize turns out as of old to promenade the high street. There is something heroic in the inveterate bourgeoisie, for they emerge from their warrens more tidily, more smartly and more fashionably dressed than their social equals in an English country town. And how black and startling the crowd looks in these broad white streets where no shadows can fall, where all is flat beneath the white spring sky.' He continued his journey, from Sermaize to Bar le Duc, stopping at each ruined village as he went. At Nettancourt he received a letter from Rose Vildrac asking him to visit her husband Charles, the poet and art dealer, who was at the front at Auzéville. Having already lost a friend, for whom he had great affection, Henri Doucet, through the war, Fry made every possible effort to see Vildrac, whose writings he admired, but his attempts, which nearly led to his arrest as a spy, failed. This experience and that of the ruined towns and landscape left him with a feeling of helplessness: 'One can never do the sum even for oneself, it always begins to step back into the abstract, to become mere history, there is no calculus for human suffering. Still less can one convey it to anyone who has not got even so far towards the inner experience as I have.'[3]

After this tour of inspection, he put up for a few days in Paris before leaving for the South, where he had an invitation to stay with Simon and Dorothy Bussy at their villa, La Souco, at Roquebrune. Travelling down and stopping at Cassis on the way, he reflected that the Midi had now become his spiritual home. 'I know quite well whenever I get to this mediterranean country that I ought never to leave it', he wrote back to Winifred Gill at the Omega. 'It all seems just right, the right kinds of colours and shapes everywhere.'[4] The Bussy's villa looked out over the sea, across Roquebrune to Monte Carlo, and Fry sat on the terrace painting the view. Staying nearby was the Belgian artist Jan Vanden Eeckhoudt, a friend of the Bussys and of Matisse, and he encouraged Fry to adopt a brighter, more Fauve-like palette. Using pure vermilion, magenta, ultramarine and orange among other colours, Fry painted a

number of pictures, manipulating this uncongenial palette with varying success. Eeckhoudt's daughter, Zoum, and Lytton Strachey's sister, Pippa, who was also staying at La Souco, were invited to sit for their portraits, Pippa being placed beside some bright nasturtiums. Of the paintings produced under Eeckhoudt's influence, perhaps the most successful is *View of the Côte d'Azur* (Courtauld Institute Galleries).

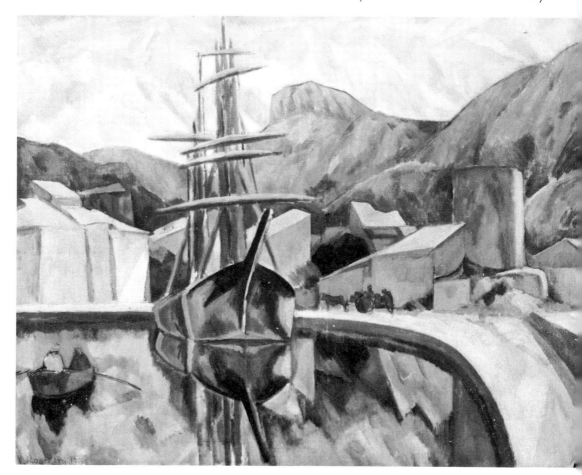

73 Roger Fry: *The Harbour, Cassis,* 1915. Oil on canvas, 70.5 × 90 cm. *Glasgow City Art Gallery*

Fry's willingness to tackle new styles during this summer reflects his need to abandon himself in his painting in order to forget Vanessa. While his eyes devoured the external world before him, his inner well-being was sustained by Pippa Strachey. Like all her relations, Pippa was unashamedly intellectual, but, instead of the Strachey coldness and reserve, she had a spontaneous warmth of character and was not unattractive. Intelligent, enthusiastic, effervescing with ideas, she was also exceptionally clear-sighted, tolerant, sceptical, and was to spend the greater part of her life working for the women's cause. Between her and Roger there developed at Roquebrune, if not an affair, an *amitié amoureuse*, and when it was time for him to leave, Fry wrote to her from the

nearby Ste Maxime, 'you gave me a kind of new belief in myself, in my power to create life around me, which I thought was gone altogether'.[5]

The holiday had been for Fry, therefore, both restorative and productive. In November of 1915 he exhibited at the Alpine Club Gallery, in a one-man exhibition, fifty-four of his recent paintings, the majority of which had been produced during the previous few months. Portraits and landscapes dominated the show but among these could be discovered three works entitled 'Essay in Abstract Design', one of which was probably the abstract collage *Bus Tickets* (Plate 59). Sickert, who reviewed the show, growled with impatience at this use of *papier-collé*, which he regarded simply as a means of filling in. Fry had, he wrote, 'undoubted gifts' as an artist, but he felt sincere regret 'that the painter who has the double advantage of power and erudition should continue to treat seriously fumisteries à la Picasso (framed posies of tram tickets, etc.).'[6]

To Fry's surprise, one of his paintings was praised in the press for its patriotic sentiment. It was listed in the catalogue as *Three Men in Long Military Cloaks*, but is better known as *German General Staff* (Plate 74), and it too employed *papier-collé*. It had begun as a joke, Fry's eye having been caught by a newspaper photograph of the Kaiser and two of his generals standing looking out over the trenches. In the original photograph the feet of the generals are hidden from sight, so Fry in his picture left them out. Then, by chance, he came across a passage by Nietzsche which he quoted in the catalogue as if to explain their lack of feet: 'I cannot tolerate the neighbourhood of this race ... which has no sense in its feet and doesn't even know how to walk. ... All things considered, the Germans have not got feet at all, they have only legs.' But if certain critics failed to see the joke, they did appreciate the exhibits and the reviews on the whole were favourable. Sir Claude Phillips, in the *Daily Telegraph*, made the penetrating comment that Fry's best results occurred when he was directly inspired by reality.

The show gave Fry the opportunity to exhibit some Omega pottery and to remind the visitors that the Workshops were still struggling to survive. The main responsibility for the venture still fell on his shoulders, but he delegated its administration to the manager, Mr Paice, and the running of the salesrooms to Winifred Gill and other female assistants. By June 1916 the routine of the Workshops had become so firmly established, Fry was able to devote the greater part of his day to his own painting, as he told Vanessa. 'I go to the Omega in the morning, see to business with Winnie and then come back and paint all day till evening.'[7] This period of concentrated painting developed in him the habit of solitude and an even greater desire to arrive in his painting at his own personal style. He tried to tap his instinctive and subconscious responses and refused to let his intellect control and direct his sensibility. But the result, he realised with despair, was the 'desolating variety of my work'.[8] Yet gradually a personal note was breaking through, as Fry must have observed because he wrote to Vanessa in June 1916, 'I'm at

74 Roger Fry:
*German General
Staff.* Collage.
Present
whereabouts
unknown

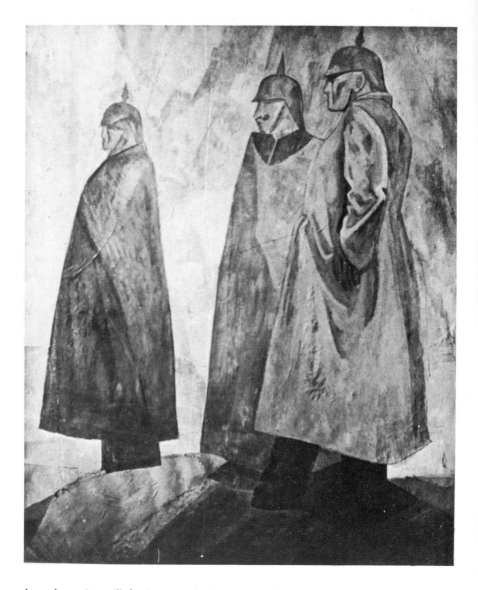

75 Roger Fry: *Nina
Hamnett*, 1917. Oil
on canvas,
81 × 61 cm. *London,
Courtauld Institute
Galleries*

last throwing off the impressionism you infected me with and I'm getting
back to a sort of idea of construction I've always had when I've been
myself'.[9]

As the influence of Vanessa waned in Fry's painting, the appeal of
the young artist who worked beside him both at the Omega and at his
studio gained in ascendancy. This was Nina Hamnett, who had a studio-
bed-sit in the same house as Fry, 21 Fitzroy Street. Apart from her tall,
slim figure and graceful, fawn-like movements, Nina had considerable
talent as an artist. She had attended several art schools, including one
of Sickert's, and prior to the war had made two important trips to Paris,
where she had moved among the avant-garde, meeting Brancusi, Modi-
gliani and Osip Zadkine among others. On hearing about the Omega,

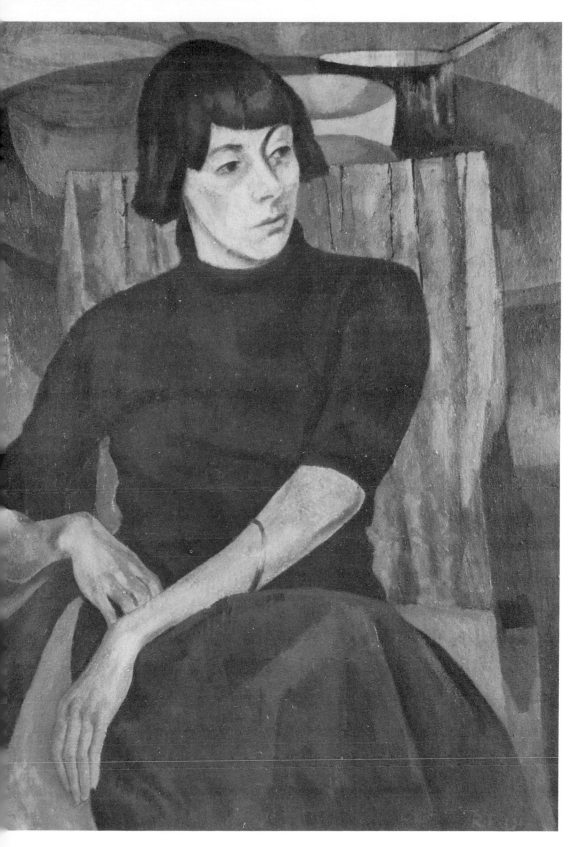

she had offered her services and Fry took her on, impressed, no doubt, by her knowledge of modern French art. Soon after, in 1914, she married Edgar de Bergen, or Roald Kristian as he was called, and he too entered the services of the Omega, assisting in the decoration of Arthur Ruck's house in 1916, after which he disappeared and was never heard of again. Nina then turned her attentions on Fry and acted as his willing model. He produced two major portraits of her in oils (Plate 75 and University of Leeds) as well as a whole series of nude drawings in pen and ink, notable for their fluency, rhythm, and freedom from chiaroscuro, and which capture her lithe elegance.

If Nina's pragmatic life-style well suited Fry's temperament, there was also a dark side to her character which Fry before long was unable to ignore. She viewed life with unwavering pessimism. Once, at the Omega, when Winifred Gill bent down to pick up a beetle off the floor, Nina rushed up, crushed the insect with her heel and muttered, 'Always stamp on anything that crawls'.[10] 'Drunk' was her brief explanation of Nancy Cunard's snoring voice. On another occasion, when asked to explain what was threatening the eyesight of a friend, she replied darkly and wholly inaccurately, 'Gonorrhea'. Her affair with Fry did not last long – a year or two at the most and it ended when he discovered how easily her attention was distracted. Boxers and sailors eventually became her regular companions, the latter being favoured for their temporality. When in the twenties Fry came across Nina by chance in Paris, he observed that she had drowned her talents in endless *petits verres* and had ended by becoming 'une vraie putain'. But during the Fitzroy Street period, Fry fell under Nina's influence. He began to employ a more deliberate sense of design, a more subtle colour orchestration and he also adopted her use of rough hessian as an attractively textured, but unfortunately less resilient, ground for his oils. Nowhere is Nina's masculine, direct handling and robust composition more apparent than in the portrait of her landlady (Plate 76) which Fry bought. But this vigour was weakened by the onset of alcoholism and gradually financial need increased the commercial element in her art. Drink, perhaps, also caused her death when in 1956 she fell from her bedroom window on to the iron railings below, but the reason for her fall was never firmly established.

The feeling of a self-reliant reality, found in the best of Nina's paintings, was precisely that which Fry was after in his own art during the war years. Unable to travel to the landscape he loved, he painted a series of still-lifes finding the genre best suited to prolonged contemplation. According to Virginia Woolf, the still-life was an integral part of his studio guarded over by the placard 'Do not touch'. With those 'symbols of detachment' as she describes them, 'those tokens of spiritual reality immune from destruction, the immortal apples, the eternal eggs'[11], he attempted to discover the classic qualities of balance and completeness. In 1917 he reviewed Vollard's book on Cézanne for the *Burlington* and noted that in his late work Cézanne arrived at 'the purest

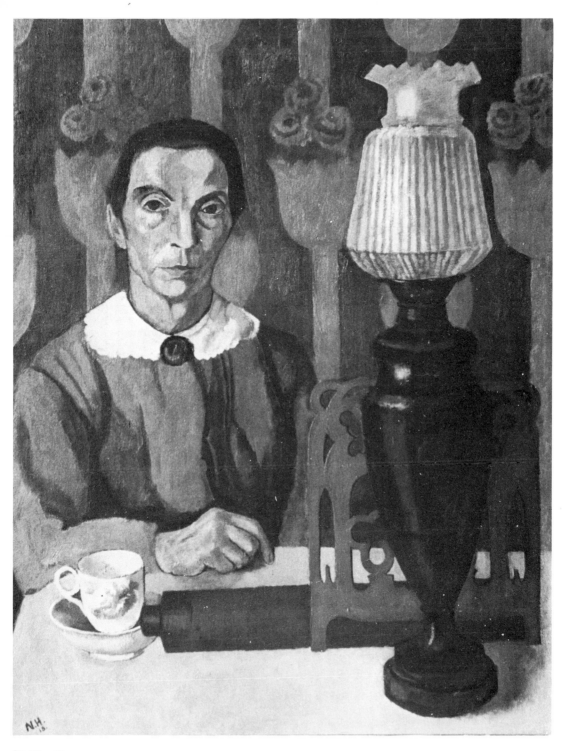

76 Nina Hamnett:
Portrait of a Landlady, 1913.
Oil on canvas,
91.4 × 71.1 cm.
Private Collection

terms of structural design'.[12] In his own art he was searching for a similar clarity and economy of means. To Charles Vildrac, he wrote:

> I am particularly working on still-life, trying to discover a more absolute construction and the ultimate simplification of all relationships. I find the idea of plasticity suggested by flat, or scarcely-modelled volumes is much more powerful than that evoked by means of chiaroscuro. But it needs a very special drawing to succeed: it needs deformation to give the real idea.[13]

In reality the degree of distortion used to give the sense of plasticity is slight. Among the more significant of these still-lifes are *Bowl on a Chair* (King's College, Cambridge), *The Blue Bottle* (on loan to the Scottish National Gallery of Modern Art), *Still-Life with Biscuit Tin and Pots* (Walker Art Gallery, Liverpool) and *The Madonna Lily* (Plate 77). In the latter, Fry's desire to extract the utmost from a few items enables him to arrive at a subtle balance between aggression and sensitivity; the strong, almost Vorticist black line down the left hand side contrasts with the soft treatment of the flower, the delicate curves of which are echoed in the forms of the oriental figure.

In November 1917 Fry exhibited at the Carfax Gallery a series of his recent flower paintings and they pleased not only himself but also his public and nearly all sold. Sickert gave them his seal of approval in the *Burlington Magazine*:

> ... his [Fry's] position as an Editor of this magazine prevents criticism in detail. But it is not exceeding a reasonable limit to characterise these twenty paintings as serious and thoughtful work, full of feeling for the possible dignity of this branch of still-life, and showing appreciation of colour, growth and pictorial structure, expressed without the tedium of over-literal representation.[14]

Fry's reading of Okakura's *Book of Tea* had influenced his taste for displaying the whole plant, not cutting away extraneous foliage. He also follows Okakura's advice that nothing should be placed nearby to detract from the flowers unless the object harmonises aesthetically with them. 'Modern European art has always maltreated flowers', Fry had written in 1910, 'dealing with them at best as aids to sentimentality until Van Gogh saw, with a vision that reminds one of Blake's, the arrogant spirit that inhabits the sunflower, or the proud and delicate soul of the iris.'[15] Always suspicious of ease, he was surprised by the success of his 1917 exhibition, and, not wanting to become known as a flower painter, he vowed he would not return to this subject; but his life-long interest in botany prevented him from keeping this resolution and he continued to paint flower subjects now and then all his life.

77 Roger Fry:
Madonna Lily, 1917.
Oil on canvas,
90.9 × 47 cm. *Bristol
City Art Gallery*

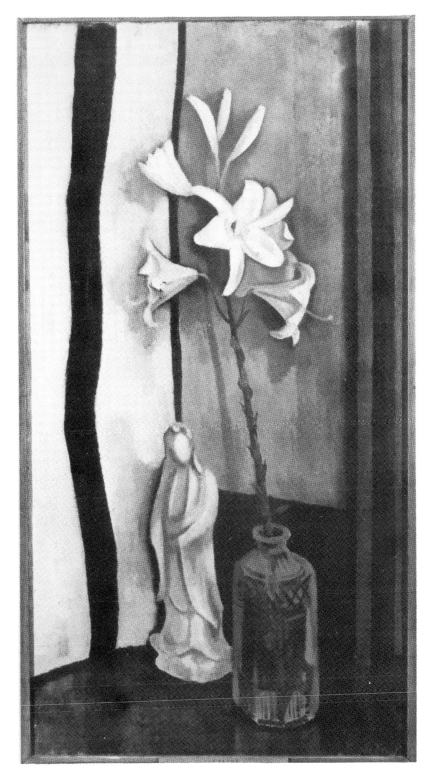

Throughout the war Fry continued to enjoy an active social life, receiving invitations from society hostesses such as Lady Cunard and Sibyl Colefax (both of whom he tried to avoid), as well as moving more happily among intellectuals, artists and writers. In 1916 Lady Ottoline attempted a reconciliation, now that five years had passed since their bitter row, by inviting Fry for the Easter weekend to her house at Garsington. He went, found her affable and without any trace of previous ill feeling. No explanations on either side were either asked for or given, even when Fry sat alone with Ottoline in her boudoir. But he felt uneasy. 'No there was no chance for me to do any love-making', he recounted to Vanessa, 'so I had to listen to the doors opening and shutting all night long in the big passage though in common decency I suppose I ought to have gone to the W.C. once or twice to keep up appearances.'[16]

In June 1916 he enjoyed a brief visit to Paris in the company of Madame Lalla Vandervelde and while there he attempted to obtain as many reproductions of Seurat's work as he could find, now recognising that Seurat was the great master he had overlooked at the time of the Post-Impressionist exhibitions. He also visited Matisse at his studio and showed him photographs of the Berkeley Street Omega decorations and of his *German General Staff*. To his delight Matisse praised his work and said that they were both moving in the same direction, referring, perhaps, to Fry's sense of architectonic construction. In turn, Fry was more impressed with Matisse's paintings than ever before, finding them 'more solid and more concentrated than ever'.[17] Meanwhile Madame Vandervelde's diplomatic connections forced him to spend a large part of his time in the world of ministers and the Avenue du Bois-de-Boulogne. When freed of this commitment he hastened to an artists' rabbit warren behind the Gare Montparnasse where he met Diego Rivera and his wife, and a small Spanish hunchback, Maria Gutierrez, otherwise known as Maria Blanchard, whose intense, primitive paintings he admired and bought.

Attracted to Madame Vandervelde's forceful intelligence, Fry also enjoyed her company in London where she entertained frequently in her Omega-decorated flat. On one occasion, Fry dined there in the company of Edward Elgar and Bernard Shaw. Elgar talked so voluminously and continuously about music that Fry, catching the eye of his hostess, understood that he should attempt to redirect the conversation. He offered the interpolation that all the arts were in fact the same. Bernard Shaw recounted what followed:

> I heard no more; for my attention was taken by a growl from the other side of the table. It was Elgar, with his fangs bared and his heckles bristling, in an appalling rage. 'Music', he spluttered, 'is written on the skies for you to note down. And you compare that to a DAMNED imitation.'
> There was nothing for Roger to do but either to seize the decanter and split Elgar's head with it, or else take it like an angel with perfect dignity. Which latter he did.[18]

For Shaw the dinner marked the beginning of a lifelong friendship with the musician; on Fry's side there is no indication that Elgar ever spoke to him again.

In 1916 Fry rented out Durbins to the Strachey family for just over a year. Lady Strachey lived there permanently with Oliver and Ray Strachey, while other members of the family came for visits. Joan Fry had moved into a cottage in Guildford and Fry himself, though he continued to visit Durbins at weekends, was mostly based at his bed-sit studio in Fitzroy Street. On his brief visits to Guildford he enjoyed the Strachey intellect and wit. In the evenings Lady Strachey would read aloud Restoration plays or a game would be played which entailed a book being chosen from the library, its covers concealed and a passage read aloud from which the others had to guess the author. Throughout the summer of 1916 the garden bloomed as never before. Lytton Strachey, on one of his visits sat outside amid hollyhocks and lavender writing his life of Thomas Arnold. It was probably on one of Lytton's visits to Durbins that Fry painted the portrait of him reading by lamplight, using purples, blues and greys (Plate 78).

In August 1916 Fry holidayed with his children at Bosham on the South Coast, from where Ezra Pound caustically informed Wyndham Lewis that he 'had the ineffable pleasure of watching Fry's sylphlike and lardlike length bobbing around in the muddy water off the pier'.[19] The village was popular with fringe-Bloomsbury and Fry enjoyed visits from Mary and Jack Hutchinson, Dora Carrington and Mark Gertler, Noel Olivier and James Strachey. Goldsworthy Lowes Dickinson came to stay for a few days, as did Amber Blanco White, a bright young Cambridge graduate and socialist. She had earlier enjoyed a brief affair with H. G. Wells, who had put her likeness into his character Ann Veronica in the book of the same name. Now married, with three children and a job at the Admiralty, in the Wages Department for the Ministry of Munitions, she entertained Fry and Dickinson with her tales of bureaucratic officialdom (as she did the author sixty years later), revealing her gift for sympathetic but barbed insight into human nature. She made no attempt to disguise her attraction to Fry. He complained to Vanessa: 'I wish I knew Clive's secret of having women and throwing them aside without any bitterness resulting, whereas I don't have them and yet can't get rid of them. Even my non-affairs are so much more serious than his amours.'[20] Turning his attention to the landscape he found that he had to acquire a sketching permit before he could paint out-of-doors. Even then he felt doubtful he could make anything of the 'dumpy and absurd' English landscape. 'It's heresy I know to say that but what I mean is that the forms don't excite me straight away nor the colours neither.'[21]

In the intervals, between portraits, still-lifes, duties at the Omega, holidays with his children and a demanding social life, Fry was still active as a critic. Lectures and articles were written mostly on trains, while travelling between London and Guildford, in a fluent script that

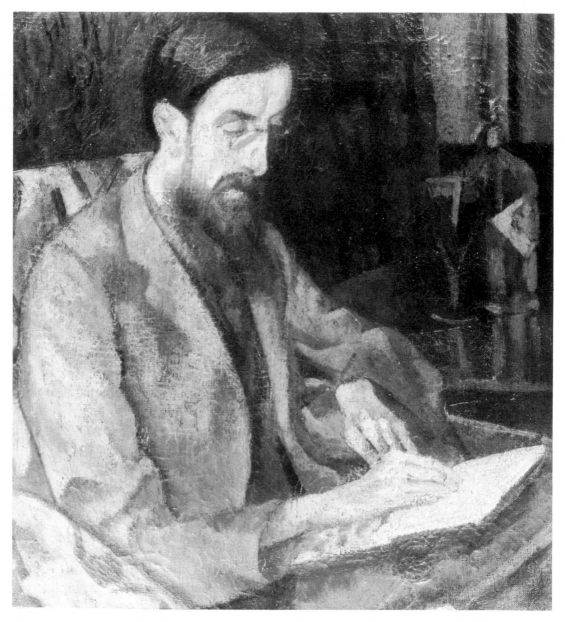

78 Roger Fry: *Lytton Strachey*, 1917. Oil on canvas, 45 × 39.5 cm. *Iconography Collection, Humanities Research Centre, University of Texas*

tells of the ease with which he put his ideas into words. The onset of war had however cut down the number of magazines produced and the relatively few articles that he wrote at this time appeared mostly in the *Burlington Magazine*. In his role as joint editor of this periodical he kept a look out for articles on modern art and wrote to Rose Vildrac in Paris asking if she knew anyone who would write on Negro art or on Matisse. Under his editorship the number of articles on contemporary art increased, making the *Burlington* one of the most advanced art magazines published in England. Fry, himself, undertook the sad task of assessing

208

Gaudier-Brzeska's achievement after his untimely death at the Front in 1915. He wrote that this 'magnanimous, genial and sympathetic character' had shared the concern of several of his contemporaries, 'to create a classic art, one of purely formal expressiveness'.[22] He regretted Brzeska's attempts to find inspiration in machinery, which had placed him in the Vorticist camp, and had been pleased when, shortly before his death, the sculptor had announced his intention of returning to organic form. Fry's humanism barred appreciation of the Vorticists' mechanistic aesthetic, and his preference for the ideal rather than the fabulous later affected his understanding of Surrealism.

On reading his war-time articles it becomes apparent that his approach was becoming more severely formalist. Writing about Gauguin's masterpiece, *Que sommes-nous? D'ou venons-nous? Ou allons-nous?*, he audaciously declared, 'Nor do I imagine that one's pleasure in the picture would anyway be heightened by an elucidation of the symbolism'.[23] For him the revelation of Gauguin's formal achievement was in itself rich and fascinating enough, but the blind fallacy of Fry's argument has been disproved by subsequent criticism. Similarly, in an appreciative article on Rossetti's watercolours, he declared that it was not the critic's business to enquire into the origins of inspiration. 'In strict justice I believe the critic has only to consider the nature of the formal result.' And Fry praises Rossetti, not for his sensitive interpretation of his subject matter, but for 'that close-knit unity of design which distinguishes all pure art'.[24]

Early in 1917 a selection of paintings from Hugh Lane's collection went on loan to the National Gallery in London. Fry's review of the exhibits further underlines his belief that the success of a painting is directly related to the intensity and purity with which the artist has comprehended its form. For instance, in the Belgian artist Alfred Stevens' work he noticed 'a purely external sensibility, that his technique is not the outcome of a passionately felt vision, but merely a sensual delight in particular kinds of *matière*'. Renoir's *Les Parapluies* (Plate 79), on the other hand, he regarded as a classic. It perfectly fulfilled his aesthetic requirements and the greater part of his article is devoted to this work.

> It is a work which cost even Renoir immense effort and years of work, and its freshness and gaiety, its brilliance and directness are not the result of clever improvisation, but of that passionate intensity of feeling which broods upon a theme until it yields up its last particle of material; until all is informed with a single idea; until every touch takes its place inevitably in the whole. . . . It is this positive creative effort that marks the classical work of art, and if ever a picture had the quality of a classic, this is one. Here nothing is for effect, no heightening of emotion, no underlining of the impressive or the delightful or the surprising qualities of things, but an even, impartial, contemplative realisation of what is essential – of the meaning which lies quite apart from the associated ideas and the use and wont of the things of life.[25]

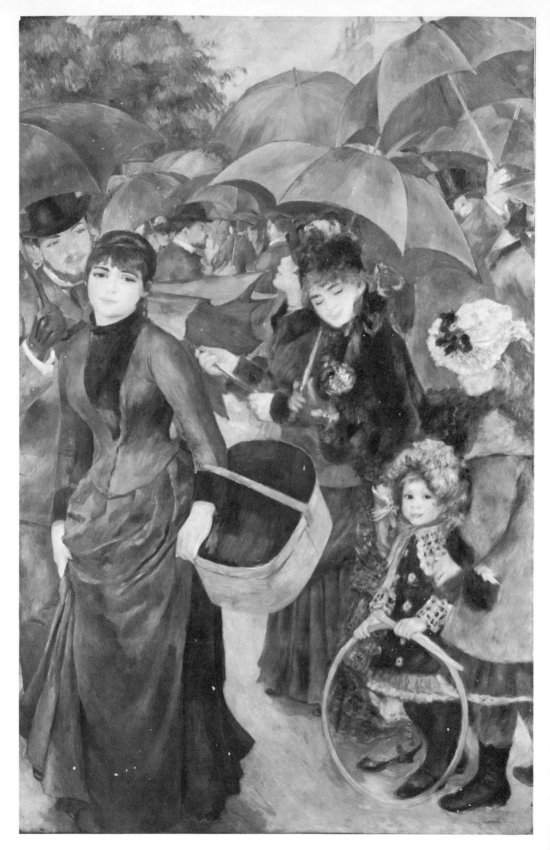

210

Fry not only expressed the wish that the painting should enter the National Gallery's permanent collection (as did eventually happen), but he also composed a letter to Renoir telling him of the honour felt by a group of artists and amateurs at having *Les Parapluies* on show in London. The letter, beginning 'Cher et Honoré Maître', was sent to Bernard Shaw for his signature and was returned with the following reply:

> I am deeply gratified by this tribute; but I fear it is undeserved, as I am not a painter and have no recollection of contributing any umbrellas to the National Collection except temporarily. I have always retrieved them on leaving the building. G.B.S.[26]

Renoir's *Les Parapluies* confirmed Fry in his belief that the French artists upheld a classic tradition which the English lacked. Whenever possible he exhibited modern French art at the Omega and urged young English artists to learn from the lessons taught by their French contemporaries. His emphasis on the importance of French art led him to undervalue the qualities of his native school. When he was eventually elected to the London Group in 1917 – a body of artists among whom Wyndham Lewis had been a founder member in 1913 – he was criticised for directing the group exhibitions away from a wide diversity of styles towards more singular emphasis on design and plasticity, indebted to the example of French art and, in particular, to Cézanne.

A certain parochialism in Fry's taste was detected in the exhibition, 'The New Movement in Art' which he organised in 1917 and which was shown in Birmingham and London. All the artists represented in this exhibition, both English and French, were friends of Fry; twenty-two of the sixty-seven exhibits belonged to him and seven others were painted by him. Even Clive Bell criticised the selection, remarking on the exclusion of Spencer, Lewis, Bomberg, Roberts, Matisse and Picasso. This suggests that already Fry was beginning to withdraw his interest from the avant-garde. Significantly, the same year he organised at the Omega the exhibition 'Copies and Translations of Old Masters', indicating a fresh interest in great art of the past. But he was not alone in his dissatisfaction with recent contemporary art as Clive Bell published a damning statement in 1917 that must have confirmed Lewis in his hatred of Bloomsbury. 'There is no live tradition', wrote Bell in an article entitled 'Contemporary Art in England', 'nothing but fashions as stale as last week's newspapers. . . . All that is vital in modern art is being influenced by French masters.' On Vorticism itself, Bell wrote that it 'already gives signs of becoming as insipid as any other puddle of provincialism'.[27]

79 Pierre Auguste Renoir: *Les Parapluies*, 1881–2 and 1885–6. Oil on canvas, 180 × 115 cm *London, National Gallery*

If certain young artists felt Fry's ideas verged on the rigid and dogmatic, his immediate circle of friends were constantly surprised and enriched by the flexibility of his mind. Virginia Woolf recorded in her diary for 1918 a chance meeting with Fry in the Charing Cross Road.

He was wearing a wideawake hat and carrying four or five French books under his arm.

> He is the centre of a whirlwind to me. Under this influence I was blown straight into a book shop, persuaded to lay out 3/7 on a French novel, *Et Cie*, by a Jew, made to fix a day for coming to Durbins, invited to a play and fairly overwhelmed – made to bristle all over with ideas, questions, possibilities which couldn't develop in the Charing Cross Road.[28]

Fry enjoyed discussing literature with Virginia Woolf and took a keen interest in her career as a novelist. He immediately spotted the emergence of her personal style in the short story 'The Mark on the Wall' when it first appeared in 1918 and particularly admired her preoccupation with the texture of prose. He wrote to tell her of his impressions:

> I've re-read it twice and like it better every time and am more and more delighted with it. Of course there are lots of good writers in one way and another but you're the only one now Henry James is gone who uses language as a medium of art, who makes the very texture of the words have a meaning and quality really almost apart from what you are talking about. Nearly all the other good writers have something of rhetoric however hidden beneath reserve and good taste.[29]

This hatred of rhetoric remained with Fry all his life; he could detect it in Ruskin, Wyndham Lewis, Delacroix or Dürer.

Bristling with ideas, he acted as a catalyst on almost anyone he met who had some creativity. When in 1917 he put on an exhibition of children's art at the Omega, it was visited by a young teacher from the Black Country, Marion Richardson. She was at that time teaching at Dudley High School and had come to London to show the London Education Authorities examples of her pupils' paintings and drawings in the hope of obtaining an inspectorate. In her teaching, instead of encouraging the children to develop representational skills, she championed individual expression. She would tell the children to close their eyes and would then read a story or describe a scene – a brightly-lit fruit shop on a dark winter's evening, for example, – and then asked her pupils to produce the image they had seen in their mind's eye. The extraordinary vividness of the results failed to impress the Education Authorities, accustomed to mimetic skills, but Fry, on looking through the folder which Miss Richardson produced at the Omega after her dispiriting interview, immediately appreciated the quality and freshness of these imaginary images.

Fry was delighted to discover that this young woman with the round face, red cheeks and deep brown eyes had trained at Birmingham and had lived in University House, where his sister Margery had been Warden up till the First World War. Moreover, examples of his own Post-Impressionist paintings which hung on the walls of the hostel had first encouraged Miss Richardson's interest in art. After that first meet-

ing, he did all he could to further her career. He exhibited her pupils' work at the Omega and contacted the Secretary to the Board of Education, H. A. L. Fisher, to see if Miss Richardson could be allowed to set up her own art school for children in London. Nothing came of this idea immediately, nor were her ideas adopted in schools for some time. After his failure to interest Fisher in her revolutionary teaching methods, Fry wrote to Vanessa, 'here's an inexhaustible supply of real primitive art and real vision which the Government suppresses at a cost of hundreds of thousands of pounds'.[30] But when in 1923 Marion Richardson exchanged her full-time post for part-time teaching at Dudley, she advertised herself in London as a 'teacher of drawing' and used Fry's name as a reference. Later, in 1928, when the Whitworth Art Gallery in Manchester put on an exhibition of her pupils' work, Fry contributed a catalogue introduction. 'She gets them to trust to their own mental images and then gradually to enrich and improve them', he wrote. 'The result is that many of these drawings have the special quality of freedom which is essential to all real art.'[31]

Against this background of incessant activity, Fry's restoration of Mantegna's *The Picture Bearers* at Hampton Court hung like an albatross around his neck. The painting is one of nine pictures that make up the *Triumph of Caesar* cycle, originally brought to England by Charles I and housed at Hampton Court. By the beginning of the eighteenth century it was noticed that paint was beginning to flake off the canvas. William III commissioned the French painter Louis Laguerre to restore the paintings which he did by repainting in a thick coat of oil paint, obscuring the original. In 1910 Roger Fry was asked to investigate their condition. He removed a small amount of Laguerre's repaint from one corner of *The Picture Bearers* and Lionel Cust, Keeper of the King's Pictures, then gave his opinion that this had been sufficiently successful to justify the removal of all repainting. When this was done large areas appeared that had suffered seriously prior to Laguerre's restoration and in some places only the outline of the figures was left. Mantegna's draughtsmanship was found to be remarkably free and the paint applied in very thin layers. In the eighteenth century the paintings had been relined and an iron passed over their surface, slicing off the crown of the weave and probably removing scumbles and glazes that Mantegna would have used to cool and tone his colours. Fry's knowledge of Mantegna would have led him to assume that the original of *The Picture Bearers*, as it appeared, was far from complete and perhaps concluded that the loss of surface quality justified his decision to repaint.

Fry's work on *The Picture Bearers* continued at intervals over a period of eleven years, with assistance from young artists, such as Dora Carrington and Paul Nash, who were not trained in the art of restoration. Whereas Laguerre had used oils, Fry did at least use egg-tempera in keeping with the medium of the original, but as the work progressed

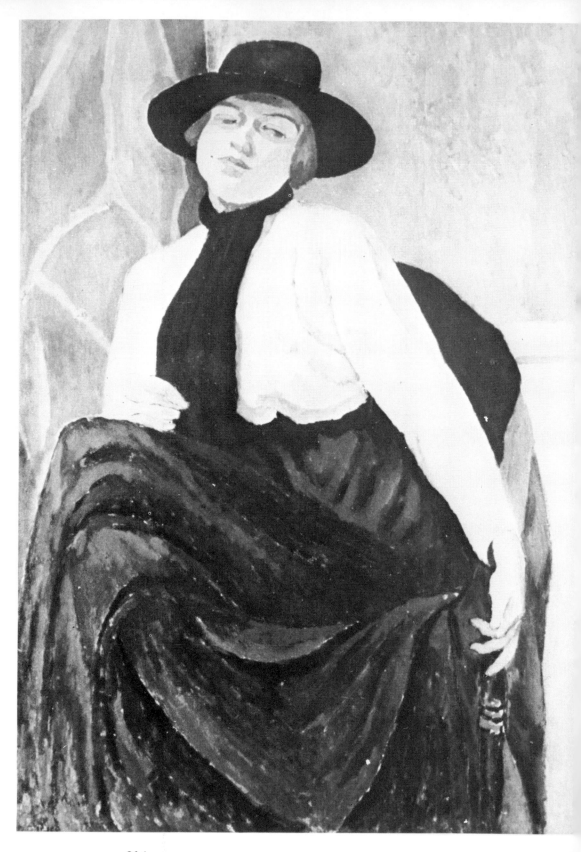

214

unforseen difficulties arose. Where the gesso priming had lost its 'temper', the paint sank and changed tone, demanding heavier repainting. Aware of the loss of surface detail, Fry and his assistants began to invent folds of drapery in a Mantegnesque style; they repainted the facial features, giving them a hard, metallic look, and, worst of all, they changed the Negro standard bearer into a Caucasian. John Brealey, who in the 1960s restored the entire series to as near as possible their original condition, said of Fry's restoration: 'How such a great and sensitive critic could do something so . . . *uncritical*, I will never understand.'[32] A loss of nerve must lie behind Fry's recommendation that the rest of the cycle should be left untouched but be covered with a celluloid solution to prevent further decay, and later, in 1925, he confessed that *The Picture Bearers* had been 'one of my maddest follies'.[33]

With relief Fry turned from this uninspired imitation of Mantegna to his own painting. He produced at this time an impressive series of portraits marked by a distinctive personal style. Ironically, this formalist critic succeeded with a subject that demanded a compromise between formal considerations and the need to capture the sitter's personality. Fry, who criticised Sargent for concealing the man behind his obsessive concentration on appearances, told Will Rothenstein that he thought 'imaginative characterisation' the only end worth pursuing in portraiture.[34] This he achieved by exaggerating certain aspects of the sitter's appearance to bring out their character and by discovering a pose and design that would give rhythm and energy to its expression.

A slightly earlier example of this 'imaginative characterisation' is found in his 1915 portrait of Iris Tree. Though still young and not yet the poet and actress she was destined to be, Iris Tree had already developed her theatrical and semi-Bohemian life-style. She was one of the first women in England to 'bob' her hair. She whistled for taxis with her fingers in her mouth or would step out into the road to bring them to a halt. Once, on finding the taxi occupied, she jumped on to the running board and was seen clinging to its side as it rattled its way down the Cromwell Road. Fry, in his portrait, had to find a design equivalent to her panache. He therefore positioned her carefully, letting the main thrust of her right arm balance the tilt of her head, contrasting the purple-blue of her skirt with her brilliant yellow blouse. The handling is also very bold and the face is modelled with a few patches of colour that are not fused into each other. Grant and Vanessa Bell also painted Iris Tree about this time, producing successful paintings, but less effective characterisations, Grant making her look sulky, overweight and thoroughly bored. Only Fry was able to capture her exuberance in his confident, lilting composition.

Though Fry's war portraits were limited to his circle of friends, they include some of the leading figures of the day – Maynard Keynes, Edith Sitwell, Lytton Strachey, Arthur Waley, Viola Tree, André Gide and Lalla Vandervelde. He brought to each portrait not only his mature experience as an artist but also his understanding of the sitter's person-

80 Roger Fry: *Iris Tree*, 1915. Oil on canvas, 98.5 × 71 cm. *Private Collection*

215

81 Roger Fry: *Edith Sitwell*, 1918. Oil on canvas, 61 × 45.5 cm. Sheffield City Art Galleries

ality. This undoubtedly helped him arrive at, for instance, the gentle looping movement in one portrait of Edith Sitwell (Plate 81) which successfully conveys her eccentric, quizzical personality. Here it is the design that has been exaggerated and not the facial features as, if

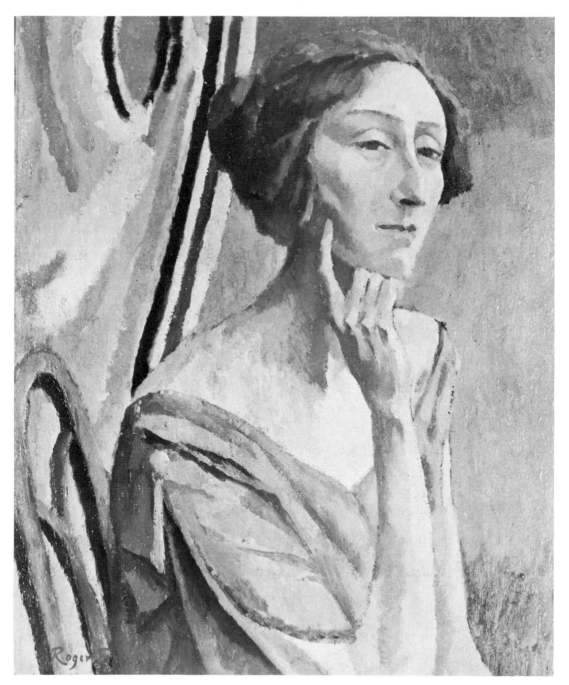

anything, he has softened the emphatic bone-structure of her face to suggest a poetic, though still arch, effect. In other examples, the desire to capture character or mood would allow him to depart quite radically from actual appearance; Arthur Waley who had a pianist's short, square hands is given attenuated fingers, his brown eyes are painted blue, and his bronze-blond hair is turned brown and uncharacteristically parted down the centre. The choice of pose – Waley looks up from his book as if lost in thought, head resting on one hand – however aptly conveys the quality of his mind though the portrait was probably painted from only one sitting (Private Collection).

Fry's portrait of Gide was painted during his trip to England in 1918 when he and Marc Allegret stayed at Cambridge, in close proximity to Dorothy Bussy, who later translated many of Gide's books into English. Gide and Allegret visited Durbins and while Allegret established a friendship with the young Pamela, Fry and Gide discussed Mallarmé. Fry had already begun his attempts to translate Mallarmé's inscrutable poems and was surprised to discover in conversation with Gide that he

82 Roger Fry:
André Gide, 1918.
Oil on board,
48 × 63.5 cm.
Private Collection

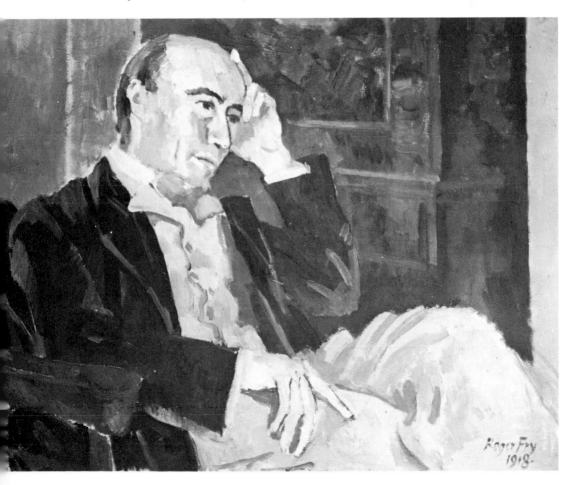

217

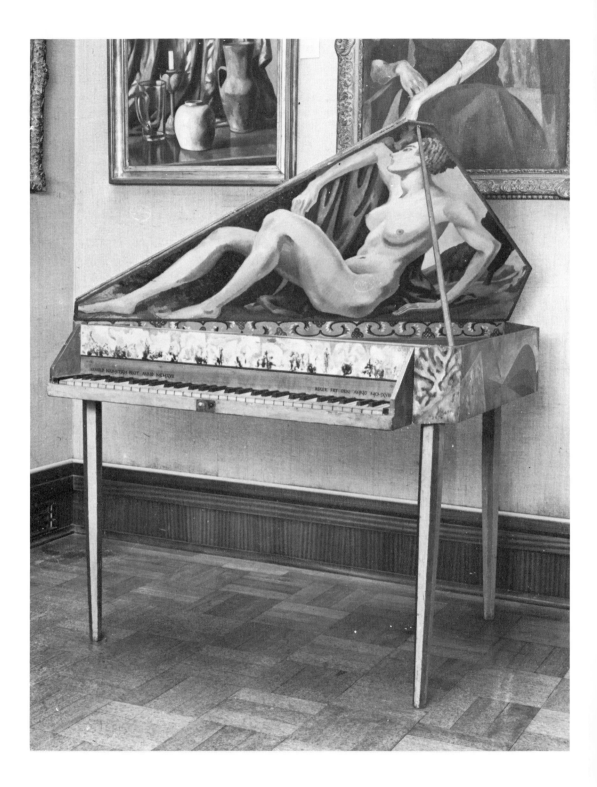

83 Painted
Virginals. Made by
Arnold Dolmetsch
in 1917 and
decorated by Roger
Fry in 1918.
*London, Courtauld
Institute Galleries*

had gone further than the famous author in deciphering their meaning. Their friendship was fully sealed when Gide sat down at the virginals, recently made for Fry by Dolmetsch, and played with exquisite sensibility early Italian keyboard music. The portrait of Gide, painted during this visit, shows him leaning back in his chair, head on one hand. Its naturalness suggests that the pose was adopted in mid-conversation and that Fry, seizing a piece of old board, caught Gide's likeness there and then in one sitting.

When Arnold Bennett asked to buy this portrait, the old piece of board on which it was painted caused a small misunderstanding. The portrait was delivered to Bennett's house, the delivery man presenting to him the reverse side on which is painted a half-finished Post-Impressionist landscape. Bennett hurriedly returned the work with a letter of protest. Fry replied with a soothing letter, informing Bennett that he was not 'the victim of a deliberate plot ... to palm off one of my eccentric landscapes', as the portrait was on the reverse. He hoped 'knowledge that the landscape is at the back won't spoil your enjoyment of the front'.[35] Bennett had, however, good reason to be wary of Fry's disorganised ways, as a table he had ordered at the Omega for his mistress had been delivered by mistake to his less fashion-conscious wife.

In spite of Bennett's disapproval, Fry continued at infrequent intervals to make an assault on the English landscape. He painted the view from his studio window at Durbins, the countryside around Logan Pearsall Smith's home at Warsash on the Hampshire coast, and the estuary at West Wittering where Jack and Mary Hutchinson gave him the use of their 'shed', a disused boathouse with a view across the mud-flats to Thorney Island. Its sparse furnishings – a wooden bed, washstand with china bowl, slop pail and soap dish, and china chamber-pot – filled all his requirements. When painting he was oblivious to physical hardships.

In 1918 Degas's collection came up for sale and Duncan Grant, after seeing a catalogue of the sale in Fry's studio, urged Maynard Keynes to approach the Treasury over possible funds for acquisitions. Keynes eventually acquired a £20,000 grant and he, C. J. Holmes, then Director of the National Gallery, and Austen Chamberlain crossed to France to attend the sale. Prices were low and fell further when, half way through the sale, a bomb fell nearby. By the end of the sale only a handful of people remained in the room and Holmes and Keynes had difficulty finding packing cases for their acquisitions. Holmes had acquired for the nation works by Ingres, Delacroix, Manet and Corot. Despite low prices, he had no intention of acquiring a Cézanne and it was Keynes who bought for himself the small *Pommes* (Plate 84), which, on his arrival back at Charleston (the Sussex farmhouse rented by Vanessa Bell in 1916), he left in the hedge at the bottom of the farm track for Grant to find.

This small painting had an electrifying effect on the Bloomsbury

painters. It set a standard against which all their achievements could be measured; it was charged with that indescribable quality that turns paint and canvas into a work of art. Virginia Woolf witnessed the excitement it caused when Fry called at 46 Gordon Square to examine the painting.

> There are 6 apples in the Cézanne picture. What can 6 apples *not* be? I began to wonder. Theres [sic] their relationship to each other, and their colour, and their solidity. To Roger and Nessa, moreover, it was a far more intricate question than this. It was a question of pure paint or mixed; if pure which colour: emerald or veridian [sic]; and then the laying on of the paint; and the time he'd spent, and how he'd altered it, and why, and when he'd painted it – We carried it into the next room, and Lord! how it showed up the pictures there, as if you put a real stone among sham ones; the canvas of the others seemed scraped with a thin layer of rather cheap paint. The apples positively got redder and rounder and greener.[36]

84 Paul Cézanne: *Pommes.* Oil on canvas, 17.1 × 24.1 cm. *On loan to the Fitzwilliam Museum, Cambridge*

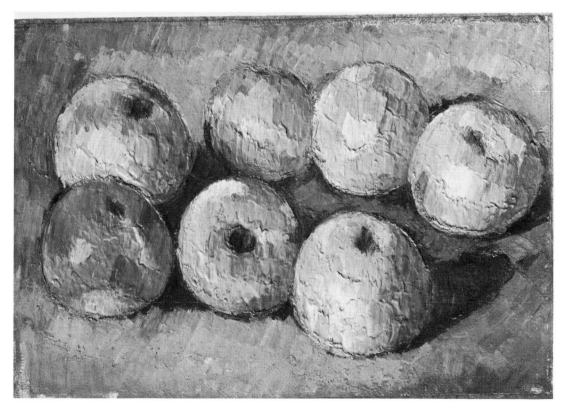

Cézanne's small picture confirmed Fry in his belief that 'Art is a passion or it is nothing'.[37] He continued in his conviction that his painting would provide him with the most personal means of expression. 'It's disgusting that you can't get more leisure to paint', Fry wrote to the artist E. McKnight Kauffer in 1918 from Bo Peep farm in Sussex where

he was enjoying a painting holiday. 'However, I've been trying all my life and am only now at last being allowed to paint at all regularly. I'm working hard at landscape here, quite remote from all theories and fixed ideas. I think I see that one can only go on the line of a gentle and continual pressure towards synthesis – it's no use to *brusquer* it.'[38] One painting executed during this holiday in which this synthesis is achieved is *Willow Trees in front of Chalk Pits* (Sheffield City Art Galleries). Fry uses a bold colour harmony of pale blue-greens, purples, violets and yellows and handles these vibrant hues in such a way that their iridescence spreads to the very edges of the canvas.

Fry had chosen Bo Peep farm at Alciston in order to be near Vanessa at Charleston. He hoped that much of his time would be spent in her company, but Vanessa, he found, was too absorbed in her 'domestic hole' to pay him much attention. Angry scenes occurred and Fry had to accept the bitter fact that Vanessa was with child by Duncan Grant. At one moment during this holiday Vanessa even suggested that her relationship with Fry should be cut off completely. Fry, on his side, dared not confess how important she still was to him. Considering this, his friendship with Grant, untinged by any ill will, seems remarkably generous. Not only did he assist in the selling of Grant's paintings, but he took evident enjoyment in his company, admiring his vivid visual responsiveness and the half humorous fantasy displayed in his work.

With the return of peace and the opportunity to travel once more, Fry decided to resign his position as joint-editor of the *Burlington Magazine*, but remained an influential force behind all editorial decisions up to the time of his death. He selected the young Aldous Huxley as a likely successor and invited him down to Durbins to offer him the editorship. There Huxley would have seen the Dolmetsch virginals which Fry had recently decorated in a variety of styles: a form of synthetic Cubism based on the shapes of musical instruments covered the outside of the lid; free abstract patterning decorated the panel over the keyboard; and inside the lid a realistic nude had been significantly distorted to fit the angular shape of the format. Dolmetsch, who liked to have total control over the production and appearance of his instruments, was horrified with the result, but to Aldous Huxley the virginals may have provided visual evidence of Fry's mental agility and adaptability, qualities that gave strength to his criticism but caused a distressing variety of styles to appear and disappear in his painting. Impressed and charmed by Fry's personality, Huxley wrote to his brother: 'I went last week to stay with old Roger Fry, who for a man of fifty is far the youngest person I have ever seen. I am not sure that he isn't really younger than oneself. So susceptible to new ideas, so much interested in things, so disliking the old – it is wonderful'.[39] As to the editorship, he refused it on the justifiable grounds that he knew nothing whatever about art.

Vision and Design

Bloomsbury celebrated the armistice at the hot, noisy party given by Monty Shearman in his rooms in the Adelphi where the pastel-coloured walls of the Adam rooms were hung, appropriately, with some of the few paintings by Matisse then to be found in England. Everyone danced. Even Lytton Strachey executed an inimitable jig, and the women's colourful dresses, which looked home-made or designed at the Omega, contrasted pleasantly with the uniforms worn by some of the men. Henry Mond, the chemicals manufacturer, strummed out tunes on the piano while others poured champagne over him to keep him cool. Augustus John appeared dressed in uniform, with two land-girls in leggings and breeches in tow. Outside people danced in the streets and on top of motor cars to the accompaniment of horns, police whistles, songs, shouts and screams.

The first action Fry took after the country returned to peace was to sell Durbins, which had become too expensive to run, and he bought instead 7 Dalmeny Avenue (now demolished), a large house in the then unfashionable Camden, in full view of Holloway Jail. Packing up his possessions, papers and photographs at Durbins, he reflected sadly that the house had symbolised his last hope for Helen's recovery. His mournful thoughts were instantly dispelled when the removal men arrived because instead of professional packers, two porters from Smithfield Market appeared with a van that reeked of blood. They were quite untrained in the packing of fragile objects and Fry had to supervise the entire removal and invent various methods of safe packing. In the end

he even entrusted to their care his valuable Chinese sculpture of Kwan Yin (now in the Worcester Museum of Art, Massachusetts) and nothing was broken. He ended the day dead with fatigue.

At Dalmeny Avenue, the large attic room with a top light, previously used as a billiards room, became his studio. He therefore exchanged his two first floor rooms at 18 Fitzroy Street for the smaller attic rooms above, formerly rented by Nina Hamnett, thus retaining a foothold in this artists' street occupied by Sickert, Thérèse Lessore, Grant, Vanessa Bell, Matthew Smith and Meninsky among others. The two larger rooms he let to the young painter Keith Baynes.

Fry set to work immediately to decorate the Camden house. The existing paintwork was good, his own financial state poor, and so an expedient compromise had to be found. His studio he simply painted with large rectangles of different colours which provided varied backgrounds for his still-lifes and portraits. But for the living-rooms, he obtained rolls of old wallpaper and on the back hand-printed a single colour, using varnished paper as his printing block to give an imperfect repeat. On the top of this he then dotted by hand a complementary colour – ultramarine on yellow ochre base, or, for another room, brilliant red on pale green – with the result that the colours buzzed and vibrated. These panels of colour were then pasted at intervals around the walls and in the corners, giving height and shape to the room. It was a simple, effective method of turning expensive, but dull and tasteless rooms into something personal and courageous. The blues, browns and ochres of the main sitting room had deliberately been chosen to set off his paintings by Marchand, Vlaminck, Matisse and Sickert, the latter's *Queen's Road, Bayswater* (Courtauld Institute Galleries) hanging in pride of place over the mantelpiece. As at Durbins, the paintings on the walls changed frequently, being sold or exchanged for others as his interests fluctuated. Occasionally, a young artist's painting, about which he felt uncertain, hung in the lavatory from where it had to be quickly retrieved if the artist paid a visit.

Fry shared the house with his sister Margery and he took great care over the decoration of her study, giving it a brightness that suited her efficiency. Here hung paintings by Fry, Grant and Bell, including Grant's *Cyclamens* (Private Collection) built up entirely out of hatching. Here Margery carried out much of her important work for penal reform, having been inspired by the words of her aunt, Susanna Pease, who, shortly before her death in 1917, had written a paper addressed to her relatives in which she referred to 'our failures in our methods of reforming criminals' and of the need in this field for 'more enlightened and humane methods'. The Quakers, who as conscientious objectors had earned considerable experience of the inside of prisons during the war, played an important part in the general post-war effort to review the situation in prisons. In 1919 Margery became Honorary Secretary of the Penal Reform League and through diplomatic manoeuvres managed to unite this body with the Howard League for Penal Reform, whose first

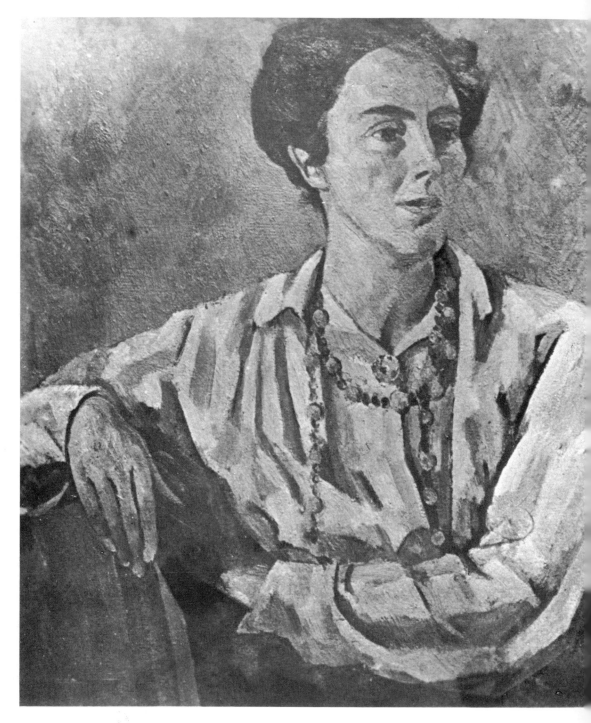

85 Roger Fry:
Margery Fry, c.1919.
Present whereabouts
unknown

Secretary she became in 1921. Driven by a fundamental hatred of cruelty and oppression and by a deep-rooted faith in justice, she turned her essentially practical mind to the problems in hand. Many of her ideas

224

are still in practice today: the present system of classification in prisons owes much to her inspiration; payment to prisoners, educational classes and radios in prisons were fought for by her; and in 1923, after visiting in Holloway Jail Mrs Edith Thompson, condemned to death for the murder of her husband, she became a confirmed opponent of capital punishment.

Margery shared with her brother a mutual respect, sympathy, love and an irreverent sense of humour; but she felt ill at ease in the presence of Bloomsbury. She suffered most from Vanessa who refused to admit her into their inner circle. Bloomsbury was not easy to please and Margery lacked that lightness of touch, that subtle note of irony or playful teasing that punctured their most serious discussions. She was aware of a dissimilarity of interests, hers being practical and political, theirs primarily imaginative and creative. She therefore never talked of her work to them and they were probably unaware of the important changes brought about by her 'persistent pressure'. When in 1932 she travelled to Greece with Roger, Leonard and Virginia Woolf, Margery, who always placed truth before poetry, felt obliged at Delphi to tell Virginia that the eagles over which she was enthusing were really vultures. Mostly, she was perfectly aware that Bloomsbury tolerated her only because she was Fry's sister. Her antagonism to the Group hampered Virginia Woolf's writing of Fry's biography and little mention is made of her important presence during the Dalmeny Avenue years. Fry, however, not only praised the happiness their domestic life gave him, but acknowledged his debt in the dedication of *Vision and Design*: 'To my sister Margery without whose gentle but persistent pressure this book would never have been written.'

When in 1919 Picasso and Derain dined at 7 Dalmeny Avenue, it was Margery who acted as hostess. They had arrived in connection with two of Diaghilev's ballets, *La Boutique Fantasque* and *The Three-Cornered Hat* for which they had designed sets. Both were on terms of friendship with the artists in Bloomsbury and at Fry's suggestion Derain put up at Vanessa's flat in Regent Square. The two great artists could not have been more different in character and appearance: Derain was a charming, lazy giant, as yet unaffected by fame; Picasso, short, energetic, with piercing eyes, insisted on ceremony due to the influence of his wife Olga, and stayed at the Savoy. At Dalmeny Avenue, the three men relaxed in the conservatory after dinner and Picasso told amusing tales about tortoises and cacti. Afterwards he accompanied Fry upstairs to his studio, but what he said about Fry's paintings has not been recorded. Derain, on a visit to the London Group exhibition, had picked out Fry's paintings as the best without knowing the name of the artist, but Picasso is unlikely to have shared this opinion. He thought all English art either pretty or sentimental and was only moved to praise by the pottery he saw at the Omega which must surely have influenced his own decorative work in this field.

The presence of Picasso and Derain in London revitalised interest in

modern French art. To satisfy this fresh curiosity, Osbert and Sacheverell Sitwell, together with the Parisian-Polish dealer Zborowski, organised in London in 1919 an exhibition of recent French art. They netted paintings by leading artists as well as by the lesser known younger generation just beginning to emerge and among the artists represented were Matisse, Picasso, Derain, Vlaminck, Friesz, Modigliano, Utrillo, Kisling, Léger, Lhôte, Dufy and Archipenko. Arnold Bennett, who wrote the preface to the catalogue, declared that it was the most important show since the 1912 Post-Impressionist exhibition. The paintings and the interest they aroused inculcated afresh a sense of inferiority in certain British artists. 'They are all very nice and fine and clever', wrote Mark Gertler to a friend, 'but "exquise" and "oh c'est formidable!". They all make me feel as if I were on the stage.'[1]

The show acted like a catalyst on British art, confirming a tendency that had begun during the war, namely the move away from abstraction back to more straight-forward representation. The pre-war experiments with faceted form and dynamic abstraction seemed, with hindsight, to prefigure the inhumanity of war. Even Wyndham Lewis who organised in March 1920 the 'Group X' exhibition and urged in the catalogue, 'the experiments undertaken all over Europe during the last ten years should be utilised and developed and not lightly abandoned',[2] later admitted that his Vorticist style gradually came to seem 'bleak and empty' and in need of 'filling'.[3] Significantly his 'Group X' disbanded after their first exhibition. The Bloomsbury painters' return to a more representational style, therefore, is only part of this general retrenchment, shared alike by English and French artists.

Fry, aware of the importance of the Sitwells' show, strolled round from his Fitzroy Street studio to the Mansard Gallery at Heal's in the Tottenham Court Road during the hot July evenings while the paintings were being unpacked. He wrote a review of the show for the *Athenaeum*, devoting most of his attention to Derain, whose rejection of Cubism in favour of a more classic style and whose new interest in the atmospheric fusion of tones won Fry's approval. He declared the exhibition as a whole to be ten times more interesting than the average London Group show.

Inevitably the French paintings reawakened Fry's desire to return to the Midi; but before he could do so the Omega had either to be established on a different footing or closed down altogether. Its existence during the first half of 1919 was precarious. Having participated briefly in the immediate post-war boom, it had then been hit by the influenza epidemic that reached a peak in November 1918 and broke out again at the turn of the year. Fry found, as his employees fell sick one after another, that the brunt of the furniture decoration fell on him. As it was still impossible to order furniture to be made, he was painting old farmhouse chairs and tables, executing, he estimated, one piece per day. He had lost in the epidemic one of his most energetic and inventive young helpers, Edward Wolfe, who had been introduced to the Omega by

Nina Hamnett and who instantly won Fry's approval by extemporising on the lampshade designs that he had been given to copy *ad nauseam* for a chandelier. After Wolfe had recovered, Fry did all he could to raise funds to send him back to his home country South Africa to convalesce.

In February 1919 Elspeth Champcommunal, the widow of a French painter, visited the Omega in the company of a woman friend who had acute business instincts. She took one look at the showrooms and workshops and proceeded to lecture Fry on the reasons for the Omega's financial ill-health. 'It was fascinatingly interesting', he admitted to Vanessa, 'and entirely true.'[4] He was at the time designing sets and costumes (never used) for Arnold Bennett's play *Judith* and in the course of his correspondence with the author tried to tap his business acumen. 'I should like to talk to you about the Omega one day. It is at a critical point. There is a chance of getting it placed on better commercial footing or else of its failing ignominiously. In either case I shall retire from the chief position'.[5] Only ten days later, he wrote again: 'I wonder whether you will be surprised, glad, shocked or what – to hear that the Omega is disappearing . . .'[6] This may have been a taunt to induce in Bennett some action, as a month later he was still hoping that the author might perform the healing miracle and save the Omega from extinction.

> Have you seriously got any suggestion to make about the Omega because I must close down soon. In fact I intend to do so the moment I can let the premises. Of course it's irritating to lose 5 years of pretty continuous work and £2,000 and nothing to show for it but its the kind of chance one has to take and I'm not personally much worried. I think it's a pity because the commercialists will have it all their own way and there will be no attempt at really creative design. However people have the world the average man likes. I don't understand the animal and can't hope to manage him.[7]

In June the Omega held a clearance sale and in September Margery Fry, assisted by Francis Birrell and Robert Tatlock, packed up and cleared out the final remains, Fry having already disappeared to France.

On arriving in Paris Fry found that rooms had been booked for him in an old hotel on the rue Bonaparte by Angela Lavelli. Lavelli, half-Russian, half-Italian, was to be Fry's companion during the first part of his trip. A shadowy personality, she had first written to him from Paris during the war asking for employment at the Omega. Something about her letter had caught Fry's attention and he invited her to England and on her arrival encouraged her interest in art, educating her to such an extent that she later took up employment showing Americans around the Louvre. For a brief period she became his mistress but her unstable temperament left her unable to play an important role in his pragmatic,

energetic life and they soon parted but remained friends. She continued to live in artistic circles in Paris, endured unremitting poverty and finally took her life during the Second World War.

In Paris in 1919 Fry was severely hit by the shortage of tobacco and found the railways services unpredictable, chaotic and crowded. But despite the economic hardship, the Parisian art world was in full swing; exhibitions flourished and were discussed with new energy and enthusiasm. With Angela Lavelli, Fry visited the Vildracs, the Louvre, Paul Guillaume – to see his African sculpture, and Derain's studio. 'He [Derain] . . . talked a great deal of getting rid of the quality of painting', Fry informed Vanessa, 'I think I know what he means. He wants the vision to be communicated directly so that one is quite unconscious of the medium through which it is given.'[8] He also found time to help Elspeth Champcommunal go through the paintings left in her late husband's studio, selecting the best for the Salon d'Automne where a section was to be devoted to artists killed in the war.

The first week of October found Fry and Angela Lavelli in a hotel at Avignon from where they presently moved to a fly-filled, dirty, chaotic and insanitary inn at Aramon, close to a valley that Fry particularly wanted to paint. The peasants regarded the inn as a meeting place and came and went continuously, and each evening a pianola ground out its repertoire of three tunes incessantly. But none of these physical discomforts grated on Fry who was delighted to be back in the Provençal landscape, and he set off early each morning on his bicycle to paint, Angela walking to join him with their lunch, both returning to the inn only when the light failed. When the mistral set in, making painting out-of-doors impossible, he had a chassis made by the local carpenter for a large painting of the kitchen, where he sat in one corner making sketches of various poses. He had no difficulty in finding sitters, and one eighty-year-old peasant woman sat for her portrait in oils. Fry filled a sketchbook with studies of these peasants, and their directness and freedom from sentimentality indicate his respect for Provençal peasant life. 'The fact is they really are our sort of people', he told Vanessa, 'with our ideas of what's worth-while and our absence of all notions of arrivism and they all accepted me at once as being one of them.'[9]

After their stay at Aramon, Angela Lavelli left for Italy via Lyons where she was to meet up with friends, and Fry bicycled to Les Baux which had been recommended to him by Ottoline Morrell. The ancient ruined town perched on an outcrop of rock disappointed him; it was too dramatic for his taste and he soon decided not to stay the night. At lunch time he stopped at a café, flung down his bicycle with its saddle pack of paints, canvas and easel and as he did so there ran towards him a dog which had learnt to associate the smell of linseed oil that clung to painters with a source of chocolate. Observing the dog's greeting from the terrace were a young couple familiar with the animal's habits. They immediately struck up a conversation with the English painter who

seemed to them to laugh continuously – at the dog, the sunshine and at their comments, and they pressed him to show them his paintings of Aramon. They insisted he should accompany them back to where they were living for a cup of real coffee and on the way did all they could to attach him to the old town, taking him inside the twenty empty rooms of a dilapidated Renaissance palace. The friendship between them had been struck up so easily and instantaneously, they begged him to stay the night and accompany them that evening to a barn where a mountebank was to perform.

That evening the party was joined by a young local schoolmistress who shared the house where the young couple lived. Her name was Marie and she had recently married Charles Mauron, a young chemist who had had to return the evening before to the Faculty of Science at Marseilles where he was studying. Marie had a long, thin face, a high forehead, quick, sharp eyes and graceful movements and Fry mentally described her as an educated Nina Hamnett. The evening began badly; the mountebank was dull and after he had finished his tricks he began to proclaim Breton patriotic songs. These so incensed the young schoolmistress, she turned to the audience which consisted largely of elderly peasants, and prevailed upon them to give a performance of Provençal songs for the English stranger they had in their midst. In their black silk caps, the old peasants sang like children, their voices artless yet expressive. To Fry's surprise their repertoire was not confined to folk music but included ancient and modern songs and poems. Charmed and moved, he recognised in these songs a sense of equality and the possession of a democratic culture of which Carpenter would have approved. Here at last was that reconciliation of the freedom of the spirit with the life of self-supporting labour of which they had talked thirty years ago at Cambridge.

The following day Fry accompanied his new friends to Paradou where they called on a local poet, famous for his authoritative knowledge of the Provençal language. Here again, as they helped the rustic genius light his fire and stew his apples, Fry was able to absorb the experience of the simple life, where art and thought found natural appreciation, integrity and honesty freed human beings from social ambition. A fortnight after his visit to Les Baux, Fry wrote to Marie Mauron, summarising its importance. 'You speak of my visit to Les Baux as an event, but you cannot imagine what an event it was for me. The glimpse you gave me of the life of your friends, the poets and bards of Provence has remained with me a very special experience. There I saw life as it should be, a life where poverty and wealth are accidents of little importance, where one can enjoy the things of the spirit without ceasing to be a peasant.'[10]

During the rest of this trip, painting at Martigues, at Longesse near Aix, and at Cagnes, Fry discovered the secret of the Provençal landscape; its colourfulness lay not in bright hues but in the purity and beauty of its greys. These, he found, could be obtained by mixing mainly earth

colours – terra-verte, burnt sienna, Indian red and yellow ochre, with black or white. At Longesse he stayed at a small pension, La Bouscatière, hidden among pine-woods and in walking distance of a view of the Mont Ste-Victoire. He could not forget the example set by Cézanne in this countryside yet he felt free of any desire to imitate the master. He selected views of the mountain very different from those Cézanne had painted, and only when he began work on an entangled group of pine trees, did he recognise some similarity with the work of his great predecessor.

> Now the odd thing is that when one paints these particular firs without any *parti-pris* it simply becomes like the modelling of Cézanne. I almost think he must have got his idea of the *enchevêtrement* of planes from his studies of them – you know he was always doing them. I don't think till this one my things have been the least bit Cézannian, but this has the general look of his pictures, though quite different in colour ...[11]

He left the area around Aix, convinced that Cézanne was the great naturalist and ended his visit with a wander around the artist's house, the Jas de Bouffan.

In December Fry returned to England, stopping en route at Paris for six days where he imbibed afresh the tremendous excitement then current among artists, dealers and critics. Clive Bell was also present and agreed with Fry that it was as if a new renaissance had occurred. The two men had a number of artist friends in common – Picasso, Derain, Marchand, Segonzac, Dufresne, Friesz and Vlaminck to name a few - and it surprised Bell to discover that certain of these artists regarded Fry as a little *démodé*. To Vanessa, he wrote:

> Tomorrow I lunch with Picasso, to meet Cocteau and Satie ... I seem to see most of Derain. ... The activity and excitement of the painters here is unheard of: there seems to be no end of pictures and picture dealers ... I imagine Florence in the fifteenth century must have been something like it. ... I perceive they all like or rather admire Roger; but laugh at him. They consider him doctrinaire in his views: very few of them seem to realise that he makes pictures himself.[12]

Any rigidity in Fry's views did not prevent him from appreciating at this time two very different artists. In Cagnes he had met Jean Marchand for the first time and painted for a few days in his company. He already owned five of Marchand's paintings and told Marie Mauron that he found in his art 'that austerity and that solidity of construction which, for me, are the great qualities of the French tradition from Poussin to Cézanne'.[13] Then, in Paris, Fry was asked to look at a young man's poems. Finding in them little of merit, he felt dismayed when he was afterwards asked to look through a folder of drawings by the same artist, but, as he turned over one sheet after another, the realisation grew on him that the almost hallucinatory drawings had a content that lay beyond

86 Georges
Rouault: *Woman
and Child*. Gouache
on paper,
30.5 × 19.6 cm.
*London, Courtauld
Institute Galleries*

the immediate apprehension of their formal means. The artist was Georges Rouault and to Marie Mauron Fry expressed the belief that he was 'one of the geniuses of all times'.[14] He bought four of the wash drawings and reproduced one in his chapter on the French Post-Impressionists in Vision and Design praising its 'strangely individual and powerful style'. He had entirely forgotten that eight of Rouault's drawings had been included in the first Post-Impressionist exhibition and appended a footnote to the illustration saying that he had been 'unrepresented' in the two exhibitions.

Preparations for Vision and Design began in March 1920 and the book appeared in November of that year. Fry collated a selection of his best articles, expanding on some and pruning others where particular criticisms of works of art could not be illustrated. As one critic noted when a revised, cheaper edition was published in 1923, it constitutes 'a singularly vivid account of growth in an artistic faith'.[15] Recognising this fact in 1920, Fry wrote for the book a concluding chapter entitled 'Retrospect' in which he traces the development of his aesthetic belief and with it a certain trend, underlying the various changes in his opinion, which he thought 'symptomatic of modern aesthetic'.[16] There had been, he argued, 'a return to the ideas of formal design which had been almost lost sight of in the fervid pursuit of naturalistic representation.'[17] and consequently the most positive line that criticism had pursued during the previous ten years was the attempt to isolate the aesthetic from the non-aesthetic. He now doubts his conclusion to 'An Essay in Aesthetics' – that our response to the formal values in a work of art is enhanced if the forms are allied to a representational purpose – and wonders if in fact there is any such close relation between form and non-formal experience. Like Bell, he still circumambulates the notion of 'significant form' and only approximates to a definition.

> I think we are all agreed that we mean by significant form something other than agreeable arrangements of form, harmonious patterns, and the like. We feel that a work which possesses it is the outcome of an endeavour to express an idea rather than to create a pleasing object. Personally, at least, I always feel that it implies the effort on the part of the artist to bend to our emotional understanding by means of his passionate conviction some intractable material which is alien to our spirit.[18]

The book, the critics agreed, was stimulating, provocative and infused with Fry's enthusiasm, but not all accepted his aesthetic standpoint. The Times Literary Supplement critic noted, 'He has fallen into the old error of separating form from content, and, believing that he values form apart from content'. Indeed, the recurring criticism of the formalist approach is that it attempts to turn all content into problems of form. Yet several of the articles included in Vision and Design contain examples of non-formal appreciation. One of the finest essays is on Claude Lorrain, a deeply nostalgic and allusive artist, and it was singled out by the Times

Literary Supplement as an example of Fry being 'like the lady who, whispering she would ne'er consent, consented'.[19]

The breadth of *Vision and Design* surprised many; Fry ranged with confidence, erudition and sensitivity over the art of different ages and cultures. Nor did he confine himself to the Western European tradition. While preparation for the book was underway, the Chelsea Book Club put on an important exhibition of negro sculpture and Fry's review of this show was included in the text of the book. African art had been collected and discussed by French artists prior to the First World War, but in England (apart from Jacob Epstein's unique collection) it was still largely unappreciated. Imagine, therefore, the shock that Fry's enthusiasm must have caused in his readers.

> We have the habit of thinking that the power to create expressive plastic form is one of the greatest human achievements, and the names of the great sculptors are handed down from generation to generation, so that it seems unfair to be forced to admit that certain nameless savages have possessed this power not only in a higher degree than we at this moment, but than we as a nation have ever possessed it. I have to admit that some of these things are great sculpture—greater, I think, than anything we produced even in the Middle Ages. Certainly they have the special qualities of sculpture in a higher degree. They have indeed complete, plastic freedom; that is to say these African artists really conceive form in three dimenions. Now this is rare in sculpture.[20]

Fry then proceeds to analyse the success of this sculpture, noting its frequent exaggeration of form to underline three dimensionality and the use of emphatic sequences of plane. The result (as he found in all great art) was no mere echo of reality but a 'disconcerting vitality', the figures having 'an inner life of their own'.[21]

The essays in *Vision and Design* on African art, Ancient American art, Mohammedan and Bushman art helped in the general move away from the previous hegemony of the Greco-Roman tradition, which can, in its emphasis on mimetic representation in art, now be seen as the odd-man-out among the great civilisations of the world. *Vision and Design* therefore had a liberating influence; it also cut through the seemingly tangled confusion of modern art by giving a simple directive – to look at form; this simple approach, as Fry demonstrated, could be applied to any age or culture. The book therefore had immense influence. For the young sculptor Henry Moore the essays on African art and Ancient American art had particular relevance and he later admitted, 'Once you'd read Roger Fry the whole thing was there'.[22]

The title of the book stemmed from Fry's own experience as a painter: for him, the visual impression or the emotional idea had to be ordered before aesthetic experience is created; the 'vision' had to be subordinated to the 'design' before significant formal relationships could be discovered. He explains how this principle is worked out in practice in the essay 'The Artist's Vision':

Almost any turn of the kaleidoscope of nature may set up in the artist this detached and impassioned vision, and, as he contemplates the particular field of vision, the (aesthetically) chaotic and accidental conjunction of forms and colours begins to crystallise into a harmony; and as this harmony becomes clear to the artist, his actual vision becomes distorted by the emphasis of the rhythm which has been set up within him. Certain relations of directions of line become for him full of meaning; he apprehends them no longer casually or merely curiously, but passionately, and these lines begin to be so stressed and stand out so clearly from the rest that he sees them far more distinctly than he did at first.[23]

And when he attempted to describe for Marie Mauron the process that went on inside himself when painting, he spoke of a similar desire to extract fundamental relationships from the apparent chaos of nature.

These fundamental relationships are recognised by a kind of sensual logic. It's exactly like music where one looks for the specifically significant interval among all possible notes – relationships whose contemplation is the affair of the human spirit.[24]

In the spring of 1920 Fry left London again for an extended holiday in France, stopping briefly in Paris, en route to Vence, to hang an exhibition of paintings by himself, Grant and Bell at Vildrac's gallery. Once the paintings were hung, he noticed that they looked curiously in harmony with each other due to the restrained use of colour. He was surprised and not a little delighted when his work was praised over that of Bell and Grant. He met for the first time the two Russian artists, Mikhail Larionov and Natalia Gontcharova, and while the tall, round-cheeked Larionov talked distractedly in voluble Russian, the warm, brown-faced Gontcharova attempted to translate into French, but before she could finish what he had just said, he began speaking again and Fry found conversation almost impossible. Nevertheless their meeting was a success: Fry arranged that his daughter should take lessons from Gontcharova and the Russians showered him with presents including a Cubist lithograph by Larionov that incorporated Fry's name into the design.

At Vence, Fry put up at the Maison Barrière, rue de la Barricade where Jean Marchand, his common-law wife Sonia Lewitska and the sculptor Marcel Gimond and his wife were also staying. At first disappointed by the surrounding mountainous terrain, he wrote disconsolately to Vanessa, 'Marchand goes about saying it's like Claude or Poussin and how wonderful it is. The fact is he is a genius for interpretation'.[25] But his interest in his surroundings soon picked up and before long he was back in his old routine, painting from dawn to dusk, working on four different subjects throughout the day, attempting to capture the scene before the fast-changing light radically changed its structure. On more than one occasion he painted alongside Marchand in front of the same motif and dedicated to him a small oil-panel of a farm building. Under

Marchand's influence he developed his use of close-toned subdued hues and an interest in a consistent texture, one colour being softly brushed into the next.

The products of this period of concentrated painting went on show at the Independent Gallery in June. Fry exhibited eighty-one paintings at low prices and was dismayed when very few sold. The critics damned him with faint praise. The criticism in the *Spectator* was, however, not only fair but also very true: 'Mr. Fry does always paint; that is to say, with each stroke of paint he defines, as a good writer defines with every word. At his worst, he would look honestly academic among a lot of fashionable pictures, and they would look trashy. At his best, he is an artist who can express his own interests, his own values, in terms of art.'[26] Fry himself gave a good explanation why these realisations of quiet unpicturesque scenes failed to sell:

> My painting is not sufficiently accentuated; there's nothing fashionable in it. There's no formula one can recognise at once. . . . Now I am not a great artist; I am only a serious artist with some sensitivity, enough taste and more intelligence than average painters. Thus the scorn of the public becomes hard to understand. . . . Its partly because of my writings. I have defended artists like Picasso and Matisse who are more extraordinary. I am taken for a sort of Bolshevik and then they find that I paint more like Claude Lorrain or Poussin and they are completely baffled.[27]

After this failure Fry momentarily decided never to exhibit again. By late summer, however, he was hard at work in the north-west of France on a large canvas for the forth-coming Salon d'Automne.

At Auray in the Morbihan when Fry settled in August with Margery and his daughter for a fresh spell of concentrated painting, the well-proportioned granite architecture and the estuary flanked by pinewoods provided ample subject matter. The Vildracs were staying nearby and this explains his non-characteristic choice of Brittany. The light and colour, he noted, were quite different from those of the Midi. Here he needed to use the more expensive paints which he never touched in the South – cadmium orange, viridian and burnt lake – but the end result was again a saturated, monochrome grey. He was fascinated by the blue-greens and pink-greys that tinged the pine-woods under damp light and put these colours into *The Bridge, Auray* (King's College, Cambridge) which in its calm, monumental design based on the slow rhythm set up by the arches of the bridge re-evokes the classicism of Poussin. His large painting for the Salon, entitled *In the Morbihan* (Plate 87) was equally sombre and as carefully designed; cold dark and light greens and browns set the background against which sings out the single red sail of a boat on the estuary. At the Salon, it received much praise, was mentioned and reproduced in art journals and admired by Matisse. Even Clive Bell gave it his approval. 'I like Roger's picture extremely', he admitted to Vanessa, '– it is far the best thing he has done in my judgement. It

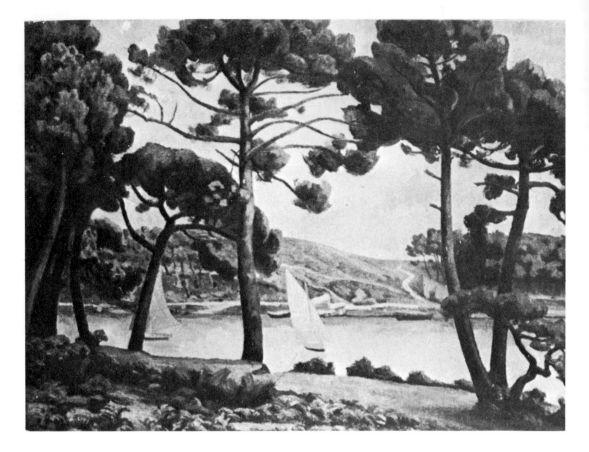

87 Roger Fry: *In the Morbihan*, 1920. Oil on hessian, 112.5 × 157.5 cm. Oxford, Somerville College

hangs beside two or three pictures by Girieud and very much more than holds its own.'[28] He rescinded this view a few days later, swayed by the opinon of others: 'I begin to suspect I may have been too well pleased with Roger's picture. ... Everyone likes Roger very much – and everyone, Friesz, Marchand, etc. etc., – says "c'est très distingué: on n'aime pas die des choses comme ça d'une personne qu'on aime mais que voulez-vous? Il n'y a que ça à dire." I fancy he must really be deceived by French manners.'[29]

Lack of success in England as a painter did not however prevent Fry from playing an influential role in the London Group during the 'twenties. He favoured artists who imitated the French example and D. S. MacColl observed that under his influence 'sedulous and dowdy imitations' of Parisian art began to clutter the exhibitions.[30] Even Frank Rutter in his unbiased account of the period admits that Fry's satellites, 'the rag, tag and bobtail of his followers, lowered the standards'.[31]

Fry's ascetic influence on the London Group also led to an altercation with C. R. W. Nevinson. After the war, Nevinson had resumed his position as Secretary of the London Group and before sending out invitations to a private view, combed through a copy of *Who's Who* for names of people to invite with the result that the opening was well

attended and several sales made. Fry, however, accused Nevinson of attempting to turn the London Group into a fashionable gathering and argued that this was not the sort of public the Group was hoping to interest. Nevinson bristled at what seemed to him intellectual snobbishness and sourly replied that they were a body of professional artists in need of sales and not all had cocoa behind them. In his book, *Paint and Prejudice*, Nevinson attacks Fry's 'amateurish dilettantism' and uses it to explain his resignation from the Group which he found too dominated by Fry's star artists – Grant, Bell, Keith Baynes, Meninsky, Gertler, Matthew Smith and Frank Dobson.

The hanging of each annual London Group exhibition was a trial of diplomacy. Inevitably someone was offended. After a number of complaints Fry resigned from both the jury and the hanging committee and he described what followed to Marie Mauron.

> I proposed the Jury should be drawn by lot. Everyone was delighted and I did nothing about the exhibitions. The result was that very incompetent people did the hanging and in two years the Group had no more funds. Then they asked me back. I reconstructed the constitution of the society, forming rules that would give a certain responsibility to a few elected artists; in fact, I re-installed government and de-democratised the Society. It's the only way to do something. When everyone shares the responsibility, nothing gets done.[32]

Wary of further complaints, Fry refused an official position and the Presidency went to Bernard Adeney, whose temporary success in the 'twenties owed much to Fry. Rutter describes him as 'a blameless echoer in biscuit and pale green tints of Cézanne's less successful nudes and landscapes'. He adds that this devotion to Cézanne made him worthy of the presidential chair, 'but Mr Fry remained the power behind his throne'.[33]

The success of *Vision and Design* had confirmed Fry's role as an arbiter of taste and during the twenties his influence was stronger than ever before. His reviews of young artists' exhibitions, which appeared in the *Athenaeum*, the *New Statesman* and, from 1924 onwards, in the *Nation and Athenaeum* noticeably affected an artist's success or failure. Some artists were easily antagonised by his power and influence, and Mark Gertler was one who felt Fry's French interests narrowed his understanding of English art. Yet the articles he wrote during these years reveal the extraordinary openness of his response; his criticism is always searching, sensitive, constructive and never didactic. His aim was to reveal, explain and advise, and he did not hesitate to point out failures even when writing about his favoured associates; in 1920 he criticised Grant's loss of resonance in his use of colour and two years later Vanessa Bell received the harsh comment that her recent work did not reflect her personal approach. Few denied that he had that rare gift to translate into easy, understandable prose the visual characteristics that contributed to each artist's personal style, and, after his death, even Mark

Gertler executed a large still-life which he entitled *Homage to Roger Fry*.

Concerned to discover in the work of his contemporaries both vision and design, Fry inevitably found design easier to discuss. Vision he related to the artist's curiosity about the nature of reality; in front of a painting he questioned how far the artist had enquired into the facts of the scene presented. He criticised Nina Hamnett in 1926 for having not enough curiosity about appearance or character to make her statements 'more penetrating or richer.'[34] Earlier he had upbraided John Nash for never totally subjugating himself to his vision, for never wrestling with it to extract its utmost significance, but passing instead from the immediate vision to the creation of tasteful arabesques. Greatness in art for Fry, therefore, directly related to the extent which an artist had grappled with his vision.

Throughout the twenties Fry spent a large part of each year in France, painting without interruption. In 1921 he stayed for a month with the Maurons at the home of Elspeth Champcommunal at Vaison and then moved south to spend the autumn at St Tropez. He wrote from there to Vanessa, urging her to take a house in the area; life in the south he said, was more natural, varied, amusing, and above all the climate made painting possible. In October Vanessa arrived, bringing Duncan and her children in tow and Fry soon despaired at her domesticity. He had, however, recovered from the hurt caused by the birth of Angelica, whom he now observed with amusement as she rushed up and down the water's edge, shrieking with delight, and his fondness for her soon equalled that he had always felt for Vanessa's two sons, Julian and Quentin.

As the days passed he noticed that his paintings were developing in a different direction to those of Vanessa and Duncan; his were marked by a greater concern with plasticity and a purposeful deliberation of design. Occasionally this led him dangerously close to over-literal representation, as in the church interior which he painted this autumn at the nearby Ramatuelle (Manchester City Art Gallery), but his paintings are always saved by his subtle orchestration of colour, design, and, in this case, chiaroscuro. His classical bias led him to distrust drama and reject stylistic tricks, and to Marie Mauron he defined himself as 'one who enjoys above all pure art without any rhetorical emphasis, art which expresses sensation without wishing to impose it'.[35]

At St Tropez in 1921 Fry met a Polish Jew, Madame Mela Muter, who was to sit for the first of what proved to be a series of solidly-realised portraits. Mela Muter was herself a painter and she sat with aplomb on the jury of the Salon d'Automne and ensured for Fry that three of his works were accepted that year. At the start of their friendship, Fry thought for one moment that she might replace Vanessa in his affections, but as it turned out their relationship was stormy and incon-

clusive. Mela was not only powerful of limb (as Fry's portrait reveals), but also of mind; a political idealist and extremist, she fervently supported the communist cause. In the spring of 1922 she confessed to Fry that since the death of her lover (a communist called Lefèbvre who had drowned in Russia) she had vowed herself to eternal widowhood. (He later discovered that her financial resources would be discontinued if she remarried.) She could, she said, include Fry in her life at intervals, take him, as it were, medically for her health and comfort. Fry accepted this proposal immediately, admitted that he did not love her, but found her charming, beautiful and affectionate. Mela, accustomed to male devotion, found this approach a little novel, if not unflattering. Before long each was uncomfortably aware of their differences: she was slavonic, romantic, impulsive, inclined to play the *grande dame* and stand on her pride; he was irritatingly direct, unselfconscious, reasonable. Against a background of growing discontent, Fry's portrait of Mela, and hers of him progressed.

The portraits were completed in Paris in the spring of 1922. Fry disliked Mela's capable style, finding it too Germanic for his taste. Yet he had to admit that, from the point of view of likeness, she had been successful; the natural pose, relaxed yet alert, thoughtful yet affectionate, expresses far more of his character than he was able to reveal of hers. (Plate 88 and dust jacket). He chose to present her as a cross between an athlete and one of Picasso's heavy neo-classical nudes, a monument of sensuality. Uncharitably, he argued that the success of her portrait of him was due to the curb he placed on her expressionistic tendencies. 'There's very little Dostoievsky in my portrait', he told Vanessa, 'so I suppose I've had a restraining influence.'[36] The tail-end of their affair petered out that summer at St Tropez when Fry indicated the limitations of his interests. 'Muter has made one or two scenes', Vanessa was informed, 'but I'm inexorable and give all the energy I have to work.'[37]

Fry followed this portrait of Mela Muter with one of Lydia Lopokova (Coll: Julian Fry), two of Bertrand Russell (National Portrait Gallery, London and Professor Philip Rieff) two of Logan Pearsall Smith (both lost), and one of the Bolton millowner and collector, Frank Hindley Smith (now lost), to whom Fry had been introduced the year previously by a dealer. He had visited Hindley Smith's house in the north, admired his collection of nineteenth century French art, encouraged his recent interest in modern art, and was impressed by his knowledge of French literature and admiration for Proust. His request to paint Hindley Smith's portrait received the following reply: 'To continue my existence in your paint is immensely attractive and if artists can make beautiful things of old pots and pans and paper flowers, you may be able to make something tolerable of me.'[38]

Then Fry turned his attention on the poet Robert Bridges, producing three portraits under difficult conditions as temperamental differences between artist and subject left Fry feeling uneasy during the sittings. The first, painted at Bridges' home at Chilwell in February 1923, pleased

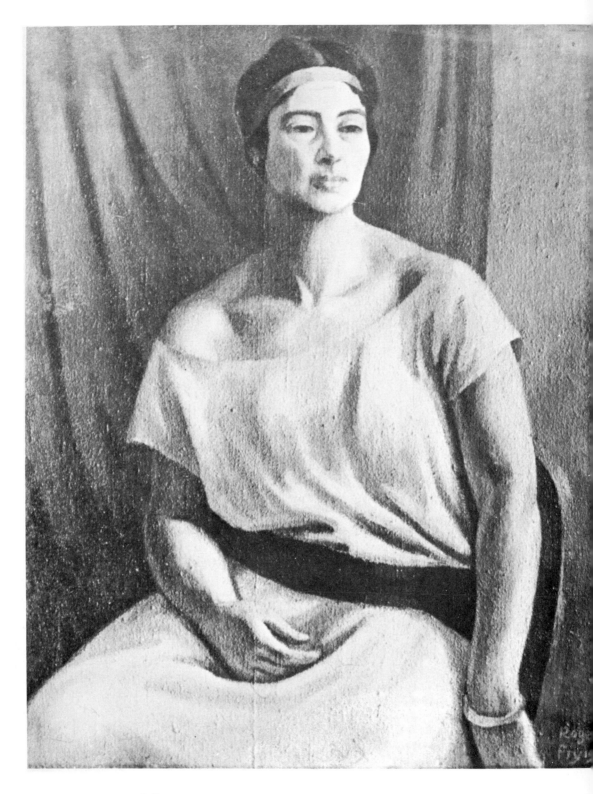

no-one and was destroyed. The second managed to avoid the sickly look of the first, which had so distressed the poet, but it was the third that Fry chose to exhibit at the Independent Gallery in April 1923. This is surprising as it is clearly a studio product, painted not from the sitter but from the second version; the painterliness of the earlier portrait has been exchanged for greater perfection of design, but at the same time the expression of the face has hardened into a grimace. (Both portraits are still with the Bridges family.)

Fry's Independent Gallery one-man show coincided with an exhibition of Augustus John's portraits at the Alpine Club and inevitably the sobriety of Fry's portraits was compared to John's love of bravura. Hindley Smith went to see himself in the Fry exhibition and proudly told the gallery owner, so he informed Fry, that he found 'more in the three portraits in the front gallery than in all the John lot'.[39] But if generally the portraits were praised, the show as a whole was roundly abused. 'Lacking in spontaneity' declared the *Birmingham Post*;[40] 'lacking in sensuous charm', intoned P. G. Konody. 'Mr Fry', he continued, 'the enemy of "representation" and champion of self-expression is very often purely representational – because he has nothing to express.'[41] Critics now frequently made adverse comparisons between Fry's writings and paintings. 'When Roger Fry changes the pen for the brush, he does not for a moment allow the inexorable logic of his intellect, to slacken at the urging of his artistic emotions. He remains cool, calculating and learned. . . . It seems incredible that the man who burns incense to Rouault in print should use his brush to produce things of such cloying prettiness as the portrait of Mlle Lydia Lopokova.'[42] Faint praise, such as *The Times'* estimation that his work was 'firmly built, self-contained, self-existent',[43] did not wipe out the echoes from such damning phrases as 'laborious and dry, often clumsy in drawing and muddy in colour, and usually rather too obvious in design'.[44] The gallery owner Percy Moore Turner, advised Fry to give up painting and for a short while he felt severely depressed by his failure to charm the British public. 'It wants lyricism and I ain't a lyric', was his final comment.[45]

Any painter less resilient to public opinion might then have given up; but for Fry disapproval could be regarded as a sign, if not of success, at least of artistic integrity. In Paris in September 1923 he was asked to give evidence at the preparatory enquiry for the Hahn v. Duveen case concerning Mrs Hahn's version of Leonardo's *La Belle Ferronière* which Duveen had publicly denounced just as its owner was about to sell the painting to Kansas City Art Gallery. Fry, one of ten experts called on to give an opinion on the matter in Paris where the copy could be compared to the original, was cross-examined for almost three hours and entertained the entire court room. 'It is the highest art of the portrait painter to make a likeness, isn't it?', the Counsel for the Plaintiff demanded. 'Oh dear, no,' Fry replied, 'nothing of the kind', adding that a good artist aims more at creating a work of art. When asked if, as a painter, he had ever won a prize at the Salon, he replied: 'No, I have

never had that insult. I should give the whole thing up if I got a prize, unless, I think, it was given as a joke. If it were sincerely given, I should know there was no chance for me.'[46]

In spite of his optimism, the failure of his 1923 exhibition may explain why the chief product of his summer visit to Spain that year took the form of a book. *A Sampler of Castile*, initially published by the Hogarth Press in a limited edition of five hundred copies, drew on his impressions of Spain noted down at odd intervals, in halls of hotels, waiting rooms, trains and trams. The result is perceptive, relaxed, humorous and descriptive. He passes at ease from discussion of the Spanish language to descriptions of landscape, beggars, boot-boys, the beauty of Spanish women, art and architecture, to recognition of the Jesuit monopoly over the supply of fish and antiques in Madrid. ('They never confuse the issues. They never provided antique fish, and their antiques were never unpleasantly fresh.'[47]) He accused Spanish art and architecture of the unaesthetic desire to teach religious dogma, but detected beneath its extravagant trappings and love of mystery, 'something of the significance of pure form'.[48] He sketched in each place he visited and produced careful illustrations for the book. They are formally satisfying but lack the same verve and energy that animates his prose, spiced as it is with his own prejudices such as his dislike of Art Nouveau which he noted had spread like a disease in Barcelona.

Naturally gregarious, Fry whenever possible enjoyed the company of friends. In Spain he met up with Vanessa and Duncan for a few days but was saddened by the easy intimacy they obviously enjoyed together. At Segovia, he met by chance Saxon Sydney Turner, the Bloomsbury intellectual who had submerged his talents in the Civil Service. 'He approached the table in perfect style', Fry recounted to Virginia Woolf, 'with just a little guttural noise, a sort of burble which expressed everything that the moment demanded and sat down, and we went about very happily together for some days.'[49] In the autumn of that year he enjoyed the company of Elspeth Champcommunal and her friends at Vaison in France. The party was voluble and a little drunken. They went for picnics beside the river Ouze discussed ants, crickets, Fabre, Bergson, Miguel de Unamuno and occasionally fell into violent arguments. Fry read aloud passages from Tristram Shandy, played chess, drank a great deal of local wine and announced his intention of writing a book on the principles of poetry. On the morning of his departure, he rose early, snatched a cup of coffee, scrambled on to a cart with his boxes and paints and drove off through the wet morning dew to catch a train to Paris.

Since the war he had suffered at intervals from severe internal pains. He approached several doctors; one said his liver might be causing the pain, another that he had neuralgia of the visceral nerves and that old, forgotten anxieties and moral complexes were acting on his sensitive nervous system. In short, Fry concluded, his puritanical upbringing was to blame. He took a series of injections and tried various diets and as a

242

last resort agreed to follow Margery's suggestion and visit Coué's clinic at Nancy. Coué's cure for all ills was a process of auto-suggestion; his pupils repeated regularly the sentence 'Tous les jours, à tous points de vue je vais de mieux en mieux', and, when in pain, the phrase, 'ça passe, ça passe'. Fry first visited his clinic at Nancy in 1922. He expected humbug and pretence, but instead recognised in Coué good sense and a gift for inspiring confidence and cheerfulness in others. After three days of Coué's teaching and the continued muttering of the relevant phrases, Fry found he was free from pain and could eat and drink normally without having to lie down after meals to aid digestion. He left Nancy believing himself cured.

At Nancy Fry met Josette Coatmellec, a thirty-four year-old woman from Le Havre, thought to have consumption and, like Katherine Mansfield, hoping that hypnosis would provide a cure. Her condition was worsened by her highly nervous temperament. After their initial meeting Josette wrote regularly to Fry, letters which Fry considered some of the most charming he had ever received. He detected beneath her plain appearance a rare and curious being and decided, on his next trip to France, to visit her and her family at Le Havre. Josette then declared that her fondness for Fry amounted to more than friendship; he, in turn, confessed that he could not return her love but wanted their relationship to continue if she would allow him at all times to be frank about his feelings.

Josette travelled to Paris to be with Fry while he gave evidence at the Hahn v. Duveen deposition in September 1923 and though she did not understand a word of English she sat patiently through four hours of the proceedings. Fry, as much in demand in Paris as he was in London, was unable to give Josette his full attention and she complained that he had deliberately ignored her. Just at the moment when his affection for her had turned to love, she began to regard him with suspicion. Then, in Paris in the spring of 1924, Fry showed Josette an African mask (Plate 89) which he had bought and its savage expressiveness jarred on her nerves, leaving her frightened and alarmed. On his return to London Fry received a letter from Josette accusing him of taunting her with the sculpture, and of putting all his love and energies into art, leaving little or nothing for her. He replied immediately, urgently denying her accusations, but before the letter reached its destination Josette had shot herself on the cliff at Le Havre, looking towards England.

Fry suffered bitterly from this event: the man who experienced profound emotion in front of Poussin's rational, ordered compositions, had again to experience the triumph of mental chaos over reason and love. He attended with difficulty the funeral at Le Havre and himself designed her tombstone but when he had finished recording the development of their friendship in a long manuscript written in French, he still had not exorcised his grief and he remained darkly pessimistic. He dined with Leonard and Virginia Woolf soon after hearing the dreadful news, as Virginia recorded in her diary:

89 African Dancing
Mask. Height
61 cm. From Ulvira,
Lake Tanganyika,
Zaïre. London,
Courtauld Institute
Galleries

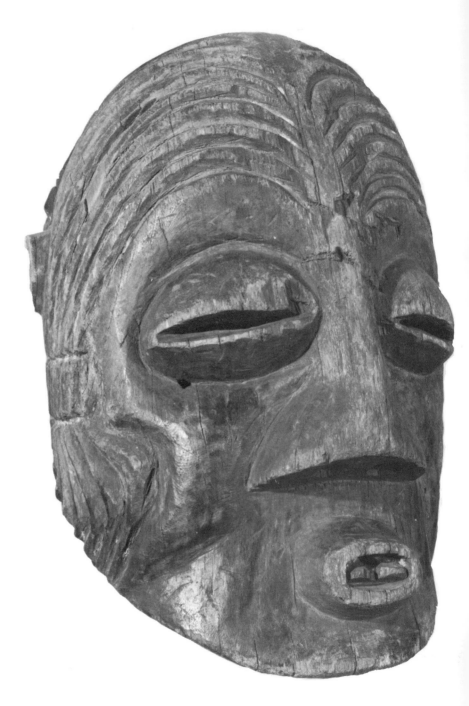

'And so my last chance of happiness is gone' said Roger. And so we walked down Tottenham Court Road in the pouring rain, I protesting affection, and Roger saying that he was fated; he was cursed; he had never

244

had more than 3 weeks happiness in his life. 'I have pleasure – I enjoy my friends – but no happiness.' I see what he means. And he's so young, he says – and so fond of women. To which Nessa adds, pertinently, that he'll recover, and do it again.[50]

For a brief moment Fry forgot the capacity of art to create a solid reality immune from time and gave this power solely to love. Yet Fry, like other members of Bloomsbury as J. K. Johnstone observed in his *The Bloomsbury Group* (1954), turned more and more to art as love and friendship disclosed their instability, and his ability to lose hold of relationships and achievements ensured the continuation and flow of his life. 'He was always leaving things behind', commented his daughter, 'people and styles.'[51]

Before a month was out he had left England for France, intending to pour his mind and energies into his painting and thus ease his sorrow. He let his studio at 18 Fitzroy Street, with its wine and grease-stained furniture (reflecting Nina Hamnett's previous occupancy) to the young writer Gerald Brenan who, as he lay on the bed looking up at Fry's paintings that lay across the overhead beams, saw 'ugly women painted in depressing colours gazing stonily down at me.'[52] Fry, meanwhile, went straight to St Rémy-de-Provence to join the Maurons where he remained in their welcome company for several days before moving on to Montpellier and Toulouse, finally settling at the nearby Souillac. He returned briefly to London at the end of July to see to his affairs, but by early September was back in France, painting hard at St Tropez. His pictures had lost their previous aridity and claustrophobic level of finish. A change had occurred, as he observed, towards 'far more colour and a more downright direct method'. His confidence gradually returned and he wrote happily of his painting, 'I feel a new sense of power and ease'.[53]

12 The White Knight

'Now one can breathe more easily', said the Knight, putting back his shaggy hair with both hands, and turning his gentle face and large mild eyes to Alice. She thought she had never seen such a strange-looking soldier in all her life.

He was dressed in tin armour, which seemed to fit him very badly, and he had a queer little deal box fastened across his shoulders upside-down, and with the lid hanging open. Alice looked at it with great curiosity.

'I see you're admiring my little box,' the Knight said in a friendly tone. 'It's my own invention – to keep clothes and sandwiches in. You see I carry it upside-down, so that the rain can't get in.'

'But the things can get out,' Alice gently remarked. 'Do you know the lid's open?'

'I didn't know it,' the Knight said, a shade of vexation passing over his face. 'Then all the things must have fallen out! And the box is no use without them.'

In appearance, Roger Fry in his sixties was worn, seasoned, ascetic and tough, but the planes of his face still had that luminous beauty that Vanessa Bell had observed in 1910. Suffering and loss had refined his character, melting away ambition and gross matter, and the jewel had been cut. In old age he shone, and his last decade saw no lessening of intensity in his approach to art and life. Instead his energy and activities seemed to increase: he produced eight books, gave a series of highly successful public lectures, was involved in the setting up of the London Artists' Association and in his own painting arrived at a new ease and

246

lyricism. Mentally, he was more open than ever before, to the extent, some thought, of credulity.

> 'You see', he went on after a pause, 'its as well to be provided for everything. That's the reason the horse has anklets round his feet.'
> 'But what are they for?' Alice asked in a tone of great curiosity.
> 'To guard against the bites of sharks,' the Knight replied. 'It's an invention of my own!'

Fry's elasticity of mind meant that he refused ever to dismiss a statement or theory off-hand. At one time he toyed with the idea that the unconscious mind was much more sensitive to aesthetic emotions than the conscious. At others he held a pendulum over paintings and over his Old Master photographs to determine their authorship. He advised the wearing of saffron-coloured vests to prevent tuberculosis. This willingness to consider any new idea no doubt contributed to the feeling Virginia Woolf had that she had been 'fed to the lips, but impressed almost to tears by his charm,' after dining with him in 1928. 'Roger is the only civilised man I have ever met,' she wrote half teasingly to Vanessa, 'and I continue to think him the plume in our cap; the vindication, asseveration – and all the rest of it – If Bloomsbury had produced only Roger, it would be on a par with Athens at its prime (little though this will convey to you).'[1] Having taken as many tumbles as the White Knight, he had the same slightly preposterous optimism and the same ability to linger in people's memory.

> Of all the strange things that Alice saw in her journey Through the Looking-Glass, this was the one that she always remembered most clearly. Years afterwards she could bring the whole scene back again, as if it had been only yesterday – the mild blue eyes and kindly smile of the Knight – the setting sun gleaming through his hair, and shining on his armour in a blaze of light that quite dazzled her – the horse quietly moving about, with the reins hanging loose on his neck, cropping the grass at her feet – and the black shadows of the forest behind – all this she took in like a picture, as, with one hand shading her eyes, she leant against a tree, watching the strange pair, and listening, in a half-dream, to the melancholy music of the song.

During the winter of 1924–5 Fry attended a party given by Vanessa Bell in her Fitzroy Street studio and spent most of the evening engrossed in conversation with Helen Anrep. Helen, who was almost twenty years younger than Fry, had a round face, short nose, blue eyes and a sincere love of art. She was at the time living with her husband the mosaicist Boris Anrep, in a *ménage-à-trois* in Pond Street, Hampstead, Boris having brought back from Russia during the First World War a young Russian girl to whom he was distantly related. Helen had learnt to accept Boris's need for two wives, as she had learnt to accept that when he went out socially in Mayfair, both wives were expected to stay at home. According

90 Helen Anrep.
Photograph

to Romilly John, Boris (who read mainly detective stories) sent the younger woman out to the public library to select books for Helen on the infallible principle that she would select books which Helen would not have chosen for herself. After the party at Vanessa Bell's studio had ended, Boris angrily accused Helen of having given too much attention to Roger Fry. Helen, tired of his demand for unfailing devotion, left their Hampstead house and returned to Fitzroy Street where she knocked on the door of Fry's studio. Fry, surprised and perplexed, let her in and a moment later was seen dashing across the street to ask Vanessa for advice.

Helen's arrival marked the beginning of a relationship that was to alter, subtly but profoundly, the tenor of the last nine years of Fry's life. Of Scottish parents, Helen (née Maitland) had been born in California where her father, after having squandered a good part of his family fortune in Europe on operas, theatres and entertaining young dancers, decided to try his luck producing wine. He acquired the best and most suitable grapes from France and his vineyards did well, but being a difficult man he quarrelled with all his neighbours and afterwards found that he could not transport his wine without crossing his neighbours' land. Barrels and barrels of wine lay stored up in the barns and then one day their owner disappeared and was never heard of again. Helen's mother stayed on at the farm in some danger; on Saturday nights she and Helen were locked in the barns by the Chinese cook for safety while the American labourers drank. Before long they moved to Stanford University where Mrs Maitland was employed as a librarian and from there they moved briefly to New York before returning to live with Scottish relatives in Edinburgh. All this time Helen had little, if any, education and it was not until her mother moved to Florence that her

life began to take on any direction. There she took singing and violin lessons (later blaming her crooked spine on excessive violin practice) and went on a brief tour with a small opera company. From Florence, mother and daughter moved to Paris where they took a flat over a high class restaurant which sent up each evening whatever dishes they had left over.

In Paris, Helen's interest in art began. She met Duncan Grant, Augustus John and Henry Lamb and with the latter she had a brief affair. Meanwhile her mother was taking painting lessons from a lunatic who taught his pupils to dance in the sun on the roof before preparing their canvases with the yolk of ducks' eggs. Then, Lamb's place in Helen's life was rudely usurped by Boris Anrep, a young Russian from an academic bourgeois family, who had grown bored with his law studies, taken lessons from Stelletsky and come to Paris to study at the Académie Julian. He had unusual aptitude and excessive self-confidence; in order to woo the musical Helen he learnt to play the piano, developing the art, so he said, in a matter of minutes. He had no intention of marrying Helen, but when in 1918 she bore him a son he immediately made her his wife. Had the child been a daughter their unmarried state would have continued, but Boris disapproved of illegitimate sons. 'There's no sense in marriage', he once said: 'I prefer collages – associations that everyone knows about.'[2]

By 1924 Helen's marriage to Boris was under severe strain. After Vanessa's party, Helen and Fry dined together whenever possible at a nearby Spanish restaurant and it soon became evident to both that their lives should combine. Yet the situation was complicated on both sides: the break with Boris would affect the lives of Helen's two children, Igor and Anastasia, and Boris at first had no intention of letting her leave and made ugly threats; Fry, on his part, was not free to remarry and his sister Margery jealously guarded their domestic happiness. Fry, anxious to avoid scandal that would hurt his mother or damage either his or Boris' career, was aware that they were treading on an emotional minefield, and he urged Helen to act with patience and caution. 'Have you forgotten,' he wrote to her in April 1925, 'how I said to you at the very first that our relation was worth so much that it was worth waiting and waiting to get it in all its completeness.'[3] Meanwhile Vanessa, who was consulted at every turn of events, was assured, 'Everything that happens to me makes my affection for you greater and our friendship more precious'.[4]

It took over a year to convince Boris of Helen's decision to leave and during that time endless letters passed between her and Fry through the intermediaries Dorelia John, Gerald Brenan and Vanessa Bell. To outsiders, Helen, who dressed in Augustus John-style dresses of her own making, seemed unsuited to Fry: in the company of Bloomsbury she occasionally became pretentious to disguise her lack of knowledge. Yet she had optimism, eagerness and sensitivity, and under her influence Fry's prejudices softened and his awareness was enriched. 'You touch

almost every part of me', he once told her. 'You'd be surprised how much of me Vanessa temporarily suppressed because of her peculiar narrowness and intensity.'[5] Helen was a good listener and a great believer in talking things out; Lytton Strachey thought her stimulating. Fry found her qualities so complex he had to resort to a pictorial metaphor: '... one would have to say Cézannian to give what I mean of exhilarating richness, gravity and austerity.'[6] And the other side to her character was an exuberance and responsiveness that matched his own.

In January 1925 Fry had a one-man show at the Joseph Brummer Gallery in New York. Not a single work sold and he was left with two hundred pounds of expenses to pay. To off-set this financial disaster he sold his Chinese statue of the goddess Kwan Yin to Worcester Art Museum, Massachusetts, for more than thirty times the sum he had paid for it. With this money in hand he planned another protracted visit to France, but before leaving England went down to Charleston in order to advise Vanessa on the studio she intended to build within the four walls of the old farm house courtyard. As usual, his visit lasted not just the weekend but several days. His presence always animated the lives of the residents, particularly Angelica's, whom he taught how to make paper boxes, and for whom he built a merry-go-round with flying birds.

Paris in the spring deepened further his love for France. 'The sight of decently logical, even if not great, buildings, of decent colours everywhere, the absence of the peculiar contorted and intentional ugliness of nearly all English life and then large significant landscapes, real big views, well kept fields and woods and a clearer air – in short the *sensibleness* of everything as compared with our so twisted, upside-down, obstinate irrationality. Don't forget that I'm much more thrilled by the sensible than the picturesque.'[7] The main purpose of his visit was to see the Cézannes in the Pellerin collection on which he had been commissioned to write a lengthy article for the magazine *L'Amour de L'Art*. He also visited the Louvre where he attempted to rid himself of all theories and preconceptions in order to assess the work afresh; and he revelled in an exhibition of French landscape painting at the Petit Palais which reconfirmed his love for the classical landscape tradition. After looking at the sublime and impressive Claudes and Poussins included in this show, he felt intensely dissatisfied with the paintings of Miró and Masson which he saw for the first time. He talked at length with young poets and intellectuals about the new avant-garde, the Surrealists, and scented *arrivism* and pretentious humbug. He wrote to Gerald Brenan of a tendency to 'mysticism, obscurantism, symbolism, expressionism' in the new art and thought. Because of the literary aspect in Surrealism, it seemed to Fry to be directly opposed to all that he had striven to establish in England. To Brenan, he gave the biased conclusion: 'The positive classic spirit is dead for a moment. And with everything is mixed an element of violence and fascism.'[8]

Fry left Paris for St Rémy and the Maurons, and arrived at the small farm owned by Charles' parents to find that E. M. Forster had just left. The previous year Fry had found Charles suffering from the onset of blindness which put an end to his career as a chemist. Knowing his literary interests Fry suggested that he should undertake, with Marie's help, translation work, and he recommended the novels of Virginia Woolf and E. M. Forster. In May 1925 Fry, on his arrival, learnt that not only had Mauron listened to his suggestion but that the translation of *A Passage to India* had already been completed. Fry himself never tired of discussing literature and aesthetics with this intellectual and he did all he could to see Mauron's writings published in England, accepting articles on aesthetics for the *Burlington Magazine* and persuading Leonard Woolf to publish Mauron's *The Nature of Beauty in Art and Literature* in 1926. Recognising in both Charles and Marie good sense, humour, intelligence and scepticism, he did all he could to expand the limitations imposed by their provincial position, providing money for Charles to visit Italy before blindness set in, seeking for him contacts with publishers and authors in Paris, and urging Marie to publish her tales of Provençal life. That summer Fry took Charles with him to the *Décades de Pontigny* (an annual meeting of select intellectuals at the Abbaye de Pontigny), where the two men upheld scientific rationalism against the prevailing attitude of Christian metaphysics.

From Pontigny, Fry moved to Cassis and established himself at the Hotel Cendrillon, in those days the only hotel in the small fishing village. Vanessa and Duncan were also present and had become so attracted to the place, Vanessa had arranged the repair of an old villa standing vacant on some land belonging to a Colonel Teed, a former Bengal lancer living in happy retirement at Cassis with his mistress and his vineyards. The shifting community, the sunshine and Mediterranean light filled Fry with a sense of freedom after the severe intellectualism of the *Décades* at Pontigny. 'Oh the joy of the Midi,' he wrote to Helen. 'It's irresistible – life suddenly seems to have just twice its value.'[9] He attended a fancy dress party given by Duncan's Aunt Daisy and constructed for the occasion a suitably bizarre headdress. After another celebration, returning to the hotel late at night, he fell hard on his face, suffering the loss of a front tooth, cuts, grazes and severe shock. A doctor was called in to examine him and pronounced favourably, not on Fry's health, but on his paintings.

Five of the paintings Fry executed at Cassis were included in the first London Artists' Association exhibition in May 1926, where to his surprise seven of his ten works exhibited sold. Even the critics expressed bewildered admiration and in the *Daily Telegraph* a climactic note was reached: 'Mr Roger Fry never painted as well as now. His large picture, entitled *Cassis* (54) baffles criticism. It illustrates his wonderful power of bringing everything in the scene before him into harmonious relationship with the whole.'[10] Such praise contributed to Fry's pleasure in the success of the enterprise which he himself had helped guide into being.

Maynard Keynes had had the original idea for the London Artists' Association, aimed to give a select number of artists greater financial security. He secured financial support from Samuel Courtauld, F. Hindley Smith and L. H. Myers and contributed generously himself. The Association began with a membership consisting of six painters and one sculptor. These artists were paid an annual salary of around £150 while the Association took a thirty per cent commission on all works sold. Though the annual salary was guaranteed, it was also deducted from the sale of paintings and sculpture. Certain members (Fry included) agreed to forego their salary in order to gradually swell the ranks and give opportunity to young painters. After four and a half years the Association had sold seven hundred works for the total of £22,000, but as its membership was severely limited, it had benefited only a few. Fry, who was chiefly responsible for recommending artists, must take the blame. The original enclave was undeniably selected from his circle and included Bell, Grant, Bernard Adeney, Frederick Porter, Keith Baynes and Frank Dobson. When Keynes suggested including Paul Nash, Fry opposed his membership, preferring to let in Edward Wolfe, R. V. Pitchforth, George Barne, Raymond Coxon and others. With Fry's reputation as a critic and Keynes' financial wizardry it is not surprising that the Association flourished; but outsiders regarded it as an exclusive offshoot from the more democratic London Group, concerned to create and protect the reputations of the favoured few.

While the first exhibition of the London Artists' Association was in progress, Fry occupied himself with the final preparations for his second book of essays, *Transformations*. Earlier that spring he had moved into a house in Guilford Street with Helen Anrep and she now severely criticised his writing and urged him to take it more seriously. As a result several of the previously published essays included in this book were substantially rewritten, and at her persuasion he agreed to add articles on Fra Bartolommeo and the Seicento. His most important new contribution, however, was 'Some Questions in Esthetics' in which he set out to answer criticisms made by I. A. Richards in his *The Principles of Literary Criticism* (1924).

Richards had questioned Fry's and Bell's assumption that there exists an aesthetic state *sui generis*. He had disagreed with Fry's contention that the pattern of our mental disposition in front of art differs from that with which we approach life: 'When we look at a picture, or read a poem, or listen to music, we are not doing something quite unlike what we were doing on our way to the Gallery or when we dressed in the morning.'[11] If one accepts the idea that there exists a particular aesthetic attitude then this leads to the corollary that there is in art some pure aesthetic quality, and with this too Richards disagreed, positing instead a psychological theory of value. Fry, therefore, set out to reargue the case for aesthetic experience being distinct from our experience of everyday life.

According to Fry, the distinguishing characteristic of aesthetic expe-

rience is that it is aroused by the perception of a relation, between forms, colours, sounds, words or whatever. The reason why there is no art of smell, he argues, is because we are unable to perceive one perfume in relation to another. Now in order to appreciate art, we need 'a special focusing of the attention, since the act of esthetic apprehension implies an attentive passivity to the effects of sensations apprehended in their relations'.[12] He admits that much art does evoke associations related to our experience of everyday life, yet he retains his belief in the existence of some distinctly 'aesthetic' value by positing the existence of pure and impure art: an impure work of art is that which moves us primarily by its literary and psychological appeal; a pure work of art acts upon us solely through its form. As psychological appeal in art is often closely related to the period in which the work was produced, Fry argued its value does not endure. 'I believe that ... wherever a psychological appeal is possible this is more immediately effective, more poignant than the plastic, but that with prolonged familiarity it tends to evaporate and leave plasticity as a more permanent, less rapidly exhausted, motive force. So that where pictures survive for a long period their plastic appeal tends to count more and more on each succeeding generation.'[13]

The concept of pure and impure art enables Fry to admit the effectiveness of representation in art at the same time as he relegates it to a secondary position. He had earlier introduced this idea into his lecture 'The Artist and Psycho-Analysis', read to the British Society of Psychoanalysts in 1924 and published in the same year by the Hogarth Press: art which appeals to emotions *associated* with objects, is popular, commercial and impure; that which depends for its effect solely on the manipulation of form is 'classic' and pure. Because of this, Fry argues, 'the accumulated and inherited artistic treasure of mankind is made up almost entirely of those works in which formal design is the predominant consideration'.[14] What separates this lecture from the more measured, interpretative, theoretical structure which emerges from 'Some Questions in Esthetics' is Fry's refusal to allow any colloquy between the two types of art. In 'The Artist and Psycho-Analysis' Fry concludes:

> Now I venture to say that no one who has a real understanding of the art of painting attaches any importance to what we call the subject of a picture – what is represented. To one who feels the language of pictorial form all depends on how it is presented, nothing on what. Rembrandt expressed his profoundest feelings just as well when he painted the Crucifixion or his mistress. Cézanne, who most of us believe to be the greatest artist of modern times, expressed some of his grandest conceptions in pictures of fruit and crockery on a common kitchen table.[15]

This is Fry's most severe formalist statement. Two years later he had modified his position and become less dogmatic.

In spite of the reference to Rembrandt in the above passage it was this artist who forced Fry to reconsider his theoretical standpoint. In *Transformations* Fry draws attention to Rembrandt's ability to combine

psychological insight of the highest order with his outstanding gift for the realisation of form. Thus in his analysis of *Titus at His Desk* (Plate 91) Fry is forced to admit that the subject matter contributes to our enjoyment of the picture. The painting represents a moment of distraction in that Titus looks up from his book lost in thought. Rembrandt suffuses the whole painting with this mood of contemplation, expressing it even through his painting of the scratched and battered wood of the desk, as Fry observed:

> Realism, in a sense, could go no further than this, but it is handled with such a vivid sense of its density and resistance, it is situated so absolutely in the picture space and plays so emphatically its part in the whole plastic scheme, it reveals so intimately the mysterious play of light upon matter that it becomes the vehicle of a strangely exalted spiritual state, the medium through which we share Rembrandt's deep contemplative mood.[16]

But if in the hands of a lesser artist subject matter is merely used to refer the spectator back to the external world, then, Fry argues, it detracts from the aesthetic effect of the whole and the result is an impure work of art. Visual data must always be incorporated, interpreted into the 'spiritual whole' and it is to this process of transformation that the title of the book refers.

Stylistically 'Some Questions in Esthetics' is more discursive and lacks the brilliant compression of argument found in 'An Essay in Aesthetics'. The analyses of certain paintings are lengthy and the reader, instead of being led by flashes of inspired thought, moves steadily and at times a little laboriously to each conclusion. While attending to Helen Anrep's desire for carefully reasoned argument, Fry lost something of his former revolutionary fervour. His wit sparkles more freely in his devastating essays on 'Culture and Snobbism' and on the art of John Singer Sargent. Aesthetics, however, was his life-long preoccupation and he therefore treads warily but with conviction.

Transformations is full of small observations that reflect on Fry's taste. He admires Chinese bronzes for their classic qualities, their 'grave dignity of mien and that weighty austerity of plastic rhythm'.[17] In Seurat's art he praises the 'complete transmutation of the theme by the idea', the transformation of the original scene into a world of pure, abstract harmony.[18] At times the language Fry uses verges on the metaphysical; in a chapter on sculpture, he describes how the artist's rhythmic urge gives surface movement to his art and 'transmutes it from dead matter into a medium of the spirit'.[19] Throughout he provokes the reader to reconsider the nature of creativity and of aesthetic experience. For instance, he states: 'For the production of the greatest art there is needed not only great sensibility and creative energy, but also the synapsis between them must put up just the right amount of resistance to hold back the sensibility from too immediate an outlet in creation.'[20]

Writing brought Fry only rare moments of enjoyment: generally, he

91 Rembrandt van
Rijn: *Titus at his
Desk*, 1655. Oil on
canvas, 77 × 63 cm.
*Rotterdam, Museum
Boymans-van
Beuningen*

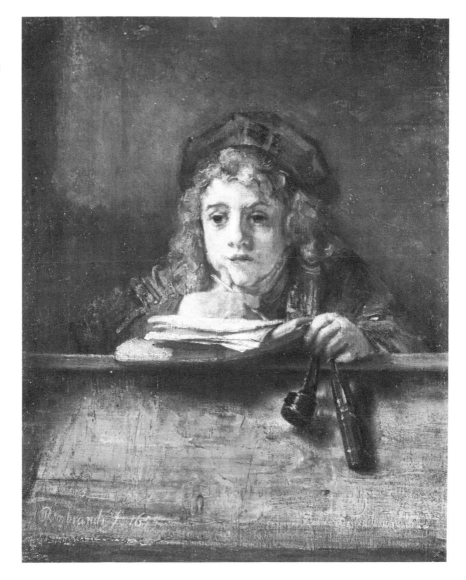

felt an acute lack of words with which to talk about art, disliked the turn
of his phrases and sickened of his style. While writing his long article
in French on Cézanne for *L'Amour de L'Art* at Charleston during the
summer of 1926, he wrote to Helen Anrep, 'I have enough critical sense
to know that although I write more sense than most it's not nearly good
enough as a rule. I have done good articles but so occasionally.'[21]

As this same article neared completion, Fry felt confident that he had
caught the drama inherent in Cézanne's heroic development. He then
enlarged upon this article, simultaneously translating it back into Eng-

255

lish, for his book, *Cézanne. A Study of His Development* which was published by the Hogarth Press in 1927 with a cover designed by Fry imitating a Cézanne still-life. It was the first critical assessment of this artist's work to appear in England and it rapidly became a classic. Not only was Fry the first critic to look seriously at Cézanne's early work, but he was also the first to notice the influence of his watercolour painting on his post-1885 oils. A present day authority on Cézanne, Theodore Reff, has described Fry's book as 'the first comprehensive account of Cézanne's development and the first to appreciate the distinctive character, both stylistic and thematic, of its latest phase'.[22]

Fry's opening reference to Cézanne as a 'tribal deity', capable of nourishing spiritual being, warns the reader that his Quaker capacity for devotion has been reawakened. Yet his assessment of this artist's development is the exact opposite of an uncritical eulogy. The weaknesses in Cézanne's early paintings are revealed and his lack of assurance noted. With his intimate knowledge of Provence, Fry perceived that Cézanne's classicism is directly related to the countryside around Aix and that the artist himself had the simplicity and directness of a Provençal peasant. Having praised the 'acuity of Cézanne's chromatic sensibility'[23] in the early paintings, Fry notes that as the work advances Cézanne's apprehension of form becomes more sensitive, his tonal transitions more delicate, his contours more searching. Cézanne's humility underpins this development as according to Fry 'every artist who is destined to arrive at the profounder truths ... requires an exceptional humility'.[24] Then Fry arrives at the crux of Cézanne's originality: the reconciliation of the data of Impressionism with an underlying structure indicative of some hidden reality. 'He saw always, however dimly, behind this veil (of surface appearances) an architecture and a logic which appealed to his most intimate feelings. Reality, no doubt, lay always behind this veil of colour, but it was different, more solid, more dense, in closer relation to the needs of the spirit.'[25]

Cézanne's art, therefore, perfectly united 'vision' and 'design', but for Fry it was also a symbol of the triumph of the individual. When in 1922 James Strachey's translation of Freud's *Group Psychology and the Analysis of the Ego* appeared, Fry, who read it with interest, agreed with Freud's statement that prestige paralyses critical faculties, filling men with astonishment and respect and reducing their powers of judgement to the 'herd instinct'. Freud had taken this term, the 'herd instinct', from Wilfrid Trotter's book *Instincts of the Herd in Peace and War* (1916) which when it first appeared was read and discussed by Bloomsbury. Fry, in his conclusion to *Cézanne*, declares that the artist, whom he compares with Flaubert, opposed the 'herd instinct' by his utter disregard for worldly recognition and by his single-minded pursuit of his idea. Cézanne and Flaubert, Fry ends, 'are both protagonists in that thrilling epic of individual prowess against the herd which makes the history of French art in the nineteenth century'.[26]

Fry also applied his inherent distrust of recognition to himself; he was

horrified when seven female American post-graduates invaded his London flat, questioned him solidly for an hour over tea and revealed that they had assiduously read all his books. It was, he said, a desperate scene, watched over by Helen Anrep with a faint ironic smile.

Helen's position in Fry's life was now fully assured. With the security and domestic happiness that she offered, a new relaxation entered Fry's life and work. Though youth and ambition had gone, his delight in the intermingling of pain and pleasure that makes up life, remained. On one occasion, writing to Gerald Brenan, he declared that *joie de vivre* was 'the special privilege of those who are more or less artists ... the best because it's so completely detached from the actual conditions of life.'[27] Reflecting on his own life, he discovered that his relationship with Helen filled out aspects of his nature that had previously been left empty or exposed. 'My passion for Vanessa was the intensest thing in my life,' he told Helen; 'it's impossible that that should be repeated, but you are infinitely better as my wife than she could have been; she is so intense, so concentrated and in a way so narrow in her vision, whereas my insatiable curiosity devours everything. It makes me inefficient and makes me arrive very slowly at any real result, but it's rich and full and your spirit is like that.'[28] As if to mark the end of his old life, he gave up his studio in Fitzroy Street and looked around for another.

In January 1927 the Royal Academy put on the first of a highly successful series of exhibitions of art from different countries. Under the auspices of the National Art-Collections Fund, Fry lectured on all the exhibitions that occurred during his life time and three sets of these lectures were published in book form: *Flemish Art* (1927), *Characteristics of French Painting* (1932) and *Reflections on British Painting* (1934). (All three were later republished by Chatto and Windus under one title, *French, Flemish and British Art*, in 1951.) His aim in these lectures, he said, 'was to estimate as precisely as I could what was the special contribution of each of these schools to the spiritual inheritance of mankind'.[29]

He did, however, approach his task with a considerable bias against Flemish and British art. He judged the Flemings according to the architectonic standards set by the Italians and therefore concluded that Flemish artists were incapable of sustained 'plastic phrases' (a term he coined on the analogy to a musical phrase); and he certainly let no patriotic sentiment soften his adverse verdict on his native school.

> We have nothing that corresponds to the moral sublimity, the disinterested detachment of the great French artists of the nineteenth century. There has been among British artists a lack of that spiritual torment, that anxious effort which in the lives of the greatest artists forces them always to wrestle with new problems, to probe more and more deeply into the possible implications of the visual world. There is among us a certain easy-going complacency and indifference to the things of the spirit which

has attacked even some of our highly-gifted artists and prevented them from achieving all their latent possibilities.[30]

On top of this, English art is guilty of an inability to grasp three-dimensional form, the attempt to turn art into literature, and suffers from a lack of honesty and clear thinking.

French art, on the other hand, is characterised by precisely those qualities that English art lacks – detachment, intellectual thought, an 'alert psychological curiosity,' and a 'peculiar quick awareness of the subtlest shades and implications of actual life'.[31] The finest passages are those on Poussin, Chardin and Watteau, but whereas Fry praises Poussin and Chardin for their formal achievement, he praises Watteau for his delicate, imaginative interpretation of the human mores of social life. At no point in these lectures does Fry depart from his central aim in order to construct elaborate theoretical structures, but always directs the reader to the consideration of the art under discussion.

By themselves, Fry's books on Flemish, French and British art do not explain the astonishing success of his public lectures. He regularly filled the Queen's Hall at Langham Place (now destroyed), which had a seating capacity of almost two thousand and, despite bad acoustics, held the attention of his audience for over two hours. He had of course a supreme belief in the importance of his subject, as well as a deep, musical voice; Arthur Waley once said that one of the most beautiful things he ever heard was Roger Fry reading Gerard Manley Hopkins 'Golden and Leaden Echo'. Added to this was his attractive personality and his appearance, transformed for the occasion by evening dress and the taming of his normally wild hair. But the chief loss to the reader of Fry's lectures is his ability to extemporise, to snatch out of thin air the necessary phrase to explain an artist's intent or to lay bare a significant sequence of forms. Sickert, fascinated by his glinting spectacles and his lecturer's wand, executed a small pen and ink drawing of Fry lecturing (Plate 97) which provided the basis for his etching *Vision, Volumes and Recession*. Never completely converted by Fry's admiration for Cézanne, the renegade Sickert nevertheless attended his lectures with eagerness. 'No sooner do I see the feet of Mr Roger Fry on the mountains,' he once admitted, 'then I scamper, bleating to sit at them.'[32] Numerous other testimonies could be quoted to underline Fry's capacity to stimulate and to expose an artist's sensibility; but the chief lesson of all was that the spectator had to strip himself naked of prejudice before judging a work of art.

The same openmindedness that Fry inspired in others he brought to his reading of literature. He read widely, in English and French, and during the war had discovered Proust's *Du Côté de Chez Swann*, which he introduced to Bloomsbury. When assessing a novel, he judged it by the same aesthetic standards that he applied to art: it was the form that mattered, the *matière* of the prose, and the ideas and emotions described had

only secondary importance. In Virginia Woolf's opinion, he was a stimulating literary critic but not a safe guide: 'He looked at the carpet from the wrong side; but he made it for that very reason display unexpected patterns. And many of the theories held good for both arts. Design, rhythm, texture – there they were again – in Flaubert as in Cézanne.'[33] Yet if Woolf was wary of Fry's conclusions, there is considerable evidence that she allowed her aesthetic of the novel to be partly shaped by Fry's ideas. It is even possible that Fry influenced the form of *The Waves*. In *Transformations* he had argued, echoing an idea of Charles Mauron's, that the formal relations in a novel on which aesthetic sensation rests are 'rhythmic changes of states of mind'.[34] When in December 1930 Virginia Woolf recorded in her diary the achievement of *The Waves*, she spoke of 'a saturated, unchopped completeness; changes of scene, of mind, of person, done without spilling a drop'.[35]

As has been mentioned, Fry had perceived Virginia Woolf's originality as a writer as early as 1918. When in 1927 *To the Lighthouse* appeared, he wrote to the author, praising it over *Mrs Dalloway*, and adding, 'You're no longer bothered by the simultaneity of things and go backwards and forwards in time with an extraordinary enrichment of each moment of consciousness'.[36]

At one point Woolf had considered dedicating the book to Fry, but at the last moment she suffered doubts as to the book's worth and did not do so. Explaining to him this non-dedication, she wrote, 'What I meant was (but would not have said in print) that besides all your surpassing private virtues, you have I think kept me on the right path, so far as writing goes, more than anyone – if the right path it is'.[37] Then in 1928 came the appearance of *Orlando*, which Fry felt more than justified his faith in her. 'There's no doubt this is in the great company,' he told her, '– it's what I've dreamed of your doing ever since *The Mark on the Wall* – to let your spirit free like this simply revolving and scintillating in space and eternity uncontrolled by anything but its own inherent motion.' Though he had doubts about the ending which he found unconvincing, he ended his letter in flights of praise. 'Anyway there it is and you happen to have genius, my dear Virginia. It might have happened to any of us but it didn't. But it doesn't matter where it happens so long as it does happen somewhere quite near to one in space and time, which makes me desperately glad that you have it.'[38]

Fry's alert mind, always ready to test a new idea, occasionally exasperated his friends. On a visit to the Woolfs in September 1927 his theory about Lord Salisbury's foreign policy infuriated the more politically-minded Leonard Woolf. After a day's work at Charleston, painting either Duncan Grant at his easel or a virtuous still-life of apples, he would galvanise all the inhabitants into action: Vanessa's eldest son, Julian, was coerced into translating a poem by Mallarmé or challenged to a game of chess; Vanessa (having vowed earlier to refuse) found herself driving Fry to visit Frank Hindley Smith, then living at Eastbourne. On one of his visits to Charleston Fry suffered an attack of

influenza and convinced himself that his end was near. The others left him sitting in a chair beside the dining-room fire and before long he noticed that the arch of the small niche over the fireplace was meanly proportioned. Calling for a hammer and chisel, he set to work to improve its shape and his deathly state was quickly forgotten.

Since late 1926 his London life had been based at 48 Bernard Street, a large terrace house which he took with Helen, hoping that his sister Margery would make use of the top flat, which she never did. Situated opposite Russell Square tube station, the clank of the lift could be heard throughout the day. Fry used a large room on the first floor as his sitting

92 48 Bernard Street. Dining Room. Photograph

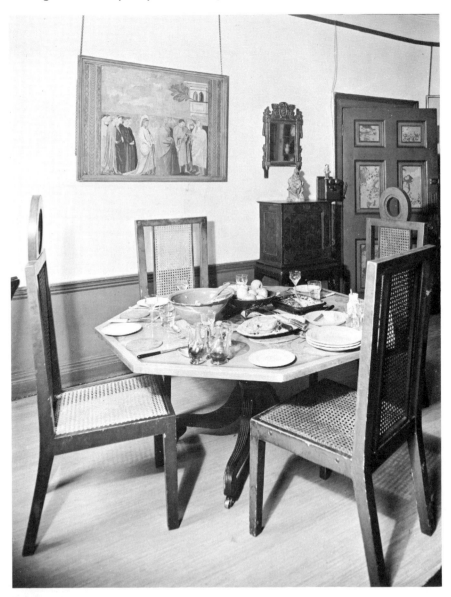

room and study, and constructed elaborate bookcases capable of housing both books and pots. The décor, though composite and made up of objects, paintings and pieces of furniture from all periods, was more ordered and intellectual than that at Charleston. The paintings, which were always changing (sold or simply rehung) attracted many visitors. The young artist Julian Trevelyan, son of Fry's friend the poet, called to show Fry his work and received the discouraging advice that he should try to paint like the Renoir head of an old woman that hung on one wall. To others, such as the young Jack Pritchard, the painted furniture seemed gauche and out of date. Through Helen's son, Igor, who was living nearby in Regent's Square, Fry met the young artist William Coldstream (also living in Regent Square) whom he promptly introduced to Kenneth Clark, an introduction that was to have an important effect on the formation in 1937 of the Euston Road School which Helen, herself, did much to support.

Now a highly respected, established figure in the London art world, Fry found he was continually being asked to sit on committees, to write, to lecture and broadcast. In January 1929 Robert Tatlock suddenly requested a contribution for a *Burlington Magazine* book on Georgian art. 'My ignorance of 18th century England is fairly complete', Fry informed Vanessa, 'and now in three days I've had to rig up something, I've nearly done it. I fear it is a triumph of journalistic skill, and if I haven't made some terrible blunder will make people think I'm an authority on the period.'[39] He continued to contribute to the *Burlington*, the *Nation and Athenaeum*, to the American magazine *The Dial* and in 1929 began a series of talks for the radio entitled 'The Meaning of Pictures' which were later reprinted in the *Listener*. 'I am getting too old for London', he half-complained to Mary Berenson, 'for I am beset by everyone who wants anything in the art world – they always imagine I can be of use to them and the worst of it is I often can. But I wish they would let me retire. It's very difficult to retire from an unpaid, unofficial position.'[40] None of this prevented him from enjoying a lively social life: witness his appearance as the White Knight at Angelica Bell's twelfth birthday party, as described by Virginia Woolf: 'Roger had taken the place by storm. The children crowded round him like the piper. He was a masterpiece, having called out all the resource and ingenuity of Woolworths stores. Candles, mousetraps, tweezers, frying pans, scales ... dangled from him by brass chains, infinite in number; his legs were bound in cricket pads; he wore chain armour on his breast; his cheeks flowered in green whiskers, and the surface of the body where visible was covered in white yeager [Jaeger] tights.'[41]

Fry continued to travel whenever possible. In May 1928 he set out with Helen on a tour of Germany intent on familiarising himself with the contents of its famous museums. The journey began well: they crossed by boat to the Hook of Holland and boarded a train that rattled its way across the Dutch countryside, the inclement weather causing sudden changes in the colour and atmosphere of the landscape. The

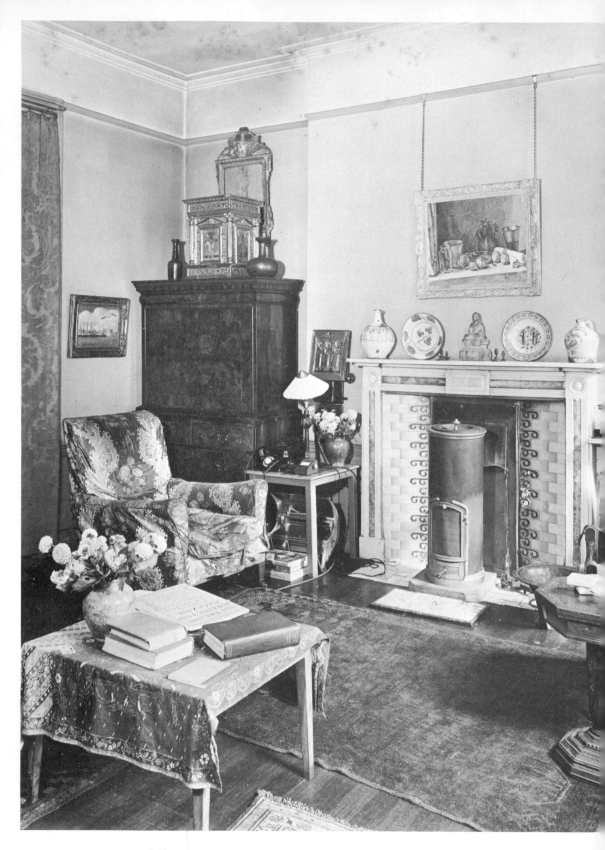

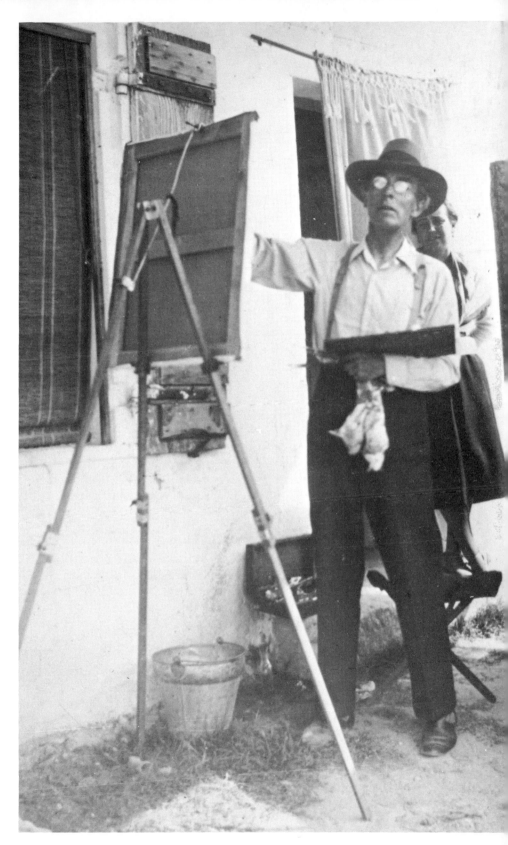

93 48 Bernard Street. Sitting Room. Photograph

94 Roger Fry painting at the Mas d'Angirany, St Rémy-de-Provence. Photograph

263

meal on the train was good and they accompanied it with an excellent moselle. Everything contrived to induce in them a state of pleasant expectancy, but this congenial mood was quickly dulled by the hotel at which they arrived, opposite the station at Frankfurt-am-Main. Though it had every convenience, the hotel was dead and banal; in the dining room perfunctory bunches of flowers had been placed on every table. Fry's quick eye noted everything, particularly the depressing town architecture, which to him seemed 'either drearily competent and commercial or else hideously picturesque and medieval'.[42]

This tour, which lasted two months, took them from Frankfurt to Munich, Salzburg, and Dresden and many smaller places. At Munich, Quentin Bell joined them and on visits to galleries had no hesitation in disagreeing with Fry, particularly over the value of German rococo which Fry thought revealed definite aesthetic merit. Both, however, continued to uphold the Bloomsbury dislike of Dürer. Fry spent six hours everyday in galleries or museums and afterwards mused on the reasons why German museums reflected a far better acquisition policy than any to be then found in British provincial museums. This led him to an appraisal of the creative collecting instinct: 'Those who collect what is already valued highly add nothing to the spiritual wealth of the world. The really useful collector is what one may call the creative collector, the collector – who by merely bringing objects together, classifying them, interpreting their interrelationships creates new values altogether.'[43] It was this type of creative collecting that made Germany's museums and galleries so impressive, Fry thought, but he also admitted that omnivorous curiosity and open-minded acceptance could falsify values; he observed that the Germans treated their Primitives with a lack of critical severity, treating the feeblest artist with the honours of a great master. In spite of close, careful study, the trip as a whole did not revise his adverse opinion of German art which ultimately eluded him. He looked again and again for evidence of genuine inspiration behind the extensive creative activity evidenced in German art, but found none. He found skill, ingenuity, ambition and infinite pains, but very little personal sensibility. 'They always overlook, in their desire to create, the only justification, the only valid motive for creation – the expression of an individual personal experience.'[44]

Fry still believed that the most important expression of *his* personal experience would be left in paint. 'I shall never make anything that will give you or anyone else the gasp of delighted surprise at a revelation', he once told Vanessa, referring to his paintings, 'but I think I shall tempt people to enjoy a quiet contemplative kind of pleasure – the pleasure of recognising that one has spotted just this or that quality which has a meaning, tho' mostly one passes it by.'[45] He therefore continued to produce, at Cassis, La Ciotat, Port Vendres and Brantôme, landscapes that are never dramatic or picturesque, but the product of quiet, prolonged contemplation of space, texture, colour, light and shade, weight, rhythm and mass. Whatever the limitations of the scene before him, it

could be made to reveal an aesthetic order.

In 1927 he extended his media when he took up lithography and discovered a shop in Paris that sold lithographic paper. The design drawn on this paper was then transfered on to the stone and when finally printed appeared, not in reverse, but identical to the original drawing. A handful of farmyard scenes and landscapes were executed in this medium, but he used it most for his rendering of church interiors, which he thought symbolised the totality and isolated nature of the aesthetic experience. In these he could use the rich build up of tone that lithography allows to create the atmospheric interiors of French churches, and in 1930 published a set of these entitled *Ten Architectural Lithographs* with the Architectural Press.

When the Royal Academy put on a winter exhibition of Dutch art, on which Fry wrote and lectured, his prolonged examination of the Dutch masters confirmed his own leanings towards traditional concerns. The chief quality in Dutch paintings, he noted, was not the organisation of the two-dimensional surface design, but their rhythmic and significant ordering of the imagined three-dimensional space, and this became a governing interest in Fry's later landscapes. Like de Hooch, he attempted to capture subtle effects of light, a convincing harmony of spatial values, an exquisite balance of directions and movements of plane with small repetitions and echoing responses in the forms. In Paris in the spring of 1929 he sat in the Louvre wrapped in his greatcoat, painting *La Salle des Caryatides* (Ashmolean Museum, Oxford) in which a restrained green light suffuses the entire room. He made only slight alterations to the actual proportions of the room but these are enough to emphasise certain rhythms set up by repeated forms and they give to the static facts of the scene a melodious harmony. By 1932 he was not disturbed to note: 'I find myself more and more in the mood of some quite unfashionable Schools such as the Dutch landscapists of the seventeenth century. I have entirely ceased to belong to my age and I feel myself more and more disappointed by the academic results of the Cubists and others – ultimately the *avant-gardisme* seems to me more and more nugatory.'[46]

Another influence on Fry's late style was incurred in Paris during the spring of 1930 when he visited the Pissarro Centenary Exhibition and a show of Sisley's work at Durand-Ruel's. 'Both seemed best in the early stage,' he informed Vanessa, 'that first step towards Impressionism gave a wonderful balance of pictorial and plastic values which they never quite recovered. There was no question that Sisley was the bigger of the two, he has a much more significant architecture and also a rarer sense of colour.'[47] After visiting these two shows, his own paintings began to reflect a more subtle observation of light and shade and the light to be found in shadow which he now rendered with surer, lighter touch. His brushwork loosened and in his small pochades each mark made began to create more directly the forms described. The results are thoughtful, lively and transparently honest in their approach. Richard Morphet has spoken of 'the appealing openness' of Fry's paintings, 'with

95 Roger Fry:
Charles Mauron,
1931. Oil on panel,
42 × 34.5 cm.
Private Collection

which they make manifest the thought processes that produced them.'[48] This can be seen in such works as *Carpentras* (Courtauld Institute Galleries) and *Rabat* (Sheffield City Art Galleries), in which, after forty years of painting, there is no trace of slickness, but instead searching enquiry; the mind leads the eye in order that the eye may see more clearly, and no form or colour is used without Fry's understanding of its relationship to the whole.

Fry's late period also sees a fresh flowering of his interest in portraiture. He now felt enough confidence in his ability as a portraitist to undertake a few commissions for which he charged around £100. These always caused him problems. He painted the history don W. H. Macaulay for King's College, Cambridge and almost despaired over the set expression of the sitter's mouth due to his lack of teeth. For the Economics Department of Cambridge University he painted Mary Paley Marshall, the wife of the economist Alfred Marshall, whose sour facial expression did not do justice to the ebullience of her temperament. But the least successful of his commissioned portraits was that which he painted for H. G. Wells of his mistress, Baroness Budberg, whose calm appearance hid an agitated history as she had at one time narrowly escaped death in Russia from the Soviets. She had a *mouvementé* personality, but Fry managed to reduce this passionate lady, quite inappropriately, to a respectable *Hausfrau* and the portrait, which still remains in the family, was for many years used as a firescreen.

Less arduous were his portraits of family and friends. His mother, whose character had considerably softened since the death of Sir Edward, played the coquette (though aged ninety-four) and required a great deal of flattery and entreaty before she would agree to sit (Coll: Mrs Pamela Diamand). Charles Mauron was caught with one arm resting on the table beside him, head resting on hand. The result is vital, assured and expressive of Mauron's alert intellect (Plate 95). Fry hoped for a similar success with his portrait of Aldous Huxley (now lost) but the author distracted the painter with his incessant, brilliant talk.

Then Fry executed a series of self-portraits, remarkable for their psychological penetration. For though he adopted the attitude of the disinterested spectator, the results testify to his reflective mind, his tolerance, curiosity, benevolence, and to his passionate interest in the visual world. The most successful is perhaps that in which he wears a felt hat, dark suit, blue shirt and dark pink tie through which is pressed his pearl tie-pin (Coll: Sir Geoffrey Agnew). The composition hinges on the line of the brim of the hat which catches the light and creates an important but unemphatic horizontal to balance the vertical mass of the head and shoulders. Its wavering delicacy suggests that it has been felt and discovered in the act of painting and its formal role justifies the slight incongruity of his wearing a hat indoors.

In February 1931 the Cooling Galleries in association with the London Artists' Association put on a retrospective show of his work. In January he began preparations for this show, arousing withering comments from

267

Vanessa: 'When I last went to his house', she informed Clive, 'I was horror struck to find an enormous portrait of myself looking like a handsome but shapeless cook in a red evening dress painted about fifteen years ago. . . . The show will be very trying I expect. All sorts of things one hoped never to see again are being fished out.'[49] Despite these gloomy premonitions, the show contained some of Fry's best work, including his portraits of Edward Carpenter, Edith Sitwell, Viola Tree and Nina Hamnett. Fry, looking around at the varied exhibits, felt convinced that beneath their waywardness lay a guiding principle.

While Fry's paintings underwent re-examination, his aesthetic ideas were also being given careful reconsideration. For sometime he had been troubled by the role of representation in art. In 1930, in an essay on Matisse, he prefaced his analysis of this artist's work with a reference to the dual nature of painting – its simultaneous existence as a coloured surface and a three-dimensional world. 'It is this equivocal nature of painting that is at once its torment and its inspiration.'[50] Recognition of this 'dual nature' had earlier led him to re-evaluate the role of associated ideas and emotions in art in a lecture entitle 'Representation in Art', to which he referred in a letter written to Helen Anrep in December 1928:

> I am at last getting under way with my lecture. I propounded a few of its heresies at Vanessa's last night. She, poor dear, is deeply shocked but I believe I'm on a tack that will make things a little clearer and relieve the strain which I have felt of late on the other orthodoxy. One runs a theory as long as one can and then too many difficulties in its application – too many strained explanations accumulate and you have to break the mould and start afresh. I'm going to divide pictures into Opera pictures and Symphony pictures and then we can begin to analyse them according to these two ideas instead of trying to pretend that all pictures produce similar effects by similar means.[51]

This idea, that pictures can be divided into two categories, one making its appeal through the formal harmonies, as in symphonic music, the other making its appeal through the associated ideas and emotions evoked by Opera, led eventually to the restatement of Fry's aesthetic position in his lecture 'The Double Nature of Painting', written and delivered in French at Brussels in the autumn of 1933. Having previously, in *Transformations*, relegated representation to an uneasy, secondary role, he now admits that representational content can play a role equal in importance to the formal means, with which it can and does interact. This shift of emphasis separated Fry's standpoint from that of Clive Bell because Fry was no longer content to regard aesthetic emotion as solely the product of form.

Behind this shift of emphasis lay the persuasive charm of Helen Anrep. Fry made three trips to Italy during the last years of his life, in 1929, 1931 and 1934, and each time he attempted to re-evaluate his assessment of Italian art. On the last of these trips, while in the Brera,

in Milan, he noted in Correggio's *Adoration of the Magi* how much of its content he had previously missed due to his emphasis on form. 'I see I'm in danger of getting shockingly "literary" under your influence,' he reported back to Helen. 'But I see that the pictures that "count" most *generally* have some quite new and personal conception of the situation'.[52] In this case it was the reluctance and tenderness expressed in the figure of the Virgin that had caught his attention.

In 1928 Helen bought Rodwell House at Claydon, near Ipswich, as a home for her children during the school holidays. Fry had suggested Suffolk because he found the light and lie of the land comparable to that found in Holland. The acquisition of a second-hand Citroen enabled him to visit small towns and villages in the area and take in the churches of interest. He instinctively avoided the main roads, preferring to go across country with the aid of a map, as he told Vanessa. 'The map was quite correct except that it omitted to mention that one road turned for about ½ a mile into a field of mustard but I find that a motor will go on No. 1 gear almost anywhere and we got through all right.'[53] On another occasion in the same car, when travelling through the Roman Campagna with Helen, Vanessa and Duncan, Fry was the only member of the party not thrown into complete despair when they broke down miles from anywhere. Getting out and opening the bonnet, he was overheard to say, 'Well, the mind of man made it. . . .'

In 1931 his life was further enriched by the acquisition of the Mas d' Angirany on the Route des Antiques leading out of St Rémy-de-Provence. This he shared with Charles and Marie Mauron. Down one side of the old farmhouse runs a pergola beneath which one can sit looking out on to the Alpilles, rising blue and silver above the olive trees and topped by the Lion d'Arles. Fry's bedroom had French windows which opened directly on to the patio and he often slept at night with them open, listening to the continuous whir of the crickets. From St Rémy, he drove to Beaucaire where for £30 he bought all the furniture they needed, most of it old Provençal, as well as two large earthenware vases which he stood between the pillars of the pergola on either side of a great stone table. Situated in an area of France that he loved and knew well, it is not surprising that some of Fry's most lyrical late landscapes, with their observation of flickering light and their intense responsiveness to the 'spirit of the place', were painted in the area around St Rémy.

Fry's absorbtion in life and art could cause him to be incredibly absent-minded. Once at a private view, with all the formality demanded of the occasion, he politely shook hands with Helen Anrep. His vagueness made him oblivious of all physical discomfort and when abroad his intense enjoyment of travel aroused in him a seemingly endless supply of energy. On a visit to Greece in 1932 with Margery, Leonard and Virginia Woolf, this sixty-six year old man astonished the Woolfs when after a sixteen hour day of strenuous sight-seeing and sketching, he

96 Roger Fry:
French Landscape,
c.1933. Oil on
board, 20 × 32 cm.
Private Collection.

would demand of Leonard a game of chess. Gerald Brenan was equally impressed by Fry's energy when he visited Spain in 1933. Fry accompanied Brenan to Cuevas de Almanzora and there painted until the sun sank. The two men then spent the rest of the evening playing chess in the Casino and Fry aroused such friendship in the local inhabitants they begged him to settle in the area and even offered to show him a house.

In the same year a Slade Professorship at Cambridge, which had eluded him for almost thirty years, was finally offered him. He accepted it with sardonic amusement and told Brenan, 'It must be put down mostly I think to the English worship of antiquity. If one lives long enough one becomes a British Institution and they all love you whatever you do.'[54] Traditionally Slade Professors were distinguished connoisseurs, cultivated literary men who spoke on specialist subjects, making subtle appreciations. Fry filled the role in quite a new way. Instead of bringing to a small area of art a personal, exclusive body of knowledge he decided to apply certain aesthetic ideas that all could share to the entire history of art. He began with a lecture on the nature of art history itself and urged that it should become an accepted part of the University's Tripos. He then set out on his mammoth task but unfortunately died after only ten of the twenty four lectures had been given and reached only as far as the later Greeks.

In effect the lectures expanded upon a small book Fry had written a year earlier for Gollancz – *The Arts of Painting and Sculpture*, a concise account of painting and sculpture in all countries and ages. His aim in this book had been to consider how far the art of any period was the product of a free aesthetic impulse and to what extent this impulse had

been curtailed by practical considerations. He assessed the degree of freedom in a work of art by its sensibility, a quality often obscured by the demand for finish because highly skilled (and therefore expensive) art objects denote social superiority on the part of the owner. This use of art to signal social status had been examined in depth by Thorstein Veblen in his book *Theory of the Leisure Class*, to which Fry admitted his debt. It confirmed him in his belief that the contrary value in art – its spiritual significance, is the product of the 'free aesthetic impulse'. It is unlikely that this idea has the universal validity which Fry ascribes to it and Kenneth Clark has called it 'an entertaining but extravagant hypothesis', adding that the idea is not simply the result of Fry's aesthetic experience, but 'deeply coloured by his moral ideas'.[55]

When in 1933 Fry began to prepare his Slade lectures, he decided to isolate 'sensibility' and 'vitality' as two exploratory tools with which to assess works of art. They lead him to unexpected conclusions. Greek art, hitherto the only art given any serious consideration at Oxbridge, is found to be too conceptual, generalised and geometric to allow for the free functioning of the plastic sensibility. A Niobid is compared to a Maillol to bring out the dead unaccented surface of the Greek statue as opposed to the subtle nuances of surface found in the work of the French master. Emphasis on 'vitality' leads Fry to value the crudest representation of animals in primitive art over highly skilled representations of more sophisticated cultures. For Fry: 'In proportion as gestures conform to a rhetorical type they tend to lose the full complexity of living beings.'[56]

The Slade lectures (published posthumously with very little alteration under the title *Last Lectures*) reveal Fry's natural impulse to theorise, his undimmed aesthetic curiosity and, above all, his experimental approach. They were totally unorthodox and a considerable success. They began a tradition, continued by Lord Clark in his television series and book, *Civilization*, in which great art is discussed on terms of equality with the spectator, the speaker not presuming knowledge or accepted taste, but making a subject, previously the concern of the learned, widely and easily assimilable.

As he entered the last year of his life, Fry noticed that his body had begun to creak and groan under stress. He observed the process of physical disintegration with detachment, but had too much energy to seriously consider the closeness of death though he faced the loss of several close friends at this time. The death of his mother in 1930 meant that Failand House had to be sold and his sister Agnes found a new home. Charles Sanger's death the same year was also, he felt, a great loss as he had a rare, unselfish character and an ironic but gentle sense of humour. Lytton Strachey's death in 1932 Fry regarded as most untimely. 'I always thought of him as like Voltaire waiting to begin at 60', Fry said of him, 'and now the world knows very little of what it's lost for he was a bigger nature and intellect than he brought through in his books.'[57] But the death that left him quite distraught was that of

Goldsworthy Lowes Dickinson in 1932, as a result of poor medical treatment following the removal of the prostrate gland. He wrote to Vanessa in a mood of despair, telling her he had lost one of the few friends with whom he could sympathise and be understood in return. With the approach of his own death, Fry continued to reject any specific religion (though he never doubted the existence of the spirit), finding them all deeply-dyed with wishfulfilment and standing in the way of that disinterested attitude which he regarded as essential for progress, in art and science.

For many years Fry had slowly been bringing to completion his translations of Mallarmé's poems which travelled with him wherever he went. When Charles Mauron first met Fry in 1920, two-thirds of the poems published after Fry's death had already acquired their final shape, only a word needing to be changed here and there. However Fry continued to tinker away at them at odd intervals and then in June 1933 he had the misfortune to have his suitcase stolen from a Salle d'Attente on a Paris railway station while he went in search of a cup of coffee, and in it were his Mallarmé translations and his inaugural Slade lecture. The loss of both manuscripts was devastating; almost any amount of money would, he thought, have been less immediately painful and worrying.

He continued his journey to the spa-town Royat where he bathed three times a day in carbolic acid to cure some trouble he was having with one of his legs and was shortly joined by Charles Mauron. Together the two men set to work to reconstruct the translations. Fry now persuaded Mauron to write commentaries on certain poems and was so pleased with Mauron's ingenious results he immediately translated them so that they would be included in the book which eventually appeared in 1936, edited by Julian Bell and Charles Mauron.

Of all the French poets, Fry had chosen the least translatable. Not only do Mallarmé's poems have a plurality of meaning, easily lost in translation, but they place a great premium on sound, his words becoming almost objects in themselves, to be played with, heard and mouthed. The chief virtue of Fry's translation is his close fidelity to the text; their weakness (resulting partly from this fidelity) is a certain flatness and limpness that contrasts strongly with the taut, brittle quality of the originals.

Fry was attracted to the purity of Mallarmé's verse. What to other readers appeared a wilful use of obscurity, to Fry seemed the result of the poet's concentration upon the actual means used to bring out detached aesthetic emotion. As one critic has said, 'a poem by Mallarmé is never a logical whole, but rather a train of feeling.'[58] Fry explained Mallarmé's poems by reference to Cubism: in both the subject or theme is broken to pieces, analysed and reconstructed 'not according to the relations of experience but of pure poetical necessity'.[59] And to Vanessa, he explained, 'I think more and more that he's a great poet, certainly almost the purest poet that ever was in the same sort of way as Cézanne was, in the end, the purest of painters'.[60]

Fry returned from Royat early in July 1933 in time to hang a one-man show at Agnew's of his recent paintings, executed in Greece, Spain, Morocco and France. They had a freshness and joyousness that appealed and several sold, one – a view of the Alpilles seen through an open door at the Mas d'Angirany – to Vancouver Art Gallery. Reflecting on his debt to other artists, he had earlier written to his old friend, L. C. Powles, 'Of course there is much in them that couldn't have been there without Cézanne, but then too there is much also due to Poussin, to Corot, to Seurat. The question is whether I have fused these idioms into a personal one and that of course others must answer.'[61] Since the war he had in his paintings attempted to arrive at a harmonious balance of form, line, colour, light and space that reflected his love of the classical landscape tradition, epitomised in the art of Poussin and recreated in the work of Cézanne. He would, one thinks, have liked his own painting to be seen as a continuation, not merely a reminiscence, of that tradition, an extension of its principles into the twentieth century, filtered through his modern sensibility and given his own personal note. Inevitably his achievement as a painter is overshadowed by the great artists he wrote about and with whom his name is popularly associated. Yet this classical quality characterises his art, separates it from that of his contemporaries, and will ensure him a distinct position in the history of twentieth-century British art.

Fry's achievement as a critic has received, so far, much greater recognition. It is generally acknowledged that he helped free art from the cloying associations and moral turpitude that clung to it during the Victorian and Edwardian periods. By peeling away the inessentials he threw fresh light on the work of art. In his attempt to discern and underline that which is specifically aesthetic in art, he reasserted its importance. His influence affected more than one generation and Kenneth Clark has declared, 'In so far as taste can be changed by one man it was changed by Roger Fry'.[62] What gave his criticism such potency? – simply, his lucid, fluent prose, his enthusiasm, persuasiveness, his openminded search after the truth of his experience and his compelling desire to share his great love of art. His desire to share enjoyment contributed, so Charles Mauron noted, to the equilibrium of his nature, to 'the correction of fastidiousness by generosity, and of generosity by fastidiousness'.[63] He had an extraordinary ability to reveal a subtle shift of plane or contour and the emotion this implied. His achievement, therefore, was to make people see, to share in the bewildering complexity and richness of experience offered by art. To share freely in this experience the spectator has first to shed all preconceptions, prejudices, and all the pressures and practical interests of everyday life. Even in Fry's own day, this belief in the essential disinterestedness of aesthetic experience fell out of favour; but as Kenneth Clark has written: 'It may be many years before Roger Fry's sense of values is once more widely acceptable. Yet I am convinced that they represent a lucid interval in the history of the spirit.'[64]

273

At Bernard Street one evening in September 1934, shortly before he was due to go out and dine with Kenneth Clark and Bogey Harris, Fry slipped on a rug and broke his pelvis. Helen telephoned Clark who came round immediately and found Fry crumpled in an unnatural heap on the floor. He called for a doctor and Fry was taken that night to the Royal Free Hospital where shortly after arriving he fell into a coma. He was visited by Margery and Pamela Fry and, after some difficulty (due to her not being next of kin), by Helen Anrep. Two days later, on Sunday 9 September, he died suddenly of heart failure.

The funeral service took place the following Thursday. It was a hot Indian summer's day and on top of the old, red brocade which covered the coffin lay two branches of bright, many-coloured flowers. Music by Bach and Frescobaldi was played. Virginia Woolf, who was present, later wrote in her diary, 'Dignified and honest and large – "large sweet soul" – something ripe and musical about him – and then the fun and the fact that he had lived with such variety and generosity and curiosity. I thought of this.'[65] In Leonard Woolf's opinion, with the death of Fry something was torn out of their lives. The cremation was followed by a memorial service at King's College Chapel on October 19 and Roger Fry's ashes were placed in the vault, in a casket decorated by Vanessa Bell.

At both the cremation and the memorial services three passages were read out aloud, from Milton, Spinosa and from Fry's *Transformations*. The latter, in this context, aptly summarised the significance of Fry's career; more than any other of his generation he had furthered a widespread appreciation of art, believing that a life touched by the experience of art is immeasurably enriched.

Baudelaire compared the great names in art to lighthouses posted along the track of historic time. The simile, as he used it, seizes the imagination and represents a great truth, but it allows of an interpretation which the limits of a sonnet form forbade him to develop. He takes the lights of his beacons as much for granted as the sailor does the lights of real lighthouses. But the lighthouses of art do not burn with so fixed and unvarying a lustre. The light they give is always changing insensibly with each generation, now brighter, now dimmer, and often enough growing brighter once more. But we sometimes forget that the lights have to be tended or they grow faint and may expire altogether. For them to burn brightly they must be fed by the devotion of some few spirits in each generation.

Transformations, p.82

97 Walter Sickert:
Roger Fry Lecturing,
c.1911. Pen and ink,
17.2 × 9.5 cm.
*Islington Borough
Libraries*

A Note on Unpublished Sources

The three main sources of letters and manuscripts referred to in the course of this book are the Fry Papers and the Charleston Papers (both now in the library at King's College, Cambridge) and the letters Roger Fry wrote to Helen Anrep. These last are in a private collection and to avoid confusion with the Fry Papers I have labelled them the Anrep Papers. In the footnotes, for the sake of brevity, these three sources are referred to by the initials, FP, CP, and AP. In all other instances where manuscript material has been quoted, the whereabouts of the source is given in full in the footnote. One important store of information on the Omega Workshops is to be found in the letters from Winifred Gill to Duncan Grant in the Victoria and Albert Museum. These abound in anecdote and reminiscence, only a small sample of which could be used here.

Notes

Chapter 1

1 Memoir Notes, 'The first conscious impression . . .': FP
2 Agnes Fry, *A Memoir of the Right Honourable Sir Edward Fry, G.C.B.* (Oxford University Press, 1921) p.57
3 *A Journal of the Life, Travels, Sufferings, Christian Experiences and Labour of Love of George Fox* (W. and F. G. Cash, 1852, Seventh edition) Vol. II, p.4
4 Quoted in *Memoir of Sir Edward Fry*, p.11
5 John Fry, *Select Poems* (Mary Hinde at No. 2 George Yard, Lombard Street, 1774)
6 *Memoir of Sir Edward Fry*, p.14
7 Denys Sutton (ed.), *Letters of Roger Fry*, (Chatto and Windus, 1972) Vol. II, p.516
8 Virginia Woolf, *Roger Fry*, (Hogarth Press, 1940) p.18
9 Ibid., p.22
10 Quoted in *Memoir of Sir Edward Fry*, p.64
11 Ibid., pp.185-6
12 Memoir Notes: FP
13 R. Fry to Lady Fry, 20 May 1885: FP
14 Quoted in O. F. Christie, *A History of Clifton College, 1860-1934*, (J. W. Arrowsmith, 1935) p.113
15 Woolf, *Op. cit.*, p.38

Chapter 2

1 R. Fry to Lady Fry, 26 October 1885: FP
2 R. Fry to R. C. Trevelyan, 11 June 1899: R. C. Trevelyan Papers, 4: 26, Trinity College Library, Cambridge
3 'My Mental Development'. *The Philosophy of Bertrand Russell. The Library of Living Philosophers*, ed. P. A. Schilpp (La Salle: Open Court Publishers, 1945). Vol. 5, p.9
4 Sutton, *Letters of Roger Fry*, Vol. I, p.109
5 Ibid., p.122
6 Ashbee Journals, 20 June 1886: King's College, Cambridge
7 Ibid., 26 June 1886
8 Ibid., 22 July 1886
9 The Madonna was sold in 1976 by the Guild of St George to the National Gallery of Scotland
10 E. Carpenter to C. R. Ashbee, 29 July 1886: Ashbee Journals, King's College, Cambridge
11 R. Fry to E. Carpenter, 22 August 1890: MS 386. Sheffield City Libraries
12 Sutton, *Letters of Roger Fry*, Vol. II, p.596
13 E. M. Forster, *Goldsworthy Lowes Dickinson*, (Edward Arnold, 1934) p.35
14 Dennis Proctor, *The Autobiography of Goldsworthy Lowes Dickinson*, (Duckworth, 1973) p.90
15 Ibid., p.92

16 Sutton, *Letters of Roger Fry*, Vol. I, p.115
17 R. Fry to G. B. Shaw, 25 July 1926: Add. MS 50534, British Museum. A draft for this letter is found in Sutton, *Letters of Roger Fry*, Vol. II, p.633
18 Woolf, *Roger Fry*, p.56
19 Sutton, *Letters of Roger Fry*, Vol. I, p.115

Chapter 3

1 Sutton, *Letters of Roger Fry*, Vol. I, p.122
2 Francis Bate, *The Naturalistic School of Painting*, London 1887 (pamphlet)
3 R. Fry to Sir E. Fry, 29 May 1893: Mr and Mrs E. Robinson
4 Sutton, *Letters of Roger Fry*, Vol. I, p.126
5 Ibid., p.125
6 Ibid., p.135
7 *Cambridge University Magazine*, 7 December 1886, p.166
8 Sutton, *Letters of Roger Fry*, Vol. I, p.141
9 Ibid., p.144
10 Diary in the possession of Captain Francis Widdrington
11 This and all subsequent quotations from Ida Widdrington's letters are taken from those among the Fry Papers at King's College, Cambridge. Almost none of her letters are dated
12 R. Fry to H. Anrep, 26 March (c. 1925): AP
13 Frank Rutter, *Art in My Time*, (Rich and Cowan, 1933) p.57
14 William Rothenstein, *Men and Memories* Vol. I, (1931) (Rose & Crown Library Edition, 1934) p.39
15 Rothenstein, *Men and Memories*, Vol. I, p.76
16 MS Lecture notes, given at Bangor, 18 January 1927: FP
17 *Cambridge Review*, 22 June 1893. Reprinted in *The Cambridge Mind*, Homberger, Janeway and Schama, (ed.), (Jonathan Cape, 1970) pp.211–14
18 MS The Philosophy of Impressionism: FP
19 Sutton, *Letters of Roger Fry*, Vol. I, p.353
20 Ibid., p.155
21 Woolf, *Roger Fry*, p.94
22 R. Fry to V. Bell, 17 April 1919: CP
23 Sutton, *Letters of Roger Fry*, Vol. I, p.158
24 R. Fry to Lady Fry, 22 May 1893: FP
25 Ibid, 4 March 1894
26 R. Fry to Sir E. Fry, 27 September 1894: FP
27 Quoted in Alfred Thornton, *The Diary of an Art Student of the Nineties*, (Pitman & Sons, 1938) p.72
28 Denys Sutton's chronology in *Letters of Roger Fry* lists only one visit to La Roche Guyon in 1895. However, a letter Fry wrote to his mother reveals that he arrived in June 1894 soon after the assassination of President Carnot at Lyon by Italian anarchists: 'No one talks of anything but the assassination of Carnot just now . . .'. (R. Fry to Lady Fry, June 25 [1894]: FP)
29 Thornton, *Diary of an Art Student of the Nineties*, p.47
30 Sutton, *Letters of Roger Fry*, Vol. I, p.160
31 Ibid., pp.165–6
32 R. Fry to Lady Fry, no date [1896]: FP
33 R. Fry to R. C. Trevelyan, 19 December 1900: R. C. Trevelyan Papers, 4: 41, Trinity College Library, Cambridge
34 'The New "Magpie and Stump" – A Successful Experiment in Domestic Architecture' *Studio* 1895, V, p.67
35 Sutton, *Letters of Roger Fry*, Vol. I, p.168
36 *Cambridge Review*, 22 October 1896, p.29

Chapter 4

1 Quoted in Christopher Hassall's *Edward Marsh: A Biography*, (Longmans, 1959) p.75
2 Ibid., p.109
3 Mackmurdo's claim that he introduced Helen Coombe to Roger Fry was made in conversation with Mrs Pamela Diamand and is repeated in Sutton, *Letters of Roger Fry*, Vol. I, p.10
4 H. Coombe to R. Fry, no date [1896]: FP
5 Ibid., 3 October 1896
6 R. Fry to Lady Fry, no date [1896]: FP
7 R. Fry to H. Anrep, 26 March, 1925: AP
8 Woolf, *Roger Fry*, p.98
9 Present whereabouts unknown. Reproduced in *The Art of 1897*, (*Studio* special edition). Plate 52
10 See Giles Robertson, *Giovanni Bellini* (Clarendon Press, 1968)
11 Roger Fry *Giovanni Bellini*, (Sign of the Unicorn, 1899) p.14
12 Ibid., p.30
13 Notebook 5. All Fry's pocket notebooks are in the possession of Mrs Pamela Diamand
14 R. Fry to Lady Fry, no date [1898]: FP
15 Sutton, *Letters of Roger Fry*, Vol. I, p.172
16 *Athenaeum*, 16 November 1901, p.668
17 Bernard Berenson, *Sunset and Twilight*, (Hamilton, 1964) pp.455, 489
18 'Italian Art', in *Guide to Italy* (Macmillan, 1901) p.xli
19 Florentine Lectures I: Lecture VI-Trecento Florentines: FP
20 Ibid., Lecture VII – Transition to Quattrocento: FP
21 Ibid., Lecture IX – Masaccio: FP
22 Ibid
23 See note 20
24 Sutton, *Letters of Roger Fry*, Vol. I, pp.173-4
25 See Note 21
26 *Quarterly Review*, April 1905, p.609
27 Sutton, *Letters of Roger Fry*, Vol. I, p.179
28 'The Present Situation' MS notes of a lecture delivered February 1923: FP
29 *Pilot*, 8 September 1900, p.300
30 *Pilot*, 15 September 1900, p.334
31 *Quarterly Review*, April 1905, p.612
32 *Athenaeum*, 25 July 1903, pp.133-4
33 Roger Fry, *Vision and Design*, (Chatto & Windus, 1920) p.190
34 'The New English Art Club' *Studio*, March 1945, p.72
35 Osbert Sitwell, *Noble Essences*, (Macmillan, 1950) p.166
36 Quoted in *Robert Ross: Friend of Friends*, Margery Ross (ed.), (Jonathan Cape, 1952) p.76
37 R. Fry to T. Sturge Moore, 8 January 1901: University Library, University of London
38 Rothenstein, *Men and Memories*, Vol. II, p.131
39 *Independent Review*, September 1904, 3, p.526
40 *Athenaeum*, 15 November 1902, pp.656-7
41 H. Fry to A. H. Mackmurdo, 18 November 1901: J841/78 William Morris Gallery, Walthamstow
42 Sutton, *Letters of Roger Fry*, Vol. I, p.263
43 R. Ross to R. Fry, 30 April 1903: FP
44 E. Marsh to R. Fry, 17 April 1903: FP
45 *Burlington Magazine*, 1907, 11, p.162
46 Ibid., 1903, 1, p.4

47 C. J. Holmes, *Self and Partners (Mostly Self)*, (Constable, 1936) p.21
48 Quoted in the above, p.224

Chapter 5

1 Sutton, *Letters of Roger Fry*, Vol. I, p.224
2 Ibid., p.231
3 Ibid., p.241
4 Henry James, *The American Scene*, (Chapman and Hall, 1907) pp.192–3
5 Sutton, *Letters of Roger Fry*, Vol. I, p.233
6 Ibid., p.231
7 Woolf, *Roger Fry*, p.129
8 Roger Fry (ed.), *Reynolds' Discourses*, (Seeley & Co, 1905) p.x
9 Ibid., p.vii
10 Ibid., p.xix
11 Ibid., pp.178–79
12 Woolf, *Roger Fry*, p.125
13 F. Ehrich to Sir C. Purdon Clarke, 27 May 1905: Metropolitan Museum Archives, F947
14 Sutton, *Letters of Roger Fry*, Vol. I, p.252
15 R. Fry to W. Laffan, 29 January 1906; typescript copy in Metropolitan Museum Archives
16 Sutton, *Letters of Roger Fry*, Vol. I, p.259
17 Ibid., p.254
18 Ibid., p.252
19 'Ideals of a Picture Gallery', *Metropolitan Museum of Art Bulletin*, Vol 1, March 1907, p.59
20 Sutton, *Letters of Roger Fry*, Vol. I, pp.263–4
21 Report submitted 30 April 1906: Metropolitan Museum Archives
22 Sutton, *Letters of Roger Fry*, Vol. I, p.258
23 Ibid., Vol. II, p.631
24 Vanessa Bell Memoir VI: Professor Quentin Bell
25 R. Fry to Sir C. Purdon Clarke, 18 September 1906: Metropolitan Museum Archives, P.1665
26 Typescript report sent to Sir C. Purdon Clarke, received 25 October 1906: Metropolitan Museum Archives, P.1666
27 Quoted in Calvin Tomkins, *Merchants and Masterpieces: The Story of the Metropolitan Museum of Art*, (Dutton & Co, 1970) p.108
28 Sutton, *Letters of Roger Fry*, Vol. I, p.283
29 *Burlington Magazine*, 1903, 3, pp.86–93
30 Ibid., 1906, 9, p.363
31 See Lionello Venturi, *Pittore Italiane in America*, (Milan: Ulrico Hoepli Editore, 1931) tav.ccxc
32 Sutton, *Letters of Roger Fry*, Vol. I, p.237
33 *Burlington Magazine*, 1926, 48, p.274
34 R. Fry to J. G. Johnson, 11 May 1907: Johnson Collection Archives, Philadelphia Museum of Art
35 Sutton, *Letters of Roger Fry*, Vol. I, p.321
36 R. Fry to J. G. Johnson, 26 January 1909: Johnson Collection Archives, Philadelphia Museum of Art
37 *Metropolitan Museum of Art Bulletin* June 1907, Vol. II, No. 6, pp.102–04
38 Sutton, *Letters of Roger Fry*, Vol. I, p.287
39 Woolf, *Roger Fry*, p.142
40 *Burlington Magazine*, 1913, 23, p.65
41 Woolf, *Roger Fry*, p.141
42 A. Jaccaci to R. Fry, 23 November 1908: D.119 Archives of American Art

43 H. Fry to R. Fry, no date: FP
44 Fry's letter to Morgan is reproduced in Sutton, *Letters of Roger Fry*, Vol. I, p.32. A photo-copy of the actual letter is in the Metropolitan Museum Archives
45 H. Horne to R. Fry, 4 August 1909: FP
46 R. Fry to H. Fry, 7 June 1907: FP

Chapter 6

1 'Ideals of a Picture Gallery' *Metropolitan Museum of Art Bulletin*, March 1907
2 *Vision and Design*, p.109
3 Ibid., p.110–11
4 Roger Fry, *The Artist and Psychoanalysis*, (1924) Reprinted in *Inscape No. 6. Journal of the British Association of Art Therapists*, p.11
5 Sutton, *Letters of Roger Fry*, Vol. I, p.293
6 MS Lecture notes: FP
7 *Vision and Design* p.18
8 Leo Tolstoy, *What is Art?*, translated by Aylmer Maude, (Brotherhood Publishing Company, 1898) p.13
9 *Art Journal*, 1909, p.374
10 Quentin Bell, Introduction to *Mark Gertler. Selected Letters*, Noel Carrington (ed.), (Rupert Hart-Davis, 1965) p.9
11 Sold Christie's, 11 March 1960, lot 167. Bought by de Lisle
12 Rutter, *Art in My Time*, p.82
13 Sutton, *Letters of Roger Fry*, Vol. I, p.285
14 Sutton, *Letters of Roger Fry*, Vol. I, p.289
15 R. Fry to Sir E. Fry, 8 April 1908: FP
16 *Vision and Design* p.191
17 *Athenaeum*, 13 January 1906, pp.56–7
18 Rothenstein, *Op. cit.*, Vol. II, p.123
19 Sutton, *Letters of Roger Fry.*, Vol. I, p.300
20 *Nation*, 3 December 1910
21 Sutton, *Letters of Roger Fry*, Vol. I, p.299
22 *The Times*, 23 April 1909
23 *Morning Post*, 23 April 1909
24 See Alfred Barr, *Henri Matisse: His Art and His Public*, (New York: Museum of Modern Art, 1966) p.110. There is no evidence in Fry's letters or papers to verify or disprove Barr's statement which was probably based on a conversation with Clive Bell
25 R. Fry to H. Fry, 17 May 1909: FP
26 *Vision and Design*, p.23
27 *Burlington Magazine*, 1909, 15, p.14
28 *Vision and Design*, p.18
29 Ibid., p.22
30 Ibid., p.25
31 See Berel Lang 'Significance or Form: The Dilemma of Roger Fry', *Journal of Aesthetics*, Winter 1962, pp.167–76
32 R. Fry to J. G. Johnson, 27 February 1908: Johnson Collection Archives, Philadelphia Museum of Art
33 Woolf, *Roger Fry*, p.148
34 Sutton, *Letters of Roger Fry*, Vol. I, p.337
35 Virginia Woolf, *To the Lighthouse*, (Hogarth Press, 1927) p.250

Chapter 7

1 Sutton, *Letters of Roger Fry*, Vol. I, p.336

2 Ibid., p.327
3 Clive Bell, *Old Friends*, (Chatto and Windus, 1956) p.64
4 Vanessa Bell Memoir, No. VI: Professor Quentin Bell
5 Ibid
6 *The Flight of the Mind. The Letters of Virginia Woolf 1888–1912*, ed. Nigel Nicolson (Hogarth Press, 1975) p.201
7 Virginia Woolf, *Moments of Being*, (Sussex: The University Press, 1976) p.175
8 Gerald Brenan, *South From Granada*, (Hamish Hamilton, 1957) p.144
9 Stephen Spender, *World within World*, (Hamish Hamilton, 1957) p.139
10 Fry's two part review was reprinted as 'The Munich Exhibition of Mohammedan Art' in *Vision and Design*, pp.76–86
11 Quoted in *Robert Ross: Friend of Friends*, p.181
12 Sutton, *Letters of Roger Fry*, Vol. I, p.354
13 Desmond MacCarthy 'The Art-Quake of 1910', *Listener*, 1 February 1945
14 Ibid
15 *Pall Mall Gazette*, 10 November 1910
16 *Morning Post*, 7 November 1910
17 *Nation*, 3 December 1910
18 *The Times*, 7 November 1910
19 *Saturday Review*, 12 November 1910
20 W. S. Blunt, *My Diaries, Being a Personal Narrative of Events 1888–1914*, (Martin Secker, no date) pp.343–4
21 *Reynolds Discourses*, p.347
22 Woolf, *Roger Fry*, p.108
23 *Fortnightly Review*, 1 May 1911
24 *Nation*, 3 December 1910
25 See Ian Dunlop's *The Shock of the New*, (Weidenfeld and Nicolson, 1972) and William C. Wees *Vorticism and the English Avant-Garde*, (Manchester University Press, 1972)
26 *Daily Herald*, 25 March 1913
27 Alice Comyns Carr (ed.) *J. Comyns Carr. Stray Memories*, (Macmillan, 1920) p.60
28 *Vision and Design*, pp.192–3
29 Quentin Bell, *Roger Fry. An Inaugural Lecture*, (Leeds University Press, 1964), p.13
30 Woolf, *Roger Fry*, p.152
31 *The Flight of the Mind, The Letters of Virginia Woolf*, p.470
32 Lady Ottoline Morrell to R. Fry, no date: Mrs P. Diamand
33 R. Fry to Lady Ottoline Morrell, 22 September 1901: University of Texas
34 Ibid, 14 October 1910
35 Ibid., 23 November 1910
36 Lady Ottoline Morrell to R. Fry, 2 January 1911: Mrs P. Diamand
37 Quoted in Sandra Jobson Darroch, *Ottoline: The Life of Lady Ottoline Morrell*, (Chatto and Windus, 1976) p.85. The present whereabouts of the portrait is unknown and it was probably destroyed. Henry Lamb, on a visit to Durbins at this time corroborated Lady Ottoline's opinion of the portrait. (See Sutton, *Letters of Roger Fry Op. cit.*, Vol. I, 339)
38 R. Fry to Lady Ottoline Morrell, 4 April: University of Texas
39 Ibid., 13 April 1911
40 Ibid
41 Ibid., 22 April 1911
42 Vanessa Bell Memoir VI: Professor Quentin Bell
43 *Ottoline. The Early Memoirs of Lady Ottoline Morrell*, ed. R. Gathorne Hardy (Faber and Faber, 1963) p.213
44 Jobson Darroch, *Ottoline. The Life of Lady Ottoline Morrell*, p.107
45 *Nation*, 19 November 1910
46 *Nation*, 3 December 1910

47 Sutton, *Letters of Roger Fry*, Vol. I, p.348
48 *Nation*, 16 September 1911
49 R. Fry to H. Brodsky, no date: University of Texas
50 V. Bell to R. Fry, no date [June 1911]: CP
51 *New Age*, 2 June 1910
52 V. Bell to R. Fry, 5 June 1911: CP
53 V. Bell to R. Fry, 16 August 1911: CP
54 This exchange is recounted in King's College, Cambridge Annual Report of the Council under Statute D.III.10 on the General and Educational Condition of the College, 17 November 1934, which includes an obituary on Roger Fry.
55 *Nation*, 11 November 1911
56 *Morning Post*, 4 January 1912
57 *The Times*, 5 January 1912
58 E. M. Forster to Mrs E. Barger, 24 December 1911: Forster Papers, King's College, Cambridge
59 Recounted in P. N. Furbank's *E. M. Forster: A Life*. Vol. I. (Secker & Warburg, 1977) pp.205–7
60 Sutton, *Letters of Roger Fry*, Vol. I, p.359

Chapter 8

1 *Nation*, 9 March 1912
2 *Mark Gertler, Selected Letters*, p.47
3 Sutton, *Letters of Roger Fry*, Vol. I, p.344
4 *Nation*, 11 June 1910
5 W. Rothenstein to R. Fry, 19 March 1911: FP
6 R. Fry to W. Rothenstein, 28 March 1911: Houghton Library, Harvard University
7 W. Rothenstein to R. Fry, 17 April 1911: FP
8 Michael Holroyd, *Augustus John: The Years of Innocence*, (Heinemann, 1974) p.371
9 Sutton, *Letters of Roger Fry*, Vol. I, p.345
10 *Observer*, 27 October 1912
11 *Observer*, 24 October 1912
12 Introduction to the Second Post-Impressionist Exhibition catalogue. Reprinted in *Vision and Design*, pp.156–9
13 Ashbee Journals, 11 October 1912: King's College, Cambridge
14 Benedict Nicolson, 'Post-Impressionism and Roger Fry', *Burlington Magazine*, January 1951, 93, p.11 ff
15 Sutton, *Letters of Roger Fry*, Vol. I, p.362
16 *Nation*, 22 February 1913
17 Quoted in Michael Holroyd, *Lytton Strachey: The Years of Achievement*, (Holt, Rinehart and Winston, 1968) p.23
18 *Fortnightly Review*, 1 May 1911
19 Clive Bell, *Art*, (Chatto and Windus, 1914) p.44
20 Ibid, p.25
21 *Nation*, 7 March 1914
22 The portraits by Grant, Bell and Fry respectively belong to a private collector, Mr Richard Carline and the Humanities Collection, University of Texas
23 *Nation*, 2 August 1913
24 Reproduced in Zervos, *Picasso*, Vol. II, p.431
25 In conversation with the critic Michael Shepherd, who recounted this remark to the author
26 Sutton, *Letters of Roger Fry*, Vol. II, p.377
27 *New Age*, 26 January 1914
28 *Pall Mall Gazette*, 8 January 1914

29 Undated manuscript notes (possibly initial draft for a letter): FP
30 V. Bell to R. Fry, no date (1914): CP
31 See note 29
32 Sutton, *Letters of Roger Fry*, Vol. I, p.366
33 V. Bell to C. Bell, 14 June 1931: CP

Chapter 9

1 *Vision and Design*, p.41
2 Ibid., p.45
3 Ibid., p.49
4 Ibid., p.51
5 L. P. Smith to R. Fry, 21 December 1912: FP
6 R. Fry to G. B. Shaw, 11 December 1912: Add. MS. 50534, British Library, Manuscripts Department
7 *Daily News and Leader*, 7 August 1913
8 R. Fry to H. Anrep, 14 May 1929: AP
9 Undated Omega catalogue, Victoria and Albert Museum Library
10 *Nation*, 18 January 1913
11 Ibid., 1 February 1913
12 Wyndham Lewis, *Rude Assignment*, (Hutchinson, no date) p.124
13 See W. K. Rose (ed.) *The Letters of Wyndham Lewis*, (Methuen, 1963) p.51
14 See Quentin Bell's and Stephen Chaplin's 'The Ideal Home Rumpus', *Apollo*, October 1964, pp.284. ff, and Richard Cork's *Vorticism and Abstract Art in the First Machine Age. Vol I. Origins and Development*, (Gordon Fraser, 1976) pp.85 ff
15 R. Fry to G. B. Shaw, 11 November 1913: Add. MS. 50534, British Library, Manuscripts Department
16 Lewis, *Rude Assignment*, p.124
17 William Roberts, *Abstract and Cubist Paintings and Drawings*, (A Canale Publication, no date [1956]) p.7
18 G. B. Shaw to R. Fry, 22 May 1914: typescript copy in the possession of Mrs P. Diamand (original lost)
19 The Hyde Park Gardens mosaics and stained glass are still in position; the Bedford Square decorations (like the Cadena Cafe) are destroyed, as are those at 4 Berkeley Street. The latter are reproduced in *Colour Magazine*, July 1916, pp.187–88
20 This incident is recounted in a letter from W. Gill to D. Grant, 27 November 1966: Victoria and Albert Museum
21 See note 9
22 Harold Acton, *Memoirs of an Aesthete*, (Methuen, 1948) p.90
23 R. Fry to G. B. Shaw, 22 March 1914: Add. MS. 50534, British Library, Manuscripts Department
24 *Vision and Design*, p.40

Chapter 10

1 Sutton, *Letters of Roger Fry*, Vol. II, p.381
2 Ibid., p.385
3 MS 'The Friends work for war victims in France': FP
4 R. Fry to W. Gill, 17 May 1915: Victoria and Albert Museum Library
5 Sutton, *Letters of Roger Fry*, Vol. II, p.388
6 *Burlington Magazine*, 1916, 28, p.118
7 Sutton, *Letters of Roger Fry*, Vol. II, p.398
8 Ibid., p.390
9 Ibid., p.398
10 This incident is recalled in a letter from W. Gill to D. Grant, 18 August 1966:

Victoria and Albert Museum Library
11 Woolf, *Roger Fry*, p.215
12 *Burlington Magazine*, 1917, 31, pp.52–61
13 Sutton, *Letters of Roger Fry*, Vol. II, p.419
14 *Burlington Magazine*, 1918, 32, p.38
15 *Nation*, 3 December 1910
16 R. Fry to V. Bell, 29 April 1916: CP
17 Sutton, *Letters of Roger Fry*, Vol. II, p.400
18 Shaw's letter recounting this incident to Virginia Woolf is quoted in Leonard Woolf's *Beginning Again* (Hogarth Press, 1964) p.126
19 *The Selected Letters of Ezra Pound*, ed. D. D. Paige, (Faber and Faber, 1971) p.86
20 R. Fry to V. Bell, no date [August 1916]: CP
21 Ibid., 15 August 1916
22 *Burlington Magazine*, 1916, 29, pp.209–10
23 Ibid., 1918, 32, p.85
24 Ibid., 1916, 29, p.100
25 Ibid., 1917, 30, p.148
26 Typescript of lost original in the possession of Mrs P. Diamand
27 *Burlington Magazine*, 1917, 31, p.30
28 *The Diary of Virginia Woolf, Vol. I. 1915–19*, ed. Anne Olivier Bell, (Hogarth Press, 1977) p.134
29 R. Fry to V. Woolf, 18 October 1918: University of Sussex
30 R. Fry to V. Bell, 17 March 1917: CP
31 'Exhibition of Drawings and Designs by Children', Whitworth Art Gallery, Manchester, Spring 1928
32 *Daily Telegraph Colour Supplement*, 18 April 1975
33 R. Fry to H. Anrep, 26 September 1925: AP. Fry's official report on the Mantegna cycle is in the files of the Surveyor of the Queen's Pictures, St James's Palace, London
34 R. Fry to W. Rothenstein, 6 June 1909: Houghton Library, University of London
35 R. Fry to A. Bennett, 16 February 1919: University College Library, University of London
36 *The Diary of Virginia Woolf, Vol. I, 1915–19*, pp.140–1
37 *Vision and Design*, p.162
38 R. Fry to E. M. Kauffer, 30 May 1918: Pierpont Morgan Library, New York
39 *Letters of Aldous Huxley*, (Chatto and Windus, 1969) p.169

Chapter 11

1 *Mark Gertler, Selected Letters*, p.175
2 Foreword to the 'Group X' exhibition catalogue, Mansard Gallery, London, March 1920
3 Lewis, *Rude Assignment*, p.129
4 R. Fry to V. Bell, 22 February 1919: CP
5 R. Fry to A. Bennett, 3 March 1919: University College Library, University of London
6 Ibid., 13 May 1919
7 Ibid., 2 June 1919
8 Sutton, *Letters of Roger Fry*, Vol. II, p.458
9 Ibid., p.462
10 Ibid., p.467
11 Ibid., p.469
12 C. Bell to V. Bell, 20 November 1919: CP
13 Sutton, *Letters of Roger Fry*, Vol. II, p.474
14 Ibid., p.476

15 *Saturday Review*, 8 December 1923
16 *Vision and Design*, p.188
17 Ibid., p.192
18 Ibid., p.199
19 *Times Literary Supplement*, 30 December 1920
20 *Vision and Design*, pp.65-6
21 Ibid., p.67
22 *Henry Moore on Sculpture*, Philip James, (Macdonald, (1966)) p.33
23 *Vision and Design*, pp.33-4
24 Sutton, *Letters of Roger Fry*, Vol. II, p.497
25 R. Fry to V. Bell, 17 April 1920: CP
26 *The Spectator*, 18 June 1920
27 Sutton, *Letters of Roger Fry*, Vol. II, pp.481-2
28 C. Bell to V. Bell, no date [1920]: CP
29 Ibid., no date [1920]
30 *Saturday Review*, 29 October 1921
31 Frank Rutter, *Since I was Twenty-Five*, (Constable, 1927) p.193
32 Sutton, *Letters of Roger Fry*, Vol. II, p.498
33 Rutter, *Art in My Time*, p.187
34 *Nation and Athenaeum*, 1 May 1926
35 Sutton, *Letters of Roger Fry*, Vol. II, p.502
36 R. Fry to V. Bell, 28 April 1922: CP
37 Ibid., 14 September 1922
38 F. H. Smith to R. Fry, 7 August 1922: FP
39 Ibid., 12 April 1923
40 *Birmingham Post*, 3 April 1923
41 *Art and Artists*, 8 April 1923
42 *Observer*, 8 April 1923
43 *The Times*, 10 April 1923
44 See note 42
45 Sutton, *Letters of Roger Fry*, Vol. II, p.533
46 Typescript record of Roger Fry's deposition: Professor Quentin Bell
47 Roger Fry, *A Sampler of Castile*, (Hogarth Press, 1923) p.6
48 Ibid., p.8
49 Sutton, *Letters of Roger Fry*, Vol. II, p.540
50 *The Diary of Virginia Woolf. Vol. II. 1920-1924*, Anne Olivier Bell (ed.), (Hogarth Press, 1978) p.303
51 Tape recorded conversation between Mrs Pamela Diamand, Philip Troutman and the author, at the Roger Fry Portrait Exhibition, Courtauld Institute Galleries, 13 October 1976
52 Gerald Brenan, *Personal Record*, (Jonathan Cape, 1974) p.77
53 Sutton, *Letters of Roger Fry*, Vol. II, p.559

Chapter 12

1 *A Change of Perspective. The Letters of Virginia Woolf, Vol. 3*, Nigel Nicolson (ed.), (Hogarth Press 1977) p.566
2 Quoted in Frances Partridge's *A Pacifist's War*, (Hogarth Press, 1978) p.201
3 R. Fry to H. Anrep, 1 April 1925: AP
4 R. Fry to V. Bell, 28 December 1925: CP
5 R. Fry to H. Anrep, 15 April 1925: AP
6 Ibid., 8 July 1925
7 Sutton, *Letters of Roger Fry*, Vol. II, p.565
8 R. Fry to G. Brenan, 30 April 1925: University of Texas
9 R. Fry to H. Anrep. 17 September 1925: AP
10 *Daily Telegraph*, 25 May 1926
11 I. A. Richard, *The Principles of Literary Criticism*, (Kegan Paul, 1924) p.16

12 Roger Fry, *Transformations*, (Chatto and Windus, 1926) p.5
13 Ibid., p.25
14 *The Artist and Psycho-Analysis* (1924) p.6
15 Ibid., p.11
16 *Transformations*, pp.40–1
17 Ibid., p.80
18 Ibid., p.194
19 Ibid., p.147
20 Ibid., p.176
21 R. Fry to H. Anrep. no date [Summer 1926]: AP
22 Theodore Reff 'Painting and Theory in the Final Decade' in *Cézanne. The Late Work*, William Rubin (ed.), (Thames and Hudson, 1977) p.13
23 Roger Fry, *Cézanne. A Study of His Development*, (Hogarth Press, 1927) p.17
24 Ibid., p.29
25 Ibid.. p.37
26 Ibid., p.88
27 R. Fry to G. Brenan, 16 October 1925: University of Texas
28 Sutton, *Letters of Roger Fry*, Vol. II, p.597
29 Roger Fry, *French, Flemish and British Art*, (Chatto and Windus, 1951) p.4
30 Ibid., pp.138–9
31 Ibid., p.14
32 *Morning Post*, 9 June 1923
33 Woolf, *Letters of Roger Fry*, p.240
34 *Transformations*, p.5
35 Virginia Woolf, *A Writer's Diary*, (Hogarth Press, 1953) p.164
36 R. Fry to V. Woolf, 17 May 1927: University of Sussex
37 *A Change of Perspective. The Letters of Virginia Woolf. Vol. 3.* p.385
38 R. Fry to V. Woolf, 3 December 1928: University of Sussex
39 R. Fry to V. Bell, 21 January 1929: CP
40 R. Fry to M. Berenson, 6 February 1932: Berenson Archives, I Tatti, Florence
41 *A Reflection of the Other Person. The Letters of Virginia Woolf, Vol. 4,* Nigel Nicolson (ed.), (Hogarth Press, 1978) pp.128–9
42 MS. notes on The German Tour: FP
43 Ibid
44 Ibid
45 Sutton, *Letters of Roger Fry*, Vol. II, pp.526–7
46 Sutton, *Letters of Roger Fry*, Vol. II, p.675
47 R. Fry to V. Bell, 7 March 1930: CP
48 *Studio International*, Jan/Feb 1977, Vol. 193, p.69
49 V. Bell to C. Bell, 23 January 1931: CP
50 Roger Fry, *Henri Matisse*, (Zwemmer, 1930) pp.9-10
51 R. Fry to H. Anrep, 31 December 1928: AP
52 Sutton, *Letters of Roger Fry*, Vol. II, p.688
53 R. Fry to V. Bell, 17 August 1930: CP
54 R. Fry to G. Brenan, 19 March 1933: University of Texas
55 See the Introduction to Roger Fry's *Last Lectures*, Kenneth Clark (ed.), (Cambridge University Press, 1939) p.xx
56 Ibid., p.44
57 R. Fry to M. Berenson, 6 February 1932: Berenson Archives, I Tatti, Florence
58 G. M. Turnell, 'Mallarmé', *Scrutiny*, March 1937, p.428
59 Roger Fry, *Some Poems by Mallarmé*, (Chatto and Windus, 1936) p.306
60 R. Fry to V. Bell, 20 June 1933: CP
61 R. Fry to L. C. Powles, 18 February 1928: FP
62 *Last Lectures*, p.ix
63 *Some Poems by Mallarmé*, p.1
64 *Last Lectures*, p.vi
65 Woolf, *A Writer's Diary*, p.244

Select Bibliography

For all Roger Fry's publications the reader is referred to Donald Laing's *An Annotated Bibliography of the Published Writings of Roger Fry*. New York: Garland Publishing, Inc. 1979

ACTON, Harold. *Memoirs of an Aesthete*. London: Methuen 1948.
ALLEN, Frederick Lewis. *The Great Pierpont Morgan*. London: Victor Gollancz 1949.
BARON, Wendy. *Sickert*. London: Phaidon Press 1973.
—— *Miss Ethel Sands and Her Circle*. London: Peter Owen 1977.
BEARDSMORE, R. W. *Art and Morality*. London: Macmillan 1971.
BEITH, Gilbert (ed.). *Edward Carpenter. In Appreciation*. London: Allen and Unwin 1931.
BELL, Clive. *Art*. London: Chatto and Windus 1914.
—— 'Mr Fry's Criticism'. *New Statesman*, 8 January 1921, pp.422–3.
—— *Pot-Boilers*. London: Chatto and Windus 1918.
—— *Since Cézanne*. London: Chatto and Windus 1922.
—— *Civilization*. London: Chatto and Windus 1928.
—— 'How England Met Modern Art'. *Art News*, October 1950, Vol. 49, pp.24–7, 61.
—— *Old Friends*. London: Chatto and Windus 1956.
BELL, Julian. *Essays, Poems and Letters*. London: Hogarth Press 1938.
BELL, Quentin. *Roger Fry. An Inaugural Lecture*. University of Leeds 1964.
—— 'The Omega Revisited'. *Listener*, 30 January 1964, pp.201 ff.
—— and Stephen Chaplin. 'The Ideal Home Rumpus', *Apollo*, October 1964, Vol.80, pp.284–91.
—— and Stephen Chaplin. 'Reply with Rejoinder'. *Apollo*, January 1966, Vol.83, p.75.
—— and Philip Troutman. *Vision and Design: The Life, Work and Influence of Roger Fry, 1886–1934*, catalogue to Arts Council exhibition, 1966.
—— *Bloomsbury*. London: Weidenfeld and Nicolson 1968.
—— *Virginia Woolf: A Biography: Volume One. Virginia Stephen 1882–1912*. London: Hogarth Press 1972.
—— *Virginia Woolf: A Biography. Volume Two: Mrs Woolf 1912–1941*. London: Hogarth Press 1972.
BENNETT, Arnold. *The Journals of Arnold Bennett*, edited by Frank Swinnerton. London: Penguin 1954.
BERENSON, Bernard. *The Italian Painters of the Renaissance*. London: Phaidon Press 1952.
BERTRAM, Anthony. *A Century of British Painting 1851–1951*. London: Studio Publications 1951.
BRENAN, Gerald. *South from Granada*. London: Hamish Hamilton 1957.
—— *A Personal Record*. London: Jonathan Cape 1974.

BROWN, Oliver. *Exhibition. The Memoirs of Oliver Brown*. London: Evelyn Adams and Mackay 1968.

CAMPOS, Christopher. *The View of France: From Arnold to Bloomsbury*. London: Oxford University Press, 1965.

CANFIELD, Cass. *The Incredible Pierpont Morgan. Financier and Art Collector*. New York: Harper Row 1974.

CARPENTER, Edward. *My Days and Dreams*. London: Allen and Unwin 1916.

CARRINGTON, Noel (ed.). *Mark Gertler. Selected Letters*. London: Rupert Hart-Davis 1965.

CHAMOT, Mary. *Modern Painting in England*. London: Country Life Ltd. 1937.

——, Dennis Farr and Martin Butlin. *Tate Gallery Catalogues: The Modern British Paintings, Drawings and Sculpture*, 2 vols. London: Oldbourne Press 1964-65.

CLARK, Kenneth. *Another Part of the Wood*. London: John Murray 1974.

COOPER, Douglas. *The Courtauld Collection: A Catalogue and Introduction*. London: Athlone Press 1954.

CORK, Richard. *Vorticism and Abstract Art in the First Machine Age. Volume One, Origins and Development*. London: Gordon Fraser 1975.

—— *Vorticism and Abstract Art in the First Machine Age. Volume Two. Synthesis and Decline*. London: Gordon Fraser 1976.

DANGERFIELD, George. *The Strange Death of Liberal England 1910-1914*. London: New York: Paladin 1961.

DARROCH, Sandra Jobson. *Ottoline: A Life of Lady Ottoline Morrell*. London: Chatto and Windus 1976.

DICKINSON, Goldsworthy Lowes. *John McTaggart*. Cambridge University Press 1931.

—— *The Meaning of Good. A Dialogue*. London: R. Brimley Johnson 1901.

DUNLOP, Ian. *The Shock of the New: Seven Historic Exhibitions of Modern Art*. London: Weidenfeld and Nicolson 1972.

DUVEEN, Joseph. *Thirty Years of British Art*. London: Studio Special Autumn Number 1930.

EASTON, Malcolm. *Art in Britain 1890-1940*. Catalogue of an exhibition held at the University of Hull in 1967.

—— and Michael Holroyd. *The Art of Augustus John*. London: Secker and Warburg 1974.

EDDY, Arthur Jerome. *Cubists and Post-Impressionism*. London and Chicago: Grant Richards Limited 1914.

EGBERT, D. D. 'English Art Critics and Modern Social Radicalism', *Journal of Aesthetics*. Fall 1967, Vol.26, pp.31-4.

EMMONS, Robert. *The Life and Opinions of Walter Richard Sickert*. London: Faber and Faber 1941.

FIELDING, Daphne. *The Rainbow Picnic: A Portrait of Iris Tree*. London: Eyre Methuen 1974.

FISHMAN, Solomon. *The Interpretation of Art*. University of California Press 1963.

FORSTER, E. Morgan. *Goldsworthy Lowes Dickinson*. London: Edward Arnold 1934.

—— *Two Cheers for Democracy*. London: Edward Arnold 1951.

FRY, Agnes. *A Memoir of the Right Honourable Sir Edward Fry*. London: Oxford University Press 1921.

FURBANK, P. N. *E. M. Forster: A Life*. Volume One. *The Growth of the Novelist (1879–1914)*. London: Secker and Warburg 1977.

—— *E. M. Forster: A Life*. Volume Two. *Polycrates' Ring, (1914–1970)*. London: Secker and Warburg 1978.

GARNETT, David. *The Golden Echo. The First Part of an Autobiography*. London: Chatto and Windus 1954.

—— *The Flowers of the Forest*. London: Chatto and Windus 1955.

—— Introduction and selection of – *Carrington: Letters and Extracts from her Diaries*. London: Jonathan Cape 1938.

GATHORNE-HARDY, Robert, (ed.). *The Early Memoirs of Lady Ottoline Morrell*. London: Faber and Faber 1963.

—— (ed.) *Ottoline at Garsington*. London: Faber and Faber 1974.

GLENAVY, Beatrice, Lady. *Today we will only Gossip*. London: Constable 1964.

GOLDRING, Douglas. *The Nineteen Twenties: A General Survey and Some Personal Memoirs*. London: Nicolson and Watson 1945.

GROSSKURTH, Phyllis. *John Addington Symonds: A Biography*. London: Longmans 1964.

GUNN, Peter. *Vernon Lee*. London: Oxford University Press 1964.

HAMILTON, George Heard. *Painting and Sculpture in Europe, 1880–1940*. London: Penguin 1967.

HAMNETT, Nina. *Laughing Torso: Reminiscences*. London: Constable 1932.

—— *Is She a Lady? A Problem in Autobiography*. London: Allen Wingate 1955.

HANNAY, Howard. *Roger Fry and Other Essays*. London: Allen and Unwin 1937.

HARRISON, Charles. 'Roger Fry in Retrospect', *Studio International*, May 1966, Vol.171, pp.220–1.

HARROD, Roy. *The Life of John Maynard Keynes*. London: Macmillan 1951.

HARTRICK, A. S. *A Painter's Pilgrimage through Fifty Years*. London: Cambridge University Press 1939.

HASSALL, Christopher. *Edward Marsh. Patron of the Arts. A Biography*. London: Longmans 1959.

—— *Rupert Brooke: A Biography*. London: Faber 1964.

HIND, C. Lewis. *The Post-Impressionists*. London: Methuen 1911.

HOLMAN-HUNT, Diana. *Latin Among Lions: Alvaro Guevara*. London: Michael Joseph 1974.

HOLMES, Charles. *Self and Partners (Mostly Self)*. London: Constable 1936.

HOLROYD, Michael. *Lytton Strachey: The Unknown Years 1880–1910*. London: Heinemann 1967.

—— *Lytton Strachey: The Years of Achievement 1910–1932*. London: Heinemann 1968.

—— *Augustus John*. Volume One. *The Years of Innocence*. London: Heinemann 1974.

—— *Augustus John*. Volume Two. *The Years of Experience*. London: Heinemann 1975.

—— *Unreceived Opinions*. London: Penguin 1976.

HOMBERGER, Eric. et al. (ed.). *The Cambridge Mind*. London: Jonathan Cape 1970.

HONE, Joseph. *The Life of Henry Tonks*. London: Heinemann 1939.

HUBBARD, Hesketh. *A Hundred Years of British Painting 1851–1951*. London: Longmans 1951.

HULME, T. E. *Speculations. Essays on Humanism and the Philosophy of Art*. edited by Herbert Read. London: Routledge and Kegan Paul 1924.

HUWS JONES, E. *Margery Fry. The Essential Amateur*. London: Oxford University Press 1966.

HYNES, Samuel. *The Edwardian Turn of Mind*. New Jersey: Princeton University Press 1968.

ISICHEI, Elizabeth. *Victorian Quakers*. London: Oxford University Press 1970.

JACOMB-HOOD, E. P. *With Brush and Pencil*. London: John Murray 1925.

JEPSON, Edgar. *Memoirs of an Edwardian and Neo-Georgian*. London: Martin Secker 1937.

JOHN, Augustus. *Chiaroscuro: Fragments of Autobiography: First Series*. London: Jonathan Cape 1952.

JOHNSTONE, J. K. *The Bloomsbury Group*. London: Secker and Warburg 1954.

KEYNES, John Maynard. *Two Memoirs*. London: Macmillan 1949.

LAGO, Mary M. and Karl Beckson (ed.). *Max & Will: Max Beerbohm and William Rothenstein Their Friendship and Letters 1893–1945*. London: John Murray 1975.

LAGO, Mary M. (ed.) *William Rothenstein. Men and Memories*. London: Chatto and Windus 1978.

LAIDLAY, W. J. *The Origin and First Two Years of the New English Art Club*. London: 1907.

LANG, Berel. 'Significance or Form: The Dilemma of Roger Fry', *Journal of Aesthetics*. Winter 1962, pp.167–176.

LAVER, James. *Portraits in Oil and Vinegar*. London: John Castle 1925.

LEHMANN, John. *The Whispering Gallery: Autobiography 1*. London: Longmans 1955.

LEWIS, Percy Wyndham. *Blasting and Bombardiering*. University of California Press 1967.

—— *Rude Assignment*. London: Hutchinson, no date.

LILLY, Marjorie. *Sickert. The Painter and His Circle*. London: Elek Books 1971.

MacCARTHY, Desmond. 'The Art-Quake of 1910', *Listener*, 1 February 1945.

—— *Memories*. London: MacGibbon and Kee 1953.

McLAURIN, Allen. *Virginia Woolf: The Echoes Enslaved*. Cambridge University Press 1973.

MacCOLL, D. S. *Confessions of a Keeper and other papers*. London: Alexander Maclehose 1931.

MAURON, Charles. *The Nature of Beauty in Art and Literature*. London: Hogarth Press 1926.

MOORE, George. *Modern Painting*. London: Walter Scott n.d. (1893).

MOORE, G. E. *Principia Ethica*. Cambridge University Press 1903.

MORPHET, Richard. *British Painting 1910–1945*. London: Tate Gallery 1967.

—— 'Bloomsbury Painters', *Studio International*, Jan./Feb. 1977, Vol.193, pp.68–70.

NASH, Paul. *Outline: An Autobiography and other writings*; with a preface by Herbert Read. London: Faber and Faber 1949.

NEVINSON, C. R. W. *Paint and Prejudice*. London: Methuen 1937.

NICOLSON, Benedict. 'Post-Impressionism and Roger Fry', *Burlington Magazine*, January 1951, Vol.93, pp.11–15

—— 'Roger Fry and the Burlington Magazine', *Burlington Magazine*, October 1966, Vol.108, p.493.

PARTRIDGE, Frances. *A Pacifist's War*. London: Hogarth Press 1978.

PROCTOR, Dennis (ed.). *The Autobiography of Goldsworthy Lowes Dickinson*. London: Duckworth 1973.

RANTAVAARA, Irma. *Virginia Woolf and Bloomsbury*. Helsinki 1953.

READ, Herbert. *Annals of Innocence and Experience*. London: Faber and Faber 1946.

RICHARDS, I. A. *Principles of Literary Criticism*. London: Routledge and Kegan 1924.

RICHARDSON, Marion. *Art and the Child*. London: University of London Press 1948.

RICKETTS, Charles. *Pages on Art*. London: Constable 1913.

ROBERTS, Keith. 'Vision and Design, the Arts Council centenary exhibition', *Burlington Magazine*, May 1966, Vol.108, p.273.

ROBERTS, William. *Abstract and Cubist Paintings and Drawings*. London: Canale Press no date [1976].

ROSENBAUM, S. P. (ed.). *The Bloomsbury Group: A Collection of Memories: Commentary and Criticism*. London: Croom Helm 1975.

ROSE, W. K. (ed.). *The Letters of Wyndham Lewis*. London: Methuen 1963.

ROSS, Denman W. *A Theory of Pure Design*. Boston and New York: Houghton, Mifflin and Co. 1907.

ROSS, Margery (ed.). *Robert Ross: Friend of Friends*. London: Jonathan Cape 1952.

ROTHENSTEIN, John. *Modern English Painters*, Vols.1 and 2, London: Eyre and Spottiswoode 1952 and 1956.

ROTHENSTEIN, William. *Men and Memories: Recollections 1872–1900*. London: Faber and Faber 1931.

—— *Men and Memories: Recollections 1900–1922*. London: Faber and Faber 1932.

RUSSELL, Bertrand. *Autobiography, Volume 1: 1872–1913*. London: Allen and Unwin 1967.

RUTTER, Frank. *Evolution in Modern Art: A Study of Modern Painting 1870–1925*. London: Harrap 1926.

—— *Since I was Twenty-five*. London: Constable 1927.

—— *Art in My Time*. London: Rich and Cowan 1933.

SANTANYANA, George. *The Sense of Beauty*. (1896) New York: Dover 1955.

SHONE, Richard. *Bloomsbury Portraits*. London: Phaidon Press 1976.

—— 'The Friday Club', *Burlington Magazine*, May 1975, Vol.117, pp.279–84

SITWELL, Edith. *Taken Care of*. London: Hutchinson 1965.

SITWELL, Osbert. *A Free House! Or The Artist as Craftsman (Being the Writings of Walter Richard Sickert.* London: Macmillan 1947.

—— *Laughter in the Next Room.* London: Macmillan 1949.

SMART, Alistair. 'Roger Fry and Early Italian Art,' *Apollo,* April 1966, pp.262–71.

SPALDING, Frances. *Portraits by Roger Fry,* catalogue to exhibition held at the Courtauld Institute Galleries and elsewhere 1976.

SPATER, George, and Ian Parsons. *A Marriage of True Minds.* London: Johnathan Cape and Hogarth Press 1977.

SPEAIGHT, Robert. *William Rothenstein: The Portrait of an Artist in his Time.* London: Eyre and Spottiswoode 1962.

SPENDER, Stephen. *World within World.* London: Hamish Hamilton 1951.

SPRIGGE, Sylvia. *Berenson. A Biography.* London: Allen and Unwin 1960.

SUTTON, Denys. (ed.). *Letters of Roger Fry.* 2 vols. London: Chatto and Windus 1972.

—— *Walter Sickert.* London: Michael Joseph 1976.

—— *A Silver Age in British Art.* Introduction and notes to the catalogue of *British Art 1890–1928,* an exhibition held at the Columbus Gallery of Fine Arts, Columbus, Ohio, February-March 1971.

TAYLOR, David. 'The Aesthetic Theories of Roger Fry Reconsidered', *Journal of Aesthetics,* Fall 1977, XXXVI, pp.63–72.

THORNTON, Alfred. *Fifty Years of the New English Art Club 1886–1935.* London: Cowen Press 1935.

—— *Diary of an Art Student of the Nineties.* London: Pitman and Sons 1938.

TOLSTOY, Leo. *What is Art?* The Tolstoy Centenary Edition, translated by A. Maude. London: Brotherhood Publishing Co. 1898.

TOMKINS, Calvin. *Merchants and Masterpieces – The Story of the Metropolitan Museum of Art.* New York: Dutton 1970.

WEES, William C. *Vorticism and the English Avant-Garde.* Toronto and Manchester: Manchester University Press 1972.

WOODESON, John. *Mark Gertler: Biography of a Painter 1891–1939.* London: Sidgwick and Jackson 1972.

WOOLF, Leonard. *Beginning Again. An Autobiography of the Years 1911–1918.* London: Hogarth Press 1964.

—— *Downhill All the Way. An Autobiography of the Years 1919–1939.* London: Hogarth Press 1967.

WOOLF, Virginia. *Roger Fry: A Biography.* London: Hogarth Press 1940.

—— *A Writer's Diary: Being Extracts from the Diary of Virginia Woolf,* ed. Leonard Woolf. London: Hogarth Press 1954.

—— *Collected Essays. Volume 4.* London: Hogarth Press 1967.

—— *The Flight of the Mind. The Letters of Virginia Woolf 1888–1912* edited by Nigel Nicolson. London: Hogarth Press 1975.

—— *The Question of Things Happening. The Letters of Virginia Woolf 1912–1922* edited by Nigel Nicolson. London: Hogarth Press 1976.

—— *A Change of Perspective. The Letters of Virginia Woolf 1923–1928* edited by Nigel Nicolson. London: Hogarth Press 1977.

—— *A Reflection of the Other Person. The Letters of Virginia Woolf 1929–1931* edited by Nigel Nicolson. London: Hogarth Press 1978.

—— *Moments of Being. Unpublished Autobiographical Writings* edited by J. Shulkind. Sussex University Press 1976.

—— *The Diary of Virginia Woolf. Volume I. 1915–1919* edited by Anne Olivier Bell. London: Hogarth Press 1977.

—— *The Diary of Virginia Woolf. Volume II. 1920–1924* edited by Anne Olivier Bell. London: Hogarth Press 1978.

Index

Index